GEORGE COSTAKIS

A RUSSIAN LIFE IN ART

By

PETER ROBERTS

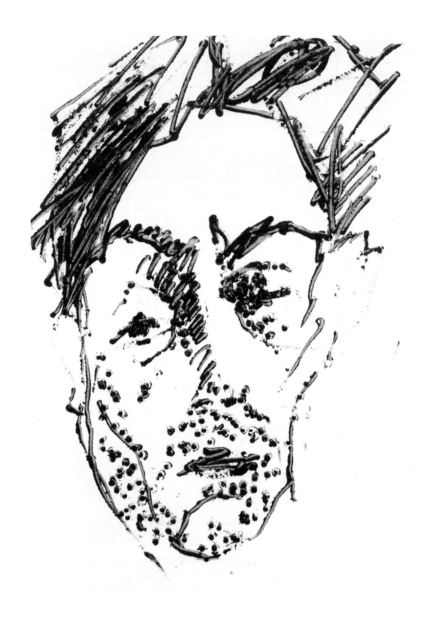

Anatolii Timofeevich Zverev. *Portrait of George Costakis*. Ink on paper.

GEORGE COSTAKIS

A RUSSIAN LIFE IN ART

PETER ROBERTS

CARLETON UNIVERSITY PRESS
OTTAWA, CANADA
1994

VLJ
ROB

CANADIAN CATALOGUING IN PUBLICATION DATA

Roberts, Peter, 1927-
 George Costakis : a Russian life in art

Includes bibliographical references and index.
ISBN 0-88629-206-9 (bound) – ISBN 0-88629-207-7
 (pbk.)

 1. Costakis, George, 1912-1990 (Kostaki,
Georgii Dionisovich) 2. Painting, Russian—
Collectors and collecting—Soviet Union—
Biography. 3. Costakis, George, 1912-1990—Art
collections. 4. Painting, Russian—Private
collections—Soviet Union. 5. Painting, Russian.
6. Painting, Modern—20th century—Soviet Union.
7. Diplomatic and consular service, Canadian—
Soviet Union—Biography. I. Title.

N5276.2.C68R62 1993 759.7'09041 C93-090452-4

Carleton University Press Distributed in Canada by:
160 Paterson Hall Oxford University Press Canada
1125 Colonel By Drive 70 Wynford Drive
Ottawa, ON Canada Don Mills, ON Canada
K1S 5B6 M3C 1J9
(613) 788-3740 (416) 441-2941

Cover and interior design by Victory Design Inc., Ottawa.
Front cover photo by Andrej Reiser / Bilderberg

ACKNOWLEDGMENTS

Carleton University Press gratefully acknowledges the support extended to its
publishing programme by the Canada Council, and the financial assistance of the
Ontario Arts Council.
 The Press would also like to thank the Department of Canadian Heritage,
Government of Canada, and the Government of Ontario through the Ministry
of Culture, Tourism and Recreation, for their assistance.

ACKNOWLEDGMENTS

The most important parts of this book were written by a man who is now dead, George Costakis. Old, ill, and often in terrible pain, he took the microphone in his shaky hands and dictated material which added up to some four hundred pages of typescript.

To the second of his three daughters, Aliki (Lilya) I am particularly beholden. At her father's side until his death, she helped him with his work on this book, as with his collection and all else.

I have to give special recognition to Queen's University, particularly to the Department of Political Studies and to its Skelton-Clark fellowship, which I had the honour to hold while I was at work on this book.

S. Frederick Starr, then president of Oberlin College, and Angelica Rudenstine, curator of the great exhibition of Costakis' collection at the Guggenheim Museum in New York in 1981, both gave me the benefit of their knowledge of Costakis and his collections.

The Montreal Museum of Fine Arts and its director M. Pierre Théberge have been generous with time and resources, and have made possible many of the illustrations.

The National Gallery of Canada furnished me with material very hard to find elsewhere, and did so with ease and friendly grace.

Vladimir Vassin and Irene Gryndahl did a superb job of getting George's Russian language, not always the easiest, from tape to paper where I could work with it.

My wife, Glenna, breathed life into the enterprise and was a searching critic of every word I have written. She came to know George Costakis in his late years, but loved him as we all did.

Finally, I owe much to Carleton University Press, especially Michael Gnarowski and Jennifer Strickland, who took on the book at a difficult stage and saw it through to publication with dedication and enthusiasm.

The author and publishers wish to thank the following who have kindly given permission for use of copyright materials:

The reproduction of all art work has been authorized by Art Co. Ltd. (The George Costakis Collection), except for Rozanova's *Green Stripe*, which appears Courtesy Annely Juda Fine Art, London, and Rodchenko's *Oval Hanging Construction Number 12*, from THE MUSEUM OF MODERN ART, NEW YORK. The latter's acquisition was made possible through the extraordinary efforts of George and Zinaida Costakis, and through the Nate B. and Frances Spingold, Matthew H. and Erna Futter, and Enid A. Haupt Funds. Photograph © 1994 The Museum of Modern Art, New York.

pp. 44, 46: Avon Books, for permission to quote from the novel *We*, by Yevgeny Zamyatin. Copyright © 1972 by Mirra Ginsburg;

pp. 45, 47: Collins Harvill (HarperCollins), publishers, London, for permission to use an extract from *Writers in Russia 1917-1978*, by Max Hayward, © 1983, by the Warden and Fellows of St. Anthony's College, Oxford; pp. 45-46: and for permission to quote several passages from *Russian Studies*, by Leonard Schapiro, © 1986 by Isabel de Madariaga and Roma Schapiro;

p. 199: *The Daily Telegraph*, London, for permission to quote from an article, "End of a Golden Run," by Godfrey Barker, published in the *Telegraph* on April 9, 1990. © *The Daily Telegraph plc*, 1990;

John de Visser, Cobourg, Ontario, for permission to reproduce photographs taken by him in Moscow, 1971;

p. 206: Dragadze, Peter, for permission to quote from an article, "Private Art in the Public Eye," © Peter Dragadze, published in the London *Sunday Times Magazine* of April 29, 1990. Permission granted by the Julian Bach Literary Agency Inc., New York;

p. 186: *The Economist*, London, for permission to quote from an article published on January 27, 1990;

p. 185: *Encounter*, London, for permission to quote from an article, "Peaceful Co-amnesia," by George Walden, published in the number of July-August, 1989;

p. 186: "Festival of Festivals," Toronto, for permission to quote from the transcript of a press conference given by Aleksandr Mindadzy in September 1988;

pp. 48, 49, 50: HarperCollins, publishers, New York, for permission to quote from *Testimony: the Memoirs of Dmitri Shostakovich* edited by Solomon Volkov. Copyright © 1978 by Solomon Volkov. Reprinted by permission of HarperCollins Publishers Inc.

pp. 75, 140, 201: Harry N. Abrams, Inc., publishers, New York, for permission to quote from *The Russian avant-garde: the George Costakis Collection*, (1981) edited by Angelica Zander Rudenstine; p. 16: and for

permission to quote from *Defining Modern Art: Selected Writings of Alfred H. Barr, Jr.*, © 1986, by Harry N. Abrams, Inc., edited by Irving Sandler and Amy Newman;

p. 12: International Publishers Inc., New York, for permission to quote from *Ten Days that Shook the World*, by John Reed;

Oleg Kaplan, for the photo on p. 82;

Aliki Kostaki, for permission to use interview tapes and transcripts of them made by the author with George Costakis (Kostaki);

pp. 212-13: Little, Brown & Co. for permission to quote a poem from *Poems of Akhmatova*, selected, translated and introduced by Stanley Kunitz with Max Hayward. Copyright © 1972 by Stanley Kunitz and Max Hayward. First appeared in *Antaeus*. By permission of Darhansoff and Verrill Literary Agency on behalf of Stanley Kunitz;

pp. 93, 99, 118, 120: McGraw-Hill Ryerson Ltd., Whitby, Ontario, for permission to quote from *Memoirs*, by Dana Wilgress;

p. 184: Geoffrey Murrell, for permission to quote from an article by him, "When the Desert Blooms: Cultural Developments under Gorbachev," published in *Survey*, December 1988;

pp. 119-20: *The New York Review of Books*, New York, for permission to quote from a letter written by Lydia Chukovskaya and published in the NYRB of April 12, 1990. Reprinted with permission from *The New York Review of Books*. Copyright © 1990 Nyrev, Inc.;

pp. 139-40: *The New York Times*, for permission to quote from an article, "Russia's Lost Revolution in Art," by Hilton Kramer, published in the *New York Times Magazine* on October 11, 1981. Copyright © 1981 by the New York Times Company. Reprinted by permission;

Yury Palmin, for photos on pp. 169, 171, 215;

Chris Shapardanov, for the photo on p. 101;

pp. 40, 41, 42, 43: Viking Penguin, a division of Penguin Books USA Inc., for permission to quote from *Russian Art of the Avant-garde: Theory and Criticism*, John E. Bowlt (translator). Copyright © 1976 by John Bowlt. Reprinted by permission of the publisher;

p. 191: Denise J. Youngblood, for permission to quote from her book *Soviet Cinema in the Silent Era, 1918-1935*. University of Texas Press, publisher.

Every effort has been made to trace all copyright holders, but if any have been inadvertently overlooked, the author and publishers will be pleased to make the necessary arrangements at the first opportunity.

CONTENTS

ILLUSTRATIONS

PREFACE

I first met George Costakis in Moscow in 1957, when I was serving as a junior officer at the Canadian embassy, and he was the embassy administrator, the head of the Soviet part of the staff. I was there on a two-year assignment, he was a permanent employee, hired locally. Although he held a Greek passport and was considered by the Soviet authorities to be a Greek national, he had been born in Moscow, had lived there all his life, and thought of himself as Russian. He and his mother believed he had been born on June 3, 1912, but his internal Soviet passport and all other official documents asserted that the date was July 3.

It was not long before he invited me and my then wife, Naomi, as he did most Canadians on the embassy staff, to his little apartment on Bolshaya Bronnaya Street to see his collections, one of icons, one of old Russian toys, and one of the group of Russian painters known as the Russian avant-garde who worked for the most part in the period 1910-1925. At the same time we met his delightful wife and children. I knew little about art and nothing about the Russian avant-garde, but with Chagalls and Kandinskys hanging on every wall, even I knew I was in the presence of something grand.

In the two years we were there, my wife and I saw much of the Costakis, invited them and were invited by them. Lilya, the middle of his three daughters, then a high school student, gave us Russian lessons. We watched the avant-garde collection grow without realizing that it was already among the world's most important collections of modern art. It still had twenty more years of growth ahead of it, before the Soviet authorities brought its development to an abrupt end in the way described in this book.

In 1957 I was not alone in my ignorance of the avant-garde. Few people other than professional art historians, and not many of those, had any detailed knowledge of this movement. Except for

those such as Chagall and Kandinsky who had gone abroad at the time of the revolution and had become famous in the West, the artists who comprised the movement were largely unknown. Most of them were dead by 1957; few of them had continued painting after 1934, when their brilliant style was peremptorily suppressed and forbidden by Stalin. Nobody beyond the Canadian embassy and the little handful of Russian collectors with whom he worked had ever heard of George Costakis.

All that was about to change. A book about the avant-garde, based on Costakis' collection, was in preparation in 1957 and would be published in England in 1962. It was the first of a tide of books, articles and broadcasts which in the years after 1960 would make Costakis famous in the world of art.

I said goodbye to Costakis at the end of 1959, returned to Canada and went to other jobs. But I kept in touch with him through friends. In May 1971, working as press secretary to Pierre Trudeau, I accompanied the Prime Minister on his extensive official visit to the Soviet Union. There Costakis and I renewed our friendship. Trudeau went to see the Costakis collection, still housed in Costakis' apartment, a larger apartment than the one I had known. A few years later, in 1973, Costakis came to Ottawa as part of a North American lecture tour. He had dinner with my wife and me and spent the evening in warm recollection of the old days in Moscow. I recall that we showed him a seventeenth century icon he had given us when we were in Moscow. A large flake of paint had fallen off, victim to central heating. He repaired the damage with raw white of egg and a cigarette paper, a skill art collectors have to learn in a country where professional art supplies are hard to come by.

For some years I heard little of him. Then, when I was Canadian ambassador in Romania, I heard that he had left the Soviet Union and was living in Athens. My wife, Glenna, and I were spending holidays in Greece, only a day's drive from Bucharest. We arranged to visit Costakis. The reunion became an annual event, continuing after I went back to Moscow in 1983, this time as ambassador, and after that when I had returned to Canada as director of the Canada Council.

During one of these visits I asked Costakis why he had not written a book about all that had befallen him over the years. After all, he had lived in Russia through one of the most dramatic times in its dramatic history, and living there, he had managed against all odds to create what many considered the greatest collection of modern art in the world. It would make a good story. He replied that the same suggestion had been made to him some years earlier by the English author of children's books, Roald Dahl, who had also introduced him to a London publisher. Costakis had written seventy pages and submitted them to the publisher, who liked them. However, the publisher had given these pages for review to several Russian émigrés living in London. They reacted negatively, Costakis believed because the manuscript contained favourable references to Lenin (as does the present book). The publisher withdrew, and Costakis, busy with his new-found hobby of painting, had

never gone further. I said that perhaps I could tell the story for him. Much of it I already knew, the rest he could give to me on tape. To my surprise he liked the idea.

It was 1987 before we got to work. When holiday time came around, in November of that year, my wife and I set out for Greece, armed with a tape recorder. Some premonition made me telephone Costakis from London before catching the plane for the last leg of the journey. He was not in Athens. His precarious health had taken a turn for the worse, and he was in hospital in Stockholm. Thus it was that George Costakis began telling me his story from his bed in the Sophiahemmet hospital. We spent two weeks at it, he speaking mostly in Russian, interrupted by the necessary rituals of hospital life. When we had both returned home, I busied myself transcribing the tapes and reading them to see what I had. He, meanwhile, having got used to the microphone, continued his story in Athens, filling in gaps, saying things in different ways, and sending me the additional tapes as he completed them. The transcription of all these tapes amounted to some four hundred pages of typescript, which form the basis of this book.

Our communication was not limited to the letter-box. We talked often, and at length, on the telephone. I visited Athens twice. Costakis came to Canada in the spring of 1989 to witness the opening of a splendid showing of his collection at the Montreal Museum of Fine Arts.

My last meeting with Costakis was at his funeral, March 13, 1990. I said farewell to him with great sadness. Yet it was a moment to reflect on what incredible wealth the life and work of one person can bring to the world.

A NOTE ON SPELLING

There is no universally accepted system for transliterating the Cyrillic alphabet to the Roman-English. I have followed the common path of transliterating exactly the affixes and stems of most Russian words, while abbreviating inflected endings where doing so involves no loss of meaning. But with proper nouns, names of people and places, I have accepted a familiar version (often a transliteration to French) when one exists. Thus Tchaikovsky rather than Chaikovsky, Marc Chagall rather than Mark Shagal, Alexander Solzhenitsyn rather than Aleksandr, since the English form is the one under which he publishes in the West. But with less well-known holders of that name I have used Aleksandr. I have ignored soft and hard signs in Russian, as well as short *i* ("i kratkoi"), and hope my Russian friends will forgive me.

George Costakis' name needs explaining. His three Russian names, given to him when he was christened in 1912 in Moscow, are Georgii Dionisovich Kostaki. That was how he wrote it (except that in Russian the two *i*'s of *Georgii* are different letters), and that is how it appeared afterwards on his internal Soviet passport. Many spellings have been used in English books and articles about him, and the patronymic *Dionisovich* has usually been written *Dionisevich*, the more common way. But stubborn person that he was, he preferred the name given him by his parents, spelled with *o*.

When he joined the Canadian embassy in 1943, he furnished himself with an English name, George Costakis. Some people pronounced the final *s*, most did not. Under that name he became an art collector of international reputation. To keep things simple I have throughout called him by this name, even when writing of a time before he had it, and have somewhat arbitrarily assigned the name Costakis to his family as well, although most of them never used it.

CHAPTER I

THE TURN OF THE WHEEL

In January 1978, Georgii Dionisovich Kostaki, or George Costakis as he is called in the West, boarded a plane at Sheremetyevo airport in Moscow and left Russia forever, as he thought. He was sixty-six. With him he took his wife Zina, his daughter Lilya, and his son Sasha. And he took twenty percent by value of his collection of Russian avant-garde art, one of the world's great modern art collections. With him went also personal memories of every important event of Soviet history: revolution, civil war, Lenin and Trotsky, Stalin's rise to power, forced collectivization, terror and the gulag, the second war, the second terror, the death of Stalin, the moment of hope under Khrushchev, the long dry years after. For him the strongest memories were of art and artists, the search for lost treasures, and the amassing of the collection. Other memories that went with him concerned years of official indifference turning to hostility and finally active persecution by the KGB, the Committee of State Security.

Behind him he left (by her choice) another daughter, Natasha, many Russian and foreign friends, and eighty percent of his collection. The value of the collection, both what he took with him and what stayed in Russia, has yet to be determined in the art market. Certainly it will be a very large sum.

George Costakis was a Russian patriot, even a Soviet patriot, and he boarded his plane with tears in his eyes, feeling, rightly, that he was being driven from his own country guilty of nothing but having given it a priceless gift.

When Costakis left Russia, the art he had collected was regarded by Soviet officialdom as worthless junk, the scribblings of lunatics. Soviet art historians and museum curators of course knew better, but they also knew better than to say so out loud. Costakis himself, although officials had their thick files on him, was officially nobody. The Union of Soviet Artists, that high priesthood of

socialist realism, wanted nothing to do with him. The ministry of culture had never, it said, heard of him or his collection. An occasional official, if questioned about the Russian avant-garde, might admit that he had heard of a crazy Greek who was collecting this rubbish.

One official agency, however, did not mind admitting its interest. The KGB had come to know all about George Costakis and probably to know more than they cared to admit about the avant-garde. Because if official Russia was indifferent to its own artistic past, the rest of the world was not. Chagall, Kandinsky, Malevich were in 1978, and had been for a long time, household names in every Western country, their works to be seen in every major art museum. As it became known that at the Canadian embassy in Moscow there was a clerk called Costakis who had dozens of works by these artists hanging on his walls, and hundreds of the same school by other artists unheard of and never seen in the West, foreign artists, art historians, curators, museum directors, and curious folk great and small began turning up at Costakis' door. Before long this "crazy Greek," this nobody, was one of the most famous people in Russia – as far as foreigners were concerned; among Russians, only the art world had heard of him. It was a situation which did not please the KGB, and which they set out, with their usual zeal, to correct. Their objective was to get rid of him, not necessarily nicely.

They succeeded, in the sense that Costakis got on his plane in 1978, expecting never to return. He did this because he was afraid of them, and with reason. They succeeded in the further sense of having him, for the time being, officially labelled "traitor," which was how a senior Soviet official described Costakis upon seeing a picture of him in the Canadian embassy. But in a much larger sense they failed.

◪

By 1986 Costakis had been living in Athens for six years, keeping in a kind of touch with his Russian friends through Natasha, the daughter who remained in Moscow. He was devastatingly homesick, having learned the hard way that although he had a Greek name, Greek parents, a Greek passport, Greek skin and eyes, and spoke Greek,* he was in fact Russian to the bone. The sense of exile was overwhelming. In his own words: "I was ignored by the Soviet apparatus, and you remember what that senior Soviet official told you about me and so on. So there was not one word about me in the newspapers or magazines, even though I left a big part of my collection to the Russians." Then the

* Greek was Costakis' first language. But it was the Greek his parents had taken with them to Russia before the turn of the century. Few European languages have undergone such radical change in the past hundred years as has Greek, and when Costakis arrived in Athens in 1980, never having been there before, he had difficulty understanding what was said on television or joining the conversation at the corner café. Russian had become in fact his first language, English his second. He was a stranger in Greece.

miracle happened. A telephone call from the Soviet ambassador in Athens. Would Costakis come for a cup of tea? He would and did.

The message the ambassador had to deliver was incredible in more than one way. First, there was to be an exhibition, to mark the opening of the new Tretyakov Gallery in Moscow, of private collections donated to the Soviet state. Costakis' collection, the collection of madmen's scribbles and obscenities, would be represented by twenty works, most of them from the avant-garde. And as if that was not enough, the minister of culture of the USSR wished to invite Mr. and Mrs. Costakis to come to Moscow as his honoured guests to attend the opening. Costakis, who not so many years before had left the country in terror of the KGB, officially branded a traitor, could not believe what he was hearing. Art which for fifty years had been non-art to open the most prestigious museum in Russia, and a collector who was a traitor to be present as the minister's guest?*

His incredulity did not prevent his taking the next plane for Moscow. Zina was unwell and stayed in Athens. In Moscow, Costakis said, they did not actually put out a red carpet, but they did everything else. Official greeting at the airport, car and driver for as long as he wanted them, suite in Moscow's most elegant old hotel, "with fruit and champagne on the table, and 130 roubles a week for expenses." The next day, Costakis was received by the deputy minister of culture (who apologized for the absence of the minister), to whom he explained what the avant-garde was all about "and the mistakes they had made and so on." This apparently went down well, because the deputy minister ended the meeting by saying, "Anytime you want to come, you will be our dear guest and we will do all we can to help you." Costakis was dazed by it all; he recalled: "I went to the Beryezka [special shop for foreigners with foreign currency] and I bought lots of food, sturgeon, and caviar … and I invited about fifty of my old friends, painters and critics and photographers … and I did a wonderful reception. We finished about forty bottles of vodka, and it was just wonderful. And I found the boys very happy. And I went to the Canadian embassy and the chargé d'affaires invited me to lunch, and there were Pierre Trudeau and Bernard Lamarre and some other people." ❖

A few months later, back in Athens, Costakis had a phone call from a very excited Natasha in Moscow. The *Moscow News,* a Soviet weekly newspaper published in several foreign languages as

* Before these events, Costakis' wife Zina had returned several times to Moscow to stay with Natasha and the grandchildren. Costakis himself, despite repeated invitations from me, then serving as ambassador in Moscow, remembered too well his persecution by the KGB, and after some hesitation decided not to return, perhaps out of fear, perhaps out of resentment. Like Solzhenitsyn, he probably wanted recognition of what he had accomplished as well as some acknowledgment of culpability from the other side. In the end he got both.

❖ This was a more important lunch party than Costakis knew. The host was Fernand Tanguay, minister-counsellor of the embassy and at the time chargé d'affaires. (He was also a long-time friend of Costakis.) Pierre Trudeau, although no longer Prime Minister, remembered Costakis and his collection from earlier visits to Moscow. Bernard Lamarre, then president and chairman of the board of Lavalin International, a Montreal firm with extensive business connections in the Soviet Union, happened also to be chairman of the board of the Montreal Museum of Fine Arts. Mme. Lamarre, like her husband, was enthusiastic and knowledgeable in artistic matters and knew about the Costakis collection. This lunch, which took place in October 1986, led directly to the splendid exhibition of the Costakis collection in the MMFA in 1989 and to a significant relationship between the MMFA and the Costakis family.

well as in Russian, in its issue no. 37 for 1986, carried an article by Alexander Kamensky, a well-known Russian art critic and a friend of Costakis. *Moscow News* was not, at that critical time, just any newspaper. Writing in the *New York Review of Books* (July 21, 1988), Murray Kempton observed that *Moscow News* "is one of the Politburo's franchised expressions of the spirit of glasnost" and that "its editors are Soviet journalists who refused to swim with the brackish current of the Brezhnev years and rejoice in their new liberation." The article which brought Natasha's call was under the headline "Russian Avant-Garde in Tretyakov Gallery." It was illustrated with three photographs, one of a work by Chagall from the Costakis collection and so identified, one of a post-impressionist work from another private collection, and the third, quite incredible for anyone who knows this history, a photograph of Costakis and Marc Chagall having a cup of tea together in Costakis' Moscow apartment. The photograph was dated 1973, about the time the KGB started its campaign of personal terror aimed at getting rid of Costakis one way or another. The text of the article is as important as the photographs; it marked a watershed in the attitude of the Soviet state to art and art history, and to art collecting:

"A question may arise quite naturally: under what circumstances did the valuable, talented works by recognized masters find their way into private collections, bypassing state museums? Is this possible under the centralized system of supplementing museum collections that operates in the USSR?

Yes, it is quite possible. You see museums are, to a certain extent, academic institutions. They collect only the items which, at the given time, enjoy a solid and stable reputation and do not arouse any doubt as to their artistic value or the absolute correctness of their ideological impact.

That is why the creations by young artists who work in an unusual or experimental manner do not get into museums for quite a long time or don't get there at all. Whereas a private collector, unfettered by strict rules and norms, is much more dynamic, so to speak, in the development of his artistic views. He is capable of taking risks and of offering his support to different quests."

Thus, in three paragraphs, the whole absurd business of clandestine collecting of officially unaccepted art (or anything else) was swept into the dustbin.

Then, under the heading "Georgeos Costaki's Priceless Gift," Kamensky goes on, in the most dramatic terms, to establish once and for all the great artists of the Russian avant-garde in their proper place in world art history; and in pretty clear language he lets the world know what it should think of the system which allowed large quantities of these marvellous works to be lost, as well as what it owed to Costakis, who saved most of those that now exist:

"I'd like to dwell only on one group of the presented pictures, the very fact of whose appearance within the Tretyakov Gallery context constitutes a phenomenon of paramount importance and a sensation, to a certain extent. I'm speaking of the exhibits from Georgeos Costaki's collection. Only a part of what he had presented is on display. But this is a significant part which is composed of really high-class works and, lastly, which belongs to that trend in 20th century Russian art that is as yet little known and has not been appraised with objective historic clarity in our country. It is the so-called Russian avant-garde.

… In our country, the Russian avant-garde is known very little and is practically not represented in our museums. This is absurd. At the recent congress of Soviet writers, Academician Dmitry Likhachev said that we forfeited the early 20th century Russian literature to the West. This is probably an exaggeration … But as for the Russian avant-garde fine arts of the 20th century that have truly been "forfeited to the West," this is a squandering that is absolutely ungrounded and unfair. I think that very soon it will become an anachronism. And Georgeos Costaki's collection, now part of the Tretyakov Gallery, will constitute one of the factors which will help in this historically important process."

Not long after the appearance of this article Costakis was made an honorary member of the Society of Soviet Collectors. He remarked with his usual dry humour and in his characteristic Russianized English, "Next will be Politburo."

What began in fear, anger and brutality ended on a very high note indeed. What happened between? What happened was Gorbachev and his policies of glasnost and perestroika.

Whether Gorbachev knew about Costakis and his collection is unknown, as are Gorbachev's views on contemporary art. We do know that Gorbachev and his wife are educated people, that Raisa Gorbacheva at least has an interest in modern art. (When they made an official visit to France, Raisa Gorbacheva's first request was to see the collection of modern art at the Centre Pompidou.) And certainly, even in the days when Costakis was going in fear of his life because of the KGB, he was being called on frequently by eminent and well-known visitors to the Soviet Union. Senator Edward Kennedy and Prime Minister Pierre Trudeau were only the most visible of these from the political world, Chagall and Stravinsky from the artistic. There were hundreds of others. It seems unlikely that senior people in the hierarchy, living in Moscow, with access to special information sources, would be unaware that they had something unusual in their midst. Russians, at least those with any kind of position were, it is true, afraid to go to Costakis' apartment, he being technically a foreigner and the employee of a foreign embassy. (Some, eminent enough not to be afraid, went: pianist Svyatoslav Richter was a friend, as was the important painter

Robert Falk.• Unknown young painters went in numbers, but they had little to lose and were hungry to see works in the collection unavailable to them in official institutions.) But if not many Russians visited Costakis, certainly every Russian in any way connected with the art world knew of him. So it seems unlikely that Gorbachev had not at least heard something of the "mad Greek" collecting artistic absurdities from the backs of barn doors and from underneath plastic tablecloths.

One thing we know for certain, and another with a high degree of probability. The general secretary who followed Brezhnev in 1983 was Yury Andropov. He fell ill and died before he was able to accomplish much, but it is likely that his views of Soviet society, of the Soviet economy and probably of other matters were akin to those of Gorbachev. Many people believe that Andropov was Gorbachev's mentor and friend. Andropov, then chairman of the same KGB which was hounding Costakis in the streets of Moscow, definitely knew all about Costakis and his collection. They never met, but Andropov played a very important role in Costakis' last years in the USSR. That is for later in this history, but it would not be stretching probability too far to conjecture that at some point, probably in 1977 or 1978, Andropov and Gorbachev discussed Costakis.

Less certain but still probable is that Aleksandr Yakovlev knew about Costakis. Yakovlev was then a secretary of the Communist party, member of the Politburo, and Gorbachev's lieutenant for ideological matters. But he also spent eleven years as Soviet ambassador in Canada. A great many of Yakovlev's most important contacts in the Canadian government, especially in the Department of External Affairs (now Foreign Affairs), were with officials who had served in Moscow and knew Costakis well. Some even possessed avant-garde and other Russian works sold or given to them by Costakis. Costakis gave an illustrated lecture about his collection in Ottawa early in Yakovlev's time there, and Yakovlev was still in Canada when the collection, or that part of it Costakis took with him in 1978, was exhibited in Ottawa as part of its world tour. Yakovlev was also still in Canada when Costakis left Moscow, so it is unlikely he had anything to do with that or even knew about it. But he was back in Moscow, in a powerful position next to Gorbachev and dealing with ideological matters, when the decision was taken to hold the Tretyakov exhibition and include works from Costakis' highly controversial collection. Yakovlev was probably involved in the further decision to rehabilitate not only the disgraced Costakis but also all the disgraced artists of the Russian avant-garde and all those who collected their work.

Those who knew Yakovlev in Canada over those eleven years knew him as a highly intelligent, educated, thoughtful person who understood the West, especially Canada, as few Russians, indeed

❋ Robert Falk, 1886-1958, was a Russian painter involved in the avant-garde from the beginning. He lived and worked in Paris for ten years, then returned to Moscow in 1938 only to be rejected by the Soviet art establishment. He is now regarded as a major figure in the history of modern Russian painting.

few foreigners, have. He knew our artists and art collections as he knew other aspects of our national life. One can imagine him returning to Moscow, finding himself with the necessary authority under Gorbachev, and simply taking an axe to the ramshackle and mindless structure which was Soviet policy on art and artists and on Russian art history. But that is speculation; what is certain is that a radical change occurred, and that George Costakis was at the centre of it.

Interesting as it is to muse about how much or how little the Soviet leadership knew of Costakis and what he was doing, it is not necessary to establish any connection at all. The artists of Russia, not only the visual artists but all of them, were the main beneficiaries of Gorbachev's glasnost. That is not because they were uppermost in Gorbachev's mind. The word glasnost is translated in the Western press as "openness," and that is the sense of it. But the Russian root of the word is *golos,* and the meaning of *golos* in English is "voice." So the fundamental sense of glasnost is making things public by speaking out. After at least fifty years during which speaking out meant loss of job, prison, or at some periods death, the significance of Gorbachev's word to every Russian was immense. For artists, for whom there is no life except in speaking out in one form or another, the proclamation of glasnost, and the sure evidence that Gorbachev meant what he said, was like being unexpectedly set free half-way through a life sentence.

Soviet society lived on lies for so long that even people who know that fact – and most Russians do know it – still cannot tell what is a lie and what is not. But truth is indivisible; you cannot tell the truth when it suits you and otherwise tell lies. Nor can you tell the truth to a few of your friends and lies to the rest of the population, not if you want to bring about change. So in Russia since 1985 the truth has come surging out in unprecedented and almost uncontrollable torrents. Truth about today, about yesterday, about Lenin, about Stalin, about those Stalin murdered, even about Trotsky, whose name had been unmentionable and unprintable in the Soviet Union for sixty years.

The effect on the Russian economy of Gorbachev's reforms and then of Yeltsin's is still in doubt. But the effect on the arts and the artists, whose stock in trade is telling the truth about life as they see it, has been enormous. Following the publication of *Doctor Zhivago,* books and articles which describe the revolution and civil war and subsequent events are appearing in dizzy numbers. The process is practically complete of reconciliation with artists who had gone abroad in despair. Costakis was one of these, a sort of living embodiment of the avant-garde, all of whom died long before he did. The great artistic director of the Taganka Theatre, Yury Liubimov, who stayed in London when the thought police made it impossible for him to carry on his brilliant work in Moscow, went back to direct plays in Russia. Baryshnikov has been back, although not to dance. And hardest of all to believe, Alexander Solzhenitsyn, the ultimate critic of the system, the scourge of Soviet rule, has been published in Russia and in early 1994 returned there to live.

In 1985, the visual arts in the Soviet Union were in a particularly bad state. Music, opera, theatre and dance, the interpretive arts, had survived fifty-five years of Stalin and his successors mainly by drawing on the nineteenth century repertoire and performing contemporary works only when political necessity made that unavoidable. Indeed, music, being an art form not easy to politicize (although Stalin and Zhdanov did their best), not only survived but produced some of the greatest Russian and non-Russian composers and performers of the past century. Literature did much less well: the writers who took their art seriously had either to leave it unpublished or smuggle it abroad for publication at great risk to themselves, as did Boris Pasternak, who overestimated the depth of Khrushchev's liberal sentiments, with *Doctor Zhivago*. The alternative was somehow to go abroad to live and work, as Bulgakov did and, later, Solzhenitsyn and Brodsky and many others. The choice for those who either could not or did not want to leave Russia, or who chose to accommodate with the regime, was either to write pap (the choice of potentially very good writers such as Konstantin Paustovsky and Ilya Ehrenburg) or to abandon the trade. Most did the latter, and Russian literature, with its magnificent roots in the nineteenth century novelists and poets and dramatists, came close to extinction. In 1994, the signs of revival are weak and still for the most part appear outside Russia.

But the visual arts fared worst in those years. The decline of the avant-garde had already begun in the 1920s. There was little public interest in the work of these artists, and they were losing confidence in themselves. The main problem, however, was that the authorities, while recognizing that these same artists had for the most part supported the revolution, which they had seen as the political expression of what they were doing visually, nevertheless detected in their work "an element of anarchy." Said Costakis, "Every artist wanted to make a statement about himself." Lenin had not created the Soviet state for that kind of behaviour. It made the authorities uneasy. "So they began, albeit delicately, to herd them in the direction of activity useful to the state."

All delicacy came to an end once Stalin had got rid of his opponents of left and right and had established himself as the Great Leader and Teacher. By 1934 socialist realism had been proclaimed the only acceptable way to paint, write, sculpt, compose, or produce films. Artists who insisted either on being non-realistic, or on not fashioning their work so that it carried a clear message of support for some aspect or other of state policy, at first simply did not get published, exhibited or performed. Later it became downright dangerous to produce their kind of work or to possess it. Before long the inclusion of adulatory references to Stalin was obligatory for any artist who wanted his or her work to reach a public. From the end of the Second World War until Stalin's death in 1953, under the direction of the unsavoury commissar (minister) of culture, A.A. Zhdanov, this madness was carried very near to the point of no return.

Khrushchev, established in power by 1955 and ready to start dismantling the worst of Stalin's apparatus of terror, knew very little about art and literature, but he did know that such grinding oppression was unnecessary and harmful. He made a few tentative signals that artists might once more raise their heads slightly. But he retreated when he saw the effects of what he had done, and he was neither secure enough politically nor sufficiently convinced he was on the right track to make bolder moves. Brezhnev, who like Khrushchev had made his career in the party under Stalin, not surprisingly showed little interest in changing an aspect of policy which appeared to work well enough since it effectively muzzled potential critics of the regime and system.

It is true that things improved somewhat during these arid years: Costakis was able during Khrushchev's time to form his little academy of young painters working in non-socialist realist styles and to sell their works privately. He was allowed to go abroad on his artistic business. Someone made the bold decision that since French impressionist painting was figurative, the Hermitage Museum in Leningrad might be permitted to bring its magnificent collection of these works out of the cellar and exhibit them publicly. But for the most part the life of the visual artist remained what it had been under Stalin. Young painters and sculptors knew very little of what was happening in the world of art beyond their borders, and they knew nothing, except the handful who had access to Costakis' collection, of their own Russian artistic roots after the nineteenth century. Of course, the talent was still there, and some technically brilliant work was produced in the approved socialist realist forms. But there was no growth, no development, no blossoming of ideas, and the country which had produced the foundations of contemporary art for the world came perilously close to having no contemporary art of its own.

Russians are no more, and quite possibly (and for good reason) much less, receptive to difficult and inaccessible contemporary art than are people in other countries. They are just as inclined as are many Canadians to say, "My two-year-old did something just like that only yesterday," or, "This artist can't even draw," or (on better critical ground), "I find it disgusting." But Canadians, and other Westerners, have at least been exposed to a great variety of contemporary art throughout their lives. Not so Russians; until recently only those over seventy might have known a world in which there existed anything but the boring clichés of socialist realism. After such a life in art, to be confronted with the full-blown contemporary work now coming from young Russian painters is to be shocked, and quite possibly repelled.

However, although art and artists are probably not at the top of the agenda of Russian leaders, these leaders know that the Soviet state did not totter in 1991 because artists were painting what they wanted to paint. There were other reasons.

One of the steadfast optimists was Costakis himself. When he died the Soviet Union still existed, and it was commonplace to speak of the genie being out of the Soviet bottle. Costakis thought that in the past, in his lifetime, many genies had been out of many bottles. But, he argued, the big genie was now out of the big bottle. He was a believer in the Russian future.

AN ORDINARY RUSSIAN

When the last Romanov Czar abdicated in April 1917, George Costakis was four-and-a-half years old and living with his parents and brothers and sister in Moscow. He was five when the Bolsheviks seized power from Kerensky's provisional government and established the Soviet state.

By that time Russia had been in political turmoil for at least twenty years. Czar Nicholas II, who came to power in 1894, was a narrow-minded autocrat who showed no capacity for dealing with any of the problems facing the country: hunger in the villages, misery among the urban industrial working population, and after 1914 a steadily deteriorating military situation in the war with Germany and Austria – which the Czar insisted on managing personally, despite the clear evidence then and in the war with Japan in 1905 that he had no talent for military matters.

There were assets which a more intelligent and flexible ruler might have used: the economy, especially the industrial sector, was developing at a reasonable rate; the empire had been greatly enlarged during the reigns of Nicholas and his father; Russia had a certain stature in the eyes of the world as a result of its defeat of Turkey and support of independence for the Slav peoples under Turkish rule. But above all there were moderate reformist forces which, given some royal encouragement, could have moved matters in a better direction than the calamitous one the Czar pursued. When the Bolsheviks carried out their putsch in Petrograd on November 7, 1917, there was no active alternative to them, the provisional government of Kerensky having lost all credibility both with the thousands of soldiers who had walked away from the war and with the armed workers in Petrograd and Moscow.

The Moscow in which Costakis found himself, aged five, on the day after the Bolshevik coup, was not a safe or pleasant place to be. In *Ten Days That Shook the World*, still the best first-hand account

by a foreigner of that time, the American communist journalist John Reed describes the streets of the city upon his arrival there from Petrograd a few days after the revolution: "The Nikitskaya ... was swept by blasts of machine-gun fire. A throng of little boys were gathered there – street waifs who used to be newsboys. Shrill, excited as if with a new game, they waited until the firing slackened, and then tried to run across the street ... Many were killed, but the rest dashed backward and forward, laughing, daring each other."

Costakis had an early memory which was similar, verging as it did on family tragedy and by an odd coincidence involving the same Moscow square, Nikitskaya:

At that time we lived in the centre of Moscow in Gnezdnikovsky Lane, in a big apartment. One night there came a banging on the door. They were beating on it with rifle butts. My father opened the door, and in burst six or seven armed men, who rushed at him. It turned out that someone had been shooting from one of the buildings into the next square, Nikitskaya, not far from our apartment block. And the military observation post had identified our apartment as the source of the fire. They grabbed my father on the spot and dragged him out to the central courtyard to shoot him. But luckily, hearing all the commotion, out ran our cook Dimitri, who worked for my father. And Dimitri at that time was some kind of boss, with a red ribbon in his buttonhole. He ran out and protected my father. He said to the commissar, "Don't touch Dionisii Spiridonovich. He's a good man, sympathetic to us."

To make a long story short, they let my father go, but the commissar sent his people up to our attic to see whether somebody was there or not. Fifteen minutes later the two soldiers came back down and said that all the dormer windows of the attic were broken, but there was nobody in the attic. However, someone had got out through the broken window on to the roof, but there was nobody on the roof either.

Well, it seemed the problem was settled. But then Dimitri whispered something in my father's ear. My father gave him a key. He disappeared, and came back in a minute with a few bottles of wine and vodka, which he put on the table. With trembling hands my mother made some *zakuskis*, and everyone sat down to drink. Then the commissar said, "Okay, Dionisii Spiridonovich, here's to you. I'm now going to write you out an order, that nobody is to lay a finger on you. And if anyone bothers you, there's the phone, give me a call, and we'll look after you." So they sat down and drank, Dimitri gave them a couple of bottles of vodka for the road, and that was that.

In their recent pronouncements about him, Russian writers go stolidly on calling Costakis a Greek. It is true that he always had a Greek passport and spent the last ten years of his life in Athens. But he was born in Moscow, lived there continuously until age sixty-six, spoke and thought in Russian, married a Russian, raised his four children as Russians, loved Russia and the Russian

people, had a peculiarly Russian love-hate feeling about all things Western, and was bound by the most profound faith to that most Russian of all institutions, the Orthodox Church.

Costakis' father, Dionisii, had, after several failed attempts at business in Greece and Egypt, tried his luck among the substantial colony of Greeks who lived and generally prospered in Moscow, St. Petersburg and the Russian cities around the Black Sea. Settling in Moscow, he joined the tobacco firm of Bastanzhoglu, marketing Central Asian tobacco in Russia and abroad. There he met and married George's mother, the daughter of another Greek tobacco merchant, an educated, polyglot woman who was to be a profound and wholesome influence on George Costakis.

It was a time of rapid industrial growth in Russian cities. The tobacco business was thriving. Costakis *père* was before long owner of the firm, and a wealthy man. By 1912, when George was born, Dionisii Costakis had installed himself, his wife and their four children, (George was the fourth; one more would follow) in a twelve-room apartment in Gnezdnikovsky Lane in central Moscow with eight servants to look after the six of them. The scene was one of solid bourgeois comfort, but it seems unlikely that Papa Costakis, a capitalist and a foreigner, could have been unaware either of the political rumblings in the factories and universities of Moscow and St. Petersburg or of the danger of war being touched off in the Balkans, where Russia had set itself up as "protector" of the oppressed Slav peoples.

The Bolshevik coup, followed by civil war and foreign (including Canadian) military intervention against the new rulers of Russia, brought a period of harsh misery to most of the country. It also marked the beginning of the end for the prosperity of the Costakis family. George gave this account:

It was a very interesting time. In the first years after the revolution life in Moscow was very hard and heavy: there were lots of problems with food – there was nothing. I remember that my father, for example, opened some kind of cafeteria, a kind of buffet in the Bolshoi Theatre, where he sold *piroshkis* [meat pies], very good ones. But they were made of potatoes because there was no flour. It was total ruin. Then they asked my father to open a restaurant, another kind of cafeteria, to feed the homeless kids. Every day thirty or forty of these kids came, and my father fed them with omelets and milk soup, things like that. He got these things from the United States. They were helping the Soviet Union by sending food. Well, these kids were in rags, filthy, lousy, and they made a lot of noise. Every day the knives and forks disappeared. They ate, banged the cutlery, and then the knives were gone. So next day we had to get more knives from somewhere.

Costakis was in fact a child of the NEP, Lenin's New Economic Policy, reluctantly adopted by the Bolsheviks in 1921 in response to a desperate situation at home and even more to the failure of the workers of Germany, France and Britain to join those of Russia in casting off their shackles. It had

always been a tenet of Bolshevik thinking that the revolution could not survive in one country alone; it had to be world revolution or nothing.

This is not the place to recount in any detail the history of the NEP except as it relates to Costakis, whose formative years were spent during it. Economically, it was a retreat (as the Bolsheviks saw it) to partial capitalism, especially in the small industry and service sectors, and a time of concession to peasants, who were allowed to produce grain in more or less traditional ways and to maintain traditional village structures. (A few years later, with Stalin in full control, this system would lead to disaster.) Politically, the time of the NEP was a period when Stalin systematically outwitted those seeking his downfall as general secretary of the party (not then the all-powerful position it later became). It ended in total rout for the opposition led by Leon Trotsky, in the appalling human catastrophe of forced collectivization and de-kulakization, and in the establishment of the most thoroughgoing tyranny of modern times.

Of most of this Costakis knew little or nothing. His once-wealthy father had become a purveyor of *piroshkis* in a theatre lobby, a caterer to waifs and strays, and thus one of those very small tradesmen who were contemptuously known as *nepmen* by the opponents of the NEP. Costakis was a boy of nine when the NEP was introduced, and the rest of what he knew was what he saw in the streets of Moscow during the eight or nine years that followed. This was a world of relative plenty, of goods in the stores, of food and drink and nightclubs, a world of which he retained basically agreeable memories. It is a tribute to his mother and father that the despair they must have felt as their world collapsed seems not to have been conveyed to the boy. What he retained instead was a sense of awe and admiration not only for his father's ingenuity as a salesman of *piroshkis* but for the entrepreneurial skills of his older brothers, Spiridon and Nikolai:

Well, things went on, and then began the period of the NEP, and everything changed very fast. Food started appearing, stores opened again, and God knows where they got all this wealth: meat, and fish, and butter, they had everything. The Yeliseyevsky store* glowing with chandeliers, and there was nothing they didn't have: five or six kinds of caviar, and smoked salmon, and two or three kinds of sturgeon. Where did all this come from? Private restaurants opened, private cafés. Rich people turned up out of nowhere. There were private businessmen. Sausage factories opened, and all kinds of private workshops. My brothers, for example. After everything in our family had collapsed and disappeared, still in the house we had lots of dishes and cutlery — bowls, plates, forks, knives, every kind of thing. So they decided to open a shop in the Central Market. And they did business off the ground; they spread out a bag and put the plates on it. Then

* At the time the most elegant food store in Moscow, a sort of Fortnum and Mason's. Under the communists it was called Gastronom No. 1, but has now reverted to its original name.

one fine day it rained and they got soaked. So they put up four poles and a piece of plywood, and they had a shop.

A year later they got together with Kyrochkiny – the well-known Kyrochkiny, a glass-artist, who did the grave of Vladimir Ilyich Lenin – and with this Kyrochkiny they opened an electric equipment store. The store was six metres long and three wide. But they had everything – lamps, insulators and so on. Six months went by. Then they found a place on Myasnitskaya Street, where there were already wholesale outlets selling hundreds of metres of wire, and motors and what have you. With every month and every year these NEP businesses flourished more.

Well, afterwards, my brothers bought two cars to use as taxis. Yes. These were cars that worked. They were really coaches, three metres high. Foreign makes. Well, there was a taxi stand on Strastnaya Square … There was one car that made the trip from Strastnaya to Petrovsky-Razumovsky and back and served the prostitutes and their clients. I mean, the prostitute and her client got in the car, closed the curtains, and thus the car went – to Petrovsky-Razumovsky was half an hour, and back a whole hour – and then the car came back, and the kid who was the driver's helper always swept out the car, and out flew condoms, used condoms, and all the dirty little kids would run up, grab the condoms, and blow them up. They were amusing kids, dirty faces. A round black face and not much else. At night they went to sleep on the boulevards in special boxes. There were such boxes, three metres by three, and half a metre high, where the cleaning men put dead leaves. And there they slept. When it got cold, the police had no trouble telling what boxes had occupants: they could see their breath coming through the lid. Two in this box, one in that.

On Strastnaya Square there was the Strastnaya Monastery, surrounded by a high wall. Inside there was a beautiful garden, and on the wall sat a few thousand pigeons: brown, white, red, all colours. And down below by the wall sat two or three monks with bags of birdseed for the pigeons, which they sold for two or three kopeks. I often came and bought the seed and spread it for the pigeons, and they came in their thousands. Just pigeons, and they came and sat on your head, on your shoulders. The ragged kids also liked doing this and often used the money they stole in the square to buy birdseed. And this made them so happy that they bought again and again. They were good fun.

It was an interesting time. I remember going with my brothers – they took me – when I was still small, to a restaurant called The Reindeer. It was in Sokolniky Park. There were woods and a big log building. That restaurant ran twenty-four hours a day. Gypsies, guitars. They handed around caviar in two-kilo containers made of silver. There were always fresh fish in the pond. Everything you could think of to eat. And these rich NEP types came there, to waste their time. They started at midnight and went until six in the morning, even seven, when the birds were starting to sing in the woods, when even the gypsies were going to bed. But there was always some gypsy or other who went on singing a love-song by special request. And that's how my brothers came to have that kind of client. They made enough in one night to feed the family for a month.

And in fact the taxi business was a good one, but not easy, because the cars were ancient, and there was a problem with tires. And if the tires were flat and the cars were out of action at Easter or Christmas, it was a big tragedy, because Christmas and Easter, these two holidays, yielded more revenue than all the rest of the year put together. On these holidays you could earn immense amounts. I remember that we sometimes got tires two or three sizes too small. We used to go to the Chinese laundry, where they steamed the tires in tubs of hot water and then stretched them while they were hot. But this was a short-term solution. Such tires didn't last long. It was a very, very interesting time.

Other accounts of the period confirm Costakis' recollections. The founding director of the New York Museum of Modern Art, Alfred Barr, when he was still a young man and before the Museum of Modern Art existed, visited Moscow and Leningrad in 1927-28. (While he was there he met several of the avant-garde artists, and long years later, when both he and Costakis had become giant figures in the art world, described those meetings to Costakis.) Barr's own diary deals mainly with the very lively cultural scene that then existed in Russia. But his travelling companion, Jere Abbott, contributing to a recent collection of Barr's writing, describes the Moscow scene of that time in terms similar to Costakis'own:

"In 1927, even foreigners were not in a position to judge about repression. Churches were open. There were still some private shops and some excellent book shops. The Jewish Theatre, with the delightful Chagall murals* in the foyer, put on the brightest musicals. We were drowned in theatre, cinema, ballet … Much barter was taking place, but things were sold in some private shops which still were in business. Moscow's streets were crowded day and night and there were thousands of people there from the provinces. They were in tattered native costumes. The men's clothing shops, private shops, still did a big business and prices were high … My icon I bought in an outdoor "flea" market which was private. Control was spotty. There was a lot of trading of family furnishings. The mass of forms – paper regulations – and of domestic permits had not yet developed."

* The Chagall murals which delighted Barr and Abbott in 1927 had an interesting subsequent history. The state Jewish Theatre (Goset), which performed in Yiddish, was established in Petrograd in 1919 when anti-semitism and pogroms and the pale were supposed to be things of the past. In 1920 the theare moved to Moscow. There it lived through many vicissitudes, artistic and other. It reached its theatrical pinnacle under the direction of the actor S.M. Mikhoels, who continued to act while directing the enterprise. In 1949, at the height of Stalin's post-war anti-Jewish frenzy, Mikhoels was murdered in Minsk, on Stalin's orders. The theatre closed.
 In 1920, soon after Goset moved to Moscow, Chagall (himself a Jew) was asked to paint murals for its walls, and did. These are the murals that Barr and Abbott saw seven years later. When the theatre disappeared in 1949, the Chagall murals disappeared with it. Many years later they were discovered rotting under the abandoned stage, where somebody had thrown them. They were lovingly restored by Tretyakov conservators, and in the fall of 1992 were magnificently displayed in New York at the downtown space of the Guggenheim museum.

It was a scene of light, colour, and variety, totally unlike the grey homogeneity which was soon to settle over Russia and remain there for many years.

The skills and attitudes which Costakis learned from his brothers and others like them during the NEP were to prove far more useful to him in his subsequent working life than the little formal education he had. And it would not be far-fetched to conjecture that the common touch which came from dealing with beggars, prostitutes and their clients, Chinese laundrymen, and the rich at the Reindeer restaurant in Sokolniki Park gave Costakis, twenty years later, part of what he needed to begin building his collection of the Russian avant-garde. The NEP taught George to shift for himself, to survive, to know a bargain when he saw it, to operate successfully in a marginal market. All that would work for him later, when he was sent out to find a sack of potatoes or a live pig for the Canadian embassy, and equally when he set about tracking down and acquiring a great work of art by a discredited or unknown artist.

There was another early influence which never left him, that of the Russian Orthodox Church. Although he was a fervent admirer of Gorbachev and his policy of perestroika (restructuring), Costakis nevertheless believed that there would be no end to Russia's woes until there was a return to the Orthodox faith. He described the beginnings of his attachment to the church:

Well you know, in those years, although the persecution of the church and religion had begun, nevertheless services went on, the ringing of bells was not forbidden, and grace still stood over Moscow. I remember one day, when my father took me to the church of Dmitri Solonsky, to matins. It was the first time – yes, the first time – that I had gone with my father. And I was moved by the service. Those two choirs, left and right – when one choir, interrupting the other, sang the music of the service … that flame of the chandeliers, and the light of the candles, those rich vestments of the clergy, who came and went in tens and twelves in the centre of the building and led the service, and in the centre on his throne sat the archbishop – all this made a big impression on me. And there was a young boy of twelve or fourteen who served, and carried the candles, and swung the thurible with incense. And you know, well, when I got home to my apartment, our apartment, where we lived, it seemed to me a dark place in comparison with the church, and I asked my father if he would speak to Father Dimitri and ask whether I could be a server in the church.

And there you are, from that day for the next – yes – four years, I was a server in that church. I think those were the brightest, the most beautiful days of my life.

Once a car drove into the churchyard. Beside the driver there was a type in a leather coat, and in the back there were two workers. Father Aleksandr went to meet them; he lived there in a separate building. And I heard this conversation. Father Aleksandr spoke to this commissar: "Why do you need the covers of our icons? They're not silver, they're just fake-silver, common metal. And you're chasing this stuff in every

church." The big boss answered, "You know, little father, you're a Russian, and you've got to understand that the country is hard up. We need everything, even if it's only common metal." This commissar spoke quite kindly to Father Aleksandr, but he was absolutely firm that in two days they would come and strip the icons. And that's what happened.

In two or three days a truck came with three or four workers, and this same boss in the leather coat with them. They went into the church. These Russian *muzhiks* [peasants] didn't even bother to take off their caps. And the boss gave them hell, because one of these boors even went into the church smoking a cigarette. All the same, they started pulling all the metal covers off the icons and throwing them in the back of the truck. They were all over the place, some right side up, some upside down. Well, soon there was a big pile of metal in that truck. And, well, to avoid making a second trip, these Russian *muzhiks* started packing down with their feet the very objects that they might have kissed with their lips a few years before, when they went to church. And this was a terrible thing to see.

But it came to an end, the truck went away, and the church was left with its black icons with no adornments.

There were a great many incidents, if not of vandalism, then of hooliganism, especially on the great holidays, like Easter, when the procession of the Stations of the Cross went outside the church. The atheists all crowded around and sang idiotic songs about crawling into heaven and chasing out the gods. All this was just next to the statue of Pushkin, and they put up film screens there and showed stupid films, to distract the believers. They played guitars, and whistled, and acted up. And of course, the police did nothing.

It went on like this, getting worse every year.

George's attachment to Orthodoxy gave him the strength to survive in a world which was often very tough. Equally important, it gave him a sense, perhaps unattainable in any other way, of the spiritual significance of the art he was collecting and of its links to the art of old Russia.

An important part of Costakis' mental world was his attitude to emigration, to Russians already emigrated, to his own emigration. Several years before his death he had occasion to write down some of his early post-revolutionary memories, with the idea of publication. The British publisher who had invited the memoir offered the manuscript to a Russian émigré for comment. The comment was to the effect that Costakis was too sympathetic to Lenin; the émigré community would be up in arms. The publisher decided not to proceed. The passage which had aroused the reader's ire dealt with Costakis' childhood in a communist state and with the death of Lenin in 1924 – an important event and a vivid experience for a twelve-year-old. Costakis did not keep the manuscript he submitted, but he recounted the story, which reveals the beginnings of an ambivalence towards the revolution, the Soviet state and the church, which stayed with him to the end of his life:

[In my manuscript] I described the post-revolution period and the beginning of the NEP through the eyes, you know, of a ten-year-old boy, who wrote about the events of the time as he saw them. I wrote that people were exultant, that everyone was happy. They welcomed the revolution. Everyone hoped that life would be a lot better. Everyone lived with great expectations. They went out on the streets with flags and banners, they sang songs. Strangers kissed as though they were brother and sister ... I wrote that when Lenin died – Lenin whom the émigrés speak of as some kind of vile person – there was great sorrow in Russia. People went out in huge crowds in those frigid days [Lenin died January 21, 1924], when it was so cold the sparrows were freezing in the trees and falling to the ground. People stood outside day and night. They lit huge bonfires that reached the second floor of Moscow houses. And there wasn't a single person who didn't weep.

I wrote that it was surprising that here was I, a boy from a good family, a religious family, who served in the church of Dmitri Solonsky and went around with candles with the priest, and at the same time I was a member of the Forpost. The Forpost was not exactly a Pioneer group, nor a "Red Corner," but at that time it was very popular. Parents would assign one room in the apartment to the children, and we would meet in this room, five or six children. On the walls we had pictures of Soviet heroes – Lenin, Kalinin, Budyenny. We would stick up ribbons and flags, write manifestos, keep minutes of the meeting, and so forth. I always went to these things, and then, sometimes right after, I would go to church and serve at mass. So somehow I did both things, religion and the revolutionary movement. They were the same for me.

If the church and the street life of the NEP years together made a kind of preparation for the work of a great art collector, the ten years of education which George managed to get definitely did not. Even in Moscow things were difficult, with school admissions policies discriminating against the children of the former bourgeoisie. But in 1922, when George was ten, the family was invited, politely but firmly according to George, to move out of its twelve-room apartment, which was needed for the editorial offices of the magazine *Ogonyek*. A four-room apartment was promised instead, but predictably did not materialize. The family decided to move out of Moscow to the village of Vyrubovo, on the Minsk road, four kilometres from the nearest school at Odintsovo. There things went from bad to worse:

In winter I had to get up when it was still dark and walk the four kilometres to Odintsovo. And it was tough, because there were blizzards and a lot of snow. But there was a peasant who sometimes took his children in a wagon, and then I got a ride. The school building wasn't bad, stone with five or six classrooms. The teachers were from Moscow, and I fell in love with one of them, a beautiful young woman with a little moustache. But the school was awful. We kids, we wore the old Russian shirts with high collars, white, blue, red, yellow. One day I noticed on the collar of the kid next to me a whole string of white lice, the kind you get

in your uniform in the army. So everybody in the school had these, and when I came home my mother would boil my clothes, but the next day it was the same again. Nevertheless, my mother didn't want to return to Moscow. She was afraid of violence in the streets. So we stayed three years, and I lost three years. Finally they sent me back to Moscow, but I was very behind, and I never caught up. However, I managed to finish ten years.

Life in the village wasn't bad, though. In those days they had little stores that sold everything you needed – butter, sausages, cheese, sugar, toothbrushes, sometimes shoes. Pretty well everything.

Thus Costakis completed his shaky education. After that the world became his teacher, but he was the first to admit that there were dreadful gaps, even in what he knew best, art and art history. And if his transformation into a great collector cannot be explained in terms of his formal education, neither can it be in terms of family influence. He said himself that his parents knew and cared nothing about art. They may have heard rumours about some eccentric persons putting on incomprehensible exhibitions and staging lunatic plays, but they certainly took no interest, and George heard nothing from them about the avant-garde, or about any other art. What hung on their walls at home were "a few trifles from China in bamboo frames." Yet the Russian avant-garde, one of the pillars on which contemporary Western art rests, was born with George Costakis, grew up with him in the days of war and revolution, reached its apogee as he was coming of age, and died miserably under Stalin's hammer. At the time of its destruction, the man who was to collect and save Russian avant-garde art for the world had never heard of it.

One other story goes with Costakis' formative years during the NEP. It sheds light on the kind of child he was and even more on the kind of family he belonged to. It provides, moreover, a small window on the world of that time. George told it as follows:

So when we lived in Gnezdnikovsky Lane, I got to know the kids in the neighbourhood. My great friend was Sasha Andronov, who later became the chief designer of the Moskvich, the car.

Well, we were a romantic bunch. We dreamed of travel, dreamed about finding hidden treasure. We very much wanted to go to the Caucasus to look for treasure. It was all so attractive, that this idea wouldn't leave us, and we started thinking about it very seriously. And we decided that in the spring we must make a trip. But you have to get ready for trips. Andronov started to build a car. I remember that he made the wheels out of Venetian chairs. In every such chair there's a round panel. And, you see, he ordered each of us to steal one Venetian chair. So he made a car, powered by pedals, and it went very smoothly on the pavement.

But we understood that there was no way we could go to the Caucasus in this car. So we started to think about the train, and we knew we would need money. And the most independent one of us, if I may put it that way, the one from the most affluent family, was me. So it fell to me to deliver the money. But how to do it? My sister had some money. She lived with the family, but she had her own room, and she always kept lots of money in a box, to buy things for her son. Well, my friends said, "You take it. You don't have to steal it, just take it as a loan, and when we find the treasure and all that, we'll return this money to your sister, and quite a lot more." So I took the money. I stole it, stole money from my sister. We went to the market, we bought daggers, hunting knives, we bought shovels, we bought all kinds of things, and still there was plenty of money left.

Well, spring approached, and Easter. And at Easter all Moscow puts the house in order. Every housewife washes the windows and the curtains, polishes the floor. The whole apartment gleams. And at our house the same clean-up took place. Our servants were still left from the old days, probably five of them. Let's see, I remember Auntie Olya, Auntie Vera, there was a Polina, the laundress, and some others. Well … one fine day, or rather horrible day, I was sleeping in the morning in my bedroom, and I look, and there's Auntie Olya coming to clean. And I, like a fool, had hung these things of mine behind the cupboard door. Well, I lie in my bed and all I hear is a heart-rending shriek from Aunty Olya, "Madame Yelena! [Costakis' mother] Come here! There's a dagger hanging behind the door! Good Lord!"

So everyone came, and the dagger was there. And I pretended to sleep. I squeezed my eyes tight. In came my father, my mother, my brother Spira. Good Lord! Well, Spira said, "There you go. Now I know who stole the money." Because until then nobody could think or understand, that a servant could work for us for twenty years and nothing had disappeared … I considered myself the most honest imaginable child. Who could think that I would steal money. Spira started talking. My father said, "Spira, don't wake him up. Let the child sleep." But my brother said, "Papa, child or not, he's a thief, a bandit, a thief." And at that moment everyone turned against me. I thought it would have been better if they killed me. "Now," said Spiridon, "I will show him what it is to steal money." So he took a ruler, pulled down my pants and … I didn't sit down for a week. I remember Papa saying, "Enough, enough." But Spira said, "It's not enough." And so I was the unhappiest kid there was. Everyone was against me.

My life became incredible. Through all my childhood, when I woke up in the morning, I would find a basket of fruit – mandarins, apples, grapes, pears – every day. All that stopped. Nobody spoke to me. So I decided, I can't bear any more of this. I'm going to run away.

I put together a few things, a shirt, a bit of bread, and late one evening I left home and headed for the Savelovsky railway station. No ticket, but there was a train, ready to go, and people getting on. Well, I got into one car, sat for a moment. There was nobody beside me. So I crawled under the seat. Crawled under. I lay there. Some peasant came along, an old woman sat down. And they had dirty feet, and they didn't

smell good. It was awful. But I lay there. The train left. And I put my clean shirt under my head and had a little sleep.

Well, after a while I hear the conductor coming: "Citizens, show your tickets. Citizens, show your tickets." I hear his ticket punch going click, click. I stop breathing. I lie there, like this. And I don't know whether they knew or whether they sensed something. Anyway, they came to where these peasants were sitting and asked them to move over a bit. They moved. Then the conductor started poking under the seat with a cane, and hit my leg. "Come on," he says, "crawl out from under there." I say, "I'm coming out." "What do you think you're doing? Where's your ticket?" I say, "Little uncle, I have no ticket." "And where do you think you're going?" I say, "I don't know. I ran away from home."

To make a long story short, they put me off at the next station and shoved me into the room for homeless children. But I remembered my address, and they took me back to Moscow, to the militia [police] at the same station I had left from. And next morning my father and brother came, and some others, and they were so happy to find me that I became a hero. Instead of one pear I got two by my bed, and I was completely rehabilitated. And life returned to its old way.

It is somehow improbable to suggest that the twenties in Soviet Russia could have been a happy and important time in anyone's life, least of all in the life of a boy whose family had become part of the class enemy, and who had seen his parents and brothers reduced from substantial prosperity to living by their wits in the street. But the fact is that George's memories of those years were generally bright ones, the family remained strong and united in the face of considerable adversity, and by 1929 George Costakis was not badly prepared for the great work that lay ahead of him.

In 1929 Costakis was seventeen, and having completed a few months training at a "high school for mechanics" (from which he was expelled because he had a Greek passport), he was looking for a job. In the same year Josef Stalin was fifty. He had dealt effectively with all political opposition, had declared himself the Great Leader and Teacher, and was ready to lead, or drag, Russia, in the fifteen years to follow, through the most tragic and horrifying events of all its long, tragic history. Something like ten million of the country's most effective farmers were to be identified as class enemies and killed or exiled. Soviet agriculture would not to our day recover from this self-inflicted mutilation. Under the First Five-Year Plan, Soviet industry would be set in a self-perpetuating structure which would ensure its permanent backwardness, and which even Gorbachev and his successors would find extraordinarily difficult to change. The country's best minds, best generals, most effective administrators were to be tried on fake charges and shot. And perhaps worst of all, history was to be rewritten, the only acceptable truth was to be a lie, art, including the art of which Costakis would become the collector, was to be suppressed or made the servant of the state. All this would be

crowned with the most appalling war in history, in which thirty million Soviet citizens would perish, a war which Stalin, though he could not have prevented or avoided it, could certainly have made shorter and less devastating.

In 1929 all these horrors lay ahead of Costakis, as they lay ahead of Stalin. Yet it is true that no one mind, no one imagination or memory, can encompass such human devastation, even if all the facts are known. To most ordinary people they were not. So the events Costakis remembered most vividly of those years were the death of his brother Spiridon in 1931, his marriage to Zinaida in 1931 and, much later, in 1946 or thereabouts, his discovery of a painting by a then-unknown woman artist called Olga Vladimirovna Rozanova. With that discovery Costakis' real life began.

But in 1929, before any of these events, the NEP was being choked off, the First Five-Year Plan had been inaugurated, and selling *piroshkis* and owning private taxis were no longer acceptable or legal ways to make a living. The gaudy sparkle of the NEP was being replaced in the streets of Moscow by grim scenes of overcrowding and shortage as rural families came to the city to work in industry, in which the Plan projected huge growth. The Costakis family had no place in this scene. They turned to the Greek legation, where first father Dionisii, then his three elder sons, Spiridon, Nikolai and George (the fourth, Dimitri, was ten and still living at home), found work. Dionisii started as an unpaid guard, sleeping in the legation at night. Spiridon, who, as George proudly noted, "finished the gymnasium and spoke many languages," became driver to the minister, the head of the legation. This, George remarked, (this time in his own interesting English), was no small achievement in those days:

And my brother Spiridon was working as a chauffeur for the minister. I must tell you that at this time to be a driver, and especially for an ambassador or minister – it felt like, if it's nowadays, to be a pilot of a Concorde, or something like that – very important. The period when I remember, in the thirties, in Moscow you could count the drivers like this, you see. Everybody knew each other. They were driving in Moscow, and "Hello Kolya, hello Vanya. How are you?"

Nikolai and George were both given handyman's jobs, but later George was promoted to be driver for one of the legation's diplomatic secretaries. He recounted (again in English) what life was like:

Work at the Embassy wasn't easy. They paid a good salary, they fed us well, but you had to work from early morning to late evening … In the evening, every evening, to the girlfriend. Because all of them, the ambassadors and secretaries, had girlfriends. And those girlfriends were age thirty-five to forty, mostly daughters of the old czarist generals. They had mothers who spoke German and French. This was during

the Stalin period. All of them were permitted to have contact. They were living like husband and wife. Some had wives with them, some not. If a diplomat had no wife, he had a Russian woman, and if she had no place to live, she lived with him. Or if she had her own apartment, he lived with her. And nobody bothered them.[*]

The image one had of Costakis in his middle and later years was of a serious and responsible person – to be sure, with a deft sense of humour and a capacity for fun, but still conscious of his place in the world. The Costakis of 1929 and 1930 must have been very different. The Greek legation was a safe haven, the world outside a nightmare. But in a fit of pique one day, irritated by the long hours and the demeaning relationship with the Greek staff of the embassy, he told them he was quitting, fully expecting the embassy to say "George, don't go. Stay. We will change things for you." But they did nothing. The ambassador said, "If you want to leave, you can leave." And the next day he was on the street.

Then followed a period of what is still called "unofficial" business, that is, living by one's wits. George had a Russian friend working as a truck driver at the great Frunze Military Academy, when that forbidding structure, now familiar to every tourist, was going up on the north bank of the Moscow River. The friend, Garka, got George a job as a truck driver. He started hauling sand and gravel. By this time he and Zina had their first child, their daughter Inna, and the money simply did not go around. So with his friend Garka, George began doing "something unofficial," which consisted of taking the odd load of sand to a customer other than the one for whom it was officially intended:

So we drove around to apartment buildings and suggested that perhaps they needed some sand. Every apartment building needs sand for the kids to play in. "Okay. One load. How much?" "Ten roubles." So we came in the evening, a couple of loads, twenty roubles. We bought a bottle of vodka, a little sausage, and we ate. There wasn't much money left by the end of the week, but with what there was I went to the food store or to the market, bought some food and came home to Zina like a lord.

Further adventures followed. An illegal load of soap that broke open at an embarrassing moment, forcing George and Garka to take to their heels; garbage collection; removing refuse from hospitals, all at the expense of the unaware builders of the Frunze Military Academy. And in all that time,

[*] The amiable practice of permitting such relationships, and even permitting marriages and occasionally allowing the wife to leave the Soviet Union with her husband, continued throughout the war and for several years after, when the Soviet government stopped it. After that, relationships between Westerners and Soviets, when they existed at all, had to be clandestine and were therefore extremely dangerous.

1929-30, events were taking place in Moscow and throughout the country that would shock the world when it learned of them. Like most Muscovites, George knew very little about what was going on in the villages. He recalled: "In that period, as far as I remember, I didn't feel, you know, any kind of pressure from Stalin. Let's say it was more or less quiet and open."

But then, in 1931, he did feel some "pressure from Stalin," or what he at least was convinced was that. Spiridon, the talented older brother, who had "finished the gymnasium" and spoke languages and was now driver for the Greek minister, had taken up motorcycle racing as a sport. In Russia, and indeed everywhere in Europe at that time, motorcycle racing was serious business. Highways were blocked while professional racers shot across the countryside at very high speeds. Spiridon had become champion motorcycle racer of the Soviet Union and was famous. Then:

One day I noticed that Spira, my brother, had stopped coming home. I couldn't understand it. I thought maybe he'd quarrelled with his wife. But I noticed he was sleeping in the embassy.[*] Some time went by, and I found out that Spira had been arrested by the GPU [the KGB of that time] or the NKVD [a later name for the same] or whatever they were called then, and had been told he had to work for them. So he, you know, came to the embassy and told the ambassador, that this and that had happened to him. The ambassador said, "You are not to go out in the car and you are not to go home. Stay here, and I'll talk to the foreign ministry." So, well, two or three weeks later, the ministry phoned the embassy to say that it was all a mistake, that it was a provocation by some private person who had no official position. They had talked to the GPU, and there had certainly been no attempt to recruit Spiridon, and so forth, and he need not worry.

Well, things calmed down. You know. My father was very upset and said, "Spira, you shouldn't race any more." Because at that time Spiridon was the champion of the Soviet Union. At that time hockey, football and other sports were nothing compared to motorcycle racing. The whole of Moscow was decked out with posters saying "Go Costakis" in letters this high! And when my friends were around, I was a hero. Everybody said, "Look, there's Costakis' brother!"

It happened this way. They hated him, because he always came first. In the 1-kilometre, in the 100-, in the 1000-. And the NKVD had their own sports organization, called Dynamo. They had a particular racing driver who was always behind my brother. They ordered a new motorbike for him, the Brown Superior, and still they couldn't catch Spiridon. So they planted a mine under him. A year or so after the events at the embassy, there were races of several kilometres on the Vladimir highway, a relay race. And they chose a part of the highway, God knows why, where the railway crossed the highway. There were barriers, that came down when the train passed. And when there were objections (the racers wanted to know why it was

[*] George usually referred incorrectly to the Greek legation as an embassy, and to the minister as an ambassador. Legations are a lower order of diplomatic representation, common in those days but rare now.

arranged that way) they said that there was only one train a day, a special freight carrying bricks, and the barriers were open all the time except at night, when the train went by. So … the race began. My brother went one way. There were ditches on both sides, and a few hundred people in them. Kids, old people. To watch the race. They sat there and watched. My brother just raced. He didn't look ahead, just to the two ditches.

Well, to make it short, I was sitting, waiting, to watch him go by. Then I saw a crowd run on to the highway, shouting. Then an ambulance appeared, and another. Then they screamed, "The Greek has been killed." They had closed the barriers. There was no train. When he saw that there was no place to go, right or left, without killing twenty or so people, he decided to go through. He ducked the first barrier and got on to the tracks. Then there was the second barrier. In three hours …

The problem was that they asked him to work for them. Because he was very smart, and educated, and the Greek minister and all the staff used him as an advisor. About politics, everything. The minister talked to him for hours. I saw them. There was a winter garden in the legation, and they walked there together for hours.

That was the great tragedy of George's life. To the end of his days, nearly sixty years later, he wept when he told the story of the death of his wonderful brother. His conviction that the secret police were responsible, either because Spiridon had refused to work for them or out of envy of his prowess as a racer, was unshakeable and did much to form his attitude to that organization. And he would come to know something of them.

Within a year of Spiridon's death, George's father was also dead, of grief George believed. A more sober George than the one who hauled illegal sand with his friend Garka went to the Greek legation and asked to be forgiven and taken back. He was, and was given Spiridon's old job as the minister's driver, behind the wheel of a French Hotchkiss. He recalled that his first boss was a difficult man, given to wiping under the fenders with his handkerchief to see whether George had washed the car. That was in 1933, and George was to stay there as driver until the legation closed following Stalin's accommodation with Hitler in the Molotov-Ribbentrop pact of 1939.

George had two powerful memories of those years, which were also the years during which he became an art collector, although not yet of the Russian avant garde. By 1934 that movement no longer existed in Russia, and George had still not heard of it. The memories had nothing to do with art. They had to do with the long arm of Stalin, reaching first the Greek community in Russia, especially Moscow, and then the Costakis family itself.

The horrifying story of Stalin's terror is well known and within the memory of many. It followed the equally grim events, briefly outlined above, of forced collectivization and de-kulakization. What

it is important to understand about the "first" terror, as Costakis called it – that is, the events between the murders of Kirov in 1934 and of Trotsky in 1940 – is that it did not consist only of the show trials of 1936-37, when Stalin disposed, mostly by shooting them, of everyone who had ever had anything to do with Lenin, and everyone, including the secret police, who might conceivably pose a threat to him. That was bad enough, but the terror acquired a life of its own, sweeping uncontrollably through every profession, every trade, every level of society. Employees denounced their bosses, children their parents, friends and neighbours one another. Some people got a trial or hearing of some kind, others simply disappeared. The camps, an invention of Lenin himself, were vastly expanded, and millions died there.

We are now learning more about this period, thanks to the policies of Gorbachev and his successors and their understanding that a nation cannot live with secrets of that sort in the closet. Khrushchev knew that too, but because he had himself been high in the hierarchy under Stalin and had survived, there were limits to the number of files he could make public. We still can only estimate the number of deaths, both by execution and in the camps, and we have only the roughest idea of what the camp population was at any moment. Nevertheless, Western scholars have put the number of deaths during Stalin's terror at ten million.

That was Costakis' world when he was aged twenty-two to twenty-eight. The terror touched him first through the Greek community, of which he was technically part. The victims of the three great show trials of 1936-37 were not all accused of the same crimes, but in two of them the accusations included that of working for foreign intelligence services. A spy mania followed, and the finger was pointed at foreigners in Moscow, not least, and perhaps especially because there were so many of them, Greeks. All except those working in the legation were given a choice between going back to Greece and going to the camps. They lined up at the legation for passports, but were refused them by the Greek government, which, Costakis thought, feared having to support the poor, and also feared those who might be communist. Only those with means were allowed to go. Costakis was always bitter about this, blaming the Greek rather than the Soviet government for the subsequent imprisonment of his own family and of many other Greeks. He recounted that the Greek minister of the day committed suicide because he was unable to do anything to help the hundreds lined up at the legation for passports. Whether or not George was right to blame the Greek government for what were, after all, Soviet actions against the Greek community, is a matter of judgment. But these were Greek nationals, and in the normal conduct of international affairs, the Greek government would have been expected to let them go home if they were no longer welcome in their country of residence.

The finger of Stalin touched the Costakis family a second time, and more closely. George's mother, aunt, and youngest brother, Dimitri, then twenty, were refused permission by the Soviet authorities to register as Greek nationals because, unlike George and his older brother, Nikolai, they did not work at the Greek legation. Deprived of this protection, they were arrested and sent to the camps.

The story that follows is the most extraordinary of all Costakis' stories about the pre-war period. People who knew the old Soviet Union might say that what Costakis described simply could not have happened. "They" would not have allowed it to happen. But we must put in the balance the remarkable man he was, the chaotic time, 1938, and the rich circumstantial detail, recalled after fifty years by a very feeble Costakis from his hospital bed:

Our whole family was registered at the Ministry of Foreign Affairs and had immunity. But in thirty-one or thirty-two, at the beginning of thirty-two, a new [Greek] ambassador came, and someone on the Greek staff told him that it wasn't right that the wife of Dionisii and his youngest son and his aunt [actually George's aunt] should be registered. Only those who worked at the embassy should be registered with the Ministry of Foreign Affairs. And the Greek embassy sent a note to the foreign ministry. There, needless to say, they were very surprised. But when the embassy asked that the names be crossed out, they crossed them out. Years went by. In 1937, 1938, the arrests began. On one horrible day my mother, aunt and younger brother, who was then twenty, were arrested. They were arrested as enemies of the people and convicted under article 58. My mother was sent to the Butyrsky prison, and my brother too. Later they sent him to a prison camp.

They sent him to Kotlas. In the north. You know, my mother and aunt were first in the Butyrsky prison, then they were transferred to the Tagansky prison. Why they weren't sent to the camps I don't know. They were three years in prison. But my brother was sent to Kotlas.

So one day I got a letter. A prisoner from Kotlas arrived, someone they had released. Not a political type. A thief or burglar. I don't know. But they had let him go. And my brother asked him to deliver a letter to us. And he did, he brought a letter from my brother. And this letter, you know, was soul destroying. My brother asked for help. He said conditions were unbearable, that he had got very thin, weak, he ate badly, he had no money. If only he had money, there were things to buy. You could buy bread, butter, even sugar and cigarettes. Well, when I got this letter, I decided to go to see him. Zina was against it.

It's maybe fifteen hundred kilometres from Moscow. Maybe more. Kotlas. That's where the camps were. Well, I bought a ticket, I bought a lot of food, I got some money, I bought some good tough boots, and I went.

At that time ... it was the time of Stalin and the authorities didn't know ... the right hand didn't know what the left was doing. Nowadays, as you know, for a worker in a foreign embassy to make such a trip would be unthinkable. But then, they didn't know everything.

To make it brief, I went to Kotlas and went into the administration building of the gulag. A short, bald chekist [secret policeman] with fishy eyes met me: "What do you want?" I said thus and so. I had come to visit my brother and give him a package. If I could meet him, I would be grateful. He pulled out a book, looked, and said, "Your brother is an enemy of the people. There will be no meeting. You will receive nothing from him, and there will be no package. And if you aren't out of Kotlas in twenty-four hours, you'll be in there with him." I said (I was young then and in a hurry), "All the same, I'm not leaving until I've given my brother either this package or some money." He said, "Do you see that wall?" I said yes. "Can you knock it down with your head?" I said I would try if I had to.

He turned around and went out, and I thought, What have I done to myself? They can arrest me. So for a few days I hid. But I had to eat, and very quietly I went up to the railway station in Kotlas. The station had a restaurant, better than the Metropole, better than any restaurant in Moscow. They made supper you wouldn't believe. Borshch, Kiev cutlets, and anything you like. I found out that the cook there was a convict, formerly the chef from some big Moscow or Leningrad restaurant. So bit by bit I started walking around, looking at things. I got to know some people who had come for the same reason I had. There was one woman, from Kiev, whose husband, a photographer, was in for the same reason as my brother, article 58. There was a man, and a Greek woman. So we hung around together. I asked them, "What can I do for my brother?" Somebody said, one of our little group, "You know, there's a prisoner, they call him the Tutor." Twice a week this Tutor is allowed to come into Kotlas and take back parcels and letters for the other prisoners. You can talk to him and ask him to take something to your brother." So I talked to this type. He looked like a crook. But I explained everything. "Now look," he said, "I know your brother. He's a profiteer, a bad one. But I'll help him." So I happily gave more than half the food and more than half the money, hoping that he would deliver it. I didn't have much choice. I waited a day, another day. Nothing. He let me down.

From there, from the gulag headquarters, to the camp was eight kilometres. You had to take the train. The camp stretched out on the right side of the railway. It was colossal, vast, with four towers. Machine-gunners in the towers. And there, when you arrive at five or six in the morning, you see the gates opening, and out of the camp comes a black mass, like some kind of intestine, of people, and they weave to the right and the left and back to the right. You see nothing but this wide black belt, stretching to the horizon, the forest where they are going to fell trees. The belt gets narrower and narrower and becomes a point. And you know, they herd them along, guards on both sides, dozens of dogs straining at their leashes and barking. And pray God that nobody strays to left or to right, because then it's "poof" and that's it. Well, that's the scene I saw.

I wandered around, wondering what to do. My boots were falling apart. I had already spent a week with nothing to show for it. Then one happy day I was outside the camp. Here was the camp, and just outside it was a little … *slobodka* [settlement] … five or six houses. In these houses – just wooden *izby* [huts], in these houses lived some of the camp guards: a senior lieutenant, a junior one. For a while I held back,

and walked around, and waited. Maybe this Tutor will turn up, so that I can give him a punch in the nose or at least find out what happened. It started to rain, and I got wet. There was no going back, because I was frozen. So I went up to one house and knocked. A young woman opened the door, with a baby she was breast-feeding. I said, "May I spend the night?" She replied, "Excuse me, but why? But of course you may." So I went in. She said, "Maybe you're hungry. Would you like some bread and milk?" I said, "Tea, if I may." Because I was frozen. So she poured me some tea, I warmed up a bit and sat down. And late in the evening her husband came home, a lieutenant, two stars on his shoulder-boards. He didn't pay much attention to me, didn't ask who I was or from where or why. Anyway, they sat down to eat and invited me to join them. There was some kind of cabbage soup, some other things, potatoes. We had supper. Then he asked me, and I told him that I had a brother here, in the camp, called Mitya [Dimitri]. He said, "I know a prisoner by that name." And we had a talk about everything.

Next day (I still had some food left) I had pretty well settled down there, I was living there. He came back. We sat down to have supper. I produced half a litre, and we drank it in a little glass, handing it around. He said, "You know, brother … I don't understand what's going on. There are people locked up over there who shook Lenin's hand. And they sit there and think, What kind of madness is this? Stalin's not guilty, nobody's guilty. It's some kind of evil force, doing all this. There are many like that," he said. "But look," he said, "don't you worry. I will fix a meeting for you with your brother. One night in the next two or three days, I'll come here about two in the morning, take you into the zone and call Mitya."

I didn't know what to do. I was grateful, and I was scared. But I looked at his face: open, good, sad. I thought, It can't be … and I agreed. So I went to bed and waited. At two he came, and said, "Not today. Today the district commander came. There will be an inspection, and then they'll all get drunk, today and tomorrow."

The next day he came at two or two-thirty in the morning. From the house to the camp was maybe three hundred metres, with nothing but the railway track between. We crossed. A door. He opened, and we went into a little room, maybe ten square metres. He sat me down and said, "Sit here. If anybody comes, say that Lieutenant So-and-so brought you. Don't say anything else." So I sat ten or fifteen minutes, and in he came with Mitya. And when I saw my brother I had to speak, but he couldn't. His hands were shaking, his teeth chattering, his head shook. There was no hope of speaking. I said to him, "Pull yourself together. We have to talk about things. About how to live." Then we talked. He said, "It's very bad. And the worst is that we have no money. Because there's a good shop, with almost everything. You can buy bread, and butter, and jam, and candy, cigarettes – everything you need. And you know," he said, "there are a lot of Greeks here, and they're dying from hunger. How can we help them?" Well, I had brought what was left of the food and money, and I left him everything, and we went on talking. But we had been there a long time, and I was scared. Well, we kissed, and it was over.

I mentioned the woman I had met, the wife of the photographer from Viatka, from Kiev. I didn't hide from her that I had seen my brother. Maybe it would have been better not to talk to her, because I found out later that after I left, my brother was put in solitary for a month. There may have been trouble for my friend, too. Anyway, this woman, whose name was Vera Vasilyevna, said, "So what are you complaining about? You've seen your brother and everything's okay for you." I said, "You know, there are a lot of Greeks here. I would like to help them, but I've got no money. I gave a lot to that bandit. And it would be very dangerous to go to the station and send a telegram asking for more. I'd be afraid to do that." She said, "How much do you need?" I said, "A lot. 8000." "You know," she said, "I've got 9000 in my letter of credit." I didn't even know what a letter of credit was. Apparently it was the same as a bank account. "I can't give you 8000, but 7000 I can give you." I asked her how she could give me all this money, when she didn't even know me. She said, "It's nothing. You know that my husband's locked up in there, and he's in the same mess as your brother. You can't not return me the money. You'll return it." So I got the money to my brother through the same lieutenant, and he used it to help the Greeks.

Well, there's the story. After all this I pulled myself together little by little and went back to Moscow. I arrived and right away sent the woman her money. And I thought, Maybe some time she will come to Moscow, and I'll take her by the hand to Red Square, and I'll fall on my knees in front of her. But she never came.

Life went on quietly enough at the Greek legation from 1934 to 1939, while the terror raged outside. The Costakis family could not ignore what was going on around them: three of their own were in the camps, and every night one or other of their friends or neighbours disappeared. But the Greek legation, no doubt like other foreign missions in Moscow at that time and later, lived in its warm cocoon, aware certainly of the public facts – the show trials – but not the full horror. In some ways they had easier access to information than foreign diplomats of a later era. The single (and sometimes not only the single) Greek men working in the legation all had, according to Costakis, Russian mistresses, from whom they might have learned something about the extent of the terror. But for many Soviet citizens, contacts with foreigners were dangerous. Even George's wife's family were at risk by her marriage to a man considered foreign:

It was, I think, before the war. Some time before the war. Zina had a brother, Slava. He was then sixteen or seventeen years old. A very nice boy, smiling, friendly. And he liked Zina very much. I don't know how it happened, but someone got him into naval college, for naval officers, and he was studying there.

One day he came with his friend, both in uniform, to visit his sister. At that time I had a little car, a Willis. Not the military Willis, but an ordinary car, an American Willis, very nice. I drove this in Moscow. And I

had a diplomatic license. Later, they gave me an ordinary license, but they could still tell I was a foreigner even without the "D." But at that time I had "D."

I don't remember how it happened. I came home and I think I went to rest for half an hour or so. The keys for the car were on the table. Slava took the keys, asked his friend to come with him. They started the Willis and drove around in Moscow. They were stopped and arrested. I woke up and saw the car was gone. The next day they brought it back. Fifty years passed, and Zina never saw her brother again, except once, when her father died. They saw each other at the cemetery, and said just two or three words.

He became a captain, and then something very high. Maybe admiral. His name was Panfilov.

Just as, five years before, the ordinary citizen could not know the full extent of the mass tragedy of collectivization, so now it was impossible for anyone outside the circle of power to know how vast Stalin's terror had become. Costakis – his oldest brother dead, he believed, at the hands of the police; his mother, youngest brother, and aunt in prison; his fellow expatriate-Greeks incarcerated en masse; his neighbours disappearing in the night – knew as much as anyone. Apparently protected, along with his wife and children, by his Greek nationality and passport and especially by his employment in the legation, he did what the other survivors did during this period, kept his head down and moved quietly, driving the minister to dinner parties and meetings and washing the official car. And he collected art.

For it was during those years that George embarked on that most ancient and honourable and obsessive of all Russian activities. The former bourgeoisie, hard pressed for money to stay alive, or living in one or two rooms instead of their spacious pre-revolutionary houses or apartments, were selling their treasures and their collections at rock-bottom prices. Then, in the 1930s, and indeed up to about 1960, bargains were plentiful. George started collecting almost at random. His collecting had nothing to do with contemporary paintings, for he still had no inkling of the existence of the Russian avant-garde. Instead it was conventional collecting of objects from the eighteenth and nine-teenth centuries, the kind of collecting practised then and now by thousands of Russians. He had found a modest three-room apartment, part of an old wooden house, which he stuffed with minor Dutch masters, Afghan carpets, French porcelain, icons and much else. He and Zina were happy raising their little girl. According to George, food was not in bad supply in Moscow in those years, and he no doubt benefited from whatever privileges the legation had.

Then, in August 1939, a month before the invasion of Poland and the declaration of war on Germany by Britain and France, Stalin entered into the infamous Molotov-Ribbentrop pact with Hitler, which Russian historians have only recently begun to acknowledge as a crime as well as a betrayal and a gross error. Costakis knew nothing about that. What he knew was that the Greek

government, seeing the pact for what it was, broke relations with the Soviet Union and withdrew its legation.

Costakis was once more on the street, and there was a second child on the way. The departing Greek minister, who had been posted to the United States, offered to take George, Zina and their daughter with him, and exit visas were obtained without difficulty. However, there was a problem because Zina and the child were Soviet citizens. George could leave then, they could follow in a few months when the formalities were completed. But George would not settle for that, and the minister left without him.

Then came an offer of help from an unexpected quarter. Hitler's ambassador in Moscow was Count von der Schulenburg. Like many diplomats, he frequented the Moscow commission and antiquarian stores looking for the incredible art bargains which were to be had in those pre-war days. George, a bargain-hunter in the same places, had got to know the ambassador somewhat, and knew his driver well, who was something of an artist and a violin maker. Von der Schulenburg offered George a job in the German embassy. George was tempted but prudently consulted his brother Nikolai, who had himself found a niche in the British embassy. Nikolai's advice was unequivocal: "Never! Don't do it, because the Germans and Russians will stay together for a very little time. Then they will go to war. And if you join the German embassy, you will be lost. So stay as you are."

Accepting this excellent advice, George then turned to a Greek friend who worked in a menial job in the Swedish embassy. It was the time of the winter war with Finland. The Finnish embassy had been withdrawn, leaving its handsome building in the hands of the Swedes. A caretaker was needed; George got the job. With his family, he moved into a four-room apartment in the deserted embassy building and there spent two wartime years. The job carried practically no salary, and food was hard to get in Moscow. One solution was to sell a large part of his collection, which he did. But when that resource failed, ingenuity came to rescue the Costakis family:

You see, during this time, when everything was a mess, nobody knew what was happening. Of course, the embassies were supported with food, but still there were some difficulties. And I don't know to whom this idea came to the mind, to myself or Dimitri [the Greek friend], but … we took the embassy paper and we typed a letter to one of the factories who makes the sausages, or selling these, you know, supplying these. The letter would say that such-and-such an embassy presents its compliments and so on, asking to sell for embassy use so many of these, so many of those, say a box of milk, sweet milk, and ten kilos of ham, pork, and five kilos of this and this. And they delivered it.

It is not surprising that, living this strange life, Costakis gained limited impressions of the war. There were air raids, not very serious ones. While Zina took the children to the shelter, George would invite a neighbour into the empty embassy to share with him one of several bottles of excellent Napoleon brandy, once part of the Polish ambassador's cellar, which had found its way to the black market and into George's "collection" when that embassy closed. More seriously, he had strong memories of people who secretly, or not so secretly, hoped for a German victory. A statue of Karl Marx and another of Lenin were pulled down during the night near where he lived. People were "very afraid," and for a time, when the Germans were near Moscow, "there was no hope, because everything was very – collapsed."

In 1943 Costakis left the Swedish embassy for the British, where he found a better job, again as a driver. When the German advance approached Moscow, the Soviet government decided to move all diplomatic missions and some government ministries to the relative safety of Kuibyshev, formerly and again now Samara, on the Volga one thousand kilometres east of Moscow. George and his family were to go, but illness in the family prevented it. Nevertheless, through the British in Kuibyshev, the newly arrived Canadians would hear of Costakis, and thus would begin a relationship which would endure thirty-five years.

The death of Spiridon, marriage with Zina, the incarceration of part of his family in Stalin's gulag. These were the important events, for Costakis, of the tumultuous and awful years between 1930 and 1945. The fourth important event occurred in 1946: "Somehow, completely by chance, I happened to be in somebody's apartment in Moscow. I don't remember at all where it was or whose it was. And there I saw two or three canvases, two or three works by the avant-garde artists. At the time I had no idea who these artists were. I remember one work … and later I understood that this one work was by Olga Rozanova. And it made a very strong impression on me." Thus the "ordinary Russian" ceased to be ordinary, and the Costakis collection of the Russian avant-garde was born.

THE RUSSIAN AVANT-GARDE

ven the most assiduous art historians do not trace the roots of the Russian avant-garde movement further back than the middle of the nineteenth century. Some think even that too far. The first paintings which can be reasonably assigned to it did not appear until 1910. By 1925 the movement was moribund; by 1935 in Russia, it was dead. There were still practitioners working abroad, and the influence of the movement was even then world wide. But as a Russian phenomenon, the avant-garde was gone.

In those years, at most no more than a lifetime, fewer than fifty Russian artists turned the world of art upside down forever. Some of their ideas had come from the West, from France in particular, because in those pre-revolutionary times there was rich cross-fertilization between East and West in all the arts. But the Russians had many more ideas of their own, and they moved ahead so quickly with them that in the years immediately before the revolution, when the movement reached its apogee, they were far ahead of their time in any country and were in fact creating the art of *our* time. If we compare their work with what was then being produced in Europe or North America, it is the modernity that takes us by surprise. These artists are our contemporaries, even though they are all dead, most of them long since.

With the disappearance of the movement in Stalin's Russia, interest in it in the rest of the world declined. Of course, some avant-garde artists, such as Chagall and Kandinsky, had left Russia and become famous in other countries. But people did not think of them primarily as the remnant of an otherwise vanished Russian movement. Many who knew and loved Chagall's paintings, for example, thought of the artist as a French painter, forgetting or not knowing of his Russian origins. And since those who had stayed in Russia were prevented from creating, exhibiting or travelling, the Russian

avant-garde faded from the consciousness of all but professional art historians. For many years little was written or said about the group as a group.

Then, beginning in about 1960, as the existence of the Costakis collection in Moscow became known and visits to it became easier for foreign experts, as indeed they did to the officially held avant-garde collections in the Russian Museum and the Tretyakov Gallery, books and articles began to appear, and before long there was an outpouring. One of the first books was by a young Englishwoman, Camilla Gray, who had no claim to professional standing as an art historian but had a passion for the subject and a sympathy for the Russians. Her book, *The Great Experiment: Russian Art 1863-1922*, was published in 1962 and is a work of real exploration and pioneering. Others have followed in rich abundance. Thus, in the West, reading about the avant-garde has been possible for thirty years. Seeing the artists' works, however, has been another matter.

In the former Soviet Union the story was different. If curators of the Russian Museum in Leningrad and the Tretyakov Gallery in Moscow knew what was hidden in their cellars, they were certainly not permitted to exhibit these works, write about them for publication or overtly collect them. (By some happy oversight neither were they required to destroy them.) In Russia, until after 1985, nothing had been published about the movement for at least fifty years. As late as 1982, when Costakis had already emigrated and his collection was beginning its round of exhibitions in the West, the Academy of Arts published a lavish volume, *The USSR Academy of Arts*, containing the most important works of its members, dead and living. One would not expect to find the avant-garde artists in that company, and one does not. The long introduction, purporting to survey Russian art from the beginning to the present, contains not a single work by an avant-garde artist among its forty-five illustrations. The text of the introduction mentions members of the group only to relate how their efforts to sabotage true Soviet art and art education in the 1920s were frustrated by the timely intervention of Lenin. (But even that was progress; previously they had not been mentioned at all.)

After 1985, the avant-garde began to get the attention it deserved inside the USSR. Articles appeared in the press praising Costakis for his contribution to Soviet cultural life and comparing him with Pavel Tretyakov as a collector (to the disadvantage of Tretyakov who, as the article points out, had plenty of money and no official impediments, whereas Costakis had a clerk's salary and officialdom constantly inhibiting his activities). A handsome new book appeared, *Soviet Art 1920s-1930s*, published simultaneously in Moscow and New York and intended to serve as the catalogue for an exhibition at the Russian Museum in Leningrad. Although it did not deal exclusively with the avant-garde, it gave the avant-garde artists a prominent place both in the plates and in the introduction. Moscow exhibitions of the work of three central figures of the avant-garde, Malevich, Filonov

and Popova, in 1988, 1989 and 1990, were the occasion of lengthy articles, warm and detailed, in the press. On March 8, 1990, the day before Costakis' death, the newspaper *Sovetskaya Kultura* ("Soviet Culture") put forward the idea of a Moscow museum of modern art named for him. So it is at last becoming possible for Russian art lovers, as for Western ones, to read about the vast wealth of this movement. But for them as for us, seeing the works is less easy.

And see them one must. Everyone who looks at all at pictures has seen works by Chagall and Kandinsky, prolific artists whose works have found their way into museums and galleries all over the world. Costakis himself sold most of his holdings of these artists, considering them not essential to his collection because of their relative abundance in major galleries. Probably the greatest figure of the avant-garde, Malevich, although he did not emigrate, has been extensively collected in the West and is familiar to many. But what of Tatlin, Kliun, Rodchenko, Filonov, Exter, Puni, the marvellous Popova, Goncharova, Larionov, Stepanova, and twenty or thirty others? Twenty-five years after the West began to take the Russian avant-garde seriously, these are still little known except to specialists.

But matters are getting better. One can easily see reproductions in catalogues – many of them catalogues of Costakis exhibitions. The Montreal Museum of Fine Arts exhibited the Costakis collection in 1989. The Museum of Modern Art in New York has some important holdings, including a dazzling wooden "hanging construction" by Rodchenko, which it bought from Costakis. That same museum, in January 1991, put on a major exhibition of Popova's work, an artist central to the Costakis collection. Most encouraging of all, a massive exhibition of the Russian avant-garde appeared in 1992 in Frankfurt, Amsterdam and New York (the last at the Guggenheim Museum in the fall of 1992). This show, entitled *The Great Utopia*, included works from the Costakis collection and dozens of others previously unknown, dug out of obscure and remote Russian museums where they had been in dusty storage through all the years when they were considered unacceptable for exhibition.

Of course by far the most important collection, at least in terms of quantity, is in the Tretyakov Gallery in Moscow. But even though in Russia there is a changed attitude to the period and to the avant-garde, that collection and the other important one in the Russian Museum in St. Petersburg are only occasionally exhibited, and then not fully. They are, however, made available for exhibition outside Russia, and thus the world is coming to know this vital period in the history of its art.

Anyone interested in this legacy, which survived by a near-miracle, must see at least some of the paintings, the drawings, the sketches, the constructions, the sculptures, the designs. They are the art of our day, though created at least sixty, in some cases ninety, years ago. The works are technically superb, the artists highly accomplished professionals who had studied in the best schools of the time, in Russia and abroad. They studied with one another and, often in great poverty, had devoted their

lives to following their own visionary path. Rejecting tradition, they stood firmly on their own towering imaginations. They were unimpeded by any consideration of fashion, habit or money. And they were intellectual. Their best work was not merely talent applied to canvas; the final product was made up of a high order of artistic competence supported, as their voluminous writings show, by sustained cerebration about the essential nature of things.

◢

In 1863, twenty or more years before the first avant-garde painter was born, a minor revolt took place at the Imperial Academy of Fine Arts in St. Petersburg. Declaring the kind of art they were being taught to be sterile, a group of fourteen students left the academy determined to do something better. In a way they did: the paintings they produced over the next thirty or forty years are what most of us outside Russia were brought up to think of as Russian art, and what Russians themselves still regard as their classics. The works tended to be monumental, didactic and highly realistic, and their historical or biblical themes were usually easily understandable. Many of them are popular to this day. One has only to think of such familiar paintings as Repin's *The Volga Boat Haulers* or Aivazovsky's *The Billow*, or Surikov's *The Boyarina Morozova*, twenty feet long by six feet high and full of fascinating detail and impending violence.

The movement became known as the Wanderers or the Group of Wandering Exhibitions because in its early days it toured the countryside selling to provincial collectors. Producing works of the kind described, and largely uninfluenced by what was going on in Western Europe at the time, notably French impressionism with its focus on colour and light, the group had by 1900 itself become the acknowledged Russian art establishment. Soon it was suffering from the same artistic sclerosis which had caused the original fourteen to abandon the academy. That was the artistic environment in which the members of the avant-garde lived and studied. It was their powerful rebellion against this tradition that put its indelible mark on the history of world art.

The Wanderers were one element in these developments. There were others. The Tretyakov brothers, Pavel and Sergei, merchant-collectors with a strong nationalistic impulse, astounded the collecting world by buying the work of the Wanderers, befriending the artists of that school, and making their painting the basis of what Russians of that time, and indeed of all the intervening years until now, have thought of as "their" art. Ivan Morozov and Sergei Shchukin collected European as well as Russian art and made it available to the Russian public. In the private galleries of these collectors the young painters who would soon form the Russian avant-garde saw the work of Matisse

and Picasso. Those collections, seized by the state in 1917, now form the basis of what everyone can see in the Hermitage Museum in St. Petersburg.

In some ways more important for the future avant-garde were those other wealthy patrons whose concern was with the folk tradition in Russian art – the village tradition in building decoration and clothing design and ornamentation, the village woodcut called *lubok,* even the signboard on the village shop and tavern. All this was threatened by industrialization and the consequent movement of village populations to the cities. Some patrons, in particular Savva Mamontov and his wife, undertook to reverse or arrest this trend. In 1870 the Mamontovs bought an estate at Abramtsevo, and established there a colony of artists who based their work on village traditions – diluted, admittedly, by what they knew of some contemporary trends.

Whatever the long-term benefits of this activity, its immediate effect was on a group of artists then coalescing in St. Petersburg around Sergei Diaghilev and called The World of Art after the lavish journal which it published between 1898 and 1904. This group was involved in a range of artistic activity – exhibitions of foreign work, theatrical productions, music and ballet, its own production in the visual arts. Members of the group were well-off establishment figures, and what they did was in no way revolutionary or highly innovative. Nevertheless, they provided a new departure from the art of the Wanderers, who by now were themselves as artistically sterile as the academicians from whom they and their predecessors had parted thirty-five years earlier. Without making declarations or issuing manifestos, and certainly with no notion of moving toward abstract painting, the World of Art quietly, probably for the most part unconsciously, slid away from the notion of art for the sake of something else. Their art, unlike that of the Wanderers, did not point elsewhere; it was for its own sake. They provided a civilized, European, rational, calm setting for Russian art at the end of the century. But in their espousal of the village art tradition which came to them from Abramtsevo, in their attempt to work in what we would today call a "multi-disciplinary" or "cross-disciplinary" way (that is, in theatre, ballet, opera, and music as well as in painting) and above all in their conception of the work of art as an end in itself, with no external obligations, they opened the way for the avant-garde painters who were to follow.

About the importance of two events the historians of the period agree. One was the appearance, in 1890, of a canvas called *Demon Seated,* by Mikhail Vrubel. Vrubel is still largely unknown in the West, but the most important of the Russian avant-garde artists, notably Kandinsky and Malevich, have explicitly acknowledged their debt to this one canvas. An essentially realistic, figurative work dominated by a mysterious young man seated on the ground with his bare arms folded across his legs, it nevertheless contains the shades of mystical blue which came to characterize the next phase of the avant-garde development, and departs radically from the painting of its time in an

unmistakably cubistic background, also ethereally blue. *Demon Seated* is to this day a riveting work, the more so if one looks at the contemporary fashion in Russian art. Vrubel was ahead of his time and died unknown and in poverty.

The other early development of fundamental importance was the appearance of a group identified as The Blue Rose, which existed in an organized form in 1907-08 and held an exhibition of its members' works under the same name in 1907 in Moscow. It is no accident that the group chose to name itself for a nonexistent flower. The Blue Rose artists certainly did not break through to abstraction, but their "trembling silhouettes and blue diffusions," as a contemporary critic put it, their apparent lack of concern with technique and their concentration on the inner values of the painting rather than on its figures, pointed straight to where the avant-garde movement was surely going.

Between the Blue Rose exhibition in 1907 and the revolution in 1917, a bewildering series of groups was formed, one-time exhibitions held, and publications, declarations and manifestos issued. The Jack of Diamonds exhibition in 1910 led to a split with those who found their inspiration in foreign, mainly French and Italian, movements in art. They were denounced roundly by one of the principal women artists of the group, Natalia Goncharova, and her close collaborator, Mikhail Larionov (both of whom left Russia soon after this dispute to live in Paris, where they stayed the rest of their lives, and where Costakis visited them many years later). Goncharova's view, that of the "Easterners," prevailed in this classic Russian feud:

"At the beginning of my development I learned most of all from my French contemporaries ... Now I shake the dust from my feet and leave the West, considering its vulgarizing significance trivial ... The art of my country is incomparably more profound and important ... We have learned much from Western artists, but from where do they draw their inspiration, if not from the East? ... Contemporary Western art (mainly of France; it is not worth talking of the others) can no longer be of any use to us. And the time is not far off, when the West will be learning openly from us."

Responding to the "Westernizers" from the Jack of Diamonds exhibition, Larionov organized in succession three others, of which the best known is the Donkey's Tail of 1912. Although Malevich exhibited in this and Larionov's subsequent exhibitions, showing such now well-known works as *Portrait of Matiushin* and *Englishman in Moscow*, he showed no works of pure abstraction, what he called "suprematism." But he did so in 1915, at an exhibition entitled "0.10," where suprematism occupied the central place, and the road to full abstraction found its end.

With benefit of hindsight we are able to call the Russian avant-garde a movement. The forty or fifty artists involved did not think of themselves in that way at all. They knew one another, but they

coalesced around one-time exhibitions, notorious at the time for their eccentricity and sensationalism, and then went their own ways. Now, however, it is possible to see that these artists were all groping toward the same thing: pure or total abstraction. And once they had achieved it, in about 1915, they then groped toward a further objective: how to use it in realms other than painting pictures – in architecture, design, and industry, indeed, in society and life.

Abstract art is art which makes no identifiable reference to the external world. Not all avant-garde art is abstract; by the time Malevich achieved total abstraction with his suprematist paintings, he had built on the work of many who had gone before him: symbolists such as Vrubel, neo-primitivists such as Goncharova, cubo-futurists like Rozanova, rayonnists such as Larionov. Many of Malevich's predecessors tended to think that they had already found the true way and that those who claimed to see further were making a mistake. Two of the greatest avant-garde artists, Malevich and Tatlin, came to physical blows on the subject. But what we can see now is that all of them were driven by a need to make the painting a thing in itself, with its own life and its own meaning. As the movement advanced in the last seven years before the 1917 revolution, its adherents rejected with increasing stridency the notion that a work of art should carry a message, moral, or meaning beyond what was within its own frame, much less perform the menial task of holding a mirror up to nature.

Luckily for us, many of these artists tried to explain in writing what they were doing, what motivated them. This is Malevich, in a stunningly effective phrase: "I have destroyed the ring of the horizon and got out of the circle of objects." And Olga Rozanova, who was in several ways typical of the kind of person who made up this group, and whose work first drew George Costakis to the avant-garde:

"Nature is a 'Subject' as much as any subject set for painting *in abstracto* and is the point of departure, the seed, from which a work of art develops … A rearing horse, motionless cliffs, a delicate flower, are equally beautiful if they can express themselves in equal degree. But what can the artist express if he repeats them? At best, an unconscious plagiarism of nature … The artist must not be a passive imitator of nature, but an active spokesman of his relationship with her … A servile repetition of nature's models can never express all her fullness … The artist will reveal the properties of the World and erect from them a New World – the World of the Picture, and by renouncing repetition of the visible, he will inevitably create different images … Modern art is no longer a copy of concrete objects; it has set itself on a different plane, it has upturned completely the conception of Art that existed hitherto … The artist of the Past, riveted to nature, forgot about the picture as an individual phenomenon … Nature enslaved the artist."

Ivan Kliun, a pivotal figure in the movement, a close collaborator of Malevich in the crucial years just before the revolution, and one of the few who managed to continue painting and exhibiting throughout the thirties (although not in the style of his earlier years), made the same point:

"Only we have become fully aware of the principle: Art as an end in itself ... Michelangelo carved a beautiful David out of marble – but in a purely sculptural sense this work is insignificant. In it is the beauty of youth, but no beauty of sculpture. Our sculpture is pure art, free from any surrogates; there is no content in it, only form."

And Malevich, again, says much the same in *From Cubism and Futurism to Suprematism: New Realism in Painting*, published in 1916:

"The artist can be a creator only when the forms in his picture have nothing in common with nature. For art is the ability to create a construction that derives not from the interrelation of form and colour and not on the basis of aesthetic taste in a construction's compositional beauty, but on the basis of weight, speed, and direction of movement ... Nature is a living picture, and we can admire her. We are the living heart of nature ... To reiterate her is theft, and he who reiterates her is a thief, a nonentity."

Thus wrote the artists of the avant-garde, and thus they worked. The dream of Malevich and Kliun of painters as unacknowledged legislators of the world was not different from Shelley's similar claim, a hundred years before, for poets. But realistic art did not disappear from the face of the earth; quite the contrary, it came back stronger than ever in many forms. It was inevitable and not at all surprising that under the hammer of terror many of the avant-garde artists should have lost their courage, and that this art should have died in Russia. What was not inevitable and is indeed surprising is that once this handful of Russians had opened the way, the rest of the world walked with them into the art of our time.

Symbolism, neo-primitivism, cubo-futurism, rayonnism, suprematism – these and many others are the terms of those twenty or so years leading up to the revolution. Where Russian art would have gone next had there been no revolution is an interesting subject for speculation. But it is pure coincidence that Russian avant-garde art arrived at its full flower – pure art, with no external connections – and began to ask itself the questions, What use is this art? Where do we go from here? at the very moment the Bolsheviks made their move in Petrograd, and once again the world stood on its head.

Most avant-garde artists welcomed the Bolshevik revolution. Malevich declared that "cubism and futurism were revolutionary movements in art, anticipating the revolution in the economic and political life of 1917." In the opinion of many of these artists, painting had reached its logical conclusion with suprematism; there remained nothing for painters to do but throw away their easels and go out in the streets to design, build, create a new heaven and a new earth.

In their early enthusiasm for the revolution, the avant-garde artists had a powerful ally in Anatoly Lunacharsky, minister of education, or, as this high person was then called, People's Commissar for Enlightenment. At least in the first days following the civil war, he supported them and saw to it that such leading avant-garde figures as Tatlin, Kliun, Malevich and Rodchenko got responsible jobs in the various institutes and schools of art. Lenin, watching this process with some disquiet, and apparently without any idea of what the avant-garde stood for, disliked what he saw, and commented once that "Lunacharsky should be flogged for his futurism." Costakis, speaking in his shrewd way of these events, thought that Lenin saw "a little anarchy" in what was going on; that service to a higher truth, and not to the Soviet state, was uppermost in these artists' minds. But in 1920 and 1921 little of this ambivalence was apparent. The country was retreating from "war communism" to the modified capitalism of Lenin's New Economic Policy (NEP), and the retreat benefited everyone, including the artists. For a short while the avant-garde swept the world of art and art education before it, to the point where painters who had gone abroad at the time of or before the revolution, most notably Kandinsky and Chagall, came back to see what was going on and whether or not they should join in. Wisely, they decided they should not.

If the avant-garde artists were not realists in art, the Bolsheviks were definitely realists in politics. Even in the heady days of the NEP they were not disposed to let irresponsible and irrational (as they saw them) artists begin turning the fruits of revolution into chaos. Little by little the artistic scene began to change. Immediately after the revolution few new avant-garde works had been produced, the artists being too busy with such revolutionary activities as poster making and the decorating of buses and trains. Many of them never returned to easel painting and other conventional formats: Rodchenko became a photographer, Stepanova (his wife) and Popova turned to designing textiles and stage sets. Other members of the movement, convinced that it had run its course, reverted to figurative painting. One of these, the remarkable Pavel Filonov, managed to continue painting his extraordinary Brueghel-like fantasies through the twenties and thirties, although he was denied any public attention in the later years. At least one painter on the fringe of the avant-garde, Aleksandr Deineka, went on to become a pillar of the academy and of socialist realism in Stalin's time.

At the same time, the relatively independent art institutions which the avant-garde had found themselves managing after 1917 were gradually taken over by various state bodies. The last to go was

Proletkult, the Proletarian Cultural Organization, of which Rozanova was a member. That body was absorbed into Lunacharsky's own ministry, and soon became invisible. In the mid-twenties the pressure from official quarters increased, the artists read the signs, and by the early thirties the movement was in effect gone in Russia, its former members either demoralized and fearful or in some cases (not that of Malevich) convinced that they had been wrong all along. Some reports indicate that there was a sigh of relief when the country returned to the art it had known thirty years before – figurative, didactic, undemanding, and in a real sense of the word, popular.

But that was not how one of the great Russian writers of the 1920s imagined it. Peering into the future in 1920 and commenting on the world he saw ahead, Yevgeny Zamyatin wrote: "We have harnessed the once wild element of poetry. Today, poetry is no longer the idle, impudent whistling of a nightingale; poetry is civil service, poetry is useful." He could have said the same of his own art of writing prose, of music, theatre, ballet, and above all, of painting.

◤

Costakis first heard of the avant-garde, and got his first look at one of the paintings, in 1946. It was the worst possible time to begin amassing a collection of forbidden art. Soviet art of every kind – literature, painting, film, music – was about to enter the grimmest and most terrifying period of its history since the 1917 revolution.

Costakis recalled those early years of collecting the avant-garde:

The times were such that collecting was very hard. People were scared. For example, I would get an address and go and chat with them. Maybe they had a Chagall or a Kandinsky for sale. And the people would agree to sell. But they would ask me where I lived and – you know, "What's your phone number, in case we want to call you?" Next day, a phone call: "Is that Georgii Dionisovich?" "Yes." "You know, we've decided not to sell those pictures. My wife doesn't want to." And that happened often … It was in Zhdanov's time … and when these – what do you call them? articles? – appeared, our house shook. My avant-garde pictures were hanging in the main room [of our apartment] … and sometimes somebody would come to the door – the building superintendent or the local policeman or somebody with some kind of notice or I don't know what. And my wife and I, you know, we decided to move all the pictures out of the main room and put them somewhere else, in the bedroom. And in the main room we hung icons. So when people came in, they saw that we had icons. These weren't so strictly forbidden. But the pictures – we were scared. Yes, it was very difficult. If I had been an ordinary Soviet citizen, things would have been a lot

easier. As soon as they [people selling pictures] found out that I was a foreigner and, what's more, worked in an embassy, it was no good. They were afraid.

The "articles" Costakis referred to were a series of Central Committee decrees issued between 1946 and 1948, now called the "Zhdanov decrees" for their assumed author. These effectively gagged not only art and literature but every form of intellectual activity, including the natural and social sciences. The years between the end of the war and Stalin's death were certainly the most arid, culturally and intellectually, in all of Soviet history, and probably in all of Russian history. Max Hayward, who describes that period as "years of utter sterility," in his posthumously published *Writers in Russia: 1917-1978* recounts how the hopes of the artists and intelligentsia for a continuation of the relative cultural relaxation of wartime were quickly shattered. Akhmatova, the greatest Soviet poet living at that time, was denounced by Zhdanov as "half nun, half whore," and the Leningrad journal that had been publishing her poetry simply vanished, together with its staff. (To everyone's surprise Akhmatova was not herself arrested; in a typical act of Stalinist vengeance, however, her son was.) Hayward goes on to say that "for the remaining years of Stalin's life the Soviet creative intelligentsia lived in a constant state of fear, and the political demands made on writers were so excessive as to destroy even the propaganda value of literature." The same was true of all the arts and sciences.

So Costakis knew that it was very risky indeed to be collecting art that did not conform to what Zhdanov and Stalin had in mind. But how had matters evolved during the late twenties and throughout the thirties, while Costakis was driving ambassadors and loads of sand through the streets of Moscow, and how did they emerge into the final mad spasm of terror which ended only with Stalin's death?

The most perceptive and prescient artists of the day, even though they may have supported the revolution when it happened, saw within months or even weeks, and with the piercing clarity of people who know too late that they have made an appalling mistake, that the revolution was certain disaster. Alexander Blok was the supreme poet of the revolution, singing his acceptance of it and his rejection of all bourgeois values. Trotsky said of him, "He is not ours, but he rushed towards us." Blok died in 1921, heartbroken by what the revolution had so quickly become. In "The Last Years of Alexander Blok," an essay published in *Russian Studies* after the author's death, Leonard Schapiro comments:

"Blok, the inspired medium, the possessed *vates* of the revolution, grew silent and died: the depression was of a measure with the exaltation, and it cost him his life. Blok's death was not in my judgment a death of remorse: on the contrary it personified the death of the revolution which Blok

thought he discerned as an historical force in 1917, and which by 1920 had led to an ugly, rather shoddy, very corrupt, somewhat dishonest bureaucratic satrapy, with Lenin fast becoming the satrap."

"The louse has conquered the whole world," wrote Blok in his diary just before he died. Schapiro observes, "He is lamenting a revolution which has gone sour, which came in as a lion and was going out as − a louse." One of Blok's last published works was a lecture on Pushkin, in which he quoted Pushkin as saying that an artist must have "inner freedom." Blok interpreted the phrase as meaning "quiet, and personal free will" *(pokoi i volya)* and went on to say that artists had lost these things:

"Not the external quiet, but the creative quiet. Not infantile freedom, not freedom to indulge in playing the liberal, but the creative free will, the secret freedom. And the poet dies because there is nothing left for him to breathe: life has lost its meaning … Let the bureaucrats beware of an even worse description than *chern* ["mob" − the word Pushkin had used for them] when they are preparing to force poetry along some direction of their own, affronting the secret freedom of the poet and preventing poetry from fulfilling its mysterious purpose."

And in one of his last letters, in 1921, Blok wrote, "I have now neither soul nor body, and everything aches … And so after all, this dirty, own mother of mine, Russia, has gobbled me up as a sow gobbles up her young."

Blok's anguish as he saw the revolution going terribly wrong is important because he had been its poetic voice. Other poets and artists who had no such commitment arrived at the same conclusion even earlier. Anna Akhmatova, who was to suffer through all that would follow in the next forty years, beginning with the execution of her husband as a counter-revolutionary, said crisply that art under the Bolsheviks would be "like a hungry beggar, knocking at the door of strangers who will not open up." And Yevgeny Zamyatin, in his anti-utopian novel *We* (on which both Huxley and Orwell drew in part for their later works in the same genre), said, "Poetry is [now] the civil service." No single quotation can reflect the acuity with which the entire novel, written in 1923, foretold what lay five years down the road. Zamyatin was no friend of the revolution, while it was happening or later. He was pilloried and hounded out of the country.

As Costakis said, in the 1920s through 1932 the Bolshevik rulers of Russia gradually narrowed the field of opportunity for the avant-garde painters. They were urged to find more useful outlets for their talents than "a lot of cubes and quadrangles," and some of them did. Others began to doubt seriously that they were on the right artistic track. Meanwhile the artistic organizations which had

been set up soon after the revolution, and to which members of the avant-garde had been appointed as directors, professors and staff members, gradually disappeared, and artists who worked in conventional forms began once again to look upon themselves, and be looked upon, as the artistic establishment of communism. The brilliant trajectory of the avant-garde was nearly at its end.

By 1928 Stalin had routed his opponents in the Bolshevik leadership and had launched the First Five-Year Plan. The sequential nightmares of de-kulakization, forced collectivization and deliberately induced famine, together with break-neck industrialization, presumably kept the Great Leader and Teacher busy until the plan was declared fulfilled. Then it was time to turn to cultural matters. An innocent-looking party resolution of 1932 abolished, in effect, all literary and artistic organizations. In the same year the term "socialist realism" appeared in print for the first time. In 1934 the first Congress of the Union of Soviet Writers, attended by many eminent foreign writers, provided some opportunities for debate. But Zhdanov's speech in particular left not much doubt that literature was supposed to serve the heroic interests of the state. Later, as John Bowlt writes in his valuable *Russian Art of the Avant-Garde,* a conservative and conformist painter, Igor Grabar, made a speech from which it was clear that what held true for literature held also for the other arts, including the visual. According to Bowlt, Grabar in effect denounced the avant-garde as a national disgrace. Its bright day was done.

By 1934 art of all kinds had been rendered totally subservient to the purposes of the state; it was to stay that way absolutely until Stalin's death in 1953, and slightly less absolutely from then until the mid-1980s. The extinction of art was not accomplished only through exhortation and persuasion, although there was a lot of that. The secret police took a hand. Artists had a grim choice between conforming, or being jailed, exiled or shot. The third course, which some of them tried, was artistic silence. But that was dangerous too, and did not always save those who resorted to it. Max Hayward gives this summary:

"The political situation in Russia after the murder of Kirov (1934) destroyed the conditions for independent creative activity of any kind, and by 1939 the best that any Soviet writer who wished to keep his integrity could hope for was to be allowed to fall silent. Babel, Pilnyak, and many other Soviet writers were arrested and died in camps. Akhmatova chose silence, Pasternak took refuge in translation, and Mandelstam … spent three years in exile before being finally sent to his death … Meyerhold … publicly refused to accept socialist realism [and] was arrested and disappeared."

These were the great artists of their day, in all the arts. And others, not mentioned here, have recorded how they feared for their lives. When Stalin walked out of Shostakovich's new opera *Lady*

Macbeth of Mtsensk in 1936, the composer was certain that he would be arrested. He lived in fear of it until Stalin died. Shostakovich himself tells of the fate of some of his musical colleagues. Here is one example, from his memoirs:

"Gachev was a good musicologist, and after completing some difficult work he decided to take a rest and went to a sanatorium, where he shared a room with several others. Someone found an old French newspaper. To his misfortune, Gachev read French. He opened the paper and began reading aloud, just a few sentences, and stopped – it was something negative about Stalin. 'Ah, what nonsense!' But it was too late. He was arrested in the morning. Someone from the room turned him in, or perhaps they all did."•

◢

Although socialist realism displaced all new movements in Russian art, it did not bring about a complete artistic tragedy until the late thirties. In *L'Education sentimentale,* a novel by Gustave Flaubert, the high priest of realism, written one hundred years ago, before the Soviet Union or socialist realism had ever been heard of, an exchange takes place between a political radical and an artist. The political radical says: "Art must concern itself only with the moral consciousness of the masses. One must deal only with subjects promoting virtuous acts." "But that depends on how it's done," says the artist. "No, Sir," replies the radical, "You have no right to interest me in things I disapprove of. What need have we of these laborious trifles from which no good can be extracted – these Venuses, for example, that you insist on putting in all your landscapes? I don't see any education for the people in that ... Better to show them their miseries. Good lord, there's no lack of subjects; farms, workshops."

Telling people about their miseries is a form of art congenial to revolutionaries before the revolution has taken place. It is another matter once the revolutionaries have formed the government. The realism Stalin and his cultural henchman (and hangman) Zhdanov had in mind was therefore the reverse of Flaubert's. Artists were not charged with telling people about their miseries, of which they knew all too much, and which in any case were not supposed to exist. The watchword of socialist realism as it was promulgated in 1934 was optimism, romantic optimism. It did not matter whether you wrote novels and plays or painted pictures or composed symphonies; your task, and your only

• The authenticity of these memoirs of Shostakovich, published in the United States under the title *Testimony* and purportedly told to Saul Volkoff, has been questioned. When I asked the Soviet minister of culture, Nikolai Gubenko, about the matter in February 1990, he said nobody was sure, even the Shostakovich family was not sure. A former actor, the minister himself had once wondered about using *Testimony* as the basis of a play at the Taganka Theatre but had decided there were too many doubts about its authenticity. Nevertheless, he thought Shostakovich might well have said these kinds of things.

task, was to display the joy of the present and the even greater joy of the future. An additional requirement, before very much time had passed, was to attribute all this joy to Stalin. And there could be no equivocation: the novel or painting might be technically appalling, boring, absurd, but the message had to be clear, and it had always to be the same message: we are going forward from our bright present into the brightest of all possible futures.

In other circumstances a direction like this from the highest personages of the state might be laughed at as a bad joke. But there was no laughing; laughing meant the gulag and death. At first, failure to conform meant that your work went unpublished; before long it too meant the gulag. And silence, if previously you had been producing works of art, also drew the attention of the thought police. There was no safety.

Shostakovich describes this perilous artistic dilemma in his memoirs. When he was in despair and going in fear of his life, he was required, to please Stalin, to put an exultant finale on his Seventh Symphony, which had been inspired by the awful events of the siege of Leningrad, 1941. The result, as he says, was forced. "You have to be a complete oaf not to hear it … I never thought about exultant finales, for what exultation could there be?" He goes on: "It's as if someone were beating you with a stick and saying, 'your business is rejoicing, your business is rejoicing.' And you rise, shaky, and go marching off, muttering, 'our business is rejoicing, our business is rejoicing.' "

This revolting artistic dogma, ruthlessly enforced (with a slight remission during the war) until Stalin's death, came perilously close to destroying Russian cultural life altogether. There were survivors, however. Pasternak was one, although he had to make some dreadful compromises. So did Shostakovich. Akhmatova published nothing in those years, but lived to publish when it became easier. The greatest tragedy was perhaps that of the Russian avant-garde painters and other visual artists, who, had they not emigrated, simply disappeared. Some were arrested and sent to the camps; some gave up being artists altogether; a few, but not many, conformed and went from their brilliant avant-garde eccentricities of 1910-15 to depicting in high realism the joys of life under Stalin.

Historians have tried, with indifferent success, to analyze or psychoanalyse Josef Stalin. For our purposes it might be interesting to ask why cultural life and the arts received so much of his unwanted attention. He was given to telephoning artists without warning, either to berate them about something they had done wrong, ask their views on some work, or persuade them (if that is the word in so uneven a contest) to do something they would rather not do. Pasternak had calls from him, one at least, as did Shostakovich. He is said to have seen every film made in the Soviet Union between 1945 and his death, and he called in the film director Eisenstein to tell him how to do his job. One of the most amusing, and at the same time fearful, passages in Shostakovich's memoirs describes the

competition for a new national anthem, supervised and adjudicated by Stalin, who attended all the auditions.

The explanation is complex. Certainly Stalin shared the view of Lenin and the other Bolsheviks, probably even Lunacharsky, that art had to be useful to the state, had to support what the state was doing. There could be no neutrality: Those who are not for us are against us, and the camps await them. But there was more. Stalin's paranoia is well documented. Everyone was his enemy except the toadies who surrounded him, and even their lives were precarious. Two secret police chiefs were shot during the terror of 1937-38. Artists, whose job is to be visible and audible, were especially vulnerable; there was no place for them to hide if they wanted to practise their art. Then there was an obsession with omniscience: Stalin had to be seen to know everything about everything, including writing poetry and orchestrating scores. Finally, there was the evil obsession with power. It had nothing to do with communism or with Russia. Stalin had a lust for total power, and in his day he achieved it. As Shostakovich puts it, "Tyrants like to present themselves as patrons of the arts ... But tyrants understand nothing about art ... because tyranny is a perversion, and a tyrant is a pervert ... Isn't the lust for power a perversion?"

When Costakis started collecting what was left of the disgraced and forgotten avant-garde, Stalin's lust for power had reached its most obscene. Its consequences, for Costakis as for others, would not die with Stalin. They were with Costakis throughout his collecting life and ended only after he had left his country for the detested emigration, and after Stalin's heirs were no longer in the Kremlin.

CHAPTER IV

LAYING DOWN THE COLLECTION

Writers about Costakis have correctly noted that he stands in a long Russian tradition, that of collecting. Peter the Great started it, his interest focused, as in so much else, on Western Europe rather than on Russia itself. In the eighteenth century, Catherine II continued the tradition with massive acquisitions, describing herself as a glutton rather than a lover of art. In the nineteenth century, merchants imported Western art in bulk to fill the galleries of the great houses they were building for themselves. In the middle of the century one great art enthusiast, Pavel Tretyakov, departed from the practice of the Morozovs and the Shchukins and the smaller buyers by fixing his attention on Russian rather than Western art. When he sold his Dutch masters to concentrate on contemporary Russians, he was anticipating Costakis by several decades.

By the beginning of the twentieth century, when the avant-garde artists were forming their ideas and techniques, art had become big business in Russia. Not only was there frantic collecting, with trainloads of dubious as well as of valuable art arriving from Paris and London, but contemporary Russian art of all kinds drew huge crowds at its frequent exhibitions. Fortunes were made, incredibly, by many artists as well as by collectors. It was a heady time, which lasted through the war years and until the revolution.

The period of war communism and of the civil war immediately after 1917 caused a hiatus, but the introduction of the NEP restored some of the resilience of the market and some of the interest in collecting. The great collections had been nationalized immediately, but small collectors, like small businessmen (Costakis' father and brothers, for example), were allowed to operate, and the tradition remained alive. Even in the awful years of the 1930s, collecting went on. Costakis himself

became a collector in those years. But, as he described it, most Russians were selling, not buying, and those who were buying had their minds set on things other than art:

Working as the ambassador's chauffeur, I often had to take him to the commission store on Stoleshnikov Lane. There were two stores, a commission store and an antiquarian store. In the antiquarian store were heaps of all the riches and old things of Moscow. Russians, suffering as a result of the revolution, brought all their jewellery, their antiques, their silver, china, paintings, carpets – well, just about everything they had and handed it over. The store bought it from them for practically nothing because people had the idea, you know, that what cost so-and-so in czarist times, should only cost a tenth or a twentieth under the Soviet regime, so that ordinary people would be able to buy. If some rich person in czarist days paid, say, five thousand or ten thousand gold roubles for some trinket, some old object, then the antiquarian store might give five or six hundred roubles for it. And that's how objects were depreciated in value. Well, something terrible happened. They robbed the Russian educated classes, who had to sell their possessions for next to nothing, but the buyers were 99.9 percent foreigners, who got rich by snapping up these very valuable objects. Soviet people got very little of it. The foreigners were there a lot – diplomats, journalists, business-men – every kind of foreigner. And you know, this antiquarian store was like a Klondike. It was a bottomless buried treasure. They would come in with, say, a set of old silver of the seventeenth or eighteenth or nine-teenth century and plunk it down on the counter. Maybe a hundred pieces. In the course of a week nearly all of it would be bought. A week later they'd be back with another hundred or 150 pieces. And again they were snapped up. And again. And the same was true of china, and other objects.

As for the Russians, the Soviet people, at that time they were mainly interested in American gadgets – radios and so on. They thought nothing of old things. The people who were selling, the educated people, who needed money, had no choice but to sell. In those years a lot went out of Russia. An awful lot. It was a kind of torrent in jewels, that changed hands every day, piled up again, were sold again, and still they brought in more.

George Costakis may have stood in a long tradition, but the fact is that in the mid-thirties, when he bought his first piece (a porcelain horse "with Napoleon sitting on it"), he was an unlikely collec-tor. He was a chauffeur, recently graduated from truck driving. He had little education, and that lit-tle was very thin. He had grown up in a civilized and humane family, but also in the rough-and-tum-ble of the Moscow streets of the early post-revolutionary years. Furthermore, desperate Russians were selling and eager foreigners buying; Russians, by his own account, were not collecting.

But clearly Costakis' impressions of the commission store full of foreigners misled him. Russians were collecting, as his subsequent testimony shows. Certainly they were not collecting the

avant-garde, of which by this time few people knew anything. But in the thirties to collect objects, even originally Western ones, was not forbidden and not a matter of great interest to the police. Prices were low, as Costakis said. In fact Costakis became a collector swimming not against the tide, as he thought, but with it.

What kind of world was Costakis entering when he bought his horse with Napoleon sitting on it? It was a big world, a busy world. The great collectors of the past had gone, and their collections had been nationalized. But the Russian passion for collecting had not, and the small collectors (all were small by comparison with the Morozovs and Shchukins) were not important enough to attract official displeasure, especially since the kind of thing they were collecting had no political or ideological significance. In the fearful atmosphere of Stalin's pre-war and post-war Russia, and even during the war itself, Moscow and Leningrad were well endowed with men, one hears of few women, scraping together roubles to buy something at the commission shop or trading objects with other collectors. There was money to be made in it, Costakis said, and some collectors were motivated by that. He himself was making a profit from his first collection. Others did it for the love of it.

Costakis came to know many of these collectors, some of whom were still collecting in Moscow and Leningrad as late as 1990, and in his conversations he described them in detail. One of them was Yevgeny Platonovich Ivanov, who lived on Gorky Street, occupying one room in a communal apartment. The scene is an intimate one of a collector and his wife whom Costakis loved and of whom he saw much:

When I first got to know him he was about eighty. He was married to a woman called Claudia, who had once been his maid, a pleasant, smiling, good woman. She could not have been more than forty. The room I came into was like a long corridor with a window at the far end, looking on to a courtyard. To right and to left along the walls were shelves, each of them maybe a metre and a half wide. This made the room very narrow. There was almost no furniture: on the left side there was a couch, which served as a place to sit by day and as the couple's bed at night. Next to it there was a round table and three incredibly carved Russian choir stalls from the end of the fifteenth century. These Yevgeny Platonovich had brought from some northern monastery, and for a long time they served in place of chairs. There was no cupboard, no dining table, nothing, and there wasn't a square centimetre to put anything down.

The shelves on the left and right, from the floor to the ceiling, were entirely occupied by boxes and chests, containers of all kinds, in which there was everything you can imagine. Yevgeny Platonovich was an omnivore: he collected everything that any collector could be interested in. He had a huge collection of Russian and Byzantine icons, which of course caught my attention because by this time I had myself been collecting icons, together with the avant-garde, for some seven years. He had manuscript books with

miniatures from the fifteenth century, old crosses, some from the eleventh century. It was an overwhelming collection. There was a mass of old silver, of great beauty and great age. But he collected everything – toy soldiers from the Napoleonic war, other toys, a colossal collection of Russian painted boards *[lubky]* and many other objects demanding a collector's interest. There was a collection of labels from beer bottles, from lemonade bottles – different drinks from various cities of the country – Tula, Moscow, Petrograd. A stamp collection. There was so much that I couldn't begin to see it all. Let me just say that I wouldn't have been surprised if he'd brought out a collection of dried cockroaches and bedbugs. There was even an immense collection of Russian clothing of the seventeenth and eighteenth centuries. About eighty objects. And they were museum quality for beauty and conservation. Once Claudia opened two chests. On top of the first I saw a piece of brocade decorated with precious stones. There were *sarafans*, kaftans, *kokoshniks* – clothing of that time – of the greatest beauty. In the second chest was a great quantity of Turkish and Persian brocade, also of the fifteenth and sixteenth century, very beautiful and in perfect condition. I asked myself whether I should try to buy this outstanding collection, but I decided there was no point in it. For one thing, where would I put it all? And anyway, it wasn't my line.

Costakis went on to relate that he often tried to buy individual objects from Ivanov, but was always refused by the collector, who thought that his collection should be kept together. Once, he recalled, he and his wife were invited to a fancy-dress party by Svyatoslav Richter, the pianist, who was a friend throughout Costakis' life. Costakis asked, perhaps unwisely, if he could borrow one of the fabulous garments from the Ivanov collection for his wife, Zina. Ivanov and Claudia gave the matter much thought and finally agreed, but with many cautionary words about Zina's not drinking wine while wearing the dress or otherwise endangering it. Costakis proudly bore it home, only to find that even the slender Zina could not squeeze into it. The waist was at most forty centimetres, "the extent of a man's two hands."

Ivanov was so secretive that only through others did Costakis know that he was not the collector's only friend. But Ivanov was also old and wise and full of stories about the days, before the revolution, when a collector could be himself, and Costakis went often to the fabulous one-room treasure-house on Gorky Street.

One day Ivanov took him by surprise. Another kind of picture entered their relationship:

One day I was there, talking about this and that. Ivanov turned to Claudia and asked her to see if the porridge was burning [the kitchen would have been the communal gas burner at the end of the hall]. Earlier I had told him that I would soon go to Sweden for an operation and now, not knowing quite why he had dismissed Claudia, told him that the operation, to remove a kidney stone, would be in a week's time.

"God grant," he said, "that everything will go well. But Georgii Dionisovich, I have a little favour to ask of you, when you go to Sweden. I'd like you to bring me something." Well, I thought to myself, he wants a pair of shoes, or a tie, maybe a sweater. Certainly not a suit, because I never saw him in a suit.

"You know, Georgii Dionisovich," he went on, "I've heard that in Sweden there are magazines with naked women."

"What do you mean, naked women?" I asked.

"Well," he said, "I don't know. It's something they call 'porn.'"

"Yes," I said, "there is such a thing. Denmark and Sweden are famous for it. But," I continued, "it's complicated, and buying such magazines isn't quite my style. And besides, how do I get it back? It's forbidden to bring pornography into the Soviet Union."

"Georgii Dionisovich," he said, "you work in an embassy. They won't bother you at the customs. Stick them down at the bottom of your bag. Please do me this favour. I really want to see it."

Well, what can you say? So I said, "I won't make any promises, but I'll try to do something. But I'm telling you that you've given me a tough job."

So I got to Stockholm and I looked around. There it was; at every step, in every store, in every window you could see this porn: in the newspapers, everywhere. It was outrageous. Nowadays it's a bit less in Sweden. Anyway, I just couldn't bring myself to walk into one of these stores. It wasn't me. So I asked a Greek friend to buy me two or three magazines and explained I needed them for someone else. Of course he laughed and said I wanted them for myself. I told him no, they were for a collector in Moscow, a very old man. "Oh," he said, "an old man. That explains it. They like this stuff."

So he bought me four magazines. On the cover of one there was a picture of a beautiful woman with bare breasts and bottom. Nothing special. But I opened the magazine and inside – a nightmare. I'd never seen such things. But I took them back to the hotel, and I confess I had a good look at them. Then I put them in the bottom of one of my suitcases, with my suits and some clothing and shoes I had bought for Zina, and I flew back to Moscow.

I landed at Sheremetyevo airport. There was a whole delegation to meet me: the Canadian ambassador, the counsellor, the first secretary. Seven people from the embassy and my wife and children and friends. I went up to the customs control point, and all that delegation was close by. The customs officer was a young chap: "Open that bag!" My heart lurched. This is it, I thought. I opened the bag and he searched it to the bottom, but the magazines were in the other bag. "Okay, open the other bag." I opened it. But there was a second customs officer standing nearby, and he spoke up. "Aren't you ashamed?" he said to his mate. "You're dealing with a man who's just had an operation. He can hardly stand up. He's white as a sheet, and you …" The other one shrugged. "Okay, close it." I was saved.

We all went into Moscow in a great procession, and finally I got home. Then there was another problem. My wife and kids jumped on the suitcases to see what presents I'd brought them. But I got the magazines out safely and hid them, and next day I went to see Yevgeny Platonovich. I told him the story, and he laughed. "Go ahead and laugh," I said. "Do you realize what a calamity this would have been, in front of the ambassador, in front of my wife and friends?" He took the magazines, glanced at them, and I noticed he drooled a little.

The funny thing was, there was no operation. The kidney stone was small and passed by itself.

A second collector Costakis spoke of at length was Kondratii Tarasich Butkevich.

He wasn't a collector but he did a little restoration work, and picked up the odd piece, which he offered for sale to collectors. Sometimes he got hold of interesting things. He had icons and paintings and all that. I got to know him, and we had a very long friendship, if I may put it that way. Often he would bring me fakes. Once he brought me a Kandinsky with an obviously false signature. But the painting looked genuine. It became clear later, when Nina Kandinsky [Kandinsky's widow] looked at it. She said the piece was one-hundred percent genuine but the signature faked. Later we decided to correct the signature.

This man lived somewhere in the district of the Novodevichy monastery (at that time there were still old villages there) in a big village house. He had his old wife living with him, and grown children. As for himself, he looked very young. He was always telling me that to feel well you had to eat plenty of honey. In summer, when the bees are flying, and you find some beehives, you should let the bees sting you a little. At night he always took a very hot bath, and that was his cure. Obviously this worked for him, because despite his relatively advanced years (he was sixty then) he was a tough, healthy, man. A surprising man. But he was an awful bandit. He divorced his wife, married another thirty years younger than him, and produced two daughters. His old wife lived with them, doing the housekeeping, looking after the kids, and so on.

So this Kondratii offered me a "Nikola," a fifteenth century icon, shaved. "Shaved" means that a thin slice of wood, on which the actual paint appears, is cut off the main board of the icon. If an icon is damaged, they shave off the surface with the painted images, and transfer it to another board. And in this connection he told me an interesting story. At that time interest in icons was increasing. People started going around the villages looking for them. So he gave the job to his "agents," if I can call them that, that whenever they went into a village, they should bring back some icons. The "agents" took everything they could find. There were a few good icons, but most were poor.

So one day they brought him a whole bag of icons. He put them in the barn. They were third rate, from the nineteenth and eighteenth centuries. Not interesting. That winter it was ferociously cold; firewood was in short supply. He said to himself that he would make some use of the icons by burning them in the stove. So

he took an axe and went to the barn and started to split. He split one icon, then another. But for some reason, he didn't know what, when he came to the third icon he cut into it from the edge. He looked, and saw a strip of black wood, an old cut. And when he opened this – an icon from the fifteenth century, painted over and put into a new icon.

He was a smart man. He had a friend called Volodya Morozov, also a collector and artist. And these two bandits decided to go around the villages looking for icons. They went up north and started looking for icons in the northern villages. They told the local folk that they were church officials. Not priests, but people with a church connection. And you see, they explained to the peasants that their churches had been destroyed. Now new churches were being built, but they had no icons to put in them. So they were collecting icons for these churches. And, they said, they even had nice new icons that they could exchange for some of the old ones. They always had some icons with them on metal mounts. You've got these old icons in your church, and we can swap them for these new ones. And in this way they fished out old, old icons. When they were speaking to one another, Volodya called Kondratii Tarasich "Brother Kondrat."

Kondratii Tarasich, during his life, I think ruined many things – icons, paintings. It happened this way. Buying various things, including old masters, he laid hands on some old master and took it to the experts in the Pushkin museum. And it turned out that this was a canvas by a very well known French painter, very interesting. The museum bought it, and paid a big sum. After this Kondratii Tarasich went crazy. He started buying everything and looking for masterpieces. He restored them himself. He would take off one layer, look, then take off another, then a third, until he was down to the bare canvas. People told him that he shouldn't do it. Don't touch it. Take it to the museum and find out. But he kept on cleaning, and spoiled a mass of things.

Finally, Costakis speaking about the last years of the war and just after, told of poet, painter, sculptor, and collector Igor Lavrov.

In those years I got acquainted with Igor Petrovich Lavrov, a very nice and interesting man. Igor Petrovich loved poetry, knew by heart all of Khlebnikov and many other poets, and himself wrote poetry. Aside from that he was a painter and sculptor. He was often to be seen at the conservatory [of music]. What I mean is that this man belonged entirely and fully to art.

Lavrov had a big collection of Chukotka, fifteen hundred objects or more. There were objects from daily life, religious things, many carvings from walrus bone – cattle, birds, and much else. I greatly liked Chukotka art, and I asked Lavrov to let me have a few objects for my collection. For some reason he refused, but I managed nevertheless to seduce him. I had a big collection of contemporary books about art. I ordered them from London, Paris, from other places. Igor Petrovich had a great liking for such books, of

which he had some in his library. So one day I proposed an exchange: I would give him some books of interest to him, and he would give me some Chukotka pieces. Well, we started to exchange, and as a result, after a few years, I had formed a solid collection of Chukotka objects, about four hundred. Basically, as I said, they were walrus-bone carvings. But there were also wooden sculptures, Chukotka skis, masks, two or three relatively large pieces, with which you made sparks by rubbing sticks. You put a stick in one of the holes of this object, and with the help of a leather thong, you made the stick turn right and left, and fire appeared.

Among the Chukotka objects which I received from Lavrov were some unique pieces, and very old. Igor Petrovich gave me two little figures of a man and a woman, maybe four or five centimetres high. They had been found in a Chukotka mound, near a cache of weapons, or other objects. This was on an island. In pre-revolutionary times civilians weren't allowed to go there. But in the Soviet period some work was started. The Red Army, hacking away at a huge mass of ice, found these two objects at a depth of several metres. And Lavrov acquired these objects. They were dark brown, almost black with age. An analysis was done in Leningrad, which showed that they were about two and a half thousand years old. Lavrov gave me eighteen or twenty harpoons, very old; the bone had a brown-black shade. They were also two thousand years old.

◥

The business of collecting and trading works of art begins with a knowledge of the market, a keen eye (which does not happen by chance, but is developed and trained), and above all a love for it. Costakis' basic education for the art market was acquired in those days with his brothers in Sokolniky Park, with his father selling *piroshkis* in theatre lobbies. He described how it went on from there:

Nearly every time I took my ambassador there [to the Commission shop], I went in. Sometimes I went by myself after work and stood around listening to the collectors – what they said, what they bought. Gradually I became a bit of an expert. I got to understand about porcelain, and the salespeople even asked sometimes for my opinion: "What do you think, George? Whose work is it? Safronov, or ...?" You know, when it was a question of some little porcelain maker.

The German ambassador von der Schulenburg often came to this store. He bought mostly antiquities, porcelain and ancient Russian silver. I got to know him, and we often met and chatted there. So after I had made a little money at my job, I started to buy a few things. I remember the first thing I bought was a little porcelain statue of a horse, with Napoleon sitting on it. It seemed to me at the time very beautiful. Then I

bought two other porcelain statuettes. One of them turned out to be very old, very good. And so gradually I started buying things. A collection began to build up. Then I started buying pictures – Dutch masters – and silver. This went on a good ten years, and by the end I had a solid collection. I had maybe thirty or thirty-five paintings, so-called minor Dutch masters: Kalf, Berckheyde, Teniers. Artists like that. I couldn't tell you now if they were all genuine, but most were. And many were in contemporary frames, the old frames.

At that time I lived on Bolshaya Bronnaya Street. An apartment came up in a two-storey house on the same street, and I rented it. It was a three-room apartment with a good yard, a good garden and a nice view. In these three rooms I hung all these things up. My friends came to see what I had, and artists came too.

In talking with friends Costakis tended to dismiss those ten years of collecting. Not the collection itself, which he insisted was a good one, but the experience. About that he must have been wrong. Without what he learned in those years about the art market in Moscow – about the value of various kinds of things, about how to track down objects to complete a group or set, about the shadowy world of the Moscow art collectors, dealers and traders of that time – he would never have been able to conceive of, let alone complete, his work with the avant-garde.

And he spoke of the period as if there were nothing else going on but his collecting. In fact he was building this "first" collection during one of the most horrifying periods of modern history, and it is not possible that those events left him untouched. His employment at the Greek legation and, later, at the Swedish, British and, at the end of this part of his life, the Canadian embassies insulated him to some extent from what was happening. But he lived at home as though he were a Soviet citizen, his children went to Soviet schools, and his language at home and with his neighbours was Russian. Most of his friends were Russian, as were his fellow collectors. He acknowledged that those were dangerous and terrible days. Neighbours disappeared in the night, and no questions were asked in the morning. His own mother and brother went to prison during this period. But that is not the point to which his memory returned. Neither did it return to the various embassies where he worked. These were peripheral. Most people who knew him in the 1930s are no longer here to comment, but those who knew him after he began collecting the avant-garde recognized a collector's passion. There is no reason to suppose that in the earlier years he was any less in the grip of this mysterious fever.

The world of art provides few good descriptions by the artist of how the act of creation takes place. Costakis was not an artist at the time he started his collection of the avant-garde (he later became one), but to embark on a lifetime of collecting unknown works by mostly unknown artists is surely itself a kind of act of creation. What is most interesting is that there was no external impulse,

other than the strong impression made on him by Olga Rozanova's canvases, propelling him toward this important change of course. Money was certainly not an element; common sense would have told him that more could be gained from his collection of minor Dutch masters. (Common sense, as it turned out, would have been wrong, but Costakis could have had no way of knowing that in 1946.)

Nor did he stand to enhance his reputation as a collector. He sought advice on this from a well-known Moscow art historian, Nikolai Kharzhiev, who had known Malevich, worked with Mandelstam and written about Mayakovsky, and was thus, as Costakis said, directly connected with the avant-garde and their circle. Kharzhiev's advice was to the effect that what Costakis was doing might be very interesting for him, but nothing would come of it. Nobody wanted or needed whatever Costakis might manage to collect. It was all over with the avant-garde artists. They had been suppressed since 1932, no museum exhibited their work, interest in them had disappeared. But of course Costakis had to decide for himself.

Despite this I asked him for his personal opinion of the avant-garde artists. He reeled off some names: Chagall, Kandinsky, Larionov, Goncharova, Malevich, Chekrygin. These he thought pretty good, though little known in Russia. And he liked Olga Rozanova. By this time I knew a few of the names, and I asked him about Popova, Kliun, Rodchenko. He thought Popova and Kliun mere imitators of Malevich. The same was true of all the others. Rodchenko wasn't a painter at all, but a photographer. I shouldn't touch any except the ones he had named. I would only collect a pile of rubbish.

Costakis decided to reject this well-intentioned advice from a man who afterwards became a good friend. He had by this time, 1946-47, seen enough avant-garde works to have an impression of them. His impression was that although they strongly resembled one another, they were also all different. They had all at one time or another followed in the footsteps of the Great Master, Malevich, with his suprematist cubes and squares and triangles, but they had all subsequently gone on to their own styles, much deplored in some cases by Malevich himself. Costakis imagined a test on this point. Suppose you collected works by forty avant-garde artists and put them in a pile. You then invited someone with a sure eye to sort them out by painter, without giving him or her the names. Despite the fact that most of the works would contain very similar squares and cubes, despite the use in most of them of the same local paints, the sure-eyed person would have little difficulty distinguishing one painter from another. There might be one or two mistakes, not more.

Thus Costakis decided that he would defy not only prudence, by collecting the avant-garde, but also expert advice, by collecting all members of the group rather than just those with a reputation

among knowledgeable people. His friends and family felt sorry for him. Even artists and other collectors thought him a fool.

And once again, to form such a collection was downright dangerous in Stalin's post-war years. The works, in Costakis' words as well as Soviet terminology, were "proscribed" and "damned": "The artists or their relatives who had these things did not advertise the fact. Indeed, they hid them, showed them to nobody, and did not offer them for sale. And nobody asked to buy them, either." So Costakis was embarking on a collection which would, he thought, bring him neither fame nor money, which would be extraordinarily difficult to build because people were afraid to admit they owned the works, and which might well land him in the gulag. How did he come to such a decision, and why? His explanation reveals much about the man:

My old collection grew and grew. And there were some very interesting things. I collected old Dutch masters, and porcelain, old Russian silver, carpets, fabrics. Many good and valuable things. But then I started to think that if I went on with this collection, I would bring nothing new to art. Because what I collected was in every museum – in the Louvre, in the Hermitage, in every museum in every capital of the world. And in private collections. So if I went on this way, I might get richer and – that's all.

I had always wanted to do something. I mean it bothered me. Here I was surrounded by things. The electric light, for example. I always thought, Who invented it, and how, and why this and not something else? Various kinds of machines, anything at all made by man bothered me. I wanted to do something myself. When I was young I tried to write a bit of poetry. It was when I was very young. I remember writing some poetry about Lenin's death, and so on.

Costakis then described how he encountered his first avant-garde works, and continued:

They made a strong impression on me. Because take these Dutch paintings, minor Dutch masters, hanging on my walls. Somehow they irritated me. Here are twenty-five or thirty pictures hanging on the wall, all the same colour. Dull brown. Only the subjects are different. One picture shows a kitchen, another is a still life, the third – something else. I remember that there was one painting by Kalf: a kitchen, a table, and on the table a red object, some kind of little jug, and further back, a white jug. And you see, these red and white jugs, out of the twenty-five or thirty paintings hanging there, acted on me as signals of some kind. I found my eye always drawn to that picture. Sometimes my fingers even itched. I wanted to clean them, to scratch off the brown paint. Something might jump out, so to speak. And not surprisingly, I was increasingly drawn to and delighted by the frames. These were very beautiful. They glittered, set off with gold and silver. They were contemporary frames, of the seventeenth and eighteenth century. So … I didn't dream of giving up

collecting, but I was getting tired. I mean it was no longer giving me delight. It was as though I had spent all my life in a dark room with the windows closed – maybe a little lamp somewhere. But when I brought these [avant-garde] things home and put them down, the windows opened, the sunlight burst into the room and everything ... my heart ... and from that moment I decided that I had to get rid of everything I had and start collecting the avant-garde.

And that is how it began. Costakis was a highly intelligent man. He was warm and sensitive. He loved people, and they loved him in return. He was determined, tenacious, even stubborn. He had a well-developed (but not exaggerated) idea of his place in the world, and always had it, even as a "humble" clerk in the Canadian embassy; he was not, as they said of President Johnson, a man you would hand your hat to by mistake. According to his wife and children, he was a splendid husband and father. He knew how to make things happen in a society where nothing happens easily. He was articulate in three languages. He had a restrained but delightful sense of humour. All these qualities and characteristics he brought to the amassing of his collection, and without them all he could not have done it. His family relationships, like his relationship with his Canadian employers, with the young underground artists, with Soviet officialdom, were all essential elements in the complex person he was. The decision to start and the will to continue – indeed to finish, because he did finish – would not have been there, and the collection would not have been there, had not all these parts existed.

Costakis rightly stressed the difficulties of collecting the Russian avant-garde in post-war Russia. There was neither money nor reputation to be made from it, the paintings were desperately hard to find, and the work was dangerous. But there were also advantages of which Costakis may have been unaware when he set out on his journey. One was that, at least for several years, he had very little competition. After a few years some collectors began to watch what Costakis was doing, but by the time they got around to doing it themselves, there was nothing left. For the reasons so clearly explained by Nikolai Kharzhiev, not many people were interested in these artists, whose works were assumed to have no future:

[Among the collectors I knew was] Igor Vasilyevich Kachurin. An interesting person. He was a known collector, now departed, dead, they say, a year or a year and a half ago. He collected mainly Russian drawings, I think starting with the eighteenth century, then the nineteenth and twentieth. And he had many thousands of these works on paper. His principle of collecting went like this: A to Z. Under "A" there are twenty Russian artists. He had them all, and often more than one piece each. So, for example, he might have something by Arkhipov. Not just one thing but five or ten. Then Aivazovsky, let's say, and then others

beginning with "A." Then he moved on to "B," and collected all the "Bs." And in this way he collected many thousands. It was a kind of artistic encyclopedia. For every artist he recorded the artist's name, date of birth, period of artistic activity and so on. But he had no interest at all in the avant-garde. I think he had a few works, a drawing by Chagall, I think a Yivriyanenko. But generally speaking, not significant. No really serious things. To speak frankly, he wasn't interested in them.

One evening he phoned me. "Georgii Dionisovich, are you at home?" I said I was. "I want to come and have a cup of tea with you." "With pleasure," I replied. So Igor Vasilyevich came. I looked. He had a picture under his arm, wrapped in newspaper. So he sat down, unwrapped it, and put it against the wall. "There," he said, "I got this for you and bring it to you as a present. You collect all kinds of junk, so maybe this will interest you too." I took a quick look, and nearly had a heart attack. It was the *Green Stripe* of Olga Rozanova, and he somehow, somewhere, by chance, looking at some collection, saw it, and remembered that his friend Georgii Dionisovich loved cubes, squares and other such rubbish, and he took this work and brought it to me and gave it to me. Today in my collection it is one of the crown jewels. It is a kind of miracle, from 1917.

This "stripe" resembles very closely [Barnett] Newman, an American artist, who started this sometime in the sixties. Hilton Kramer wrote about this in the supplement to the *New York Times*. He wrote: "The Russians left us behind forty years ago, if not more." He also gave the example of Kliun's 'minimalist' *Triangle*.

The Hilton Kramer article to which Costakis refers appeared in the *New York Times Magazine* of October 11, 1981. Costakis' account of the article is generally accurate. The Kliun *Triangle*, reproduced in full-page colour in the article, dates, like Rozanova's *Green Stripe*, (also reproduced) from 1917.

There was another advantage. It is impossible to exaggerate the difficulties under which, until quite recently, Russian artists and collectors worked because of their nearly total enforced isolation from what was going on in the rest of the world of art. It is easy to forget that even in the late fifties it was not only impossible to see the avant-garde (except in Costakis' apartment) but it was very difficult for foreigners (and impossible for Soviet citizens) to see the magnificent collections of French impressionists seized from the Morozovs and Shchukins by the Soviet state and declared decadent and unfit for public consumption. This meant that Soviet "unofficial" painters, for example, trying to break out of the deadly circle of socialist realism, had nothing to go on but their imaginations. The wonderful East-West cultural interpenetration which had brought the avant-garde movement into existence was no longer there. The door had been firmly closed.

Much the same was true of collectors working, as most of them were, in such traditional fields as Dutch masters, Turkish carpets, and eighteenth century silver. Cut off from the world of collecting

and from access to Sotheby's and Christie's catalogues and news about their auctions, lacking contact with Western collectors with similar interests, Russian collectors lived of necessity in an incestuous world of their own and very often did not know their business. Costakis told of a visit to Moscow by the director of Christie's in London. They had dinner together, and the director admired Costakis' collection and then asked if Costakis could introduce him to a collector working in more conventional fields. Costakis introduced him to Felix Vishnevsky, who had the most important private collection in the USSR of old masterpieces, furniture, silver, porcelain, the kind of thing that interested Christie's. The director spent a day with Vishnevsky, then saw Costakis again. It was a very interesting collection, he said, but unfortunately Vishnevsky didn't know what was valuable and what wasn't, didn't know the provenance of things, and didn't know that his collection was far from unique in the world. A few days later Costakis saw Vishnevsky, who confirmed that the director had indeed opened his eyes to many things. "You know, George," he said, "we Russian collectors are like blind cats. We have no teachers, no advisers. We get things wrong and pass that on to the next generation of collectors."

In the first days of his collecting, Costakis said, there were no contacts with the West, no catalogues, no magazines, no way of knowing what was going on. Much of this problem Costakis avoided by choosing a field which had scarcely been explored in either East or West. A few Russian avant-garde artists, most notably Chagall, Goncharova, and Larionov, were still working in the West when Costakis started collecting, and they were written about. But their ties with Russia were largely broken, and they were working in new forms and under new influences. Those who had stayed behind in Russia had died or stopped painting, their works were lost or hidden, their names forgotten. For the first fifteen years of his avant-garde collecting, therefore, Costakis was working in an area where there were no experts on either side of the iron curtain. Indeed he, with little knowledge of art history, and none of the history of modern art, himself created the subject of an important part of that history, which began to be written only after 1960.

Costakis described the situation he found himself in after his conversion to the avant-garde:

In those years very few were interested in the avant-garde, and nobody bought their works. If somebody happened on an avant-garde piece, they immediately brought it to me and offered it for sale. They never kept it for themselves. I think the reason was that at that time everyone, without exception — critics, artists, the widows of avant-garde artists, the avant-garde artists themselves (those who had not yet managed to die) — they all thought that the avant-garde was a thing of the past, buried forever and ever amen, sprinkled with soil, blood and ice, and from this grave it would never rise. The works would never fetch a price. You know, collectors, even the most dedicated, when they buy a piece because they love it, still have in mind that one

day the price will go up. It's a kind of capital investment that should give a result in five or ten years. For this reason I worked absolutely alone for a good fifteen years, and that helped me get the collection together. Everyone brought things to this fool of a Greek. He buys this junk, let's take it to him. Even people with a good eye, who knew art, brought me things. They didn't believe in the avant-garde.

Many who know the Costakis collection have doubted Costakis' own account of how it was created. Here was this man with little knowledge of art in general and none whatever of the art he was supposed to be collecting. He had no money but his clerk's salary from the Canadian embassy. He worked at the embassy at least eight hours a day and often at night or on weekends, when a shipment of freight or food came in, or a new staff member arrived, or someone had visa problems at the airport. He lived far from the embassy in three rooms of a dilapidated wooden house, where he was raising, when he started collecting the avant-garde, three children, soon to become four. How was it possible? The answer, of course, lies in qualities of character, especially tenacity and persistence and a way of relating to his fellow human beings that brought instant trust and acceptance.

◧

Liubov Popova was one of the giant figures of the movement. She was only thirty-five when she died in 1925, but she had stood at the centre of the avant-garde for at least the last ten years of her life and had been immensely productive. The quality of her work, especially the spectacular *Architechtonics* series produced between 1917 and 1919, is attested to by the fact that the Tretyakov Gallery insisted on keeping most of her paintings when Costakis emigrated. Nevertheless, Costakis retained several splendid works, and his story of how he quite literally "discovered" this significant modern artist and tracked down her paintings on barn windows and under laundry tubs is among the most fascinating anyone has to tell in this genre:

The hunt for these things was very difficult. At first I managed to get my hands on only one or two Popovas. Then the trail ended. But after a time, completely by chance, I found the real trail. Somebody introduced me to Pavel Sergeevich Popov, a university professor. He had once been a professor of divinity, but I don't know what he taught after the revolution. A tall, handsome gentleman. He lived on one of the little streets off the Arbat, in a big apartment. Well, I visited him there, and in the first room, where he received me, I saw one or two small Popovas on the wall. So I asked him to talk about his sister. He said, "Yes, you know, she died early. I've got a few of her works here." I said, "I've started collecting her works. Could I buy some from you?" He replied, "Look, I've got a lot of her work. I'll show you if you like." So he took me into another

room, and there were ten or fifteen pieces, some on the wall, some piled up. All first class. I bought them all. He parted with the small ones with great difficulty. When we came to the last one, he said, "I'll keep this one. It's small and I can always hang it. The big ones maybe not."

"You'd better go," said Pavel Sergeevich to me, "to see my adopted son in Zvenigorod. I think he's got some Popovas. Go and find out." So I went. I found a village house, a big garden. I came just at blossom time; everything was in bloom, apple trees and cherries. They received me warmly. The first thing I noticed, going up the stairs to the second floor, was a Popova painting on plywood being used to support the trough where they did their laundry. Anyway, they showed me many Popovas, gouaches, drawings. Then we went for a walk around the garden. We went past the barn. I noticed that one of the windows was covered with a piece of plywood, and on the plywood was a number, then another number, then the name "Popova." I went inside, and on the inside of the plywood was a splendid painting. I said, "I'll take this one too." "No, he replied, "this one I can't sell. It will rain, and everything will get wet. Bring me another piece of plywood, and then I'll give it to you." So I had to go back to Moscow to look for a piece of plywood. They were all too small, but finally I put two together, and I got that Popova too.

Chagall was another kind of artist, the search for his works another kind of search. He was by far the best known of the avant-garde artists who had left Russia at the time of the revolution or soon after. Only Kandinsky had a comparable reputation, but he had been dead a year or more when Costakis began collecting. By then Chagall was already a towering public figure in the West, and he would continue adding to his reputation until the end of his long life in 1985. In later years he and Costakis came to know one another well: Costakis stayed with him in France, and in 1973 Chagall visited Costakis and saw the collection, rich in works of his Russian period.

Hermetically sealed though Stalin's post-war Russia was from all Western influence, it was impossible to keep some knowledge of Chagall's achievement from those such as Costakis who knew and followed the art world as best they could. Costakis told the story of his acquisition of two unusual works of Chagall, painted outside Russia only a few years before Costakis acquired them. Chagall was a Jew. Living in New York during and for a short time after the war, he met there in 1946 Solomon Mikhoels, director of the Moscow Jewish Theatre, where Chagall had worked for several years as a designer. Mikhoels was in New York on a visit, probably connected with the Soviet Jewish anti-fascist league, set up during the war to help the Soviet war effort. In those days, the war won and the cold war not yet begun, Russians were popular in other Allied countries. Chagall decided to give two of his recent works to the Tretyakov Gallery, perhaps as his contribution to these friendly relations. He asked Mikhoels to take them back with him.

The time could not have been worse. The state of Israel was about to be founded, Stalin's paranoia about Jews was building toward a peak, the Jewish anti-fascist league was on the point of being disbanded and the Jewish theatre closed. Mikhoels himself was to be an early victim of these frightening developments: he was murdered on Stalin's orders in 1947. The Tretyakov Gallery, obviously frightened almost to death themselves, declined the two paintings, which remained with Mikhoels' widow.

Costakis told more than once the story of how he came by these two now-famous paintings, *Burning Village* and *The War: Mother and Child*. One account is to be found in his introduction to Angelica Rudenstine's rich *Russian Avant-Garde Art: The George Costakis Collection* (1981). The story that follows is similar, but in somewhat different words:

There were successes and there were failures. Once somebody gave me the address of Anastasia Pavlovna Patotska. She was the wife of Mikhoels, and I heard that she had many Chagalls which she probably wanted to sell. She lived then on Tversky Boulevard in the TASS building. They had already killed Mikhoels, and she lived alone. So I went to see her, introduced myself and asked if she had any works. She said yes, she had some sketches from the Jewish Theatre, and some other things. On the wall I saw two Chagalls, but from a late period, probably the Paris or American period, fairly big gouaches. One was this *Fire in a Russian Village in Time of War*, and the other, in green tones, *The Expulsion of the Madonna from Europe*. A woman, seated, with her baby. [Costakis gave the two works different names, but they are the same works mentioned above.]

Well, we talked back and forth, and finally she said, "I've got nothing now, but come again in a few days." Right from the beginning I thought there was something wrong with this woman. She was sick. Something odd. Next time I came, and she showed me two Chagalls, gouaches, and I bought them. She said she would telephone me, but didn't. Finally I phoned her and went to see her. Yes, she had some things to show me, but they were in a trunk (which she pointed out). She had to look for them, and she was too busy. Come back in a few days. In this way she put me off again and again. Next time I went to her house, she had her head wrapped in bandages. She said she had been hit by a car. I asked about the Chagalls. She said I should come another time. I suggested that she should rest and let me look through the trunk. To my great surprise she agreed. Thank God, I thought. At last.

I started on the trunk. Files, papers, books, a mass of dust. No Chagalls, absolutely nothing. "Anastasia Pavlovna," I said, "where are the Chagalls?" Well, she must have put them some place, moved them and forgotten where. She would have to ask her daughter. I asked about the two Chagalls that I had seen on the wall when I first came. No, these she didn't want to sell now. If she changed her mind she would let me know.

About six months went by. Then I had a call from her daughter: "Mama wants you to come. She's ready to show you the two things that were on the wall, because she needs some money to make a monument to Papa. So come." I got some money together. I can't remember what value I put on the paintings for myself; I think about four thousand roubles each. So I arrived. The Chagalls were there. She offered tea, and we drank. Then she took down the two Chagalls. "Georgii Dionisovich, if it is not too much for you, I would like to have between three and four thousand roubles for the two paintings." I said nothing, but I took out eight thousand roubles and put them on the table. She gasped. "What are you doing?" "Anastasia Pavlovna," I said, "you have evaluated these pieces incorrectly. I long ago decided for myself how much I would pay for them. I don't want and I cannot take advantage of your lack of knowledge and take these works." Well, she was very happy, and I bought these pieces.

One of the most important figures in the Costakis collection as it exists today is Ivan Kliun, to whom we owe, among much else, the dazzling work *Landscape Rushing By,* which for many symbolizes the collection because it is reproduced on the front dust jacket of *Russian Avant-Garde Art: The George Costakis Collection,* which contains colour reproductions of a significant number of the works. Kliun stood at the centre of the movement, a constant disciple of Malevich, and produced what many consider its most beautiful paintings. He was one of the few in the group who, when the end came for their kind of art in the early thirties, neither ceased work nor went abroad but continued painting in a figurative style acceptable to the authorities. Costakis' most adored painting of the entire collection was a Kliun, the brilliant abstract which provided the poster for the Stockholm exhibition in 1982.

Kliun was one of the few members of the group whom Costakis knew personally. The others he knew, such as Rodchenko, Kudriashev, Goncharova, Larionov, Chagall, and one or two more, because he was collecting their work. He encountered Kliun, however, before he started on the avant-garde, and while he was still developing his classical collection. Kliun attended exhibitions and sales, as did Costakis, and there they met. At first Costakis had no idea Kliun was a painter. When they became friendly, he sometimes went to Kliun's house in the Sokolniki district of Moscow. Kliun showed him some paintings, landscapes and still lifes, conventional things and not, according to Costakis, very interesting. The artist said nothing about his work as a central figure of the avant-garde twenty years before. Not only would it have been dangerous to do so, but, according to Costakis, Kliun was one of those who in the 1930s had serious doubts about the validity of what he and the others had been doing and took to figurative painting as much out of conviction as prudence. When Kliun died in 1942, Costakis knew nothing about the avant-garde or Kliun's place in

it. Kliun went to his grave with no notion that forty years later he would be hailed as a genius and exhibitcd all over the world, thanks to the efforts of his casual acquaintance from the exhibitions.

The survival of Kliun's work, or of part of it, is one of Costakis' most extraordinary achievements. He found Popova's paintings on barn windows, but a large part of what he obtained of her work was being looked after by her brother and might well have survived anyway. Not so with Kliun. When Kliun moved from Moscow early in the war, he left his work in the care of a woman to whom he had been renting a room in his wooden cottage in Sokolniky. Finding herself short of space, the good lady put the works out on the terrace, where neighbourhood children used them as material for building tree-houses and the like. A few pieces escaped. A major artistic catastrophe occurred when, in a railway station, Kliun put down for a moment a suitcase containing most of his correspondence with Malevich, as well as many of the master's drawings. The suitcase disappeared instantly, and presumably forever.

It was some time after he started work on the avant-garde, when he had already acquired several Popovas and Rozanovas, that Costakis heard about Kliun as a member of the movement and realized who his dead friend had been. His informant was the gloomy art historian Nikolai Kharzhiev, who had already warned him against the avant-garde artists on the grounds that there was no future in collecting them. Kharzhiev gave an especially stark warning about Kliun, saying that he was a mere imitator of Malevich and not worth collecting.

Nevertheless, Costakis got some leads from Kharzhiev as to where he might start looking. Returning to the house he already knew in Sokolniky, he found the tenant still there, and from her he got the works which had survived the attentions of the children. Then he was able to track down first one, then another of Kliun's daughters. They had a considerable number of their father's paintings, which they thought unimportant and were happy to get rid of. The bulk of Costakis' holdings came from them. Later he was able to add a piece here and another there, until Kliun became a central figure in the collection, as he had been in the movement. Many of Kliun's drawings were to disappear from Costakis' Moscow apartment and *dacha* (summer cottage) when these were broken into, in mysterious circumstances, in the early 1970s.

The story ends with a curious twist. Some of the Kliun works were painted on thick cardboard, hollow inside, with white paper glued to it. Thinking to stabilize them, Costakis took them to a conservator (always a bad thing to do, he said later). The conservator opened the cardboard and found stuffed into the hollow spaces a large sum in czarist roubles, suggesting some expectation, or at least a hope, that the good old days might some timc return.

After Stalin's death in 1953, Costakis began showing his collection to foreigners, starting with his Canadian employers and moving on from there. Most of these dazzling paintings were by artists of

whom the visitors had never heard. The two exceptions were Chagall and Kandinsky, with whose incredible work the walls of the little apartment in Bolshaya Bronnaya Street glowed. For better or worse these two great figures of the art of our time do not dominate the part of the collection which is in the West: most of Costakis' holdings of these painters either stayed behind at the Tretyakov, or were sold after he left the Soviet Union.

Vasily Kandinsky was probably the most cosmopolitan of the avant-garde artists, and like Chagall always a little removed from its centre. He went to Paris as early as 1906, and after that, although he participated in most of the feverish artistic activity of the period before the revolution, he maintained his connection to the West; eventually, in 1922, he went to live first in Germany and then in France, where he died in 1944. He is usually credited with being the discoverer, if one can use such a word in art, of abstract painting. But it is a matter on which Costakis and his friends did not agree.

Costakis recalled the student through whom he came by some of his Kandinsky canvases. The story offers an example of how his humanity often served his collection without his even being conscious of it.

One fine day a young man called Volodya phoned me. He was a student, working on Bulgakov [author of *The Master and Margarita*], assembling materials, taking photos, and so on. He had got to know Bulgakov's widow. He said he would like to see my collection. He had heard a lot about it, but he had also heard that I was very busy and it was difficult to see the collection. I told him this was nonsense, that I never refused to show the collection to anyone, and when people are interested, I show the collection with pleasure. So he came. A young man of about twenty-six, good appearance. I sat down with him for two or three hours. We drank tea, and later we got hungry and had a little vodka and something to eat. He was very happy when he left. Four or five days later he phoned again and asked, very apologetically, if he could bring his wife some time. She was disappointed that she had missed the opportunity to see the collection. I said, "For God's sake, come tomorrow." So they came, and I gave them a good reception, and the wife was pleased. A month or two went by. Again he phoned, but this time he wanted to come by just for a few minutes, to talk. I told him to come. Then he asked me, "Are you interested in Kandinsky?" "Very," I said. "Do you remember I told you that I was working on Bulgakov? Well, Bulgakov's widow is a friend of the widow of Bobrov [Kandinsky's secretary]. And this Bobrov's widow has some Kandinskys that she would like to sell. Do you want me to see her and find out about it?"

Of course I said yes, and he and his wife went the next day. Then they came to see me. They told me that they had got a cold reception. It was a mistake; she had nothing for sale. Volodya was embarrassed, but I told him not to be upset. I was grateful that they had thought of me even if nothing had come of it.

Another couple of months went by. Volodya phoned again. He had received a mysterious call saying that the widow of Bobrov had been away but was now back and prepared to show her Kandinskys. So this time I went with them. As soon as we went in, I saw two or three Kandinskys hanging on the wall. After a while Bobrova brought out a package and laid it on the table. I thought I would have a heart attack, my heart was pounding so hard. On the table lay twelve gouaches of the very highest quality, painted in the period 1913 to 1917. In ideal condition. Bobrova told me that if I wanted them I could buy them. She said she needed money right away. But money was my problem too. Maybe one or two, but this was a Klondike. And in addition, there were two oils. So I left some money and said I'd come next day. Then I ran around to all my friends, collecting money. It was hard work getting enough, but the next day I bought them all, including the oils. Bobrova was pleased. She had just been talking, she said, to her daughter. She too had a very big Kandinsky oil, *Red Square,* and I got that as well.

The *Red Square* oil is one of Kandinsky's most famous works and for many years was at the centre of Costakis' collection. It is now in the Tretyakov Gallery in Moscow.

One of the avant-garde artists who survived long enough for Costakis to know him personally was Ivan Alekseyevich Kudriashev, who died in 1972, leaving with Costakis some remarkable abstract oil paintings, many of them apparently of objects flying at great speed through space. There are not many of his works in the Costakis collection or anywhere; his name is seldom found even in specialized art histories. But Kudriashev is memorable as a protégé of the master, Malevich, and notable as one of the artists who went into the revolution with full enthusiasm (he produced the design for the "first Soviet theatre," in the city of Orenburg) and ended, numb and silent, in 1928, when he realized what the revolution really meant for art and artists. Costakis' story of Kudriashev is as sad as the worn but sensitive face in an undated photograph in *Russian Avant-Garde Art: The George Costakis Collection.*

At that time I got to know Kudriashev. He was close to Malevich and a pupil of Malevich, and their group was at Orenburg. Malevich was the head of this, but they made regular contact by mail. They wrote to one another, and Malevich told them what they were to do. So the first Soviet theatre was created by Kudriashev. It was a suprematist construction. In the 1930s, when this kind of art was suppressed and Kudriashev himself was afraid, he finally stopped this kind of work, and in his later years he turned into an artist in the department of medicine. He worked also for an encyclopaedia, where he made drawings of intestines and hearts and livers, that kind of thing.

When I first met him he showed me twenty or twenty-five works from the 1920s. Up to this time he had not shown any of this to anybody or given any to anybody, so I was one of the first buyers. It is true there

was a Professor Myasnikov, who turned up for a couple of days at Kudriashev's house. He was an important specialist but was also a collector. Basically he collected Russian artists of the eighteenth and nineteenth centuries, but at the end he began to take an interest in the avant-garde, and Kudriashev was the first who came his way. Then, between us, we bought nearly everything he had. Myasnikov bought, I think, three or four works and I bought twelve or fourteen.

After this we became friends. I very often went to Kudriashev's place. He was a good man, but ill. He had tuberculosis. His wife was also an artist, and she lived with him. A year or year and a half went by, and I went to see him. He showed me some abstract pieces very similar to those I had bought from him. I said, "And where are these from?" And he said, "You know, I have just drawn them." I said, "Why are you doing this? Time has gone by, and you ought to be doing something new." He made an excuse, that he still had some drawings and watercolours from the old times, and he planned to do some pictures. But he couldn't. There was no time. So, you know, he repeated what he had done before. I didn't like what he was doing, and I told him this was a waste of time, but anyway I think he continued on this way and produced maybe ten works from this late period of his cycle.

Anyway, his health got worse. He felt worse and worse, and one day he was no more. He died. He died, and his wife remained. We were at the funeral, and his wife was there and she wept, and she said to the dead Vanya, her husband, "Okay, Vanochka, I have to tidy up your affairs, and as soon as I have finished I will come to you." After this she started to offer everything that remained of his work, including these late things. I categorically refused. I said that they didn't interest me, and besides, these could confuse things. Then she took them to the Tretyakov Gallery, and I don't know whether she said that these were late works or whether she presented them as works from the twenties. But the Tretyakov bought them, and now these things are in the Tretyakov together with the self-portrait of the artist, which I wanted to acquire, but for some reason at the last moment they got cold feet, and it now hangs in the Tretyakov. So after this, when she had made all these arrangements, she got a piece of rope from somewhere, and she hanged herself in the bathroom of her apartment just as she had promised. And that's how her life ended.

In the Museum of Modern Art in New York there is a remarkable oval wooden "hanging construction," or mobile as we might call it now. The notice tells us that it was made by Aleksandr Rodchenko in 1920 and acquired by the museum from George Costakis. Costakis himself considered it the jewel of his entire collection. This was, he said, the piece with which he would part last if he had to part with all. He believed and said it was "unique in the world." (Originally Rodchenko made five of them. According to Costakis, Rodchenko himself destroyed the others. This is not yet established.)

Rodchenko is another of the few avant-garde artists Costakis knew personally. He died in Moscow in 1956, ten years after Costakis began collecting; even after Rodchenko's death and that of his artist wife, Varvara Stepanova, Costakis kept in close touch with their children. It is clear from Costakis' conversations that of all the avant-garde artists, Rodchenko, an orthodox communist through thick and thin to the end of his life, a painter who abandoned painting for photography because it was more "useful," was the one with whom Costakis felt the most personal and artistic affinity. This was partly, no doubt, because he knew him. But he knew others too, and about some of them he had decided reservations. Not so with Rodchenko. Here is his own account of Rodchenko:

I was friends with the Rodchenko family, and after Rodchenko's death, and that of his wife, Stepanova, a little later, I often visited the family, which consisted of Rodchenko's daughter Mulya, Kolya, her husband, and Sasha, a son. At the beginning they dealt with their father's works in a somewhat slipshod way. Quite a bit later Mulya and the others came to learn that both their father and their mother were artists of interest, and they began to conserve what was left. In addition to their parents' works, they had in the house works of others, given by the artists to Rodchenko. There were some watercolours of Kandinsky, and I saw a small abstract oil of his dating from 1913. Kandinsky had left a number of works with Rodchenko, asking him to sell them. Some Rodchenko had sold, and had given the money to Kandinsky, but the others were still there after Kandinsky left for the West. The family had a substantial number of works by Stepanova, and by Rodchenko himself many gouaches and drawings. I saw many things. I found especially interesting Rodchenko's notebooks in which he drew sketches of his own paintings and dated them. Then if one were sold – and that didn't happen often – he indicated it. I was struck by one of his drawings. The notebook had relatively big pages. In the precise centre of one of them, with an ordinary pencil, Rodchenko had put a single point, a period. And this he signed at the bottom. On the next page the same, except this time it was a little dash. Also signed "Rodchenko." He was a great experimenter, but his outstanding period, 1916 to 1920, was very short, only five years. After 1920 he took up a camera and began vigorously working as a photographer. He made well-known, excellent photographs of Mayakovsky, and he worked in photomontage. At that time Rodchenko was a pioneer in this art form, highly experimental and producing much interesting work.

But in painting he slowed down. I think the reason was that even before the heavy pressure and the suppression of the avant-garde, which did not yet exist in the early twenties, Rodchenko for some reason decided that everything he had been doing all those past years wasn't what the people and the Soviet proletariat needed. I have to say that Rodchenko was a very orthodox communist and therefore gave up, without any urging from the authorities, what he had done so outstandingly between 1915 and 1920. But at some point in the 1930s he went back to painting, not abstract but figurative, somewhat like Francis Bacon but

GEORGE COSTAKIS: A RUSSIAN LIFE IN ART

without the deformations of face and body. But rather close to Bacon. In that period he painted clowns, circuses, some portraits. But this period was a curiosity, not significant in his work. In the 1940s he returned to abstraction and produced a significant body of work in the manner of Arp. In 1942 he did a composition on very long paper, very much in the manner of Pollock. It was a frieze, which he painted in order to put it on the floor beside his bed, instead of a carpet. And he did some lampshades in the same Pollock style. In addition to his paintings and drawings, in the 1920s Rodchenko produced some remarkable constructions. Five or six were hanging constructions, and there were also standing ones. I had one, but it was done in cardboard, and later Gmuzhinskaya made a metal reconstruction of it, painting it white. She made several copies. But all these constructions were lost. Clearly, Rodchenko destroyed them himself.

Costakis then went on to describe how he obtained the splendid oval construction now in the Museum of Modern Art. In about 1950 he went to visit the artist at his house. He asked about the constructions. What had happened to them?

[Rodchenko] somehow didn't reply very clearly, but he said, "I think there's one of them somewhere here, maybe up on the sleeping boards [above the stove in old Russian houses]. Go up and look." So I got a ladder and crawled up. There were masses of dust, and countless papers and magazines that had been tossed up there. In the middle of this mess lay an oval hanging construction in pieces, that is, without the wires holding its parts in place. I brought it down. Rodchenko said, "Take it. You'll find a safer place for it," and he gave it to me. This construction, even beside thousands of works of Popova, Kliun and even Malevich, was number one in my collection and my most significant work. I always thought that if some day I had to start selling the collection, this hanging construction would go last.

But things turned out otherwise. The story of how the hanging construction found its way into the Museum of Modern Art, or rather the various versions of that story, are for telling elsewhere. Two things are clear: that the transfer to the Museum took place in 1987, when Costakis was about to go into hospital for a very serious kidney transplant operation, and that Costakis was disappointed, indeed bitter, about the way the transfer was managed. Nevertheless, the piece which Costakis regarded for many years as his most valued possession is now beautifully displayed where the whole world can see it, with a marker identifying it as having come from him and his wife. Worse things could have happened to it.

In his preface to *Russian Avant-Garde Art: The George Costakis Collection*, Costakis remarks about his collecting, "All this had to be done over the abyss of the decades that separated me from those stormy years that were by then part of history." Not quite all. Costakis' friendship with the impoverished and forgotten Rodchenko provided a direct bridge over the abyss; in another way, so did his acquaintance with Kliun. There was a friendship of another kind and a bridge of another kind, provided by Marc Chagall, then reaching the height of his artistic power and fame in France. (It is characteristic of Costakis that he could be and often was impressed by power, fame, and wealth; he could be equally impressed by simplicity and honesty and in fact felt more at home in that kind of company. His friendship with Chagall was marked by a reserve on Costakis' part which almost certainly did not exist in his relationship with Rodchenko, the loyal communist.) And yet another bridge existed in the form of Costakis' acquaintance with Natalia Goncharova and Mikhail Larionov, living in exile in Paris when Costakis went there in 1955.

But the most direct link with that distant past went straight to the heart of the avant-garde in its brilliant years. Vladimir Tatlin was a strange figure. He had been to sea as a common sailor. He went to Paris in 1913, visited Picasso in his studio, saw his work, and according to Costakis, returned to Moscow determined to advance beyond it. He participated in all the avant-garde exhibitions which took place in the four following years and emerged as the leader of the "constructivist" school, which opposed itself to the suprematists, who followed Malevich. The constructivists sought the practical application of art in society through architecture, design, crafts. (One of Costakis' important Tatlin possessions was a wooden strut for an aircraft wing.) The suprematists were seeking pure spirituality through form on canvas. The constructivists and suprematists seemed at the time to represent total opposition (and the two leaders reflected this by coming to blows over it). But in fact they were really two sides of the same coin: after the revolution many of the Malevich school found themselves turning by choice to constructivist activity, that being better suited to the psychology of the time.

Tatlin is best known now for his extraordinary model of a structure which, when built, was to be four hundred metres high and was to straddle the Neva River in St. Petersburg, serving as a monument to and the headquarters of the Third Communist International. Not surprisingly, it was never built.

Tatlin was a survivor. He went on designing and painting throughout the twenties and thirties, although he did not keep the important jobs in the art education system which he was given immediately after the revolution. According to Costakis, who knew him in his later years, he was a taciturn, unprepossessing person. But he consented to talk briefly about his visit to Picasso in Paris,

where he got angry at the arrogance of the great man. Said Costakis, "Returning to Moscow, [he] decided to show both Picasso and everyone else that we were no worse, and right then he started work on those reliefs and counter-reliefs, and as we know he produced masterpieces."

But Tatlin was secretive, as apparently were many others of the group. They were doing what they regarded as research and development in art, and they were jealous of their secrets, to the point of concealing what they were doing up to the very day of exhibition. After Tatlin's death in 1953, one of his several widows told Costakis how Malevich, with whom Tatlin was on very bad terms, nevertheless came to see him one day. "He knocked on the door, but Tatlin at that very moment was working on a painting. So he shouted at Malevich, 'Kazimir, old chap, I haven't got my pants on. Just let me get dressed and I'll open the door.' Then he took his unfinished work and hid it in another room, and afterwards let Malevich in."

These were Costakis' main direct links with the past he was so avidly unearthing. Rodchenko and Tatlin in Russia, Chagall, Goncharova and Larionov in France. And he knew others. But for his special heroes and heroines: Kandinsky, Popova, Malevich, Drevin, Rozanova, most of the great names, he had to rely on what he could learn from the reminiscences of their sometimes fearful surviving families. There was practically nothing in writing about any of them except an occasional letter and reviews, generally negative, of their pre-revolutionary exhibitions.

In Costakis' opinion and that of many other collectors and experts, Kazimir Severinovich Malevich is the most important figure, artistically and intellectually, of the group. Unlike many of the others, Malevich has been well known in the West almost from the beginning, in part because in the early 1920s he exhibited in Berlin and Warsaw and became known outside the Soviet Union, and in part because he wrote and published extensively. Even when the clouds were gathering, in 1929, he was able to have a one-man exhibition in the Tretyakov Gallery in Moscow. Thereafter he, like Kliun and others, returned to figurative painting. He died in obscurity in 1935. There are important collections of his work in Western museums; a major exhibition, a Soviet-Netherlands co-operative venture, was held in Amsterdam in the spring of 1989. It was one of Costakis' hopes and ambitions to see a monument raised to Malevich at the site of his grave, which is known approximately but unmarked. Costakis' collection included several Malevichs, one of them the important *Portrait of Matiushin,* now in the Tretyakov Gallery. But these he acquired with much difficulty, and at the beginning with the help of the same art historian, Kharzhiev, who had counselled him in 1946 against embarking on his collection. It is ironic that Costakis' friendship with Kharzhiev came to an end precisely over the collecting of Malevich. Kharzhiev, the sceptic, wanted to keep Malevich to himself and resented Costakis' efforts to acquire some major works.

CHAPTER V

THE MATURE COLLECTOR

Costakis was a collector of many things. The avant-garde was certainly the collection which made his name and set him apart from the other collectors of our time. But he was a major collector of icons, nearly all of which stayed behind in Russia. He had a priceless collection of old Russian toys, which he refused to count among his achievements because he bought it as a collection rather than assembling it laboriously piece by piece. He had some important holdings of native art, the art of the Chukchi people in the far northeast of Siberia. And he had, until his conversion to the avant-garde, his "first" collection of minor Dutch masters and the rest. All of this meant that over the years he developed some thoughts on the nature of collecting, on its ethics, on its techniques, on the problem of "fakes," on what it is to have a good eye, and on what his own role was in the preservation of art works from the past. About fakes, Costakis said:

It's like this: you look, and you decide, yourself. If it's a fake – tough luck. I remember one time, when an artist sold me a fake. A fake Picasso. It's a long story.

A Picasso turned up in the commission shop. *Three Oranges*. It was put up for sale as a Picasso. I said I wanted to buy it. The director of the shop said okay, but in the end he sold this Picasso to Ilya Ehrenburg. I was very annoyed. But just then there came into the shop a well-known Moscow art specialist, a specialist in Aivazovsky. Toskin. So Toskin says to me, "Don't be upset," he says, "because this Picasso that you … isn't authentic Picasso. The real Picasso belongs to Vedensky's widow. It's also *Three Oranges*. There are two paintings called *Three Oranges*, the one that's just been sold, and the one over there, with Vedensky's widow. That one is genuine."

So I went to Vedensky's widow and bought this Picasso from her. But first I checked. Yes. I ask her, "Where did you get this piece?" She says that her husband bought it from the artist Glushchenko. [There was a well-known artist by this name, who in his time went to Paris, stayed there, then returned to Moscow, and became a friend of Vedensky.] Just to be sure, I phoned Glushchenko in Kiev, and asked him. I ask him, "Is this real, the Picasso that belongs to Vedensky's widow?" "Yes," he answers, "the master gave it to me himself, and it's one hundred percent Picasso. You can take it and not worry." Well, I bought it. I took it home.

A few days later Falk came, the artist. He looked at this piece and said, "You know, I don't like it." He didn't say exactly that it was a fake, but somehow … And next day he sent me a magazine, a French magazine, in which there were some Falk reproductions, and some reproductions by a French artist called Delacerne, looking very much like the *Three Oranges*. Well, I looked. Something wasn't right. So I started to look closely, really study the piece, and under "Picasso" I saw the letter "D." In short, it was Delacerne. On top somebody had put "Picasso." I gave this piece to the research museum, they looked at it with these … rays, and read the signature "Delacerne." That meant it was a fake Picasso.

Well, I thought to myself, what do I do now? It turned out that this same Glushchenko was having an exhibition in Moscow in Kuznetsky Most, and was coming himself. I had already phoned the widow and said thus and so. She said, "Well, expose this Glushchenko, because he sold us this piece. He's coming himself to Moscow and is staying in such-and-such hotel. The Sovietskaya." I phoned there, and we agreed that I would come to see Glushchenko. When I got there, he had company. Women in decolleté dresses, dancing, drinking champagne. I say, "Can I have a word with you?" He came out. "Hello, Georgii Dionisovich! How are you?" I say I am well. Then I say such and such. "Here's this Picasso that I bought. It's not Picasso. It's Delacerne." His face changes right away. "Well, you know, it could be. In those days there was everything and there could have been a mix-up with Delacerne and Picasso. But don't worry. I have Chagall, Kandinsky, I have … I'll send you something else, and we'll remain friends. No need to make a scandal." "Well," I say, "okay."

Some time went by. A month or two. Of course he sent me nothing. And then I was riding in a taxi with a well-known (I forget his name) collector. An old man from Leningrad. He had Chagalls, good Larionovs, Goncharovas. Very solid. Blokh! Blokh! That was his name. Blokh! So Blokh and I are riding along together, and I say to him, "There, you know … " So and so, I say. "Here's this Glushchenko," I say, "a bandit. And I want to write a letter to Kiev … where he works in the ministry of culture, and expose him." Blokh says, "Don't do it. You will lose. Don't in any circumstances do it. Because if you do it, you'll wind up on the collectors' black list, and everybody will reject you. They'll say that you have to be very careful with Costakis because, if something isn't just as it should be, he'll go for god's sake and complain. This won't help you. He's not going to send you anything, and you … I mean … "

So I did nothing.

In "Collecting the Avant-Garde," the article with which he opens *Russian Avant-Garde Art: The George Costakis Collection*, Costakis lays down five "rules" for collectors. They form the basis of his thinking on the subject and are as follows: Feel like a millionaire even when you are penniless; Never rationalize; The work you want comes first – give up everything for it; Never haggle; Ruthlessly define the limits of your collection and stick to them. These five could stand as the parameters of Costakis' life, except perhaps the last. Costakis was never good at doing anything ruthlessly, least of all putting limits to his activity.

But beyond these five precepts, Costakis had other ideas. One of the most important of them, and it was for him a rule as much of life as of collecting, was never to refuse to see, talk to or have dealings with anyone. The collector is by definition an optimist and an opportunist, he should not anticipate from what unlikely quarter his chance will come. He therefore never says no, even to the most unlikely people. Costakis put it like this:

In the course of all this time of collecting, the creation of my first collection and later the collection of the avant-garde, I met many people. And many of them were very interesting and sometimes useful. Some of them were honest people, but others were, so to speak, swindlers, who knowingly offered me fakes. But from the beginning I worked out a precise system for myself: Refuse to look at nothing and refuse to see nobody. Because, making a collection, the collector never knows where his good luck will come from. It often happened as follows: I would get to know somebody who was offering some objects for sale, and from the beginning I would see that the person was not very honest and was trying to deceive me. But I wouldn't break off contact; I would simply become more careful, more attentive, but I would not lose touch with this person. Because I knew that through this person, totally by chance while chatting over a cup of tea, I might get an address where some simple thing – not very interesting – was for sale. But by taking this step, I would meet somebody else, from whom I might acquire something of minor importance, but this second person might open doors and channels of great importance. And that's how I worked all these years.

That golden rule is not one of the five. Never haggle, however, is, and Costakis expanded on it in one of his conversations. He recalled the occasion on which he obtained the two important Chagall paintings from the widow of Solomon Mikhoels, Anastasia Patotska. Commenting on his decision to pay her more than double what she asked, he said:

Of course, I made a good deal. But I have a commandment for collectors: Collectors must not haggle. That is, it's better to overpay than underpay. The person you buy from must be satisfied, because when he sells,

after a few months he has neither money nor object, whereas you have the object. In other words, you're in a winning situation, and he in a losing one. When you do a deal like this, then you willy-nilly acquire, not exactly an agent, but someone who can help you advance your collection. Someone may come to Anastasia Pavlovna and say, "Look, I've got such-and-such a piece. Do you know anyone I could show it to?" And she says, "Show it to Georgii Dionisovich. He's an honest man, and pays well."

Costakis was also absorbed by the ethics of collecting, and he faced some ethical problems himself. He was absolutely convinced of the intrinsic value of the works he was collecting, although in the early years, at least, he knew there was no real market value for most of them, except Chagall and Kandinsky and a few others, for whose work there was a market outside Russia. Was it ethical, in these circumstances, to deprive their owners of them, when the owners had no idea of the importance of the works and were happy to get rid of them, in many cases for nothing or for trifling amounts? In the end he concluded that as long as he paid a reasonable sum for what he got, what he was doing was ethical. In his conversations he mused on the siege of Leningrad, when hundreds of thousands died of starvation as the Nazis tightened the noose around the city. Some of the most important collections in Leningrad were formed at that time, because "with people dying like flies from hunger, for a few kilos of flour or for half a kilo of meat, you could buy any masterpiece you wanted. People would rather part with their masterpieces than be carried out feet first." Many people, Costakis said, made use of these circumstances. But he did not blame them: precious objects were preserved and would sooner or later come to the state, and in the meantime lives may have been saved with the food that changed hands.

Continuing in this line of reasoning, Costakis considered the case of one big Moscow collector. He and his brother, said Costakis, went about Moscow together, calling on widows and children of artists and collectors and, with an elaborate piece of theatre, getting them to part with their most precious possessions. They would make an offer on the first thing they saw when they came into the house, of no particular value, and bargain hard for it. Then they would ask casually, as they were going out the door, if the piece they were really after could be thrown in with the lot. They did not, Costakis said, always get away with it, but in those days prices in the Moscow and Leningrad markets were unstable and generally unknown except to dealers. Sometimes this kind of highway robbery succeeded. In any case they carefully avoided letting the unsuspecting seller know that they had any special interest in the piece or that it had any particular value. Costakis also called on the widows and children of artists, but he always told them exactly what he wanted and why, and he always gave them what they asked, or more if he had it. Of course his reputation as "the crazy Greek" went before him. Collectors working in established fields had a harder job since owners were more likely to have

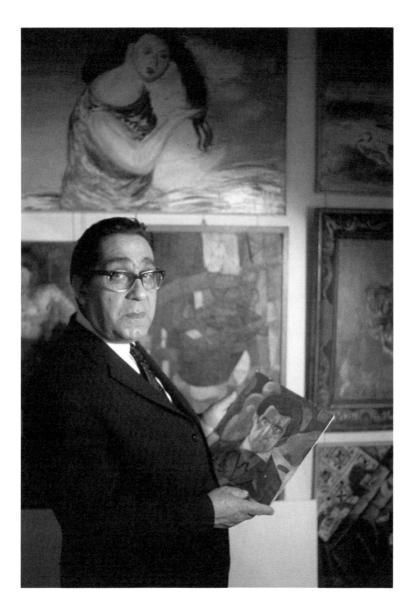

Photo of Costakis in his Moscow apartment during
the visit to the collection by Prime Minister Pierre
Trudeau in 1971. He is holding a self-portrait by
Kazimir Malevich. Above him is Aleksandr Drevin's
painting *Woman with Long Hair*.

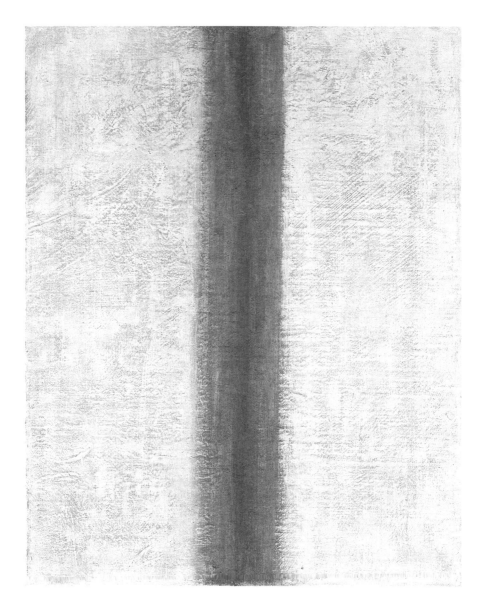

Olga Vladimirovna Rozanova. *Untitled*.
(Green Stripe). Oil on canvas, 1917.

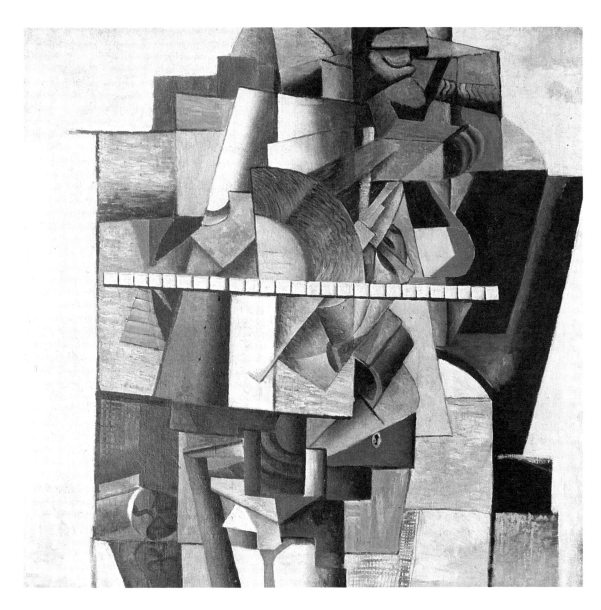

Kazimir Severinovich Malevich. *Portrait of Matiushin*. Oil on canvas, 1913.

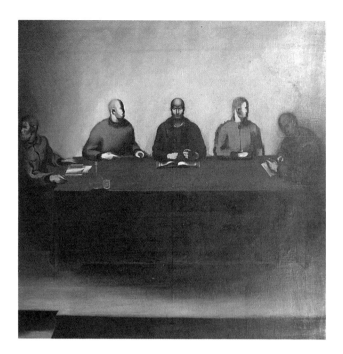

Solomon Borisovich Nikritin. *People's Court.*
Oil on canvas, 1933.

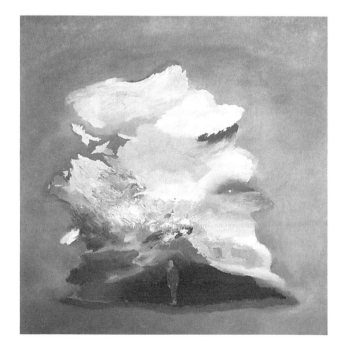

Solomon Borisovich Nikritin. *Man and Cloud.*
Oil on canvas, 1930.

Pavel Nikolaevich Filonov. *Untitled*. (First
Symphony of D. Shostakovich). Oil on paper,
1925-27.

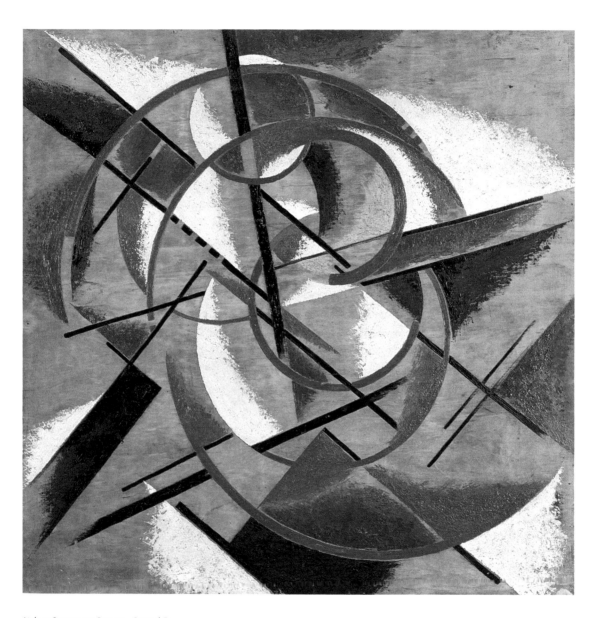

Liubov Sergeevna Popova. *Spatial Force
Construction*. Oil with marble dust on
plywood, 1920-21.

Ivan Vasilievich Kliun. *Red Light, Spherical Composition*. Oil on canvas, circa 1923.

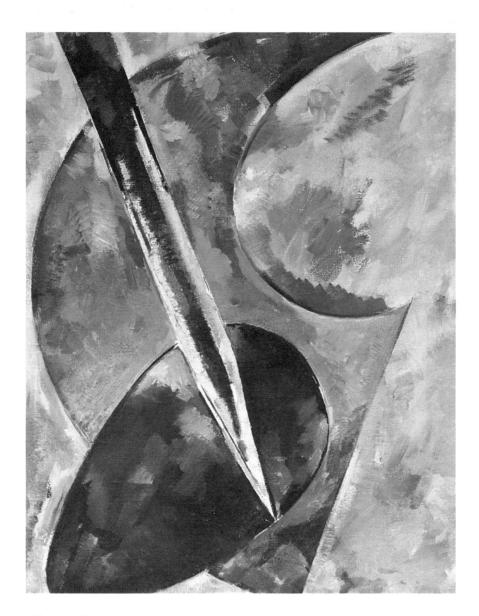

Aleksandr Mikhailovich Rodchenko.
Composition No. 125. Oil on canvas, 1920.

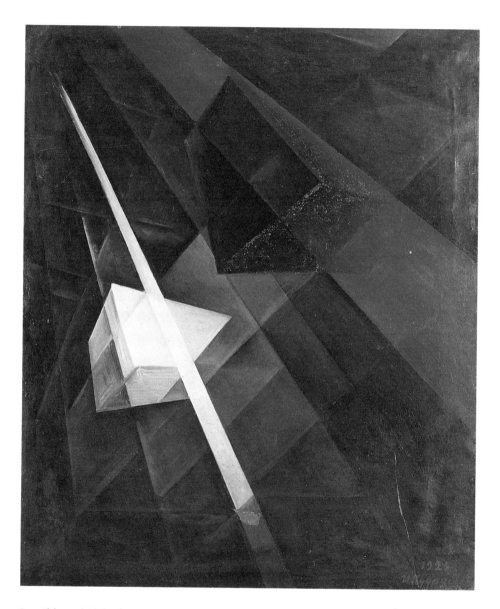

Ivan Alekseevich Kudriashev. *Construction of a Rectilinear Motion*. Oil on canvas, 1925.

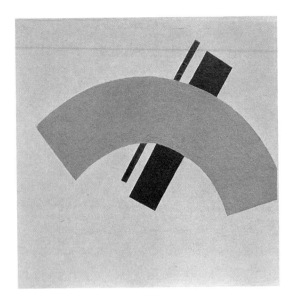

Ivan Vasilievich Kliun. *Suprematism.* Oil on panel, 1917.

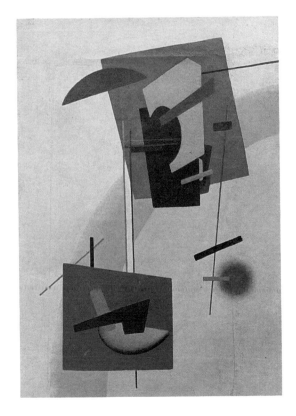

Ivan Vasilievich Kliun. *Composition With Three Centres.* Oil on canvas, 1932.

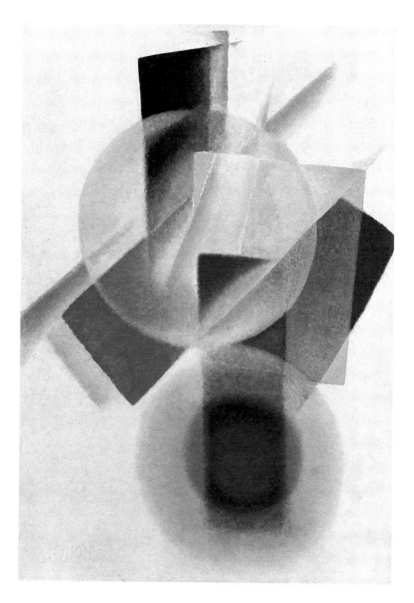

Ivan Vasilievich Kliun. *Spherical Non-objective
Composition.* Oil on canvas, 1922-25.

Mikhail Vasilievich Matiushin. *Painterly-
Musical Construction*. Oil on board, 1918.

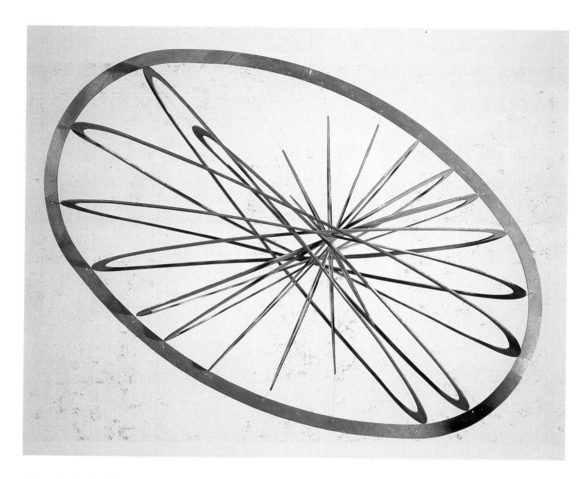

Aleksandr Mikhailovich Rodchenko. *Oval
Hanging Construction Number 12.* Plywood,
open construction partially painted with
aluminum paint, and wire, 24 x 33 x 18 $\frac{1}{2}$,"
circa 1920.

The artist gave this work to Costakis, who
considered it the finest in his collection. It was
acquired in 1987 by the Museum of Modern
Art in New York, and is exhibited there.

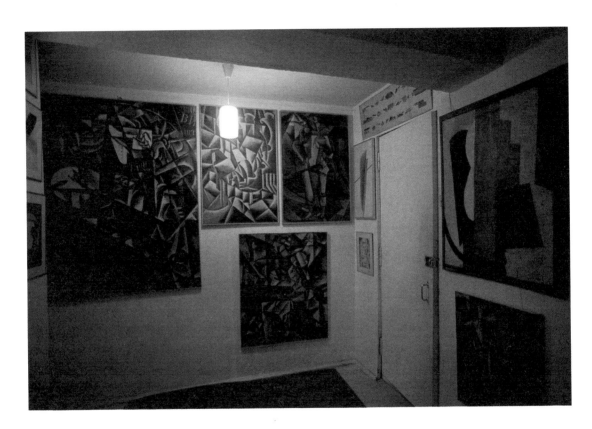

Photograph of a corner of Costakis' Moscow
apartment, 1971, during the visit to the
collection by Prime Minister Pierre Trudeau.
Six paintings by Vasilii Kandinsky are visible.

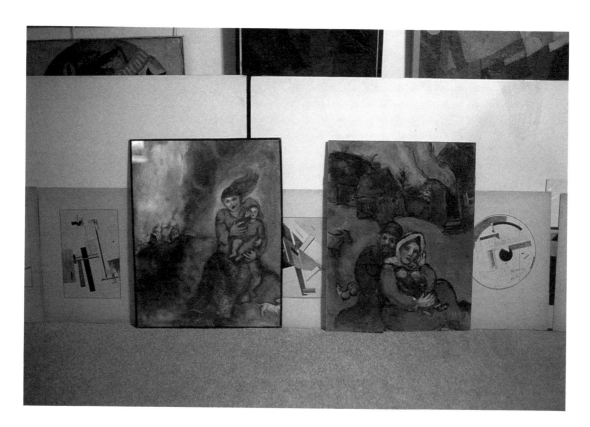

Photograph of Costakis' Moscow apartment
during the same visit. The picture shows two
"war horror" paintings by Marc Chagall
(variously titled).

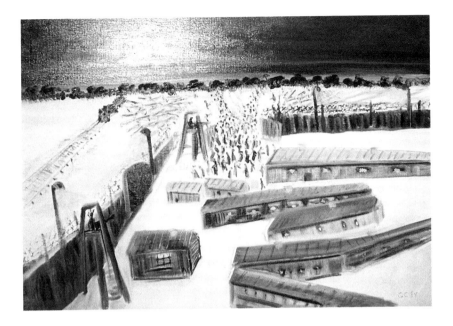

George Costakis. *Untitled*. (Labour Camp at
Kotlas). Oil on canvas, circa 1986.

George Costakis. *Untitled*. (Skeletal Trees).
Oil on canvas, circa 1989. Probably
Costakis' last painting.

some idea of the value of their possessions or were at least unlikely to regard them as worthless and dangerous junk.

Costakis wondered whether Ilya Ehrenburg did not also belong to this same underhanded school. Ehrenburg was the most prominent Soviet novelist of Stalin's time, an intellectual, a Jew, a collector of modern art (not the approved kind), and a survivor, often accused of having survived the whole of Stalin's reign and well beyond it by becoming the regime's chief literary apologist, with no conscience whatever and not even the decency to fall silent. Costakis knew Ehrenburg, who was an establishment figure in the cultural world even if a detested one in many circles, until his death in 1967. Costakis related how a Moscow Jewish family had an urgent need of money for medical treatment. Their only really valuable possession, they thought, was a Chagall painting, a self-portrait. They thought Ehrenburg, a fellow Jew and a collector, might be interested, and took the piece to him. "Yes," said Ehrenburg, "it's a Chagall and a good piece. But Chagall doesn't really have much of a reputation and there isn't much market for this, so I can offer you only" – and he named a derisory amount, a few hundred roubles. The family was desperate and accepted. "Where can you go higher than Ehrenburg?"

Two or three years later there was a Chagall exhibition in Japan. Costakis and Ehrenburg were both asked to send pieces, and found themselves sitting at the same table in the ministry of culture to determine how to value their pieces for insurance purposes. Ehrenburg's work was the same self-portrait. According to Costakis, he did not hesitate. Sixty thousand dollars, many hundred times what he had given the poor family for the work. However, reflected Costakis, maybe he wasn't guilty of any wrongdoing. Indeed, there was no real price for Chagall in Russia at the time he bought the piece. At that time, "nobody needed Chagall."

There were times when Costakis' attitude to his collecting was positively mystical, in the best and oldest Russian tradition. In the end, this approach made it relatively easy for him to leave a very large part of his collection behind him in Russia. He even urged the Tretyakov Gallery to keep some works, those of Rodchenko, for example, which they did not want, on the grounds that they were great works, and that the Russian people (Costakis was a Russian at heart and seldom talked about the "Soviet" people) were entitled to have them and enjoy them. This sense of mission became stronger as the thirty-year span of collecting went on. At the beginning it was the sheer sensual pleasure of beholding the works that moved Costakis. Letting light into a dark room, to use his metaphor. But as time passed, he began to feel that he was doing something not so much for himself as for posterity, Russian posterity in particular. It was this mystical, religious approach to his task – certainly related to his piety, his strong attachment to the Orthodox Church, and his conviction that there was no salvation for Russia except through the church – which made it hard for Costakis to

understand many Western collectors. They, in his opinion, often lacked passion, and were unable to understand the soul of a Russian collector. He had often seen Western collectors come into the mean apartment of a Russian collector (he was not thinking only of his own) and gasp at the treasures they saw stuffed in there. This man, they would say, must be very rich to own all these things, when in fact the person didn't have "enough to buy a spare suit." He had spent everything on the collection. The Western collector, thought Costakis, first buys a new car, pays the taxes and sends his children to a good school. Then he collects with what is left.

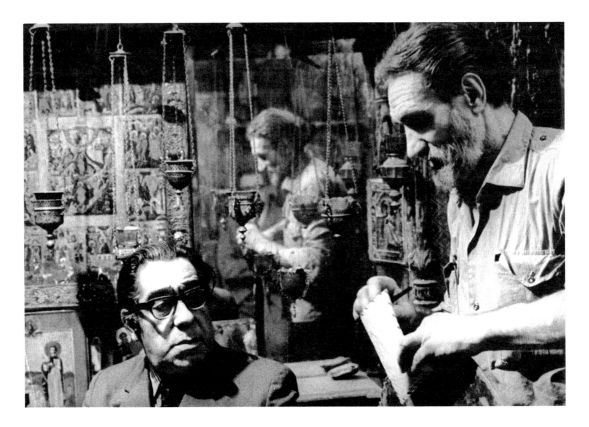

Costakis with artist Vasily Sitnikov, Moscow, 1975.

Costakis' mystical attitude to his collecting may have helped him at times and certainly drove him day and night, but it cost him heavily on at least one occasion. One of the lesser-known avant-garde artists in his collection was Nikolai Suetin, a disciple and friend of Malevich; he produced among

other things some beautifully decorated china, cups and saucers, in the suprematist style. Suetin died in 1954, leaving his widow, Lipovskaya, with a large number of important and valuable avant-garde works – hundreds of drawings by Malevich, porcelain by himself, and much else. Costakis, too busy when he heard of this treasure-trove to go himself to Leningrad, where Lipovskaya lived, sent his daughter Lilya, who was always very close to him in his collecting activity. She was warmly welcomed, tea was poured, and it was at once clear that Lipovskaya knew about Costakis and was very interested in him as a buyer of what she had. But first she had a few questions. What were Costakis' views about avant-garde works finding their way abroad, as opposed to ending up in a Soviet museum? Lilya truthfully replied as her father would have, that he wanted his collection to go, after his death, to the Tretyakov Gallery in Moscow and to the Russian Museum in Leningrad. (This was long before there was any thought of emigration.) The collection, Costakis had instructed Lilya time and again, was the inheritance of the Russian people, who were not to be blamed because their rulers had "obliterated this art and thrown it away." And she repeated Costakis' fervent declaration: "It is clear that God sent me to save this art for the Russian people."

Lipovskaya changed instantly. All warmth disappeared, together with all interest in Costakis as a buyer. A puzzled Lilya was shown the door. Later Costakis heard the somewhat trivial reason and was able to repair some of the damage. Lipovskaya had made a large gift of avant-garde works to the Russian museum. Some time after, a group of museum directors and art historians from the West had called on her and asked to see these works. She went to the museum to arrange a visit, but was told brusquely that she had given the works and had no right to bring a lot of foreigners around to look at them and cause trouble. This was in the early sixties, soon after Suetin's death, and the response was a normal one for foreigners trying to see art which was not on the approved list. Lipovskaya was deeply offended, and swore that anything else she gave or sold would be destined for export. Costakis, with his foreign passport and connections, was to have been the instrument of this policy.

The practical conclusion Costakis drew from this experience was that you should think ten times before you open your mouth. But what the incident shows is how his feelings about his art had evolved, and how he had imbued his family with the same doctrine. Costakis had often examined the reasons for his success as a collector. He followed his own five precepts. He was indifferent, in the early years at least, to the fact that there seemed to be no money in what he was doing. He ignored the dangers, which he thought not to be great in the first years, when he was unknown. (Later he thought his life in real danger and began to pay attention.)

But there were more subtle elements. Describing how he became the first buyer of the work of Aleksandr Drevin and was afterwards much admired for his sagacity, Costakis remarked on the

importance of combining good luck with good judgment and decisiveness: "So what happened? The answer isn't that I've got a better eye than other people, but rather that sometimes you get a situation where some people see the works and others don't. With Drevin I saw them, and I paid attention to this genius. When I bought these works and brought them home and started showing them to art lovers and collectors, they all ooh'd and ah'd. And I said, 'Where were you earlier?' They replied, 'Sasha [Drevin] never showed them.' But after my visit, they started to buy." Here Costakis was not totally disingenuous. In fact he did think he had a better eye than most. (He was fond, for example, of telling museum directors and art historians, for whom he had limited respect, that they judged art with their ears rather than their eyes, meaning that they listened to the price or the name of the artist rather than looking at the work.) And he was certainly more persistent than most. Here he was really saying that an important element was luck, which must be combined with skill and energy. He would not say that the combination amounted to genius, but he probably thought it did.

The real heart of the matter, Costakis thought, was that he quickly became and always remained a true believer in the value of the avant-garde artists. Not just that they were good, even brilliant – others thought so too – but that one day they would be respected and find their proper place in the artistic life of their own country. He did not expect it to happen, as it did, in his lifetime, but he knew with absolute certainty that it would happen. That, he believed, was the real reason he succeeded in his monumental work. Everyone else undervalued these artists. Shortly before his departure from Russia in 1978, he met a man who had taken a big abstract picture by Kandinsky, painted in that artist's prime years of 1913-14, to a major museum, and had come away delighted with the eight hundred roubles (then about ten thousand dollars) he had been paid for it. In the early years of Costakis' collecting, the undervaluation was much greater.

That was the situation until perhaps 1960. Then the interest began to grow. But as Costakis put it in this biblical-style parable, it was too late:

Foreigners who had seen my collection would come to Russia and try to buy things. All they could get. But the trouble for them was that, when they went to one place, it was empty – Costakis had been there. Another place – Costakis had been there too. Third place, the same. It was like a lake full of fish – small ones, big ones, red ones, white fish, different kinds of fish. And the fisherman, George, was sitting in the boat in the centre and was fishing. And around there were lots of people, but they were all meat-eaters. They had never tried fish, and they didn't know if it was good or not. And at the end, when the lake was more or less empty, I pulled one out, and it flew through the air and landed on the beach. Some of them tried it. "It's not bad." And then they too started fishing. But there were very few fish left.

The hunt for pictures was not without its amusing moments. Costakis heard of a Chagall – not the biggest or the best, but authentic – in a private apartment in Leningrad. Again he sent Lilya; for him to leave his duties at the embassy and go to Leningrad was difficult, and he seldom did it. Lilya found the man and offered him a good price, but he refused absolutely to sell. The rest of the story Costakis heard from one of his Leningrad collector friends. A few months after Lilya's disappointment, two men appeared in Leningrad and began sniffing around the art market in search of a Chagall. They were clearly not collectors but government agents of some kind. They said they had been ordered to find a Chagall as a present for somebody "very high up." Eventually they were given the name of the stubborn man with the Chagall. Their experience was the same as Lilya's: point-blank refusal to sell for any amount. "What would I do with the money?" the man asked rhetorically. "There's nothing to buy with it. Now if I could buy a car – say, a Zhiguli [the smallest and cheapest Russian car] – but I can't. The waiting list is five years long." The two agents pricked up their ears. "If it's a car you want, that's no problem. What kind?" The man raised the ante: "A Volga [a much more substantial vehicle]." "What colour?" "Black." Two days later a shiny black Volga was at the door, and the "very high up" person had his Chagall.

For Costakis' delightful Russian wife, Zinaida (Zina), and for his four children, Inna, Lilya, Natasha, and Sasha, the role of support system to the great collector was a far from easy one. The apartments in Bolshaya Bronnaya street, in Leningradskoye shosse and finally in Vernadsky prospekt – each a little grander than the one before – were in the later years continually jammed with visitors of every kind. The family protested, but in vain. Refuse to see nobody, was Costakis' first rule of life. Sometimes Zina's patience wore thin, because for every group of visitors tea and cakes and whole meals had to be prepared. Sometimes the vodka bottle came out, with ensuing long evenings. On one occasion the Greek minister of culture (a predecessor of Melina Mercouri) was in Moscow. The Greek ambassador phoned. Could he bring the minister to meet George and see the collection? Five o'clock was agreed upon. Zina prepared everything. Then, at quarter to five, Costakis saw her putting on her coat. "Where are you going? The minister is coming at five." "I don't care about the minister or the deputy minister, and if the king himself came I would still go out." There were times when Costakis sold his wife's clothing and jewellery to buy some new treasure. At other times he cancelled holidays because there was a new Chagall demanding the money. In the early years money was always short, and later, life became difficult in other ways as the political pressure increased.

Costakis was not the only collector with these problems, but not all had such long-suffering and patient wives. He recalled going to the house of a collector who had died, to buy some of the collection. The widow met him at the door. He asked about the pieces he wanted. She became shrill and tearful. "Take it all," she said. "What has it ever done for me and the children? He never had enough

to buy me a skirt or them a pair of shoes." Costakis did not take it all, but he heard later that the whole collection had been sold for next to nothing.

Costakis told little about his friends and intimates during these collecting years. He knew thousands of people. But there were some, especially the group of young "unofficial" artists which he gathered around him, now very large names in Russian painting, but then relegated to outer artistic darkness, who were very close to him. Dmitri Krasnopevtsev and Anatoly Zverev in particular were "like brothers" to him.

Once I was showing Zverev's work to a group of artists, art historians, quite a bunch that had gathered. Robert Falk was there, whom I knew well. They were noisy and quarrelsome. Many of them didn't like [Zverev's] art, thought he was just an imitator, and so on. Anyway, they were a noisy bunch. Then there was a moment's silence. Maybe a smoke break; I can't remember. Falk was a man who never praised anyone, never. Well, maybe he bowed slightly before Cézanne, but when it came to Picasso, and many others, if he didn't criticize them, he certainly didn't praise them. Looking at one of Zverev's works, Falk said literally the following: "Every touch is a jewel. Such artists are born once in a hundred years." This is what Robert Rafaelovich Falk said.

Later, when there was an exhibition in 1963 or thereabouts – I don't remember – a man called Markevich came along and took away maybe two hundred works. I wouldn't say they were the best, certainly not the masterpieces that I had in my collection. There was an exhibition in a gallery in Paris and one hundred and twenty works were sold. The prices were eight hundred dollars, one thousand dollars. I don't remember the numbers in French francs. Then the paintings were sent to a gallery in Geneva, and there a Swiss paid two thousand dollars for *Head of a Horse,* a gouache. Everything was sold.

I was talking about the period 1956, 1957. I would call the period beginning with 1957 the ascension of Zverev. [Costakis uses the Russian religious word, as in "ascension into heaven."] That year, 1957, was the crowning glory, along with 1958, 1959 and 1960. Then began the decline. Some kind of impotence set in. [But before that] everything poured out. He pounded his drum. He might produce between one hundred and twenty and one hundred and fifty gouaches in a single day. Five minutes, three minutes, six minutes, four minutes for each painting. Paint flew right and left, and sometimes even got on the ceiling. I had to put a plywood fence around the table where he worked because the whole place was covered with gouache.

Having said that, I can't refrain from adding another detail. We always like to say that you can't teach an artist anything. You don't second-guess an artist. An artist just does what he does, and we're supposed to understand. But it's not entirely true.

Back there in 1957 Tolichka [affectionate diminutive of Zverev's first name, Anatoly] was producing a sort of gouache that I called his "marble period." What did he do? He laid out or squeezed out his gouache on a big plate. Then with a brush (he always painted with the same brush, oil and gouache) he started to paint. The paint would run down into the centre of the plate and take on this marble quality I'm talking about, with a sort of sulphurous sparkle. This he often used as a halo for one or other of his portraits, and it was very beautiful …

I remember once, at the *dacha*, I made a suggestion to him. I said, "You know, Tolya, your work is exceptional, outstanding. But wouldn't it be good if you could do something like this: take a sheet of paper, paint, and go to work just as before, but so that you get on the paper a red area, a yellow, a blue, a green. Clean colours." He said, "Georgii Dionisovich, that's simple, but it would take a barrel of water." I said, "A barrel I don't have, but there's a boiler where the women do the laundry." "It will do." The boiler must have held a hundred and fifty or two hundred litres.

So he put his gouache into separate vials, not heaping them up on the plate, took a big brush and laid on, let's say, red. Bang bang! Then he washed the brush, and put on blue. Bang bang! And he produced work of colours that it's impossible to describe.

Several thousand [Zverev] masterpieces were either burned or stolen at Bakova. And there was a moment when I thought I should kill myself. But it's interesting, when I told him about this, he asked me, "Was anyone hurt in the fire, did anyone die?" I said no. "Then it doesn't matter, it's all nonsense. I'll paint some more."

But unfortunately he didn't paint more. There followed his period of insanity. In 1960, 1961, 1962, and so into the seventies and beginning of the eighties … Yes, things appeared sometimes, even some interesting things, but they weren't the same. Later, when I was preparing to leave, Tolichka often visited my daughter, painted her in gouache, oils, drew on the doors, even on a kitchen cupboard … But the portraits and landscapes were very weak. He wasn't exactly slap-dash, but …

I have to say that Zverev was there, but he isn't there any longer. The real pieces, the ones in my collection, several thousand of them, were burned, and many were stolen. They no longer exist. When there is an exhibition [the organizers] go to my daughter [Natasha, who stayed behind in Moscow after the family left. She too has since gone to the West] because I left a few works with her. But luckily here in Greece — they [the Soviet authorities] let me bring some with me, because they considered it all to be garbage. So I have maybe three hundred Zverevs, all excellent. There were also some works left after the fire which the Knorrs[*] restored for me. Beautiful things, but the edges were singed. They look fine now, and if you didn't know you would think the artist had done the restoration himself.

[*] The Knorrs were a husband-and-wife team of art restorers who worked mainly for the Tretyakov gallery. They had a little studio in central Moscow where Costakis often drank tea with them and learned something of their art.

Recently they came to see me from the Tretyakov gallery. They were looking for Zverev, and couldn't find him. I intend to give eight or ten works, probably to the Tretyakov.

Costakis went on to explain how his relations with the young artists, and with Zverev in particular, declined and ended. There were two problems, he said. The first was an American living in Moscow who also set up as a patron of the same young artists. According to Costakis, this American knew nothing about art and bought bad pieces which Costakis had rejected. But the artists were flattered, and there was money to be made. Costakis was offended, very much in character for him. So, he said, "I gradually began to withdraw from this business."

But in addition, to be honest, it was hard to maintain three lines, to collect the avant-garde, and the icons, and the young artists. There was not enough money, and not enough time either. Here's how it happened with Tolya Zverev. I had close and friendly contact with him right to the end, until I left Russia. But somewhere at the beginning of the sixties I felt that, well, somehow Tolya … It happened like this. He went looking for handouts. By this time he was already a more or less known artist. People were interested in him. He sold works, to one person for three roubles, to another for five, to a third for half a litre [of vodka]. Well, people began to turn up who invited him. He'd stay with them a month, a month and a half, draw, paint gouaches. They fed him, and helped him. After a while he'd move on to another place. Then he met some young woman, fell in love with her, and started painting portraits of her. He brought them to show me. It was a small tragedy. Cupid-bow lips painted with lipstick straight out of the tube. Eyelashes half a metre long. So I said, "Tolya, what's this?" "She likes it. When I draw something in another way, she doesn't like it."

Thus began his decline. We parted company. For about a year he travelled from one place to another. At one place he'd do a bit of work, then move to another, try to make deals. Then he came to see me and we had a frank talk. He insulted me, saying that I had thrown him out, failed to support him, and so on. But I loved him very much and valued him. We started again, by which I mean that I decided to try. But nothing came of it. That is, there came a period of – it's very hard for me to say it – of decay, spoiling. Anyway, no more masterpieces came from Tolya's brush.

But even after he had left Russia permanently, Costakis continued to support Zverev financially and in other ways. In 1989 Natasha Costakis, then still living in Moscow in her parents' old apartment, told me that she had served on her father's behalf as Tolya's financial administrator, doling out money to him and trying to ensure that he did not spend it all on drink.

Zverev is now regarded in Russia as a major artist, even a national treasure. Forgeries are appearing (the highest form of artistic praise), and his work may not be exported from Russia. The

prohibition on exporting is, however, very much a case of closing the barn door after the horse is gone. Thousands of Zverev oils, gouaches, and ink drawings found their way to Western countries, especially Canada, thanks partly to the indifference, or hostility, of the Soviet government to contemporary Soviet art, but thanks mainly to the assiduous bustling of George Costakis on behalf of his friend Tolichka.

There were many other friendships, many evenings in the company of people who, like Costakis, went on in the face of barbaric opposition and persecution, maintaining standards of civilization and culture and human intercourse. Costakis gave a glimpse of one such evening. He did not date it, but since Shostakovich was involved and was in fear of his life, the evening must have taken place in the six or seven years after the war, before Stalin's death in 1953. Before and during the war Costakis would not have been spending evenings like this.

I was a close friend of Aleksandr Georgievich Gabrichevsky, a big specialist on Bach and a well-known musicologist and art critic. Interesting people came to his house, and I was there often. We sat at a round table, in the centre was a revolving tray loaded with every kind of good thing to eat. You turned the tray, and every guest took what he wanted. Once, I remember, it was late in the evening, eleven or twelve o'clock, when the famous Neigaus turned up, a pupil of Richter. He was an amusing man, a German – but Russified of course. When he came through Gabrichevsky's door he was down on all fours, barking like a dog, and came that way into the room, where everybody laughed and greeted him. A short time later we were all there again, a big group of Russian intellectuals – Richter was there, others, I don't remember now. Again Neigaus came late in the evening, but this time he came on his feet, quietly, no barking, no crowing. He sat down, looking very serious. Finally he said, "Friends, bad news. I very much fear that today or tomorrow Shostakovich will be arrested." Well, God saved this great composer, although the persecution continued, every kind of pressure, which greatly affected his creativity.

Thus by 1960 one of the world's great art collections was established. Seventeen years of collecting, trading and managing still lay ahead. And curiously, although Stalin was dead, the terror over, for Costakis the period of personal terror was yet to come. The organs of the Soviet state, as they were sometimes called, were about to take a personal interest in him.

CHAPTER VI

THE CANADIAN CONNECTION

I started at the Canadian Embassy in 1943. The ambassador was Dana Wilgress, with his wife Olga. They both spoke Russian. And I have to say that if it had not been for the Canadian embassy, if I had not found a job there and worked there all those years, probably my … no, not probably, but certainly, my life would have been totally different and there would have been no Costakis collection.

Thus said an emotional Costakis in 1987. He probably exaggerated. Certainly his job in the embassy helped him collect. But his drive to collect was so formidable that it is hard to imagine circumstances, short of his death or imprisonment or exile, in which the collection would not have come together. Nevertheless, the embassy was important in Costakis' life, and of all the hundreds of Canadians who dealt with him during his long years there, none was so important as the first to arrive, Dana Wilgress.

The memoirs of Dana Wilgress are neither the most sprightly nor the most informative of autobiographical writings. Wilgress was too modest, too private a person, and too disciplined a public servant, to let them be either. But the story of this remarkable Canadian, published two years before his death in 1969, holds much interest for anyone thinking about Russia, especially about Soviet-Canadian relations, and for anyone considering the life and times of George Costakis.

Several things about Wilgress's life make even his own simple account of it an important book. One is that it began in 1892 in a Vancouver of unpaved streets and wooden sidewalks, and in a world enjoying the unparalleled tranquillity of the Pax Britannica; from there it wound through war, revolution, depression, another war, the end of the colonial empires (except the Soviet one), the cold war

and the division of Europe, the establishment of the political and economic institutions of the post-war era, and finally ended almost in our day. The story of Wilgress's life is a short course in modern history.

Second, Wilgress participated, actively and at a high level, in almost all these events. He was in Russia during the first war and the revolution, and there again during the second war. Representing Canada, he attended the conferences that founded the United Nations, the World Bank and the International Monetary Fund, the North Atlantic Alliance, the GATT, and much else. In Ottawa he was deputy minister of trade and commerce and later of external affairs. He was Canadian high commissioner in London, permanent delegate to the North Atlantic Council. As trade commissioner first in Omsk, then in Vladivostok, he was Canada's first official representative in Russia, which turned into the USSR while he was there. He was Canada's first ambassador to that country, learned its language, and found his Russian wife there. He thought Russians, including many Soviet officials, warm and sympathetic, and knew how to do business with them. He travelled first in imperial Russia, then in the USSR, far more extensively than foreigners were able to do in subsequent years, knew it thoroughly, and loved it. His service there was a permanent cornerstone of, and remains even now a factor in, Canadian-Russian relations.

Third, and most important for art and artists, in 1943 in Moscow Wilgress found George Costakis and gave him a job. Once again, the job did not make the Costakis collection, but it helped. In 1960 Wilgress and his wife went back to Moscow on a post-retirement visit. They had dinner with George and Zina Costakis in the Costakis apartment. Wilgress comments in his memoirs on what a pleasure it was to see Costakis' collection of modern art, and adds, "For us it was an auspicious occasion, being the guests of the man who had done so much for us when we lived in Moscow." He may not have known the degree to which Costakis reciprocated this sentiment.

Costakis spent thirty-five years at the Canadian embassy, a full working life. Nobody else, Russian or Canadian, has been there anything like as long. The nearest competitor is R.A.D. Ford, whose three postings in Moscow totalled twenty-one years, the last sixteen of them as ambassador. Costakis' job at the beginning was to solve the countless administrative problems of running a diplomatic mission in a Soviet Union still fighting a bitter war only a short distance from Moscow. The pre-eminent problem was to find enough food, and find it Costakis did by roaming the countryside, visiting collective and state farms in the embassy truck, and coming back with potatoes, carrots, and the essential Russian cabbage, *kapusta,* without which life, then as now, was impossible. Costakis said the farmers thought he was collecting on behalf of the state, and were surprised he paid so well. He did not enlighten them. And when he got back to the embassy with a truck-load of vegetables, or even a pig, no questions were asked there either. Here Costakis' street education of twenty years

earlier served him well, and when a few years later he came to visit villages looking for paintings rather than potatoes, the techniques were not very different.

Although the war soon ended, the problems did not; indeed, in some respects they increased, as the wartime alliance faded and the cold war, together with Stalin's awesome internal post-war terror, almost destroyed relations between the Soviet Union and the Western allies, including Canada. One has to remember that it was only two years after the Canadian Embassy opened, and only a little more than one year after Costakis joined it, that Igor Gouzenko defected from the Soviet embassy in Ottawa, and the Western world, shaken out of its innocence, learned the extent of Soviet espionage and subversion, in Canada as elsewhere. So life was never uncomplicated at the Canadian embassy, not then and not now, and Costakis' problem-solving responsibilities came to an end only with his final departure from the country. So difficult is it in modern Russia to get a decision or to make anything happen, that a whole shadowy profession has grown up of people who are hired by factories and other institutions to do nothing but that. In Russian they are called *tolkach,* a word used for the locomotive which pushes a heavy train from behind. Costakis, having lived largely by his wits for many years, was the Canadian *tolkach,* and was brilliant at the job. As Wilgress records in his memoirs, "I was impressed by his frankness and transparent honesty … I decided to give him a trial and took him on. Immediately our troubles were over. When any difficulty arose, Costakis would be advised and somehow or other he always found the solution."

One of Costakis' most cherished memories of those wartime days was of Winston Churchill's visit to Moscow in 1944. The British embassy had to organize a reception for Churchill and Stalin and four or five hundred others. But Moscow was still a wartime city, there were no plates, knives, forks, serving dishes to be found anywhere, most of the restaurants were closed, and there was no fruit to be had in Moscow. Costakis' skills were becoming known. The British ambassador phoned Wilgress to ask if he could borrow him for the visit. Wilgress gladly agreed, and Costakis was provided with a little truck and asked to solve the problems. First, the plates and utensils. Costakis had a friend who was administrator of the restaurant at Khimki, the port of Moscow, about fifteen kilometres north of the city. This restaurant was closed, like the others; however, Costakis' friend agreed to help. He opened the restaurant and let Costakis, with some local farm women he hired, take dishes, knives, and forks out of the cases in which they had been packed, wash them, and deliver them to the embassy.

Fruit was more complicated. Costakis visited some fruit farms. Everything had been picked, eaten by insects, taken by the Germans. There was nothing. But at one collective farm Costakis sat down with the peasants to eat some pickles and drink a little vodka. He recalled that the flies were so thick it was impossible to take a bite of pickle without swallowing three or four flies at the same

time. But (and here is the collector honing the tools of his trade) he persevered. Could the comrades not think of any place where Costakis could find some fruit or berries for Comrade Stalin and Gospodin Churchill? Well, there was one collective farmer, *kolkhoznik*, who had a large private plot where he grew fruit, a lot of it. But he charged outrageous prices. Not even the embassy would pay so much. And often he refused to sell at all. Perhaps, suggested Costakis, he would be interested in a swap. Fruit was perishable stuff, but potatoes and cabbage you could keep all winter. And these things Costakis had. So after a final vodka and pickle with flies, he and the peasant got into Costakis' little truck and went to visit the farmer, who lived in a large house with carved eaves. There was the long narrow garden, sloping down to the river, full of fruit trees and berry bushes. The farmer liked the idea of swapping for vegetables, and the second problem was solved.

Back at the British embassy Costakis was given a hug and a kiss by the embassy cook, an Englishwoman, and was offered a congratulatory drink by the military attaché, a colonel "in a Scottish skirt with a pipe in his teeth." But although the colonel bought the drink and even some peanuts to go with it, he declined to sit down himself, presumably thinking it beneath him to drink with the local help. So Costakis left his whisky on the table.

The reception took place and succeeded. Costakis was invited as a guest. Stalin and Churchill were surrounded by security policemen, but these paid no attention to Costakis, and he was able to observe two of the world's most intimidating figures from a distance of a few feet. Stalin, he recorded, "seemed a small, short, frail, thin man, with a bad complexion, marked by smallpox … But what set him apart were his sharp eyes. I mean it would be impossible to look at those eyes for long. You had the feeling all the time that you were being put down, belittled." Churchill was different: "heavy, fat, with a wide face and a cigar permanently in his mouth."

Costakis carried away a souvenir from the reception. Stalin was a pipe smoker, and his habit was to carry his pipe in one pocket of his tunic, and in the other a box of *papirosy*, the old-fashioned Russian cigarettes with cardboard mouthpieces attached. He did not smoke these, but broke them open and filled his pipe with the tobacco from them. When the reception ended, Costakis' Greek friend at the British embassy (who had recommended Costakis for the Canadian job) found Stalin's box of *papirosy* where the Great Dictator had left them, on a table, and gave them to Costakis as a souvenir. There were nine *papirosy*. Costakis meant to keep them, but an inveterate, life-long cigarette smoker himself, he found himself without cigarettes one evening and smoked Stalin's nine.

Costakis was far more than a good fixer, important as that was. He was a symbol of continuity, a window on the Soviet world for the Canadians working there, a benevolent father figure for most, a genial presence day after day and week after week. When Wilgress arrived in Moscow, the Soviet staff of the embassy consisted of two cleaning women. Gradually the number grew, and Costakis was

put in charge of this contingent of Soviet interpreters, typists, clerks, drivers, mechanics, cooks, gardeners, yardmen and housemaids. Like the Canadian diplomatic and support staff, they came and went; Costakis always stayed, a still centre around which the business of the embassy turned.

◢

Because the embassy was so important to Costakis, and he to it, his story is not complete without some account of how an embassy came to be there, and how the relationship between Canada and the Soviet Union developed both before and after Costakis appeared. It is a very Canadian story, in which fear of Bolshevism and loyal indignation with the murderers of King George's cousins mix uneasily with the absolute necessity to find overseas markets for Canadian goods, with the vulgar but inescapable exigencies of domestic politics, and with the search for Canadian independence from Britain in the formulation and execution of foreign policy.

If you travel around today's Russia visiting provincial museums and looking for some sign of interest in Canada, you find very little. What you do find, here and there, is a photograph of a battalion of Canadian troops swinging down the streets of Murmansk or Arkhangelsk or Vladivostok. The description underneath probably says that these were Canadian troops sent by the imperialists during the civil war (1918-21) to suppress the revolution, a gross interference in the internal affairs of another country. Russians are nothing if not patriotic, and there is no doubt that the 1918 Allied intervention, including the Canadian part in it, is deeply resented even now, seventy-five years later. There is also no doubt that the official Allied (and Japanese) justification for the action is only part of the story, and not necessarily the most important part. The intervention was supposed to prevent Murmansk and Arkhangelsk from falling to the Germans and to secure the Trans-Siberian Railway and help the Czech contingent, which had been fighting with the Russians on the eastern front, make its way across Siberia to Vladivostok and thus back to Europe to fight again on the western front. However, support for the White Russian armies under Kolchak and Denikin was not far from anyone's mind. Many people, first among them Winston Churchill, then secretary for war, believed (rightly) the Bolsheviks to be usurpers and thought (probably wrongly) that there was an Allied obligation to put them down. In Canada, in addition to anti-Bolshevik sentiment, there was the further consideration that, as many then believed, Eastern Siberia would split from European Russia and the Bolsheviks and would become an important state, and an important market, on its own. With this possibility very much in mind, the Canadian government, having removed Dana Wilgress from his post at Omsk and put him to work in China, posted him back to the Soviet Union, this time to Vladivostok, to ensure a Canadian commercial presence in addition to the military one.

Trade prospects were not far from the surface of Japanese thinking either, when Japan contributed the largest contingent to the Siberian interventionist force and thus obtained the right to provide its commander.

By the summer of 1919 the Canadian contingents, both the Arctic and the Siberian, were back home with not much to show for their efforts, except perhaps a certain amount of personal goodwill: Wilgress wrote that Canadian soldiers were better liked by the Russians than were most of the others. That modest achievement was more than offset by the anger of the new Bolshevik regime, and eventually of many Russians who never had a chance to meet and be charmed by Canadian soldiers. It was an inauspicious beginning to the Canadian-Soviet relationship, and for the next fifteen years there was not much improvement. The Winnipeg general strike of May and June, 1919, was considered by many to have been the work of the Bolsheviks, and there was much alarm about the subversive activities of the Third International. Trade between the two countries came to a virtual end. Meanwhile the terrible famine in the Volga was taking place. An international relief effort was organized, but Canadian apprehension about Bolshevik subversion in Canada reduced sympathy for the dying Russian peasants, and the Canadian contribution was minor.

Over the next several years there took place a sort of *mouvement de ballet* in which the urge to trade on both the Canadian and Soviet sides advanced in response to pressure from the business world and retreated in response to the latest revolutionary declaration of the Third International or the latest police raid on some Communist party headquarters. In 1922 Canada adhered to the British-Soviet trade agreement negotiated the previous year, and in 1924 a Soviet trade office opened in Montreal. In the same year Canada recognized the Bolshevik regime in Moscow. But trouble continued. The Soviet trade representative was thought to be importing subversive literature and counterfeiting Canadian money with a view to undermining the Canadian economy. When in 1927 the British police raided the Soviet trade office in London and uncovered still more alleged evidence of Soviet perfidy, Canada followed Britain in breaking off the relationship. With the return to office of the Labour party in 1929, Britain restored relations. Canada, in its first decision in this context which did not merely follow the British lead, did not. Stalin had just achieved total power in the USSR, there were anti-religion decrees, there was clear evidence of Communist activity among ethnic groups in Canada, and besides, the United States was having perfectly satisfactory trade with Russia without any formal relations at all, indeed without having recognized the Communist regime.

Between 1931 and 1935 things went from bad to worse. In the Soviet Union the First Five-Year Plan was in full swing, and then as now the Russians were exporting primary commodities, notably coal, oil, lumber, and furs, to pay for their imports of Western farm and industrial machinery.

Whether or not accusations of dumping these goods were valid, certainly there was painful competition with Canadian producers, and the newly elected prime minister, R.B. Bennett, had promised during the campaign that he would act against Soviet imports. That was the economic argument, but there were others, with a torrent of letters and editorials to make the prime minister listen. The Russians were destroying religion, not only in their own country but everywhere. They were employing slave labour to produce the very goods they wanted to sell to Canada. They were deliberately sabotaging the Canadian economy. They were out to subvert Canadian political institutions. The case against Moscow was reinforced by Moscow itself, which, through its mouthpiece the Comintern, quite cheerfully agreed that the undermining of capitalist economies and political institutions was indeed part of its strategy. In Canada there was an impressive welter of oratory and editorial writing (against which the voices of B.K. Sandwell and Henri Bourassa were heard faintly on the side of reason). So in 1931 Bennett declared an embargo against seven Soviet commodities, including all the most important. The Russians responded with an embargo of their own against Canadian goods, and the deadlock was complete. A police raid on the Toronto headquarters of the Canadian Communist party, resulting in prosecutions and imprisonments, did nothing to improve the atmosphere.

Although the embargo was eventually lifted and a trade agreement signed in 1936 (the first Canadian cabinet minister ever to visit Russia, W.D. Euler, went to Moscow to sign it), relations remained minimal through the remainder of the 1930s. Stalin's anti-Nazi policy of 1935 helped somewhat, but the benefits of that were lost in the shock of the Molotov-Ribbentrop pact of 1939, in which Stalin and Hitler agreed to carve up Poland and the Baltic states between them. Not until the Nazis invaded Russia in June 1941, did the history of suspicion and distrust begin to give way to a sense of common cause.

Through all those more than twenty years from the revolution to the Nazi invasion of the USSR, Canadian thinking about Russia had been deeply polarized. On one hand, common sense said that this was an important country, that the communists were firmly in charge of it, and that if Canada wanted to control its own destiny in international affairs it had to take the Russians into account. On the other, a not entirely irrational anxiety spoke to Canadians about the possibility of world revolution and the destruction of the Canadian system. The result was near immobility, for which the Soviet Union has to bear at least as much responsibility as does Canada.

The war changed that. The strident appeals of the Comintern to world revolution became muted; indeed, they largely disappeared. The Red Army became our ally. Canadians began to think of Stalin as a hero, or if not that, then as a comfortable old uncle, tucked up in his greatcoat and military cap and moustache, beside Churchill and Roosevelt. If religion was not restored in Russia, attacks on it

ceased, and traditional Russia was revived in the interest of winning the war. Moreover, Canadian sailors were dying on the sea-route to Murmansk (the graves of some of them are still there) so that the Red Army could be supplied. The arch-foe of Bolshevism, Winston Churchill, took to the radio to praise the Soviet war effort and Stalin himself.

In these new circumstances, those who favoured relations with the Soviet Union were at last able to proceed with the approbation of the Canadian people. But there was no point in proceeding if Hitler were to win in Russia, as in 1941 he came perilously close to doing. According to Wilgress, the Canadian government had decided that the fate of Stalingrad would be critical: if Stalingrad fell, no embassy would be opened. But it held, the long German retreat to the West began, and in October 1942 Wilgress was named Canada's first ambassador to the Soviet Union. (To begin with he was called minister, but that was a matter of the diplomatic practice of the day, and he soon became ambassador.) Wilgress was not the only Canadian with experience of Russia, but his experience had been longer than anyone else's, he spoke Russian well, and he was already deputy minister in Ottawa, senior enough to convince the Russians that the appointment was an important one for Canada.

Nowadays an ambassador going to a post gets on an airplane and starts work the next day. If the post is a brand new one, a team will have preceded him by several weeks to find accommodation, hire local staff and have everything, or most things, in working order. That was not Wilgress's experience, going to Russia. First, he had to find staff. He heard of a Canadian army officer, Jack McCordick, whose ship had been torpedoed in the south Atlantic. After several days of swimming among the sharks McCordick was rescued by the same German submarine which had torpedoed him, handed over for internment to the Vichy French in Morocco, and there freed by the Allies when they landed several months later. This seemed to Wilgress the kind of man he should have, and besides, McCordick spoke Russian. So he was hired. Another officer, Arnold Smith, who had some first-hand knowledge of the Soviet Union, was found working in the British information office in Cairo. He was hired too. Ronald Macdonnell, a professional diplomat, was recruited from the Canadian embassy in Washington. A Russian-speaking military attaché, Capt. George Okulich, turned up, and Wilgress took him on, together with another military attaché, Brigadier Lefebvre. Clerical assistance was provided by the navy in the person of George Power. That was to be the first team on the ground. And the embassy was to open not in Moscow, but in Kuibyshev, formerly and now again Samara, on the Volga River, a thousand kilometres to the east. Most diplomats, and large segments of the Soviet government, had been evacuated there in October 1941, when the Germans were at the gates of Moscow – at their closest only thirty kilometres away. Kuibyshev was to remain a kind of second capital for two years.

Costakis almost went to Kuibyshev himself. When his somewhat placid war experience in the deserted Finnish embassy ended, he had found a job as driver at the British embassy, where his brother Nikolai also worked. Early in 1942, with the war at its most desperate, the order went out to evacuate, and the British staff, including Costakis and his family, were assembled in the embassy courtyard, on the south embankment of the Moscow River, facing the Kremlin, on a dark night, waiting to be taken to the Kuibyshev train. But Lilya, the second Costakis daughter, was ill. The embassy doctor diagnosed scarlet fever. The family could not travel, and returned to their apartment in Moscow, only to find their neighbours carting away their furniture and other belongings, secure in the belief that Costakis was well on his way to the east. (It is typical of Costakis that he thought this very funny.) The meeting with the Canadians, of whom Costakis had barely heard, was to be postponed by a few months.

Travelling with McCordick, Wilgress left Ottawa for Kuibyshev early in 1943. The route was roundabout. First he flew to Miami, where he spent a month, "with nothing to do except read Russian books," waiting for space on an American military aircraft. His journey then took him via Ascension Island ("it would be difficult to imagine a more desolate spot") to Accra, then to Lagos and Kano. Then via Chad to Khartoum, and down the Nile, with a stop at Luxor, to Cairo. There he picked up the other two members of his diplomatic staff, as well as "kitchenware, chinaware and other supplies," and left for Teheran on a British military plane. The Soviet government, which had an interest in the safe arrival of this mission, sent a plane to Teheran to pick them up. They flew by way of Baku, where they spent a night. "I was thankful," writes Wilgress in his matter-of-fact way, "to have reached Russia at last, to be able to speak Russian and to partake of Russian food … The flight from Baku," he concludes, "was something of a nightmare. At first we flew very high as the Germans were not far away. Then we came down very low, flying only a few hundred feet above the Volga River."

The Kuibyshev experience seems to have been tranquil. Wilgress found comfortable quarters with the British minister, the rest of the Canadian staff fared less well in a kind of barracks. There was not much to do, but there was a social life, including an evening promenade on the main street of Kuibyshev, during which the diplomats greeted one another and exchanged what little gossip there was in such a place. On July 1, when Canada's national day had to be celebrated, Wilgress chartered a river steamer on which he took his eminent guests for a three-hour cruise on the Volga. He comments in his memoirs on the unpleasant impression the lavish diplomatic dinner parties left on him, at a time when half of Russia was starving.

Then the bizarre Kuibyshev episode was over. The Germans tried to break through on the Kursk salient, but failed. There was a massive tank battle. The threat to Moscow ended as a general

German withdrawal began. Word went round that the diplomats could return. But for the Canadians it was no return but a beginning. They had never possessed either office or house in Moscow, and had no place to go. The Swedish embassy, which had looked after the interests of so many others during the war, approached Wilgress to say that the former Danish legation, left in Swedish care when Denmark had been occupied by the Germans and forced to break its relations with Moscow, was available. Would the Canadians like it? Wilgress took a train to Moscow and examined the fine old Russian house at 23, Starokonyushenny pereulok ("Old Stable Lane") just off the Arbat, not far from the Kremlin, the Bolshoi Theatre and much else in central Moscow. He liked it, and took it on the spot. It, together with an addition built in 1960, has been the office of the Canadian embassy, as well as the ambassador's house, ever since then.

The exterior of the building today is much as Wilgress saw it forty-five years ago: an elegant two-storey facade not separated from the narrow street, and following the gentle curve of the *pereulok* (a small cross-street). Two narrow but handsome doors stand side by side at the south end of the facade rather than in the middle, where one would expect them. The doors open directly on to the street, sometimes forcing passersby to step into the gutter. One door is for downstairs, the other for up. A fine portico, contemporary with the building, stands over the two doors. At the other end of the building a driveway leads to a courtyard behind, where there were, and still are, various outbuildings, including an attractive small house of an earlier period than the main building.

Across the narrow street, an elementary school. Next door (in Wilgress's day, but long since disappeared to make way for the addition to the embassy) stood a tumbledown two-storey apartment building in which Russian families lived, like most Moscow families at that time, in conditions of incredible crowding and squalor: one small room per family (usually including at least one grandparent), with a communal stove and washroom. Next door to that was a prison-like apartment building for privileged people. (Nikita Khrushchev was given an apartment there, in addition to his country *dacha*, after he was removed from power in 1964.) Opposite the apartment was that favourite institution of all Russians, a bath house. And in the other direction there was a jumble of decrepit wooden houses, all hopelessly crowded, and for the most part now removed to make room for some green space and a number of pleasant apartment buildings assigned to senior officers of the armed forces, whose headquarters is now and was then nearby.

Only two minutes' walk away was the Arbat, one of Moscow's most famous streets, recently made still more famous by Anatoly Rybakov's novel *Children of the Arbat*. The Arbat has now been turned into a pedestrian mall on the North American model, but in a sense it was a pedestrian mall when Wilgress first saw it. In those days there were no personal cars, and the Arbat seethed with pedestrians looking for something to buy in conditions of extreme scarcity. And woe to those who trespassed

on the sacred traffic lane painted down the centre of the street, reserved for high officials headed toward their day's work in the Kremlin. Their black curtained limousines shot through the crowd; it was a criminal offence to be hit by them. But here was life. A metro station; a cinema as well as the famous Vakhtangov Theatre; one of Moscow's grandest restaurants, the Praga; places to eat and drink, however badly.

The Canadian embassy in Moscow at 23 Starokonyushenny pereulok ("Old Stable Lane") in central Moscow.

Not far away was the Kremlin itself, then closed to the public. The banks of the Moscow River were within walking distance. Around the corner from the embassy, in another narrow *pereulok,* stood the beautiful small Orthodox Church of St. Phillip, protected as an architectural monument and miraculously still being used as a church, one of only a handful in a city with a population at that time of four million. A little further on Wilgress, taking his evening walk, would have come upon the innermost of the several great concentric rings which, with the Kremlin at their centre, were, long ago, the fortifications of Moscow, and then became the basic plan of the modern city. The ring near the embassy takes the form of a muddy, treed boulevard, where in summer old men play chess,

babushky wheel their swaddled charges in old-fashioned prams, and street vendors sell ice cream and *kvas*.

The embassy building itself was put up toward the end of the nineteenth century by a flour merchant, N.I. Kazakov. The architect was K.K. Gippius, who designed a number of Art Nouveau buildings in Moscow, and whose name still figures in histories of Moscow architecture. Kazakov himself lived in the upper apartment, letting the lower one to tenants. The smaller house in the courtyard is earlier, about 1820. Between them, the two buildings could provide spacious, even elegant, accommodation. Arriving in war-time Moscow, however, Wilgress and his sizeable staff (too sizeable, he concluded after a short time) had more to think about than elegance and space. There were of course no apartments and no offices to be had in Moscow. Everything had to be accommodated within the confines of two buildings, the smaller of them about the size of an average present-day Canadian house. Wilgress took the upper apartment of the main building, which remains today the official residence of the ambassador. Since his wife and children were to join him only later, he installed the military clerk, George Power, in a room at the end of the corridor. The diplomatic officers and the military attaché, all of them bachelors, shared the small house in the courtyard, where in those more relaxed times it was possible to have a social life which included Russians, even Russian ladies (such a thing became unthinkable almost as soon as the war ended and the alliance crumbled). As additional staff arrived from Ottawa, small living spaces were found in the lower apartment and even in the cellars. Some of the Russian staff members had no place to live in Moscow and were housed in the basement of the building. One Canadian staff member fell in love with a dancer at the Bolshoi, married her, and took her to live with him.

They were not there merely to live, but to do useful work, and there was a lot of work to be done. The war was nearing its end. People in Ottawa had time to think about what Europe ought to look like following Germany's defeat, how the Soviet Union would behave, what international institutions should be created. They wanted to know how Wilgress and his staff saw these problems from the vantage point of Moscow, and they wanted all the information they could get on how Stalin and the others in the Soviet leadership saw them. So offices had to be created in the same cramped space, where political and economic problems could be thought and written about, diplomatic visitors received, telegrams enciphered and deciphered, despatches typed, the embassy administered, and the problems of food, transportation, laundry, and travel dealt with. In the ground floor apartment, living accommodation was pushed to the extremities of the building. An office for the ambassador was carved out of his apartment upstairs. Downstairs, three diplomatic officers shared an office which barely held their three desks, while next door all the Canadian secretaries shared another modest space. A tiny box of a room contained the filing cabinets and cipher books. Across the hall, in what

had once been an elegant salon, room was found for two Soviet administrators. One of them was a disagreeable woman called Vera Petrovna, commonly thought to be a KGB agent. The other was George Costakis, and he was to sit at that desk, under the chandelier, solving problems, playing the part of a *tolkach*, for the next thirty-five years.

It is a tribute to Costakis that at least three of the Canadians who moved to Moscow from Kuibyshev in 1943 claim to have been responsible for hiring him. Wilgress makes the claim in his memoirs. Both Smith and McCordick made it in conversation. Ambassadors, like ministers in their departments, are allowed to take the credit (or the blame) for anything that happens in their embassies. And the ambassador would have made the final decision in a matter of importance, as that matter was for a small embassy at such a time. It is likely that McCordick was involved, because he was responsible for embassy administration and spoke Russian when Costakis knew no English. In all probability the two non-Russian-speaking officers were consulted. What seems likely is that Costakis came with a recommendation from the British embassy, where he had Greek connections.

However he came to be hired, it is clear that for the three officers most involved with him at the beginning, Wilgress, Smith, and McCordick, Costakis kept a profound affection. Smith was to return to Moscow as ambassador in 1960. A close association and warm friendship grew between them.

In those years I got to know the American ambassador Harriman [Averall Harriman, American ambassador in Moscow 1943-46] who had become friendly with [Arnold Smith] the Canadian second secretary or third secretary, I can't remember. They were great friends. Harriman very often came to our embassy. On Saturday or Sunday Arnold Smith would arrange a picnic in the little garden of the embassy. They cooked sausages, kebabs, drank beer. Being on very good terms with Smith, I was often present at these picnics and got to know Harriman well. In summer Arnold Smith used to rent a *dacha* in the village of Bolshevo, and Harriman was often a guest at the *dacha*. And I too was there three or four times.

And so, I remember, once we were sitting there, chatting, and the talk turned to collecting. Harriman said to me, "Our president Roosevelt is also a collector. But he collects models of ships and boats. Everything that floats on sea or ocean attracts him." Now in my Chukotka collection was one very old [model] wooden boat, and one walrus-bone carving of a skiff, both of them probably three or four hundred years old. I decided to give these little boats to the president, and I asked Harriman about it. He willingly agreed, and said that the president would be touched by such a gift. So I gave him these things. About three weeks later I received a letter. On the envelope, "White House." I open the letter, and I read – but first I read the signature: "Under-secretary." And the letter said, "the President has asked me to thank you for your most

thoughtful gift" [on the tape Costakis says the last three words in English]. He was very happy with this gift and, as I learned later, these two little boats went (of course after his death) to the museum.

Many years later (I think it was in '73) when I was making my tour around the museums and universities of the United States of America, I chanced to meet Harriman again. It was at an unforgettable reception – dinner, rather – organized by Mr. Mellon. Harriman came up to me, called me by name (after so many years he had not forgotten) and asked how I was. We spoke about Mr. Smith, who remained my good friend. I was extremely surprised that after so many years this important man still remembered me. I should say that in those days in Moscow, when I went to the picnics and to the *dacha*, I was struck by the simplicity with which the American ambassador dealt with people.

Costakis also stayed in touch with Wilgress until his death, and he kept contact with McCordick as well. What most impressed him about these Canadians was that they treated him not as a servant but as a colleague and friend. Nothing in his Soviet life or in his experience at other embassies had prepared him for this. He recalled that when a shipment of some kind arrived one Saturday morning, soon after he had joined the embassy, and he was struggling alone to open it, McCordick emerged from his house in working clothes and joined in with a hammer. Costakis could not believe his eyes: "A third secretary, a very important diplomat, working like a common labourer!" (Costakis would learn more, over the years, about the importance of third secretaries, but he never forgot or ceased to admire McCordick's thoroughly un-Soviet behaviour.) Then, the job finished, McCordick invited Costakis to join him and the others sharing the little house for lunch. This was absolutely without precedent for the young driver, but it was a practice that would continue with most of the Canadians who came and went over the next thirty-five years.

From the beginning, Wilgress and his Canadian officers made a conscious effort to establish Costakis in the minds of the Soviet staff, and of the Soviet authorities, as a person of substance and responsibility within the embassy. In Moscow then, as still in the Communist world where it exists, diplomatic missions were permitted to do practically nothing for themselves: all matters of housing, hiring and firing local staff, importing and exporting, fixing the plumbing or the car, buying tickets for the train or the theatre had to be done through a special branch of the foreign ministry, in those days known as Burobin. In Moscow at least, the inadequacies of services which we regard as normal were so great that some such arrangement was probably necessary if foreign embassies were to function at all. But the system also had the advantage, from the point of view of the host government, of giving it an almost total stranglehold on the operations of foreign missions. This deplorable way of doing things became stronger, not weaker, over the subsequent years; later it would have been impossible to hire a Costakis off the street, as Wilgress did then. If the embassy wanted a Costakis,

even a few years ago, it would have had to apply to the present equivalent of Burobin and take what it was given, which might have been a KGB colonel.

So the relationship with Burobin was of the utmost importance to the life and work of the embassy, and the conduct of that relationship, day to day, was one of Costakis' main jobs. To succeed in it he had to be seen as a strong person with the ambassador's total confidence. Otherwise, Burobin would ignore him, and the embassy would suffer. As soon as Wilgress had established that Costakis was competent and responsible, he wrote a formal diplomatic note to the foreign ministry, saying that Costakis had full authority, including financial authority, in all matters assigned to him. His signature on a document was as good as the ambassador's own. This greatly impressed Burobin, who were even more impressed when, early in Costakis' career, a major negotiation between the embassy and Burobin was scheduled to determine the future of the lease on the embassy buildings. Wilgress headed the Canadian side, the director of Burobin the Soviet. The meeting was to take place at the embassy. When the Russians arrived, Wilgress sent for Costakis. He was away on an errand for Mrs. Wilgress. "Gentlemen," said Wilgress, "I cannot enter into discussions on so important a matter without Mr. Costakis being here. Let me offer you a drink, and we will wait until he comes." From that day forward, Costakis said, his position with Burobin was assured and unique. He was treated with respect, and he got action when he needed it.

With the Russian staff of the embassy it was the same story. In Russian society what people call one another is very important, a strong indicator of their relationship. Like French, German, and other European languages, Russian has two forms for the word "you." One, *vy*, is used like French *vous*, in normal conversation with most people, and always with more than one person. The other, *ty*, like French *tu*, is used between two people who are very close friends, between two members of the same family, in speaking to children, and so forth. *Ty* is also used, often, by a boss speaking to a subordinate. (But subordinates, if they know what's good for them, call the boss *vy*.) It is a gross breach of good manners to call someone *ty* when the relationship has not reached that point of intimacy, and many relationships never reach it. In this usage Russian closely resembles other European languages except English, which has lost the "thou" form in modern times.

Wilgress and McCordick, knowing Russian, realized how necessary it was to speak to Costakis in the appropriate way if they were to get the most out of him. They were scrupulous, when Russian staff were within earshot, about calling him "Georgii Dionisovich" or "Gospodin Kostaki." He replied in the same way. They never used the pronoun *ty* in speaking to him, nor he in speaking to them. In English, they and successive generations of Canadians at the embassy called him "George" and usually tried to make him use their first names too. The Russian staff were given the clear message, through these signals, that Costakis was the boss, not just one of the boys, and that the

Canadian diplomats considered him their social and professional equal. The stage was set for him in his relations with the Russian staff, of which he was in a way part, in another way not.

But few people spoke to Costakis in English in those early years. He knew no English. Wilgress and his Russian wife were absolutely at home in Russian. So was McCordick. Even Canadians not at home in Russian preferred, Costakis recorded, to struggle along in it for the sake of the practice. His daily life in the embassy with Russian staff and at Burobin with Russian officials provided little occasion to use a language he knew he must sooner or later learn. He made little progress, until, after he had been at the embassy a few years, a chance came to emigrate to Canada. Emigration did not happen then, but the chance of it sent Costakis to the language textbooks. In a short time he spoke well, and before long he became fluent. Again, in the eyes of the Russian workers in the embassy, he was set apart from them. In those days few of them spoke any English, and few tried to learn.

Despite his unique position in the embassy, or perhaps because of it, Costakis had a marvellous relationship with most of the Russians who answered to him. He of course, being the *nachalnik* (boss), called them by the diminutive of their first names (Vladimir was Volodya, Nikolai was Kolya, and so forth), and he used *ty*, the intimate pronoun for "you," when speaking to them. They, on the other hand, respectfully and invariably called him "Georgii Dionisovich" (never "Gospodin Kostaki," indicating that they counted him a Russian like themselves, not a foreigner; "Gospodin" was reserved for the Canadians). But he had a wonderful, good-humoured, often joking relationship with them, which got the best out of them. Many of them, outdoor workers, drivers, yardmen, cooks, maids, laundress, were simple people, and many were country people come to Moscow to make their way in the world. Costakis' spoken Russian, with people he knew, was earthy, larded with barnyard language. "You're not a doctor, you're a horse butcher," he once in later life observed good naturedly to his doctor, when the doctor refused to give him a cigarette. That was how he spoke to his staff, and they loved him for it. Very often Canadian staff, perhaps on their first foreign assignment, often not speaking Russian and unused to domestic help, simply could not deal with their maids or with other local staff. Costakis moved into those situations with consummate skill. An arm around the maid, a little joke, find out what the problem is, explain to both sides in both languages. He never fired anyone; his policy was to get the best out of the people he had. (The only person he wanted to fire in all those years was the same Vera Petrovna mentioned above, who he was convinced was a KGB officer, and who tried to compromise Costakis with Wilgress. Wilgress, who was a tolerant man also, refused to fire her, although he acknowledged that Costakis had a case.) In short, to all the Russians he dealt with officially, those who worked for him as well as those he saw in his daily round outside the embassy, Costakis was a person of substance and authority. Some of this derived from the tone set by Wilgress and his Canadian officers, but most of it came from Costakis himself.

He had presence and natural authority. These, combined with high intelligence and great humanity, made him an impressive figure. At the height of his vigour, he dominated, gently, the world in which he moved.

The relationship with the Canadians, of whom several hundred passed through the embassy during Costakis' thirty-five years there, was different. For him, these diplomats were very grand people indeed and had to be treated with respect. Familiarity eroded some of that attitude over the years, but it never disappeared altogether. Even the rawest third secretary, new to the business of diplomacy, to Russia and sometimes to life, was entitled to be regarded with a certain awe. Rank entered into this, rank being so central an element in Russian society. Costakis was prepared to treat a senior Canadian clerk or an administrative officer as more or less his equal, call him or her by the first name, joke and take a surreptitious glass of vodka together, pick up the guitar and sing a song when none of the "big people" was within earshot. Not so with diplomatic officers. Even if they called him "George," it took him a very long time to bring himself to reciprocate that familiarity. Only long after he had left the embassy did he find it possible to use the intimate pronoun, *ty*, in speaking to people who were there during his time.

There was a certain amount of theatre in all this. When he talked about his relationship with one or another Canadian diplomat, Costakis was fond of saying, "I was just a little clerk, down here [indicating knee level or lower], and he was second secretary, away up here." He was only half serious. He knew himself too well, as he knew too well his place in the life of the embassy, to believe entirely what he said. But the reality of rank, position, title was there, part of his experience. Ambassadors, even the most difficult of them, were near to God.

Yet he made very close friends among the Canadians, including some of those godlike ambassadors. There were altogether five ambassadors in Moscow during Costakis' thirty-five years. Two of the five, R.A.D. Ford and J.B.C. Watkins, had also served in Moscow, before their ambassadorial tours, as chargés d'affaires in the dark days following the Gouzenko defection in Ottawa. Canada decided, as a mark of its displeasure, to replace Wilgress when his mission came to an end, only with much more junior people. There were altogether three chargés d'affaires during that interregnum, which lasted eight years. The third was John Holmes. Thus, after the departure of Wilgress in 1947, Costakis found himself dealing not with dignified, senior, middle-aged and highly experienced heads of mission, but instead with very bright and energetic men his own age or younger who had never headed an embassy before. As it turned out, he got on well with all of them, and he remained close friends with Watkins and Holmes until their deaths.

Robert Ford, then Canadian chargé d'affaires at the age of thirty-eight, and Costakis' youthful boss, witnessed Stalin's funeral in 1953 and has described it vividly in his book *Our Man in Moscow*.

Within two years Khrushchev had laid his power base in the Communist party. It looked like a new beginning in the USSR; Ottawa decided to let bygones be bygones and assigned a new ambassador. The man chosen for the job was John Watkins. Most people know Watkins as the ambassador who was entrapped by the KGB in a homosexual affair and, in a monumental error of judgment, failed to reveal that fact to his deputy minister. Many years later, after Watkins had retired and was living in Paris, the story became known to Canadian security through information provided by a KGB defector. Watkins was brought back to Canada; he confessed to the entrapment but denied having done anything wrong as a result of it. Most who knew him, as well as the Canadian security authorities who questioned him, thought he was telling the truth. He died, dramatically enough, of a heart attack while being questioned in Montreal by the RCMP.

Costakis knew nothing of all this. What he knew was that in John Watkins he had a friend as well as an ambassador he could admire and like. Watkins was indeed a delightful man, and a learned one. Lester Pearson, then minister of external affairs, had brought him into the department from the university world, where he was an internationally known authority on Scandinavian languages and literatures. But Watkins' learning went far beyond that. He was a prodigious reader on every subject, an outstanding prose stylist, an accomplished pianist, a serious student and collector of art, a speaker of many languages including, of course, Russian. And all this he carried very lightly indeed. Born and raised on a farm west of Ottawa, he never lost his simplicity and directness. He loved to be with people, loved to talk and listen. He was as happy to share thoughts and impressions with a vagrant on a park bench as with another ambassador or with his friend Lester Pearson.

Like Wilgress, Watkins found the Russians warm and in many ways admirable. He never believed they were a threat to the West. Also like Wilgress he maintained this view of the Soviet Union in his official communications with Ottawa, at a time when Ottawa's view was veering sharply the other way. Well to the left in his personal politics, he persisted in seeing the good side of Soviet behaviour or in finding a rational explanation for it. He thought that most Soviet actions, at least in Europe, could be understood only in the context of the trauma of the war and persistent fear of Germany. Most of his despatches from Moscow carry the twin messages of the essential humanity of the Russian people and the need to understand Soviet politics in terms of the war and the rearmament of Germany. And he brought those views back with him, despite the fact that some of the Russians he had thought of as his close friends were in reality KGB officers bent on his destruction. This he must have known before his mission in Moscow came to an end.

So in many ways Watkins was Costakis' kind of man. Not that they had much in common on the surface: the professor and the truck driver. But in fact they were alike. The same interest in music and art, the same warmth and geniality, the same curiosity about people. Indeed, the same short

stature and rotund physical shape. Costakis recalled that during Watkins' first tour in Moscow as chargé d'affaires in 1948, he rescued Costakis from the Botkin Hospital, where Costakis had lost a kidney and, he believed, very nearly lost his life at the hands of the KGB: "Watkins after the hospital took me to the embassy and gave me a room in his residence, and I was living there, just to rest, one month. The maids looked after me, brought me good food, Watkins was playing Bach, and I was there with him, and Zina came to visit me."

Before long, Watkins, who was a bachelor with no family in Moscow, had become fast friends with the Costakis and their four children, dining with them, visiting their *dacha,* inviting them to the official residence, admiring George's fast-growing collection. When Watkins left Moscow after two years to become assistant under-secretary of state for external affairs in Ottawa, he left a regretful Costakis behind but took with him (as did many Canadians) tokens of Costakis' warm feelings in the shape of Russian icons and some impressive pieces of the Russian avant-garde. Costakis knew nothing of Watkins' unhappy story until he learned of it long after leaving Russia.

Watkins was succeeded in Moscow, in 1957, by David Johnson, a career diplomat who was not, however, the best choice for that post. He knew no Russian and felt he was too old, in his mid-fifties, to learn it. Unlike Wilgress and Watkins he had little sympathy for the Russians and not much understanding of their policies and actions. His reports to Ottawa, the few he wrote himself, were prosaic accounts of conversations he had with his colleagues, usually the American and British ambassadors. However, with these deficiencies, he was good natured and hospitable. Costakis recalled, "Johnson made me shave every day and wear a suit" – not because he gave orders to that effect, but because he included Costakis in his lunches and even his diplomatic dinners so often that Costakis felt obliged to come prepared. In those days in Moscow it was considered unmanly to shave more than two or three times a week and foppish to wear a decent suit. Costakis would have felt ashamed to turn up at his ambassador's lunch looking like that, the ambassador himself being a model of diplomatic elegance in his invariable dark blue double-breasted suit, starched white shirt, dark tie and highly polished shoes. Like his predecessor, Johnson visited the Costakis apartment and viewed the collection of the avant-garde. But he knew little about art, and although he was much too polite to say so to Costakis, he probably shared the opinion of Soviet officialdom that Costakis was wasting his time and money collecting junk. However, that was Costakis' business. What Johnson and his predecessors had in common was a healthy respect for Costakis' ability to get things done in very difficult circumstances. As far as Johnson was concerned, what Costakis did in his spare time was no concern of the embassy.

Costakis with his daughter Aliki (Lilya) and Arnold Smith, former secretary general of the Commonwealth and before that Canadian ambassador to the USSR, at the preview of the Guggenheim Museum exhibition, New York, November, 1981.

Johnson left Moscow in 1960, retired and died soon after. He was replaced as ambassador by Arnold Smith, who had been ambassador in Cairo. Once again Costakis had a like spirit in his boss. He recalled that Smith was "like a hooligan," "like a kid of eighteen just out of university." All of which he meant to be highly complimentary. It was Smith's boundless energy Costakis admired, his willingness to sit up half the night at his work, the pleasure he took in it, the zest with which he plunged into writing his phenomenally long and detailed telegrams to Ottawa. Not that Costakis saw those, but the same enthusiasm went into everything Smith did. He had a profound interest in art, and had Costakis introduce him to young "unofficial" artists in Moscow; like Watkins he left Moscow with some treasured works from Costakis' collection. Smith stayed in Moscow only two and a half years, and soon after his return to Ottawa he was named the first secretary general of the Commonwealth. Costakis remained in touch with him, and afterwards remembered with gratitude

some kindnesses which Smith and his wife were able to do in London for Costakis' daughter, Lilya, when she was very ill.

Smith was followed in Moscow by Robert Ford, who arrived in 1964, also from Cairo. He was to remain as ambassador an unheard-of sixteen years. Costakis had got on well with Ford and his remarkable Brazilian wife, Thereza, when they had been in Moscow on their earlier assignments, first during Wilgress's time and then during the interregnum after his departure. And the relationship started well this time too. Ford was different from his immediate predecessors. Both Watkins and Smith were somewhat rumpled, amiable, informal people. Ford was tall, good-looking, dignified, and serious. He had an outstanding diplomatic record both as ambassador in Colombia, Yugoslavia, and Egypt (or the United Arab Republic, as it was called when he first arrived there) and as a very able director of European affairs in Ottawa at a time when Canadian diplomacy was at its most active and effective. He observed well, wrote well, dealt with the Russians with the tough-mindedness they understand best, yet viewed them and judged them with fairness and compassion. He was more than a competent ambassador. He was a poet and had won the Governor General's award for poetry before he went to Moscow. He was a translator of poetry from Russian to English. When he went to Moscow he was already a towering figure in the Canadian foreign service, and he maintained that stature during his long years there.

Costakis recounted that for several years after the arrival of Robert and Thereza Ford all went very well. He worked hard to do what they wanted, and they treated him decently, consulted him about many things, invited him socially. But later things went less smoothly. Costakis and Ford commented, separately and in after years, that a small embassy was not spacious enough to contain two such large personalities. Ford remarked that Costakis "got too big for his boots." Costakis said that his growing international reputation as a collector, the stream of eminent people who found their way to his door, had something to do with the strain in their relations. Perhaps they were saying the same thing in different words. In the end, shortly before Costakis' final departure from Russia, he was in effect dismissed from the embassy, according to some because he was so busy arranging his emigration that he was neglecting his embassy work. Convinced that the KGB, or some elements of it, were determined to see the end of him one way or another, and that his only protection from them was his embassy employment, he asked to be allowed to stay on without pay, and this Ford permitted until Costakis left finally at the beginning of 1978. It is a sad story. Robert Ford and Thereza Ford were larger-than-life figures, and so was Costakis. It was perhaps inevitable that difficulties should have arisen. In any case, almost exactly thirty-five years after Wilgress hired him, Costakis and Zina got on the plane at Sheremetyevo and headed for exile – and, as it turned out, considerable

wealth and a great deal of fame in the art world. In his memoirs Ford does not mention Costakis or his collection at all.

Costakis was fond of saying that he was well treated by ninety-five percent of the Canadians he worked with over all those years. Certainly he made fast friends with many of them and maintained those friendships. Some he loved. Arnold Smith certainly, and John Holmes. Hearing of Holmes's death in 1989, he made the sign of the cross and burst into tears. There were a few less happy relationships. One officer persistently criticized him in front of his own staff, especially for arriving late at work, something he often did. He tended to resent Canadians, especially junior ones, who called him "George" but expected him to call them "Mr." or "Miss," and he tended to resent even more those who ordered him to do things rather than asking him to do them. His relations with military officers and staff serving at the embassy were perhaps less close than with civilians; he had never served in the army and was always startled by these officers' friendly but brusque approach. He had a run-in with one military attaché's wife, who he thought accused him of embezzling money from the Christmas tree fund, which he administered. But these were rare events. With most of the several hundred Canadians he knew he had good relations, they seeing him as both a window on a fascinating world not otherwise open to them and an incomparable "fixer." For his part he saw them as admirers of his collection, as learners, friendly companions at the end of the day's work, helpers in a tight spot.

Costakis was the first to say that the embassy helped to make his collection possible. And this was mainly because Wilgress decided from the first to treat him financially not as a local employee but as a Canadian member of staff.

Costakis' first request to Wilgress in 1943 was that he be paid partly in food. Food has long been hard to find in Moscow, harder still in provincial towns and cities. But foreigners in Russia have for many years had no trouble importing what they wanted from Western Europe, often from firms whose main business is supplying (for hard currency) the impoverished capitals of the East. They, or their employer, have only to foot the substantial bill. When the Canadian embassy opened in 1943, Western Europe was about to become a vast battlefield, and even neutral Sweden was in no position to supply much to Moscow. In wartime Moscow, foreign missions had privileged access to what food there was, but times were hard for ordinary citizens, and Costakis' request was a natural one for a man trying to feed a family. Nevertheless, Wilgress records that he had to refuse because there wasn't enough to go around. Costakis then returned with another idea, that he be paid partly in foreign currency. That seemed reasonable to Wilgress, and he agreed.

At that time and until 1960, the embassy in Moscow had a curious but not unreasonable way of paying its Canadian staff. Salaries were paid as they are now into the person's Canadian bank

account. But in addition to their salaries, government employees working outside Canada receive various special allowances to cover the additional costs of working and living away from home. In Moscow, during the early years of the embassy, employees were allowed to receive part of their allowances in roubles, the cost of which was heavily subsidized by the embassy. Thus, the official exchange rate was ten roubles to one US dollar, but Canadians working in the embassy could buy a substantial sum in roubles at twenty-five to the dollar, the embassy picking up the rest of the cost. This arrangement meant that if embassy staff could find food to buy with their roubles, the cost was low. Internal air and train travel, theatre tickets, the costs of domestic help were very low indeed. So there was an incentive to spend inside the Soviet Union, to see more of the country beyond Moscow than might otherwise have been possible, to buy Soviet books and works of art and so forth. The system was quite properly abolished with the arrival of hard-nosed accounting at the Treasury Board, but what was gained in financial propriety may well have been lost in the disappearance of a useful incentive to Canadians to get to know the country to which they were assigned.

Right or wrong, Wilgress decided that George Costakis would be paid on this system just as though he were a Canadian employee of the embassy. True, he was not a Canadian, but he was not Soviet either. So a salary was set in dollars, a very small salary to be sure, and paid into a bank account in Ottawa. At that time it would have been illegal for Costakis to have dollars in the USSR. Costakis then had the right, like the Canadians, to buy a certain number of roubles at twenty-five to the dollar. Moreover, since the Canadians at the embassy often did not take their full quota of roubles, they were sometimes willing to let Costakis have a few extra. And the existence of the Canadian bank account made it possible for Costakis to pay his expenses when he travelled abroad.

When this deal was struck, Costakis was still two or three years away from starting his avant-garde collection. But he was already collecting other things, and even for daily living the cheap roubles were of immense value. When he finally started his avant-garde collection in 1946, the significance of what he had became clear. Prices of paintings and other works by even the greatest avant-garde artists – Chagall, Kandinsky, Malevich, Popova – were very low. With his treasure-house of roubles, once he had learned who the artists were and where their works were to be found and had developed some sense of what was good and what less good, he could buy almost at will. Within five years many of the greatest works were hanging on Costakis' wall, and within ten the collection had taken the basic shape it has retained to this day. By the time the subsidized rouble was abolished in 1960, Costakis' salary had risen substantially, he was an established "unofficial" dealer operating successfully in the Moscow-Leningrad art market, and he had begun to sell a few works on the international market. For these reasons the end of the subsidy caused him little difficulty.

Grumbles are occasionally heard: the Canadian government should own the Costakis collection, since it paid for a large part of it; Wilgress made a mistake to treat Costakis differently from Soviet employees, who were then paid entirely in roubles. This is easy to say, but it's wrong. Wilgress found the person he wanted and bargained to get him. Costakis' subsequent record showed that the ambassador made no mistake there. The authorities in Ottawa also found nothing wrong with the arrangement at the time, nor did the Soviet authorities, who could hardly have been ignorant of it. As for Costakis, he had been paid in drachmas at the Greek embassy when he worked there, and he saw no reason why he should not make the same deal with the Canadians. One can only be grateful that it did happen, that none of the principals thought they were doing anything but getting on with their jobs in the best way, and that it helped produce one of the world's greatest collections of art.

◢

The story of the Canadian-Soviet relationship from the end of the war is not unlike the pre-war history: one step forward, one back. Canadian willingness to improve contacts and relations often fell victim to external events having nothing directly to do with Canada. It is clear now, with benefit of hindsight, that it was impossible to achieve much during the long rule of Brezhnev as party general secretary – the period of *zastoi*, stagnation, as it is often called. The character of that period was one of stand pat, do nothing lest what you do turn out to be a mistake. The well-intentioned foray of Prime Minister Trudeau into the Soviet Union in 1971, with extensive travel, many documents signed, dozens of reporters and cameras, hardly advanced matters against the dead weight of Brezhnev's immobilism.

There had been an earlier attempt to construct a more useful relationship. Lester Pearson, then secretary of state for external affairs, had gone to Moscow in 1955, the first foreign minister of a NATO country to do so. Encouraged by early signs of civility in the Khrushchev regime, he met the new Soviet leaders, and felt he had opened some doors both in Soviet-Canadian relations and in East-West relations generally. But in the next year came the crushing of the Hungarian uprising, then the second Soviet-inspired Berlin crisis, followed by an even more serious one in Cuba. In Canada Prime Minister Diefenbaker was calling publicly for the liberation of Ukraine, and the Soviet reaction was not unlike that of the Canadian government when de Gaulle called for the same for Quebec. In such circumstances there was little chance to make serious headway. The abrupt removal of Khrushchev in 1964 ended any hope he may have offered, although his wild and dangerous adventures in foreign affairs made it unlikely the Canadian government could have dealt with him successfully.

Costakis left the Soviet Union just as Canadian-Soviet relations were about to drop to their lowest point since Gouzenko's defection. The invasion of Afghanistan in 1979 brought all but the most essential contacts to a halt. The shooting down of KAL flight 007 in 1983, with Canadians on board, deepened the freeze. Soviet violations of its human rights obligations under the Helsinki agreement continued to enrage many Canadians. Much of that changed after the arrival of Gorbachev, including the attitude of the Soviet state to Costakis and others like him, but Canada seemed puzzled about what to do next.

Costakis never claimed great political insight. But no one had more sense than he of the shackles that have fallen off in Russia, and the importance for the West not to lose any opportunity to support the developments now taking place. From his lonely exile and his wheelchair in Athens he raged against Gorbachev's critics and opponents, wondered why Canada could not help, and demanded new policies suited to new times.

FACING THE APPARATCHIKS

Canadian and most other embassies all over the world function with the help of citizens of the country they are in, or of third countries. These "locally engaged staff" (LES), as they are called in the Canadian foreign service, do most of the menial work: driving, cleaning, cooking, serving at table, tending the embassy garden. But they also do more responsible things. Some, like Costakis, administer. Others deal with the problems of travelling Canadians, who may have fallen ill, lost their passports, or been arrested. Still others help to promote Canadian exports to the country concerned. Large numbers are involved in information and media relations. Without these local people most embassies could survive and carry on basic work, but their usefulness would be drastically reduced and in many countries they would probably not be worth keeping open.

Many local employees, again like Costakis, become deeply involved with the embassy. Its problems are their own. The Canadian staff stay for a few years, then leave and are replaced. The locally engaged stay, often for a whole working life, are fiercely loyal, and identify strongly with Canadian interests in the country.

Before 1991, when the USSR still existed, and even before 1985, when Gorbachev started the process of winding up the cold war, Soviet embassies and other offices around the world never employed local people. At great expense, every driver, every cleaner, every mechanic, was brought from home. The reason for this uncharacteristic prodigality was, of course, that the Russians of that day assumed that any foreigner they might employ would be, or would certainly become, an agent of the security authorities of the host country and would spy on them, steal their secrets, and generally threaten their security and peace of mind. At the very least the foreigner would report on their

behaviour or misbehaviour. Whether they were right or wrong in their assumption, the Russians were themselves convinced of its validity, and took no chances. Instead they went laboriously about their daily round with telephone operators who did not speak the local languages well enough to do their job, drivers who could not find addresses, repairmen unaccustomed to technical abundance. They did all this because they knew how they themselves managed things back in Moscow when it came to the staffs of foreign embassies, and they saw no reason to believe that the Canadians, or anyone else, would behave differently.

And indeed, the Canadians in Moscow and in the other communist capitals did behave in a way which to the Russians must have seemed foolhardy. From the beginning there were always more Soviet than Canadian citizens employed in the embassy in Moscow, and it was known beyond any doubt that some of them were directly employed by the KGB, that others were required to perform various unsavoury tasks against the embassy and its personnel, and that even the most humble must report to the KGB from time to time anything of interest they might have picked up. Nor was there any question, then, of "finding somebody you can trust," as Dana Wilgress wrote, with 1943 in mind. When Costakis was hired in that year, at a time of great confusion in the USSR, it was possible to take somebody more or less off the street, especially if the person being hired was a citizen of some foreign country. When the war ended, so did that relatively tolerant practice. Soviet employees of the embassy were from that time on picked and sent by the section of the foreign ministry then called Burobin ("Office for Foreigners") and later called UPDK ("Directorate for the Diplomatic Corps"). You took what you got, and your hopes did not go beyond getting competence. That your new employee was in one way or another involved with the KGB you accepted as a certainty. Or at least as an essential working assumption.

Dangerous and naive this arrangement may have looked to the Russians, who thought they profited from it, and even to some Canadians. But in fact it was a realistic way to go about the business of an embassy. Embassies are not there just to have secrets and prevent them from being stolen. In fact they do not have many important secrets at all – who has these days? They are there to serve Canadians with an interest in the country and to assess what is going on in the country and keep the Canadian government up to date on it. To try to accomplish all this with no help from people who live there permanently would be absurd. You might do it in London or Washington (although Canada does not try) but not in Moscow or Beijing. And there is another consideration. In 1994 to keep a Canadian, with his or her family, in Moscow, costs at least two hundred thousand dollars a year, more for the more highly paid, and still more for a larger family. It is not only salary that has to be paid, but the costs of getting the family there with their belongings, paying cost-of-living and other allowances, providing for children's schooling, and so on. To hire a Russian to do the same job

might cost twenty thousand a year, and chances are the job will be better done because the Russian knows the language, the city, how to operate in a difficult system. If the Russian works for the KGB as well as for the embassy, it is the embassy's responsibility to see that it gets its money's worth and that the KGB gets as little as possible.

Where did Costakis fit into that pattern? Costakis himself outlined the history of his relations with the KGB, from an early time in his life down to his departure from the Soviet Union. His story is consistent: he never reported to the KGB or helped them in any way. Quite the contrary, once they became conscious of him, they regarded him at best as a nuisance, a usurper of a position in the embassy they would rather have had themselves, and at worst as an enemy to be destroyed. This exemption from the normal requirement to serve two masters Costakis attributed to the particular combination of his Greek nationality and his position in the embassy. It was the magic formula which prevented his being arrested in 1938, when he worked in the Greek embassy and when his mother, brother and aunt, who had no embassy connection and were not even registered as Greeks, went to the camps. Being Greek was not enough if you were just an anonymous Greek on the streets of Moscow. And being in the embassy was not enough if you were a Soviet citizen. But the two together perhaps provided a degree of immunity from open persecution, or so Costakis believed. He thought that from the beginning of his time at the Canadian embassy, the authorities knew that he had the strong backing of successive Canadian ambassadors, starting with Wilgress and including Ford at the end. This backing went as far, at least until 1965, as putting Costakis' name with the Canadians rather than the Soviets in the lists of employees sent regularly by the embassy to the foreign ministry. The KGB might well have wanted to remove him and put their own nominee in his place, and they certainly could have done so. After all, he had children in Soviet schools and a Russian wife through whom it would have been a routine matter to apply pressure. But, Costakis was convinced, the KGB were not prepared to follow that route, given the uproar that would have ensued from the Canadian and Greek embassies.

In any case, to look for a reason why some, like Costakis, were not arrested while others, like his brother, were, is to seek a degree of rationality in the pattern of arrests, imprisonments, and executions of those years, 1936-38, which in fact did not exist. Lydia Chukovskaya, the daughter and recent biographer of her father, Kornei Chukovsky, one of the most talented and delightful of Soviet writers, had a letter in the April 12, 1990 issue of the *New York Review of Books*, written from Moscow. She had the following to say on the subject of arrests in those years:

"The human mind, unwilling to reconcile itself to the senseless, looks for *reasons* to explain every case. There was only one reason for the terror of 1937: quotas. The authorities set themselves the

task of arresting a certain number of professors, teachers, dentists, chauffeurs, deaf and dumb people, workers, factory managers, officers, musicians, actors, film directors, shoe shiners and many others, and it didn't matter whom they chose in each category. Those who were arrested were tortured until they admitted they were members of counter-revolutionary organizations and denounced others whose names were provided by the investigator. Afterwards they were either sent to a camp or shot. If they hadn't confessed they would have met the same fate. Why? To what end? Ask the executioners. I don't know what they'll answer. I suppose those who have stayed free must be afraid to even breathe."

In his memoirs Dana Wilgress observes that in those early days there was a tradition for Western embassies to hire as their "fixers" people who lived in the Soviet Union but were not ethnic Russians and had foreign nationality. Wilgress writes: "Practically all the diplomatic missions in Moscow had some sort of major-domo for relations with the Russians on housekeeping matters. The tradition had arisen that men of only three nationalities were suitable for this purpose: Armenians, Jews or Greeks. Of these three the Greeks were probably most effective because they were the least aggressive and knew how to get around weaknesses in the Russian character." The American embassy, he records, "had a Jew, by the name of Morris." The British had a Greek, Costakis' brother, Nikolai. In those distant days there does indeed seem to have been a sort of arrangement under which the non-Soviet human flotsam cast up by revolution and war were allowed to take these jobs, which, it could well have been argued in official quarters, could only be expected to taint good Soviet citizens.

At the Canadian embassy, for example, there was another Greek, in addition to Costakis (who had no doubt hired him out of compassion). Like Costakis' father, he had been a successful businessman before the revolution. His job at the embassy, in his old age, was sweeping the courtyard and stoking the traditional wood-fired stoves which still heated some of the embassy buildings. Eventually he applied to emigrate to Greece and with no difficulty received permission to do so.

Costakis' Greek friend Apazidi, with whom he shared the empty Finnish embassy during the war, was similarly employed by the Swedish embassy and eventually emigrated with his family. It seems likely that at the time there was a special category for these outsiders. All that changed soon after the war. The number of people with foreign passports living permanently in the Soviet Union shrank, and soon became minuscule; certainly none of them would have been allowed to work in foreign embassies. But 1943 was different. There were still many like Costakis who were regarded as class enemies because of their bourgeois origin but as unsusceptible to re-education because of their foreign nationality and suspect allegiance.

That he worked in any way for the KGB Costakis denied vehemently. That he had a lot to do with them he did not deny at all. His life, he believed, was abundantly sprinkled with contacts of the most unwelcome kind. He was convinced that on at least one occasion, which he documented in detail, they tried to murder him and nearly succeeded. On several other occasions they attempted to lure him into serious criminal activity in order to compromise him. After he became internationally known, they followed him closely on foot and by car, sent agents to see him, robbed his apartment, and burned his brother's *dacha* together with many works of art. And in the end, by a remarkable twist of fate, it was they who got him out of the country with his family and collection. That is the story this chapter has to tell.

In the Soviet Union of 1978, when Costakis left, the ideas of class origin and class enemy had practically disappeared from the domestic scene. This is not at all to say that there were no classes. As Djilas has so eloquently pointed out in *The New Class,* there always were classes in Soviet and other communist societies. There were not supposed to be classes, and Soviet apologists at home and abroad stoutly denied their existence. But it is obvious to any historian taking even a moderately objective look at the old Soviet society that it was more class-ridden than are present-day Canadian, American, or even British or French societies. These are, however, to use Djilas's term, new classes. Theory maintains that the revolution was made by a massive alliance of workers and peasants, with a few honest "intellectuals" tagging along. (In fact, as everyone now knows and as most Russians will concede, it was made by a handful of armed zealots.) All other classes were by definition and by Marxist necessity enemies of the revolution. Therefore, it behooved everyone in those stormy days to seek a way to demonstrate membership in one of the three sainted categories, and if possible to demonstrate that one's father and mother had belonged to them too.

Retirement in the former USSR was generally at age sixty, fifty-five for women. Even the oldest citizen still active in the work force when the USSR broke up was born ten or fifteen years after the revolution. Most people were by then two or three generations removed from it. In the intervening years it had been possible for practically the whole population to fit itself into one of the "revolutionary" classes, and to fit in parents and grandparents as well. By 1991, virtually all of Soviet society had acquired impeccable revolutionary credentials. There were a few exceptions. Gypsies, for example, belonged to no class and were officially labelled "parasites." But the "class enemy" was no more, except in the context of the international communist movement, if such a thing still existed in 1991.

At the time of the revolution Costakis' mother and father and their children were unmistakable class enemies, or "enemies of the people" – *vragy naroda* was the official term, and the term under which Costakis' brother was charged and imprisoned in 1938. They were not workers, peasants or intellectuals; they were bourgeois exploiters of these. When the civil war was over and the New

Economic Policy put in place, the family showed their true colours by reverting, to the extent possible, to their petit-bourgeois activity. Since they were no longer permitted to exploit on a large scale, their business having been seized, they turned to exploiting on the limited scale permitted under the NEP. But (so the communists undoubtedly said when people like Costakis senior and his sons were under discussion) their class instinct was to exploit. They were *nepmen*, the term of contempt used by the party to describe just such people. They were the class enemy.

Many others who found themselves in this situation seemed to have a better grasp than did Costakis senior of what was happening to them and left the country, which was less difficult in the years immediately after the revolution than it later became. Members of the aristocracy, owners of country estates, businessmen, czarist military officers, and many artists and intellectuals took their czarist bonds and perhaps the family silver and went to Paris, London, or New York to await the inevitable collapse of the communist regime. Dionisii Costakis was apparently another kind of person. He certainly did not consider himself an enemy of the revolution, which he had long thought inevitable and probably necessary. He does not seem to have harboured any permanent resentment at the loss of his business, large apartment and servants. His reaction was to get to work again at the only work he knew, buying and selling. Besides, he was a foreigner, part of a highly respected community in Russia, and felt he had nothing to fear. The NEP seemed to mean that things were returning to normal. Perhaps eventually he would recover his business. Perhaps the Bolsheviks would forget their crazy ideas and allow the country to right itself and get back on course. In the early twenties he had probably not so much as heard Stalin's name. He could not have predicted what lay only five years ahead, and he certainly did not know that it would be more than sixty years before a Soviet leader would acknowledge that there was something to be said for business people and a market economy. So he stayed on, with his family, a class enemy without knowing it. He died in 1931, before Stalin's terror had got fully under way. Had he lived he would have gone to the camps, as did his wife, sister, and son, and might well have died there, as did so many others.

In Stalin's Russia the sins of the father were visited on the children. George was a class enemy too. He was only five years old when the first secret police organization was founded under the communists. Called the Cheka, its creation had been Lenin's top priority, and there can be little doubt that its first set of files included the Costakis family, who would be identified as former bourgeoisie, foreigners, politically unreliable. That did not matter very much during the twenties; with the NEP in full swing and Stalin not yet in power, the atmosphere was relatively relaxed. But those files passed from the Cheka to its successor organizations, the GPU, the NKVD, the MVD, the KGB. (The changes were only of name; the domestic objectives and activity remained, and to some degree still remain, essentially the same: to keep the regime in power at all cost, and to suppress in the most

effective way any sign of opposition to it.) The Costakis files were obviously opened when the secret police tried to recruit George's brother Spiridon in 1930. They must have been opened again when three members of the family were sent to the camps in 1938, and again when George took a series of jobs in foreign embassies. The label of class enemy would have followed Costakis, through his official files, to the day of his final departure. It is worth repeating that Costakis was officially (but not publicly) described as a traitor as late as 1984. This all has to be kept in mind when one considers the history of his relations with the KGB and its predecessor secret police organizations. To Western societies the notion of class enemy is nonsense, and it is hard to imagine anyone taking it seriously. But in a communist society it is, or was, taken very seriously indeed. As long as members of pre-revolutionary classes were identifiable, those who had belonged to the non-revolutionary ones were suspect and systematically discriminated against in every aspect of life, even to the termination of life.

Costakis' first brush with the secret police, he believed, had been in the death of his beloved older brother Spiridon, killed in a motorcycle race in 1930 after an unsuccessful attempt by the NKVD (its name at the time) to recruit him as an agent. Spiridon's death, Costakis also believed, caused, and in any case was followed swiftly by, that of their father. George was eighteen when this double disaster overtook him. It shaped his attitude to the regime, to the police, and to the authorities generally for the rest of his life. He made no secret of the fact that he feared them, and feared them increasingly as the evidence grew that they meant him no good.

The arrest of his mother, brother and aunt, and his visit to the prison camp at Kotlas in 1938, provided Costakis with more than enough first-hand experience of the secret police during the thirteen years that followed Spiridon's death. But the police seem not to have attached much importance to him until he joined the Canadian embassy in 1943. Soon afterwards, with the war ended and Stalin "rampaging around with his second wave of terror," as George put it, they apparently decided that he was an object of interest. By 1948 he was aware of being followed. Not much at first, then more, then constant surveillance. At the end of 1948 came what he was absolutely convinced was a bungled attempt to murder him.

Feeling a pain in his side, he went to the Botkin, the Moscow hospital to which foreigners were usually admitted if they were unlucky enough to have to go to a Soviet hospital. A kidney stone was diagnosed.* An eminent surgeon called Frumkin was given the case. He operated successfully, and after ten days Costakis was about to go home. Then Frumkin, who was supposed to authorize his discharge, disappeared. In his place came two women doctors. They examined Costakis and declared

* This was to be the first of a long series of kidney disorders that would plague Costakis for the rest of his life. He eventually lost both kidneys to surgery and lived precariously, in his last years, with one transplanted from his eldest daughter.

the kidney not to be draining satisfactorily. He would have to undergo special treatment. They took him through endless corridors to a distant part of the hospital and into a room full of electric equipment. Using this equipment, the two women, helped by orderlies, began to raise Costakis' body temperature. For fifteen minutes he endured intolerable heat. Then they took him back to his bed. That night for the first time he ran a high temperature and began to shiver and tremble. One of the women assured him it would pass. Next morning it had not passed, but he was returned to the special room and once again subjected to fierce heat. Back in his bed, he shook and trembled violently, ran a temperature of forty degrees and became delirious. Worst of all, the drainage bottle which was supposed to receive urine from the kidney contained in the morning only clear water.

Frumkin returned. He took a quick look at Costakis, then rushed into the corridor. Costakis heard him shouting at the staff, using the coarsest possible language, "like a driver cursing his horses." "Who let them in?" he shouted. "Who gave permission?" Then, returning to Costakis, he took him by the shoulder: "Little brother, your kidney has stopped working. We've got to operate and remove it." It was removed that day. But evidently the operation wasn't very successful. There was infection. "I lay there after the operation and cried to our Blessed Lady, 'Help me! I'm dying. I can't stand the pain.'"

Costakis spent three months in the Botkin Hospital and another month in bed in John Watkins' ambassadorial apartment. He lost fifteen kilos, and his skin turned yellow. Before he left the hospital Frumkin came to see him: "I said, 'Anatoly Pavlovich, what on earth has happened to me?' And he said, 'You know what I have to say to you? If you're a believer, when you get out of this hospital go straight to church and give thanks to God. There wasn't one chance in a hundred that you would survive. You were already in the other world, and none of us knows how you got back.'"

It was more than a year after he left the hospital that the idea came to Costakis that there had been an attempt on his life, and that the two women doctors had been acting on orders. The first clue came from a hospital orderly called Geraska, "whose job was to carry sick people around." During Costakis' long stay at the Botkin he and Geraska realized they knew one another. Geraska came from the same village, Vyrubovo, where the Costakis family had taken refuge after the revolution. They had gone to school together and played football together. Now, twenty-five years later, they had something to talk about. Leaving the hospital, Costakis thought no more about Geraska until over a year later, when he saw him again, this time on the street:

I was walking along, I looked up, and there was Geraska, also walking. He saw me, and he said "Let's go drink a couple of beers. Come on." I said to him, "How are you? Still working?" "No," he said. "I left that place. I'm on pension. Come on, let's have a beer." So we went for a beer, and he told me the following

story: "You know, all the time you were lying in bed there, they told us that you were a Japanese spy. Japanese spies are very dangerous, and we were ordered to be very careful when we were dealing with you. In fact they wanted to liquidate you, but they didn't quite manage it. But they succeeded with someone else. There was a member of the Communist party of Salvador, or one of those countries. They wanted to get rid of him. They stuck something up him and ruptured his big gut. He died. A lot of funny things happen at the Botkin Hospital."

And indeed, Costakis could in a pinch have been taken for a Japanese, with his dark complexion, brown eyes and black hair.

Ruminating on this information, Costakis thought about the three other patients with whom he had shared his sick room. One had been a terminal cancer case. Another had a lung disease. The third, however, appeared in the best of health. He walked about, smoked, and never seemed to go for treatment. Occasionally he was given a pill. And he had remained there throughout Costakis' stay. Costakis concluded that this man had been there to watch him.

Several years later came confirmation of Geraska's story. In the hospital Costakis had needed penicillin, but there was none. Nikolai Costakis, working at the British embassy, was able to get some, "with an oil base," Costakis recalled:

Anyway, he got it and brought it to me. But my neighbour in the room, a film director, also needed penicillin. He needed it badly, and I felt sorry for him. So I told the nurse to split the penicillin between us, and my brother would get some more. And at the time I thought they gave him the penicillin.

Years went by. I went to see my old friend Yasha Liebman, and we were talking about this and that. The conversation turned to hospitals. Yasha said, "You know, I had a friend in the Botkin, years ago, a film director called Belokon. And you know, he told me an interesting story. He was in the same room with another man, a foreigner. And this foreigner offered to share his penicillin with him. But the doctor told him that he must in no circumstances take this penicillin, because the man was an extremely dangerous spy." "That was me," I said. The name was right, and the year was right. And that's the story.

Rightly or wrongly, Costakis was convinced that an attempt had been made on his life. He later told the story to doctors, Soviet and Swedish, who found it convincing. A simple kidney stone removal, with no complications, could not lead to kidney failure. Asked how the mighty KGB (under its 1948 name) could possibly fail once it had made up its mind to destroy him, Costakis shrugged and said, "They couldn't take a knife or a revolver to me." But the truth remains that they could have arranged a road accident, as they did with so many others, or used any one of a dozen

other devices at their disposal. A year and a half after these events a stone developed in the remaining kidney. The pain, Costakis said, was appalling. He had no choice but to return to his friends at the Botkin. This time the operation went routinely, and Costakis recorded no other attempts on his life, at least during this period.

Two present-day sources suggest that this story is not as improbable as it sounds. The first is R.A.J. Phillips, now a writer living in Cantley, Quebec, but when Costakis had his kidney operation, serving in the embassy in Moscow. Phillips remembers Costakis' illness and sojourn in the Botkin hospital. His account differs from Costakis' in the matter of the penicillin. It did not come, Phillips says, from George's brother in the British embassy, but from Canada, through our own embassy, and there was a lot of trouble getting it. As admirers of Orson Wells and *The Third Man* know, penicillin was a hot item in Europe after the war. Canada was prepared to help Costakis, but not to the extent of becoming involved in the third man theme. Eventually the penicillin came through. Costakis' memory is faulty on this point, as on many. But the basic story seems authentic.

The second source is a very different one. Svetlana Alliluyeva was Stalin's daughter. She published a number of books, the most recent called *A Book For My Granddaughters.* That most remarkable of Soviet newspapers, *Moscow News,* in its number of October 28 to November 4, 1990, carried excerpts from this book. One of them was Alliluyeva's recollection of her father's death and her last conversation with him. The other, pertinent to Costakis' experience, was her recollection of the death of her brother Vasily, Stalin's son, in 1962. Vasily was a senior airforce officer, an alcoholic, and a repeating bigamist (having neglected to divorce his first wife before marrying three subsequent ones). He also, according to Alliluyeva, knew a lot about the circumstances of his father's death, and for that spent some time in prison before Khrushchev let him out. But what concerns us here is Alliluyeva's account of Vasily's death. He was in hospital in Kazan for some medical examinations, writes Alliluyeva. "He had just been released from prison by Khrushchev and had a stomach ulcer, varicose veins in his legs and was totally exhausted." A nurse appeared. She treated him. (She also married him, and shortly after, buried him. According to Alliluyeva, the marriage was arranged by the KGB, despite its being illegal, to prevent other members of the family from demanding an enquiry into the cause of his death.) "She gave him sleep inducing and tranquillizing injections and this while he continued to drink. It was all destructive to his body. He was not under medical observation at all … The last pictures of Vasily attest to his total exhaustion; even in jail he looked far better! He died on March 19, 1962, under mysterious circumstances. There was no medical certificate of death, or post mortem … the KGB simply helped him die."

That a Moscow newspaper as important as *Moscow News* should give its entire centre fold to Alliluyeva suggests that her account ought to be taken seriously. If this could happen to Stalin's son, why not to George Costakis?

But secret police harassment continued. His assistant at the embassy, Vera Petrovna, who Costakis said unequivocally was a KGB agent, and whom he described unflatteringly, almost managed to have him dismissed for extorting money from the Soviet staff. Only by rallying the staff in his defence and proving that the money he took from them was for food was he able to be reinstated, with apologies from the ambassador. Another incident was more serious. Costakis met a man who was supposed to have important connections in the Central Committee. The man appeared to be interested in Costakis' avant-garde collection, then just taking shape. Costakis knew that even though avant-garde art was officially unmentionable, there were highly placed people who knew about it, liked it and even collected it. He had the thought that these people might be able to make it possible for an institution such as the Tretyakov Gallery to begin, very quietly, a collection of its own. This, he reasoned, would lead eventually to the recognition of the avant-garde. Costakis had it in mind to raise this possibility with his well-placed friend, who might be able to help:

One day he invited me. "Let's go eat some shashlik," he said. I said, "Let's go." Up to that time there'd been no talk about anything special, no hints, nothing. So we sat down and started to talk, poured some vodka, all that. I steered the conversation around to my collection. I said, "You know, somehow it would be good to get a collection of the avant-garde going, maybe in the Tretyakov." He said, "I can help you with that. Because it would be good if this art became official. It's true that the authorities don't recognize this art, but there are people who recognize it, and you should meet them." So we drank a little more vodka, and then suddenly he said, "You know, I've just had a meeting with my friends from the Central Committee, good people, genuine. They know I'm friendly with you, and they asked me to speak with you. There's no obligation, but the situation is this. A very dangerous man has turned up here in Moscow. A very dangerous man. And he's trying to make contact with the Canadian embassy, to give them some secret documents. The thing is, this man once worked in a top secret factory, and he knows secrets. But they can't catch him in the act of doing anything illegal. They can't manage to arrest him. So they've got one little request to make of you, if you're willing. They'll arrange for you to meet this man. Then one day, in a car or in a restaurant, he'll give you the documents for the Canadian embassy. And they'll grab him … " I interrupted him: "This isn't from the Central Committee. It's from the KGB. You tell them that Costakis hasn't gone crazy yet. I'm not such a fool as to touch a thing like that. Obviously, you'll grab him, and you'll grab me too. It's a clear provocation." And after that I never saw this man again. I tell you, they are such idiots, it's hard to imagine and believe that such a thing could happen.

Not long afterwards another, similar, attempt was made. Costakis and his wife, Zina, were invited to the wedding of a distant relative of hers. Arrived at the party, they found almost nobody they knew, the room in semi-darkness, and an oppressive atmosphere. Costakis made to sit down beside Zina, as is the Russian custom, but his host led him to another place, where he found himself beside a middle-aged man whom he had never seen but who introduced himself by name and patronymic only, evidently assuming that Costakis would know his family name. Pavel Ivanovich, a member of the family. After some vodka the man began to talk. He had wanted to meet George for a long time. They were members of the same family and could speak freely. Life was terrible in Russia. Not enough to eat, nowhere to live. And the Soviet government was making preparations for war. That was the worst part, the danger of war. He saw this every day because he worked in a top secret factory making military aircraft. He was a very humble worker, and nobody paid any attention to him. But often the senior engineers came to work drunk and left their safes open and their drawings and papers lying about. He had a camera, and he had learned how to photograph these documents. He had a collection of them at home. He knew Costakis worked in a Western embassy. Together they could do something for peace. He would give the documents to Costakis, who would turn them over to the military attaché at the embassy.

Costakis' heart was in his mouth. What if they planted some of these documents in his raincoat, hanging in the hall, and arrested him as he left? And how to respond? If he denounced his neighbour as an *agent provocateur*, he would incur the wrath of the KGB. If he appeared to go along, he might incriminate himself. No doubt the man was carrying a microphone. So he said nothing, trying to give the impression that he would think over the idea. Assuring himself that there was nothing in his pockets, he left the party and went straight to his brother Nikolai at the British embassy. Nikolai said it was certainly a KGB provocation. The only way to deal with it was to report it with a straight face to the KGB, as though he believed every word the man had said.

A day or two after the wedding, and before he was able to follow this advice, he had a phone call from one of the supposed relatives. Pavel Ivanovich wanted to invite George on Sunday to his *dacha*. It was a very nice *dacha*, with apples growing. George declined. Then he made his way to the KGB reception office at the top of Kuznetsky Most Street. There, after waiting an hour, he was allowed to tell his story and was questioned closely about himself and about Pavel Ivanovich. The police were angry that he did not know the man's family name, and even angrier that he could not remember the number of the house where the party had taken place. This he was sent back to get, although he had given an exact description which would have led the KGB to the right house without difficulty. Costakis sensed great irritation on the part of the police, but the incident had no sequel, and he heard no more from the supposed relative.

Stalin died in March 1953, and it seems likely that this event saved Costakis' life together with those of many other people. It was clear that a new wave of terror had been in the making. The "doctors' plot," supposedly to murder Soviet leaders, was revealed in January of 1953. At the same time the Soviet press was thundering against foreign spies, who were to be found under every bush. Arrests began. E. Patyson Black (Pat Black) is a retired foreign service officer and ambassador who worked in the embassy in Moscow during that period, May 1951 to June 1953. He was a good friend of Costakis, and was also his immediate superior, a situation which sometimes strained the friendship, but never fractured it. Black relates that there was palpable fear everywhere, including among the Soviet (and Greek) staff of the embassy. At that time, of course, although Costakis' collection of the avant-garde was already well launched, no Canadian in the embassy had seen it and most knew nothing of it. Costakis would not then have dreamed of inviting a foreigner to his apartment.

One day Costakis went to Black's apartment, a short walk down the hall from Costakis' office. He told Black that he was in fear of arrest and death, and besought him, asking him to pass the word to his Canadian colleagues, to treat him with respect in front of the Soviet staff. Only this might save him. Two people had already disappeared from the embassy. One, a Greek living in the embassy cellar with his aged mother, was ordered off to Kazakhstan. Another, a doorman who had lost an arm in the war, simply disappeared in the middle of a working day. The "second terror," to use Costakis' expression, was beginning. Black is convinced, as was Costakis, that no amount of respectful behaviour would have saved him if Stalin had lived another year.

�₮

I must tell you that I didn't emigrate permanently of my own free will. I started going abroad for visits sometime at the end of 1955 or the beginning of 56. I was in Sweden for the removal of a kidney stone, and in France to visit Chagall, and in London, and in the course of time even in America. So I was abroad quite a few times, long before I left finally. But somehow the West never attracted me. From the first day I started going out of my mind. Of course there's lots of everything, the stores are full. Compared with Moscow, with the Soviet Union, it's some kind of paradise. But after a couple of weeks you start seeing there isn't much to it. So you calm down, and you don't run out every day in winter to buy strawberries, because they don't have much taste, and anyway all this becomes boring. A sort of tedium sets in. I recall that after a month, or however long I was in a particular place, I felt a strong pull to go home. I wouldn't call it nostalgia. No, I always knew I could go back. But there was this pull. So I had no idea in my head of emigrating. I thought that at my age to start life in a new place, a new country, was crazy. And at the time I was no longer so young. And I always had this thought that … I had done all this collecting, and in the end, probably, I

would give the collection to the Tretyakov Gallery, or maybe the Russian Museum in Leningrad, and keep the icons. I had maybe 140 icons, and very good ones. If I needed money, bit by bit I could sell the icons. So I didn't want to live abroad. And my children weren't drawn by the West. So we lived quietly on in Moscow. But one fine day – one awful day, I should say – this quiet life was shattered. I was robbed for the first time, and right out of my apartment, out of the room where I stored my collection. They took seven or eight aquarelles of Kandinsky. It's true, at the bottom of the package they left two pieces, the sons of bitches, I suppose so I wouldn't die of a heart attack ...

Thus Costakis opened his account of the beginning of the end of his life as a Moscow art collector. At some moment in 1975 or early 1976 a decision had been taken, quite likely at a high level in the ministry of culture, the KGB and the foreign ministry, to deal with "the Costakis problem." After several years of post-Soviet regime in Moscow it is hard to recall those days, a mere twenty years ago. But then a corrupt and venal Communist party ruled supreme in everything, clung stubbornly to shibboleths and worn-out doctrines, fearing any change, and relied on the secret police to keep it in power and enforce its will in political, economic, national, and cultural matters. One has to recall that less than three years before Costakis' ordeal began, one of Russia's greatest writers, Alexander Solzhenitsyn, was bundled on to a plane, stripped of his Soviet citizenship, and sent into permanent exile, for sins more widely known but of the same order as Costakis' own. Nikita Khrushchev, relatively liberal in cultural matters, came very close in 1958 to doing the same with one of Russia's great literary figures, Boris Pasternak. From the vantage point of today's Russia, where there is practically total literary and artistic freedom, what happened to Pasternak, Solzhenitsyn, and Costakis seems ludicrous. It was not ludicrous earlier, but deadly serious, and terrifying for the people concerned and their families.

Costakis was a victim of his growing fame in the world of art. That a foreigner, a hold-over from the old regime, the employee of a foreign embassy, should become one of the best-known and most admired collectors in the world, and should do it in Russia on the basis of a forbidden school of Russian art, was simply unacceptable in the climate of those days. He had to go, somewhere. And his collection had to stay, even if it did consist of depraved rubbish. The curators at the Tretyakov presumably had something to say about this aspect of the matter. Certainly they followed the art market and knew the rapidly growing monetary value of the collection. By this time brisk trading in Chagall, Kandinsky, Malevich, Popova, Tatlin and other avant-garde artists had been going on in London and New York for twenty years. The curators could take a stand on that point, although doctrinal duty still required them to say, if asked, that the collection had no artistic merit.

Harassment came at various levels, starting with OVIR (internal passport office):

The OVIR was horrible. I had to go every year to renew my passport. It always took three or four hours. They would take away your domestic residence permit, and ask you to come back in a week or two. Sometimes the passport was ready, sometimes they would ask you to come a second time. But on the second time it would be ready.

Then they played a trick on me that I will never forget. I came once. They told me to come back in a week. I went a second time, third, fourth, fifth time. Every time I waited three or four hours. And I was working. I had to leave the embassy. It was seven or eight times like this. Every time … I remember … she had fish eyes. Bloody bitch. She told me it wasn't ready. I had to come again. The last time, it was the ninth or so, I said to myself that if I had a pistol I would kill these bastards.

So I came again. I came again to OVIR, the OVIR in Petrovka, and the place was full of people. One hundred and fifty or so. Poles, Czechs. So I waited, and she says, "Costakis, it's not ready. Come in two weeks." I can't repeat what I said. I called them fascists, worse than fascists, hooligans. "You are the representatives of the country that is telling the world you are the best … Send me away, put me in prison, but you can't do this." Ryazantsev came [Costakis mentions Ryazantsev several times as one of his tormenters] and said, "Costakis, Costakis." And I was using dirty words. "You are bastards," and so on. What I'm telling you is far less than I told them. So finally I said, "I'm not coming back, never. When one day my passport is ready, you can call me … " So I went home, and I said to myself, this night you will be arrested.

Then, three or four days later, a telephone call. There was a man who looked after our apartments, the ones rented to foreigners. He telephoned me and said, "Gospodin Costakis, [*Gospodin* is the Russian word for 'Mr.,' in Soviet times reserved for foreigners] your passport is ready. You can go to OVIR and get it." I went to OVIR, waited five minutes, and they brought it. Each year from then on, they did it in half an hour.

The KGB seem to have decided on a two-pronged strategy to accomplish their purpose. The problem was that Costakis had done nothing illegal. He had sold a few works in Western auctions but had been careful to get the approval of the ministry of culture first. They were glad to have the foreign exchange. The actual business of collecting the avant-garde had been forbidden and dangerous in Stalin's time, but since Khrushchev these rules had been relaxed and it was not against any law to buy, sell, trade, or possess these things. It was merely impossible to exhibit them publicly. The double strategy, therefore, was to terrify Costakis and his family to the point where they would abandon the collection and flee abroad, and to trap Costakis by inducing him to do something seriously illegal, such as trying to smuggle his collection or part of it out of the country. He could then be

threatened with arrest or, if necessary, be actually arrested and incarcerated. Even in the corrupt and brutal Soviet Union of 1976, it was not possible to put a person in jail for no reason at all.

Anyone who has encountered the KGB at work will have no difficulty recognizing these operational procedures. The West is familiar with them because they have been practised against Westerners (diplomats, journalists, business people) working in the former USSR. And if these methods often failed, they also often succeeded. What worked on foreigners also worked on Russians: the memoirs of Soviet émigrés are full of well-documented histories of provocation, entrapment, and terror, precisely as they were unleashed on the Costakis family in 1976 and 1977. The difference between foreigners and Russians was that foreigners could usually escape by going home. Russians had to stay and endure.

It began with the first robbery, described above. Costakis was puzzled, because there was no sign of a break-in even though he had installed a good Western lock on the door (because, he said, "Anyone could open the door of a Soviet apartment with one finger"). The artistic loss was serious, and Costakis went to the militia – the name given at the time of the revolution to the regular uniformed police. They come under the ministry of internal affairs and are separate from the KGB, which is a state committee and thus the equivalent of a ministry on its own. The militia regretted they could do nothing. But, they observed, isn't it strange that all these things have disappeared without any sign of a break-in?

Some months went by. Then one Sunday a man who was often at their apartment and was considered a family friend invited the entire Costakis family to spend the day with him in the country. It was far. They left early in the morning and were gone all day. "I had some kind of premonition, a feeling that something was going on. Finally we got home. I looked around. Everything was in its place on the walls. Nothing had been touched. But then I went into the storeroom, where, like a fool, I still had a lot of things. And I saw that for the second time I had been robbed blind. I was very worried." This second robbery was more serious than the first. Costakis had taken the trouble to hide some particularly valuable works of Kliun and Popova, and these the thieves missed. But they took a pile of "several hundred" works of Nikritin, the very best of his production in the years just before and after the revolution, bought by Costakis from his widow.

Then the pace quickened. In the village of Bakovka, twenty kilometres from Moscow, Costakis' brother and sister-in-law had a *dacha*, in which they had allotted a second-storey room to Costakis to store paintings. He had decided to keep there the works of his group of young artists, most notably those of his talented and immensely prolific protégé Anatoly Zverev, then officially ignored by the art establishment, now (after his death) hailed as one of the great contemporary Russian

artists. At Bakovka there were "several thousand" of Zverev's paintings, oils and gouaches. Only two or three days after the second theft from the Moscow apartment came a third attempt:

My brother's wife phoned from Bakovka and said, "Fire! The house is burning! Hurry, it's burning up!" I pulled myself together, so to speak, got in the car and went there. I saw the *dacha* had half burned. The fire brigade had come, but they had no water. They could do nothing to put it out. I went upstairs and looked around. Where the Zverevs were kept a lot was missing. In short, someone had set fire to the *dacha*, and before they did that they stole the works. Because when I looked out the window from the second floor and looked down into the ravine, I could see footprints (it was winter) and there were Zverev's paintings, and the works of other artists, scattered around. So they had carried all this art across the ravine to their car.

Feeling trapped, the Costakis held a family council and decided to seek help through a channel that in theory had always been available to anyone in the Soviet Union, the direct appeal to the top. There are many stories about letters written to Stalin, who, so the stories have it, promptly intervened to save the writer from injustice at the hands of the *apparat*. Even at the end of his life Costakis had a touching faith in the truth of these, as well as some personal experience of Stalin's alleged magnanimity. So he and Lilya Costakis sat down at the kitchen table and together composed a letter to Yury Andropov, then head (chairman) of the KGB, later General Secretary of the Communist party, and another one to Leonid Brezhnev, then General Secretary and the ultimate arbiter of everything:

In these letters I explained that a large number of works had been stolen from my collection. This was a collection intended for the Tretyakov Gallery, and anyone could find the story in the magazine *Amerika* [published in Russian by the United States Information Agency], where they said right out that when Costakis was asked what he thought of doing with his collection, he said that he wanted to give it to the Tretyakov Gallery, where his daughter Lilya would become its curator, and that he himself would live out his life in Moscow, content with his collection of icons. And I asked for help. I went on to say that I suspected who had stolen the paintings and burned the *dacha*, and I asked them to take measures. Then I gave the letters to the UPDK [the section of the foreign ministry responsible for the housekeeping problems of foreign missions and their staffs] to be delivered.

Whatever one may think of Costakis' judgment in citing the detested *Amerika* (detested, that is, by Soviet officials, but avidly sought out by ordinary people) as his authority, it is hardly necessary to say that this *démarche* had no outcome. Costakis was called to the UPDK and interviewed by two

"representatives" ("no doubt KGB in disguise") who explained to him that Comrade Andropov was very busy getting ready for the Party Congress and could not see him now, but Costakis should write a second letter, setting out his problem in detail, including the name of the man he suspected. They would be glad to deliver it. This offer Costakis declined, saying he preferred to send his letter direct to Andropov at the Central Committee. He wrote a second pair of letters and delivered them by hand to the Central Committee. But, he said, "Nobody received these letters either." Later Costakis learned that the man he had named, who he was virtually certain had been the thief and the arsonist and had done the job for the KGB, had been given an exit visa and allowed to emigrate to England. He was a man who had frequented the Costakis household and was considered a friend. He probably had a key to the Moscow apartment. Thus, the first attempt to go over the heads of the KGB operatives and appeal at the highest level failed.

Matters took a still more sinister turn when Costakis decided, and in those harsh days it was a desperate decision, to go to the foreign press. Of course every foreign correspondent in Moscow knew him and his collection. He told them his story, the story of mysterious thefts and fires. Articles appeared in the Western press, and worse, the story was broadcast to the Soviet Union, in Russian, by the Western radio broadcast agencies – Voice of America, Radio Free Europe, the BBC, Deutsche Welle and probably others. In present-day Russia, with information flowing in both directions, it is hard to realize what an act of defiance this was, and the perils that could follow. Once again Costakis was summoned to the UPDK, and once again he knew he was being interviewed by the KGB. "All right," said the representatives, "if you want to make a *scandale,* we can play that game too, and it will be worse for you. We will write a *podval* in the newspaper, and say who you are and that you are a speculator in art."

Podval means "basement" or "cellar," but its secondary meaning in Russian is "special newspaper article," usually printed across the whole of the lower half of an inside page of *Pravda* or *Izvestiya* or another Soviet paper and, very frequently in those days, devoted to smearing somebody's reputation. A *podval* about someone was often a precursor to arrest and prosecution. It was thought that the KGB had ready access to this newspaper space. Costakis recorded that his reply to this threat was that he was no coward, and if they wrote a *podval* about him in *Pravda,* he would have one written about them in the Western press. (Whether he knew it or not, the KGB were seldom impressed by threats to reveal their contempt for humanity and justice. They liked to be known as ruthless, efficient, and much to be feared.)

Then the telephone calls began. At first anonymous, obscene and threatening. Then artists whom Costakis had considered his friends began to call. "Georgii Dionisovich, what's all this nonsense about your collection being stolen? You know perfectly well you stole it yourself and smuggled it out

of the country for a profit. You're a speculator." In those days "speculation," if conducted on a large enough scale, could bring the offender before the firing squad, and could certainly land him or her in prison. One artist, formerly a friend, declared that he and his colleagues would go to the ministry of culture and demand that Costakis' collection be taken from him: "Someone like you has no right to Russian art."

From the beginning of his service at the embassy Costakis had been under as close surveillance, he believed, as any Canadian member of the staff. But it had been at a certain level, and he had come to accept it along with the other realities of life in Moscow. He was convinced that his telephone had long since been tapped and other measures taken to ensure the KGB knew what he was doing, who was coming to see him, and so forth. But anyone who has been followed knows that it is one thing to be followed discreetly, at a distance, without contact. They are there, but you can ignore them and eventually forget about them. It is quite another to be followed at close quarters, with no pretence at concealment. Costakis' keepers now came out in the open. Cars "with antennas three metres long" circled his apartment building day and night. Both he and Lilya were followed closely in their cars and on foot, so close, he said, that you felt that at any moment you could be seized, bundled into a car and taken away forever. "So Lilya and I didn't know what to do. I couldn't sleep. We were in torment. It was so terrible that we were afraid to go anywhere together in the car. And you know where the bridge is on Vernadsky prospekt [where Costakis had his last Moscow apartment], we stopped going that way because we were afraid they'd use a truck to knock us into the river. And we went in separate cars." (Lilya by this time was working as an English teacher in the Cuban embassy. She had been allowed to attend Moscow State University and had graduated, but she was not permitted to find a job in a Soviet institution.)

The first prong of the KGB strategy was thus harassment and fear, which might have worked had it gone on much longer. The second was to try to tempt Costakis to smuggle his collection out of the country, a serious criminal act. There were several approaches, including one by a journalist well known in the foreign community in Moscow for his connections with the Soviet authorities. The KGB frequently passed information, misinformation and dis-information to him for publication in the West. Another offer came from a Soviet diplomat, who told Costakis he was going on a foreign posting and would be glad to include some works of art in his shipment of personal effects, which, he said, would not be inspected. A third proposal was made over a comfortable dinner by the chief of ground transport at Sheremetyevo airport. He knew everyone, including the security people, at the airport, and it would be no problem for him to put the collection on a plane bound for a Western destination. He had recently sent some diamonds abroad without difficulty. Of course he expected a percentage.

Costakis assumed that all these offers (and there were others) were what he called "provocations," attempts to provoke him into doing "something unofficial," as the Soviet euphemism had it, so that he could then be arrested and put away. He resolutely declined every approach, but each of them, coming as it obviously did from the KGB, turned the screw a little tighter. Throughout most of 1977 the pressure continued: thefts, harassment, surveillance and the obvious attempts at entrapment. "But you know," said Costakis, "I always found them very stupid. They were – how to put it? – uneducated people, just *muzhiks* with power. They tell lies, you see, and they think nobody can understand."

By the fall of 1977 Costakis' despair was near total. He had lost his job at the embassy, although he continued to go there as a form of protection against his oppressors. His friends and colleagues had disappeared. His situation seemed desperate: "This scandal got such a lot of public attention that every collector in Moscow and Leningrad knew about it. Every one of them was afraid to have anything to do with me. They stopped coming to see me, they stopped telephoning. So I was alone, without any help. Nobody helped me."

◤

Vladimir Semyenovich Semyenov was a distinguished and very able Soviet diplomat. He was the chief Soviet representative at the Strategic Arms Limitation Talks in Geneva and, later, Soviet ambassador to the Federal Republic of Germany. He was also an avid art collector, specializing in late nineteenth-century Russian painting. Costakis described his collection as outstanding of its kind. "Choice" was the word he used. Costakis knew Semyenov well, had visited him at home and had received visits from him. The relationship was of fellow collectors. Costakis said of him, "[He was] a decent man who was friendly to me."

It was Lilya who first thought of going to Semyenov. Costakis rejected the idea. "Lilya, I can't go to Semyenov. I'm surrounded on all sides by the KGB, and nobody can do battle with them. Semyenov can do nothing." But Lilya and Zina insisted. Semyenov was the only person they knew high in the political world, and was, they thought, their last chance. So Costakis made a tentative enquiry. Semyenov was in Geneva and returned to Moscow only occasionally for short periods. However, Lilya had a friend who was a television reporter with access to information about Semyenov's comings and goings. He would let the Costakis know when a visit was imminent. And so it happened, and Costakis went to see Semyenov. Before he went, he decided in consultation with his family that he would make his plea for help more specific than in his letters: he would ask Semyenov to help him leave the Soviet Union with his family and with twenty percent of his

collection; the remaining eighty percent would go to the Soviet state. Costakis believed it a reasonable deal, if only it could be presented at the right level and to the right people.

He lived in a government apartment block on the Moscow River. It was a big apartment, eight or nine rooms, I imagine, with pictures on the walls. I told him my story, and it took a long time. Maybe two hours. And he listened. I told him about the letters I had written to Andropov and Brezhnev, and about how the persecution had got worse after that. I told him about the threats and the provocations. He listened for a very long time. Then he said, "I'm glad you came to me. Let's drink a little vodka and eat something, and we'll talk."

So he took me into the dining room, we had a drink, and we sat down to talk. He said, "Georgii Dionisovich, I'm going to try to help you because you're a kind man and you've done some good things." Then I remembered that about a year before, a collector called Chudnovsky, from Leningrad, had come to see me. He was a very well-known collector, and he knew Semyenov. He'd come to me and asked me if I knew of a good cardiologist. Because he had a granddaughter, two or three years old, who had been a "blue baby" and had to have an operation or she would die within a year. Well, it so happened that I was a friend of Burakovsky, who was then director of the cardiological institute, and I phoned him. He told Chudnovsky to bring the girl in, and examined her. But there was nothing he could do, because they had no specialists qualified in this field. There were specialists in America and in London, but the operation would cost seven thousand dollars. So I told Chudnovsky to ask Semyenov to get exit visas for the girl and her mother, and I would give him the dollars from my account in Canada. I said I knew the visas wouldn't be easy, but Russians are sentimental people, and when it's a question of a child's life, they will give them. So I transferred the money from Canada to London, the girl had the operation and is probably alive today. That's what Semyenov meant when he talked about the "good things" I had done.

So he said, "All right, I'm glad you came. I'm going to the top for you, to Yury Vladimirovich Andropov. It so happens that he is my closest friend. We grew up together and played football together. When I come back to Moscow, I always meet him, and I saw him recently. I will call him, I'll tell him who you are and what you've done for Russian art. I can't promise you anything, but I can tell you that Andropov is a wonderful person. He's an honest man. He's trying to sweep the KGB clean." Anyway, he obviously thought very well of Andropov. So I thanked him, and I said "May God help you, because otherwise I'm done for."

Semyenov was not alone in his admiration for Andropov. Despite the fact that Andropov was head of the secret police and had, as Soviet ambassador in Budapest at the time of the 1956 revolution, presided over the bloody outcome of that desperate event, he was becoming known as a new kind of Soviet leader, one who might have taken the Soviet Union in a new direction had he lived a

few years longer. Many Russians thought his death in 1984 a tragedy for them. It was common knowledge in Moscow that he had close relations with literary and artistic figures, and that the most famous of Soviet theatrical directors, Yury Liubimov was a good friend. Indeed, according to the London *Sunday Times* of September 18, 1983, Liubimov, then living and working in London because the theatre censors had made it impossible for him to continue his highly innovative theatre work in Moscow, had a personal assurance from Andropov that no harm would come to him if he returned home.

Andropov is even given some grudging credit by Major General Oleg Kalugin, the senior KGB officer who in 1990 was stripped of his rank and pension for denouncing the KGB in public and allegedly revealing state secrets. In an interview with *Moscow News* (number 25, 1990) the general said that Andropov, as head of the KGB, had opposed the Soviet invasion of Afghanistan in 1979, but eventually gone along with it because "he couldn't say no to Brezhnev and his friend Ustinov [minister of defence at the time]." Moreover, said Kalugin, Andropov was on the soft side as KGB heads go. "Andropov was against political assassinations. He always insisted on other means."

Cleaning up the KGB was no small undertaking. In those days the KGB was remarkable for deliberately retaining thugs of whom it could deny all knowledge if things did not turn out as planned. Costakis may well have been dealing with these thugs in his various thefts and fires. *Muzhiks* with power, as he said.

Semyenov had told Costakis that he meant to return to Geneva in three days' time but would try to speak to Andropov before that. One day passed, then a second, with no sign from Semyenov. Unable to contain himself, Costakis telephoned. Semyenov was gruff. "I'll call you when I have news. I haven't talked to him yet." Costakis assumed the worst and warned his family to expect nothing. On the third day, early in the morning, the phone rang. It was Semyenov:

Georgii Dionisovich, I saw Yury Vladimirovich yesterday and told him the story. He is very angry at what his people are doing. But, to make it short, if you want to go, as you said to me, you can go. But if you want to stay, you've got a one hundred percent guarantee that nobody will lay a finger on you. As for the pieces that were stolen from you, it's hard to say whether they can be found or not. And you said you would like to take twenty percent of your collection with you if you go. You will get permission to do that, and you will be officially informed of it all right away. I'm sorry about the things that were stolen, but that's not the main point. The point is that nobody will touch you again, and you can go with your twenty percent.

Costakis did not doubt Andropov's sincerity, or his power, but he had been thoroughly terrorized, and decided, despite his unhappy experience of foreign countries, to emigrate while he could.

Not everyone, it must be added, had such good luck with Semyenov. One of the world's greatest cellists, Mstislav Rostropovich, was forced to leave Russia in much the same way as were Solzhenitsyn and many others, including Costakis. Rostropovich's wife, Galina Vishnevskaya, who left with him, was also a great artist, a singer. In her autobiography, *Galina,* she recounts how she once approached Semyenov in a bar in Vienna, before she and Rostropovich left the Soviet Union for good, to implore him to help Solzhenitsyn — not to emigrate, but to be freed from constant harassment by the KGB. According to Vishnevskaya, her appeal was rejected, and in terms which led her to describe Semyenov as a monster, and to liken him to Hermann Goering on the grounds that both were art collectors as well as monsters. Her story illuminates Costakis' account, and both are probably true. For Semyenov it was a dangerous game. He was prepared to help his fellow art collector, who went to see him in Moscow, but not a singer who tackled him in a Vienna bar. And besides, Solzhenitsyn must have seemed a more difficult proposition, because his writings systematically demolished the Soviet state from the time of its founding, whereas Costakis had never said anything in public or private against the state. But Solzhenitsyn's sins were akin to Costakis' in that he too had made it possible for the Western media to broadcast his miseries, not only to the West but to the Soviet Union as well.

In October 1981, the Costakis collection (the twenty percent of it that left Russia with Costakis) went on exhibition in the Guggenheim Museum in New York. The opening of the exhibition was noted widely and enthusiastically in the press, as the Russian avant-garde at last came into its own. Among the most important and in some respects the best article written at that time was one by Hilton Kramer, art critic of the *New York Times,* in the cover story of the *New York Times Magazine* of October 11, 1981. The front of the magazine was adorned with one of Liubov Popova's startling costume designs from the early 1920s, the article itself lavishly illustrated in colour with works from the collection and photographs of the artists and of Costakis.

The article ends on a curious note. The collection was put together, Kramer writes, at a time when thousands were going to prison and to the camps. And it was put together on the small salary of a "minor civil servant" in the Canadian embassy. How did Costakis escape arrest, when so many others were rounded up, and how did he afford all this expensive art? In short, Kramer questions the truth of Costakis' story and implies that he must have had protection in high places and a source of money other than his salary at the Canadian embassy. Kramer does not say, or even imply, that Costakis may have been working for the KGB while he was at the Greek, Swedish, British, and

Canadian embassies, and that his protection came from that powerful quarter. But his scepticism about Costakis' story might easily lead a reader to consider that theory, and the question has been raised more than once. Indeed, Costakis said that during his first visit to Canada, in 1973, he was interviewed by the Canadian security authorities (then part of the Royal Canadian Mounted Police), who told him bluntly that they knew he was a KGB officer and questioned him about other members of the local staff of the embassy. Of course the most important thing about Costakis' life was not his work at various embassies and not even his relationship with the Soviet authorities. It was rather his more than forty-five years in the service of art. But since the question hangs in the air, it has to be examined, as objectively as possible. Because the KGB has not yet said anything about it, we have to go by external evidence.

The matter of money is perhaps most easily dealt with. When Costakis started collecting the avant-garde, in 1946, many of the works had practically no market value in the Soviet Union. Indeed, their owners, usually the widows or children of the artists, were fearful of being found in possession of them and were only too glad to let Costakis have them for nothing or for a few roubles. With his salary at that time and for many years afterwards paid in dollars, which for the first fifteen years he was allowed to exchange for roubles at 250 percent the official exchange rate, Costakis was relatively well off and could afford to be generous. Generosity still did not involve large sums. Kramer refers to Costakis' financial arrangements with the embassy as "a complicated tale," implying that it could not possibly account for his ability to buy art, and implying also that it was a fiction. That, of course, is nonsense: the tale is not complicated, and it is not a tale. It is part of the public record, and it is true. Kramer goes on to quote S. Frederick Starr, the author of the admirable introduction to *Russian Avant-Garde Art: The George Costakis Collection*, as saying that "to have comparable resources in North America today, [1981] he [Costakis] would have to be able to set aside more than $20,000 per month for art." What Starr says is perfectly true, but Kramer should have gone on to explain that in the Russia of 1946 much avant-garde art was worthless in money terms, since nobody wanted it. Even as late as 1960, when there was a brisk trade in works of Kandinsky and Popova, among others, on the London art market, major paintings by these artists were selling for less than five thousand dollars. In Russia they were selling for still less, and by 1960 Costakis had already laid down his basic collection. We can therefore dismiss the idea that Costakis could not have formed his collection on his salary from the Canadians. He could have and did. Later, of course, with the foundation of the collection built, he was able to buy, sell and trade on the Moscow market, and occasionally sell a work in the West, with the permission of the ministry of culture.

Costakis told this part of the story himself. In about 1965 (he was uncertain of the date, but remembered that at the time he had been participating in some informal exhibitions which had

included avant-garde works as well as "official" ones, from members of the academy) he had in his collection an important painting by the Dutch artist Kees van Dongen, who was born in 1877 and died in 1968 and was thus a contemporary of the Russian avant-garde painters and an artist of interest to Costakis. At the same time he had an early Kandinsky, *Murnau*, a vivid blue village landscape from 1908, stylistically well within the bounds of official approbation. Costakis continued:

Then the Tretyakov Gallery director asked me to sell one of my Kandinskys, *Murnau*, to them. At the same time, the Pushkin Museum was looking for my van Dongen *Portrait of a Spanish Girl*, which they had failed to buy when it was offered to them. They bargained; the owner wanted nine thousand roubles but they offered only seven thousand. And in the end, George Costakis got it. This caused them much pain, and they asked me to sell it to them. I spoke to the minister of culture: "Look, let's do it this way. I will give my van Dongen to the Pushkin Museum, as a gift. The only thing I want is that the museum acknowledge this as a gift from George D. Costakis. As for the Kandinsky, I will give it as a present to the Tretyakov Gallery, but on condition that it be exhibited." [It must be remembered that no work by a member of the avant-garde had been exhibited in an official institution since 1934.] From the beginning they agreed, and I sent the van Dongen to the Pushkin. I got a nice letter from Antonova, the director, with many thanks, and so on. They put my name under it for one year or so, then it disappeared. When I complained to Furtseva [then minister of culture] they put my name up again, but so small that you needed a microscope to see it.

As for the Kandinsky, they said, "Unfortunately, no. We can't exhibit it now. But it will go in the catalogue, and it will be said that it is the gift of George Costakis, and when the time comes, we will … " I said, "No. I am not going to give you the Kandinsky, because my paintings are used to live in the light, and I am not going to give my Kandinsky to your prison, in the cellar." So I refused to do this.

After, I was received by one of the big people in the ministry of culture. He was grateful for the van Dongen. "What can we do for you?" Once again I was poor, without money. Nothing. But these were years when it was easy to take paintings out of the country. I said I would be glad to be allowed to sell a few paintings in London, because I had no money. "Go ahead," he said. "What do you want to sell?"

As I remember, I had one very nice, not very important, but very nice painting. Now it's hanging in the Tate Gallery. They bought it at a Sotheby sale. And I put up for sale at the same time two or three Popovas, three or four Kliuns. About seven altogether, and good ones, I would say.

And for the first time in my life, I got some real money, about $160,000, I would say. It was a great help. And over the years I had this money in my bank in Canada. I got interest every month, several thousand, in addition to my embassy salary. It was very helpful.

All this was done officially, with the permission of the ministry of culture.

Costakis was not without friends and admirers in the art world. Semyenov was one of them. A more distant one was Khrushchev's minister of culture (also rumoured to have been Khrushchev's mistress), the formidable Yekaterina Furtseva, referred to in the account above. Costakis met her a number of times, at exhibitions and receptions, told her what he was doing with the avant-garde, and was surprised to find that not only did she know a good deal about the movement, she appeared to like this kind of art. Once she told Costakis that she wanted to see his collection. A visit by some-one of her stature to the little apartment would have been enormously important at that time, in the Khrushchev era, since it would have marked the beginning of the rehabilitation of the avant-garde. Costakis had a phone call from Furtseva's officials and prepared to receive her. She never arrived. This was when Khrushchev was striking out in all directions against the young "unofficial" artists, and Furtseva may well have prudently decided that a visit would put her in direct conflict with her chief. But Costakis' relations with the ministry of culture were not bad, and Furtseva could well have had something to do with it. His lecture tours abroad were clearly approved by that ministry, with whom Costakis collaborated in lending works for foreign exhibitions.[*] In the same way, the major institutions such as the Tretyakov Gallery knew the importance of what Costakis was doing and certainly put no obstacles in his way, even if they were unable to do much to help him.

The institution most concerned with the avant-garde was not, however, the Tretyakov gallery, but the Russian museum in Leningrad. Its director was Pushkarev. According to Costakis, Pushkarev was very correct in everything, a member of the party, and so on. But he was also a "peasant-shop-keeper" type, who knew what he wanted and how to get it. What he wanted for his museum was the Russian avant-garde, and he got it by sometimes diverting funds intended for buying "official" art. In this Costakis believed he was protected by Furtseva and by the curators and other staff at the muse-um. Of course the avant-garde works acquired by Pushkarev went into secret storage; in the art world the museum became known as the "secret museum." Its storage was accessible to no Soviet cit-izen. As late as 1985 even foreign ambassadors could make a limited visit only with difficulty.

[*] In *Galina*, Vishnevskaya draws a less agreeable portrait of Furtseva, who she says was a drunk and a toady.

There were and still are people, in Russia as in the West, who thought Costakis had friends in high places. Perhaps Furtseva, perhaps high-er still. How else to account for his success as a collector? The magazine *Druzhba Narodov* (Friendship of the Peoples), in its first number of 1990, contains the text of a letter alleged to have been written in 1974 and signed by "some 100 people" (presumably all artists; only a few names are given). The letter is supposed to have been addressed to Mikhail Suslov, the long-time politburo member under Khrushchev and Brezhnev, responsible for ideological matters. It is an explicit list of grievances against Suslov and all he stood for, and was of course not pub-lished at the time. What trouble it brought to its authors is unknown. But it contains a vicious slash at George Costakis, calling him a col-laborator of Suslov, and saying that he attached himself to the young artists of the 1960s and 1970s in order to manage or manipulate them on behalf of the authorities, and for pay. Whatever the truth of this, those who knew Costakis during the years of his work with young artists saw nothing but close friendships, some hope for the artists in an otherwise hopeless world, and the possibility for them of making a living by selling their work through Costakis to foreigners. Costakis himself said that one of these young artists, Dmitri Krasnopyevtsev, was the closest friend of his entire life.

Pushkarov was fired after Furtseva's death in 1974, but Costakis thought he had accomplished much for the museum. Costakis knew Pushkarev:

I remember once, he came to Moscow, and came to my place with Vladimir Ivanovich Kostin. Kostin was a very known Moscow historian and art critic. He was our patriarch, the head of all this business. So they came. Pushkarev said, "If the time ever comes to put your collection somewhere, you should in no circumstances give it to the Tretyakov gallery, but to us. The Tretyakov is a very poor gallery. But with us the collection will be in good hands. We'll build a special wing. You come and I'll show you."

Vladimir Ivanovich Kostin said, "Now when Georgii Dionisovich comes to see you, you show him the storage, the cellars" [where the Russian avant-garde was kept secretly]. To which Pushkarev replied, "No." At that time it was forbidden to see the cellars. He said, "Without permission from Furtseva I will not. I will look after Costakis, he will come and stay with me, we'll drink vodka, look at the place where the collection will be. But not the cellars."

Pushkarev's "peasant-shopkeeper" instinct, and the relations between two of Russia's greatest art institutions, created a drama after the death of Pavel Kuznetsov:

One day the artist Pavel Kuznetsov died. He was a well known and respected artist in Moscow. He had no direct connection with the avant-garde, but he went his own way, artistically, and differed sharply from many artists living then. So, he died, and left many works. And I have to say that at that time it wasn't so easy to come by his works. He himself wasn't anxious to sell, keeping his pictures as a private collection, not wanting to disperse them. And so he died, and left behind this legacy.

His family decided that these things should be in a museum, either the Tretyakov gallery [in Moscow] or the Russian museum [in Leningrad]. So they invited a commission to the studio. Five people came from the Tretyakov, but from the Russian museum came only one, the director, Pushkarev. They started to hand out the collection. Since the Tretyakov had more people, they got more works, and they got the best works. Pushkarev sat in a corner and didn't say much. Everyone was surprised that he conducted himself so modestly and showed no signs of being aggressive, as he had been before. Well, they divided the collection. So much to the Tretyakov, so much to the Russian. They made an evaluation and they all left.

Half an hour or forty minutes went by. Pushkarev reappeared at the Kuznetsov apartment. He said, "You know, I can't find a hotel. They're all full, and I don't fancy spending the night in the railway station. Perhaps you would allow me to sleep in the studio." They said, "Of course you may. But you'll be bothered by the cockroaches in there." Pushkarev said, "As far as the cockroaches go don't worry. I've got plenty of them in my Leningrad apartment. I'm used to them, and anyway I sleep soundly so they won't bother me."

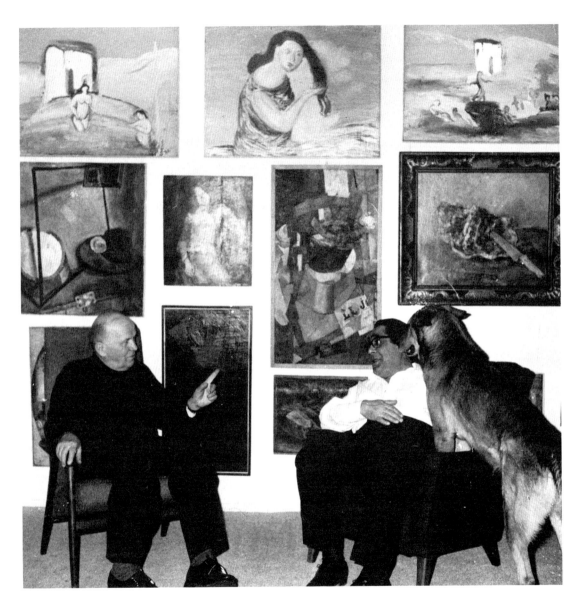

Costakis with Soviet art critic V.I. Kostin, a close friend, in Costakis' Moscow apartment. The painting at top centre is Aleksandr Davidovich Drevin's *Woman with Long Hair (oil on canvas, 1930-31)*. The other friend was named Ryzhy.

Well, they gave him the key, and arranged that when he went out in the morning he would leave it under the doormat. He went there and stretched out on the divan.

Next morning early the commission from the Tretyakov came in a car to take away their pictures. They opened the door. O! How awful! The studio had been robbed. There were no pictures. A few standing in a corner, but the great mass of them had disappeared. A thug had broken in and stolen them. Panic. They went to phone the police. But while they were hunting for the number they noticed on the table a letter from Pushkarev. He wrote: "Don't worry and don't get excited. I have taken the pictures to Leningrad. I consider that the division which took place was very unfair. The Tretyakov took ninety percent for itself. But I have left you these works for the Tretyakov." He had also found time to do a re-evaluation. Those things that the commission had valued at, say, one thousand roubles, he put at five hundred or three hundred. Cut everything in half.

Well, there was a big scandal. The Tretyakov gallery complained to the ministry of culture. But there was nothing they could do. The works of Pavel Kuznetsov stayed where they were. Because the minister of culture then was Furtseva, and she herself covered for him.

So by the mid-fifties, when he had been collecting the avant-garde for ten years and was becoming known to other art enthusiasts, there were people in Moscow, including people high in the political hierarchy, who followed Costakis' work with deep interest and sympathy. In that sense, at that time, he had "protectors." And before long, with official permission, he had a substantial sum of money from his sale on the London market, to replace the dollar part of his salary. It was at about this time, in the early 1960s, when he ceased to receive any part of his salary in dollars and was treated in this respect like any Soviet employee of the embassy.

It is something else altogether to suggest that in the late thirties and again after the war Costakis' failure to be arrested was a matter not of luck but of "protection." Certainty is hard to come by in such a matter, but Costakis had his own explanation: a combination of his Greek nationality and his employment in an embassy where he had the strong backing of a strong ambassador. It is true that a great many people were arrested in Russia in those years. But a great many were not, and it is unnecessary to assume that everyone who was not must have been a KGB colonel. A much more plausible explanation is that even if they had wanted to arrest Costakis, and we do not know that, the Russians did not want the very large fuss that would have ensued.

Another problem with the theory that Costakis was protected by the KGB (under its various names) is that, in the embassy, he had no opportunity to do anything for them. He had no access to any classified papers. Knowing that he might be suspected, he was scrupulous about his behaviour. Everyone knows by now about the KGB "dirty tricks" department, which tried to exploit the

personal weaknesses of foreigners in order to blackmail the victim. Married people were offered lovers, photographed in bed with them, and threatened with exposure to their spouses unless they co-operated. Homosexuals were found partners. People in debt were offered money. And so on. Generations of Canadians who worked in the embassy will testify that Costakis was never implicated in these now tired and boring games. There are many cases of Canadians being attacked in this way, sometimes successfully, but Costakis was never involved. He invited Canadians to his apartment, but not alone, and there was never a mysterious Russian present who picked up the relationship, as happened in so many other apartments and *dachas*.

Then there is the evidence of those who worked at the embassy and knew Costakis best. These are not naive fools. Their number includes people who served in Moscow more than once and knew the KGB and its activities thoroughly, sometimes by hard experience. They are unanimous in rejecting the notion that Costakis was a KGB officer.

The hypothesis that Costakis was protected requires a scenario of great improbability. It requires believing that at some early time, before the war (because that was when Costakis' mother and brother were arrested while he and another brother were not), the KGB recruited a young driver at the Greek embassy and promised him immunity from arrest, money to form a collection, and permission to go abroad with his family, as well as a big reward when it was all over. The scenario requires also believing that Costakis concocted, in advance, a fictitious life story for himself, concluding with a fictitious intervention by a very real Soviet diplomat as well as by the man who soon after became General Secretary of the Communist Party of the Soviet Union. Then one would have to believe that, with both these eminent persons still alive (as they were at the time; today only Semyenov remains), Costakis was willing, indeed anxious, to have all these fictions published. Beyond that, it is necessary to ask what Costakis did to deserve this bonanza. He delivered no secrets, because he had access to none. He entrapped nobody, nor did he participate in any "dirty tricks." He overheard no conversations of any importance. If it was a matter of planting microphones or bugging telephones, there were technicians far more competent than Costakis and with much greater access.

Asked the question himself, about what use he might have been to the KGB, he replied, "I suppose I could have told them how many times the ambassador went pi-pi and how many times he went ca-ca." In exchange for that or something of not much more importance, the Soviet government allowed Costakis to leave the country with fifty million dollars or so worth of art, as a reward? That is nonsense. Governments have been known to reward their spies, but only major ones and only modestly. Costakis could have been only a very minor one, and his reward would have been minor too, or, more likely, non-existent. It is plain that Costakis' own story, related in this book, is far

more credible than the theory suggested by Hilton Kramer in his article. We know in detail how Costakis financed his collection, how he amassed it, and how he left the country with part of it. We know that he had no opportunity to take anything of value to the KGB even if he had wanted to or had been instructed to. There is no requirement to find a protector, and it is therefore regrettable to suggest there was one without first ascertaining the facts and weighing the probabilities.

The one certainty in all this is that Costakis emigrated with the greatest reluctance. Those who knew him over many years knew how unhappy he was if he had to stay in a foreign country for more than a few days. He was a man whose world was made up of people: his family, his group of young artists, his fellow collectors. He was a totally social being. Things, other than art, held no interest for him. The size of his apartment impinged on his life only in so far as it determined how many pictures he could get on the walls. He was indifferent to scenery and had no interest in travel for its own sake. To suggest, therefore, that going abroad forever (as he thought at the time) was some kind of reward for services rendered, strikes anyone who knew the man as absurd. Only fear for himself and his family could have driven him out of Russia.

And finally, is it credible at all that after Gorbachev came to power, brought the KGB under a measure of control, and opened the doors and windows of the Soviet Union, one of his first cultural acts would be to honour for his contribution to Soviet art, and invite back to Moscow, a former KGB officer skulking in retirement in Greece? Is it not much more likely that these honours were a recognition of a great achievement in art, and, even more, an act of contrition for gross injustice done by the KGB under the Brezhnev regime?

Thus the scenario falls apart, and the hypothesis that Costakis was protected is exposed as rubbish, and indeed as a serious slur on his honesty.

What matters most about Costakis' life is his collection, his life in art. And that is what will be remembered. But it is not unimportant that he lived through the whole of Soviet history, up to 1978, most of the time in Moscow. And even if he was absent for subsequent events, he maintained his interest, and after his official rehabilitation (if that is the right word) became an actor on the stage once again.

There has been a tendency in the West to think that everything in Russia occurred by rule, that people's lives were regulated to the point of exhaustion, that the country resembled those of the anti-utopian novels of Huxley and Orwell and Zamyatin. A person such as Costakis could not, therefore, have led the kind of life he did. It was too irregular, too governed by chance and coincidence, too close to a life we might expect to read about in Canada or the United States. This notion is wrong, the result of Western ignorance about the former Soviet Union created deliberately by the Soviet government through its policies of extreme secrecy. Even in the most terrible times, under Stalin,

there was life still, still society, still art. After Stalin there was much more. It was not Soviet society which was stagnant (to use Gorbachev's word), but Soviet government, the party and the state. The talented Russian people went on creating and developing despite the dead hand of authority.

Costakis was part of that creative world. He was no zombie, eking out his time in the hope of reward. His reward, he thought, was in heaven: "God sent me into the world to save this art for the Russian people." The accidents and casual events which became significant afterwards are part of the real life of those years, a slice of what society was really like. We are so accustomed to reading and hearing from thriller writers that the KGB managed every minute of everyone's life that we cannot conceive of a life into which the authorities did not intrude day and night, a life where drinking tea with friends, buying and selling pictures, going to the office, and returning home were as they are for us. And we find it hard to imagine that when the going got hard, a civilized person would have intervened on Costakis' behalf. We should not be so cynical. Stranger things happened. Many intelligent and educated Russians knew their country was going through a very bad time, and had been since 1917. They made their compromises, but they continued to hope, and to observe life's decencies. After 1985 they began to think there might be a future.

Costakis was no agent, officer, stooge or stool-pigeon. He was a person of imagination and ingenuity who made his way in an extraordinarily difficult world, not by craft or deceit, but by extreme dedication to what he believed in and what he knew he could do, the one talent which is death to hide. We have to see him life size, as complex as his story shows him to have been, and part of a society even more complex than himself.

THE COSTAKIS COLLECTION IN THE WORLD

T he history of the Costakis collection is part of the cultural history of Russia since World War II, and like many other parts of that history it is a matter of success and fame bringing with them embarrassment and danger, to the point where the artist or collector had to choose conformity, silence, or emigration. Costakis' situation was less difficult than that of Solzhenitsyn, Shostakovich, Brodsky, or Pasternak. The works he was dealing with were, after all, seen as harmless, at least after 1953. Once Stalin and Zhdanov had left the scene, the state found little to worry about in the Russian avant-garde, or in icons, or even in the paintings of Costakis' "unofficial" young artist protégés. They were no real threat to the artistic establishment as long as they remained within the confines of Costakis' apartment. It was fame outside Russia that was Costakis' undoing.

He could have avoided it. He could have kept foreigners from seeing his collection, rigorously refused contact with Western journalists, maintained a strict separation between his job at the embassy and his life as a collector. But that was not the man at all. He desperately wanted people to see the wonderful things he was finding. No less vain than the rest of us, he was flattered and pleased when the great and the mighty and the wise took an interest in his "children." But while the artistic world of London, Paris, and New York beat a path to his Moscow door, and as he travelled the world telling anyone who would listen about what he had found, the artistic establishment of Russia remained dour and morose in the shadows. That was why the prospect of a visit by the minister of culture, Furtseva, was so tantalizing, and would have been of enormous importance to Russian art of that time had it occurred.

Costakis described his situation in the early 1960s as follows:

Foreigners came gladly to see my collection: ambassadors, museum directors, poets, writers. Stravinsky came. Many, many prominent people came. But as for the Russians – I don't think they were so much afraid as that they thought it was beneath their dignity to go to see the collection of some person called Costakis, unknown, a foreigner, works in some funny place, collects art that isn't recognized. So they ignored me. I remember Sir Norman Reid, director of the Tate Gallery [in London] was coming to see me. He asked if I could invite as well Antonova, director of the Pushkin Museum. So I went to the museum, spoke to Antonova, and she said, "Delighted to come. May I bring my husband?" Well, next day I was at some reception, and there I saw a senior person from the ministry of culture. A woman, the right hand of the minister. Very disagreeable. So like a damn fool I said to this woman, "The day after tomorrow Sir Norman Reid is coming to my place, and there'll be Antonova. Maybe you'd like to come too." "Yes," she said, "with pleasure." So when the day came we got everything ready and waited for the guests, who were supposed to come at eight. At half past seven came a phone call from the secretary of this woman at the ministry of culture. An unexpected meeting; she would not be coming. I said to Zina, "Now we'll have one from Antonova." Five minutes later, "I'm calling for Antonova. Her daughter is ill. There's nobody to stay with her. They won't be coming." At other times I invited for example Alpatov, the greatest Russian art historian of that time, and Lazarev, a top expert on Byzantine art. The answer was always, "I'll speak to my wife." But they never called back, and they never came.

Costakis' experience is almost laughably familiar to any foreigner who has lived in Russia. But for Costakis it was a tragic situation as he struggled, in vain he thought, to have the Russian avant-garde accepted as real art of value. He was not necessarily right in thinking that the reason for all these refusals had nothing to do with fear. Fear, even in those somewhat happier Khrushchev days, was always present. Not necessarily fear for one's life or liberty, but fear of a vengeful and vindictive establishment quite capable of making you lose your job, your three-room apartment, your car and driver, or your child's entrance to university if you did something they did not approve of. And the extent of their self-righteousness is hard to exaggerate.

It was not only foreign visitors who caused problems for Costakis. As the interest grew, so did the attention of the foreign press, and again Costakis was guilty of a deliberate self-inflicted wound. He knew that he was safe so long as he did his collecting quietly and drew no attention to it. But to ask him to do that was like asking a missionary not to seek converts. He was determined that the whole world should share his discoveries; to keep silent was impossible for him. He illustrated his dilemma in the following story:

I remember one day in Moscow an American journalist called Alexander Marshak came to see me. He said he was the nephew of the poet Samuil Marshak, and he was very interested in the young Russian artists and the avant-garde. He asked for my help. Well, I was extremely cautious and told him I'd have to think it over. I said it wasn't without risk to publish such things. Specifically he wanted to borrow my slides of paintings by Anatoly Zverev and other "unofficial" painters. I told him to come back in a few days and I'd give him an answer. He left, and came back in about a week. "Look," he said, "I've been to the Tretyakov Gallery and to Leningrad, and I've visited such and such artists." He opened his briefcase and showed me many photographs, newly printed. In one of the museums, I think the Tretyakov, they'd let him into the storage area (very rarely did anyone get in there) and given him permission to photograph what he pleased. These store-rooms in Soviet museums are terrible places: Kandinskys piled on top of Malevichs, Chagalls all over the place, some hanging on the walls, some lying on the floor. In short, a mess. And he had photographed it all. So he said to me, "You were afraid to give me anything, but look, the gallery has given me everything." This was the time when relations with the Americans were not bad, more or less warm. I said, "All right, but you've still got to be careful with this material. I'll give you some slides of Zverevs, and you can publish them. But look out …"

We sat down to eat supper, and I said, "You've got a wonderful bunch of stuff there, all kinds of photographs they let you take, and interviews with artists including Dima Krasnopevtsev and Yury Vasiliev. I advise you to do the following: first find a magazine that has nothing to do with politics, a magazine with the word *Art* in its name. Then write a general article about art in Russia, in the Soviet Union. Start, for example, with ballet, and opera, and Russian icons, and take it a bit at a time. Then go to the nineteenth-century and write about the Wanderers. Then come to contemporary Soviet art: Gerasimov, Nalbandian, people like that. And then into this dough you can knead something about the young artists and the avant-garde. Then everybody will be happy and nobody will start making accusations." He said, "It's a good idea. I like it." So we agreed on it, and I felt easy.

Two or three weeks went by, and someone who had been at the embassy and was now back in Canada, sent me a letter in a big envelope, and there was a magazine, *Life*. This letter said, "George, how could this have happened?" I opened the magazine, and I understood what he meant. On the right side, occupying the whole page, was a portrait by Zverev, paint splashed all over the place, but a very good work, perhaps a self-portrait, or possibly a Christ. And on the other page, Lenin, the famous painting of him declaring the Soviet state. To a Soviet person seeing this it would be like – how to put it? – having the Blessed Virgin on one side, and a naked prostitute on the other. In the Western press you often see that. You open a magazine and on the left side you see maybe some kind of prostitute, and on the right the Pope of Rome or something like that. Then there were the photographs, showing the mess in the storeroom of the Tretyakov Gallery, and above there was a cutline, saying "hidden art that is shown to nobody" or words to

that effect. In short, a scandal. Such a scandal that you can't imagine. This was the very moment when Khrushchev was putting pressure on the academic artists. [The article appeared in *Life* magazine of March 28, 1960]. He was telling them that with art it was *chacun à son gout*. You do your kind of art and let other people do their kind of art. "Give the young artists room to breathe," he was saying. "Maybe you don't like what they're doing, but I like it." At that time they were building a new House of Pioneers, and friends of mine, a young couple, were doing the decorating. I saw it. It was an incredible mish-mash. Every kind of art, surrealism, pop art, everything. And Khrushchev came to see it. The people with him said, "Look, Nikita Sergeevich. What a mess. It's hideous." But he answered, "Maybe you don't like it, but I do. It's interesting, amusing." Khrushchev was even going to present the Lenin Prize to them. The members of the Academy were very unhappy because the young artists were behaving outrageously too. It was like a repetition of the twenties, when the professors were barking and howling like a bunch of dogs, but Malevich and Tatlin stuck to their guns. This was the same.

Then this Marshak stuck his nose into it, full swing. The least of it was that Yury Vasiliev was called in by the KGB because of the interview he had given Marshak, and had a heart attack as a result. Krasnopevtsev was pulled in too. And every museum storeroom in the country was locked, so that it was impossible for years for anyone to get in. Several museum directors, who had held their jobs for twenty or thirty years, were fired. And Khrushchev changed his attitude completely. Next time he went to an exhibition of the young artists' work, he gave them all hell and told them they were a disgrace. All this Marshak did.

In a similar way, American friends of Costakis, Sam and Judith Pisar, worked with the best intentions to publicize him and his collection in the West. Costakis thought they were instrumental in arranging the visit of Senator Kennedy to the collection. Judith Pisar made plans to take colour transparencies of part of the collection with her to the West, but was intercepted at Moscow airport and made to hand over the transparencies after she and Costakis had unwisely discussed the matter on the telephone.

None of this did Costakis any good in the eyes of the authorities. Publication of forbidden art in foreign magazines was perhaps not so serious a crime as, for example, Pasternak's publishing his forbidden novel abroad. But it was the same kind of crime. Pasternak came very close to being forced to leave the country. Solzhenitsyn was forced to leave. Costakis was certainly on that list, and for the same reason. Why he survived at that time, 1959-60, is not clear. An intervention by Furtseva is not out of the question, and until the Marshak article appeared Khrushchev was certainly taking the side of the young artists, as to some extent he took the side of Solzhenitsyn, authorizing the publication in Russia of *One Day in the Life of Ivan Denisovich*. Had he lasted longer, Khrushchev might well have done something for Soviet culture similar to what Gorbachev did. But he was no sophisticate,

and it enraged him to find people like Pasternak, and presumably Costakis, betraying (as he must have thought) their country by smuggling works abroad which were not part of the official Soviet face. However, both Costakis and Pasternak survived that crisis. Pasternak died soon after, and since he wrote no more controversial novels he encountered no more trouble. Costakis, on the other hand, went on receiving eminent foreign visitors and being talked about in the foreign press. With Furtseva and Khrushchev dead and the KGB riding high under Brezhnev, it was probably the eminent visitors calling at Costakis' apartment through 1973 and subsequent years who precipitated the decision to force him out of the country.

But before the tide of eminent visitors, there was the North American and London lecture tour in the fall of 1973, when Costakis became a known figure outside Russia and therefore a person of interest to the KGB. Early that year an American professor, Michael Haltzer of Hamilton College in Clinton, New York, visited Costakis and was so impressed both by the man and the collection that he invited him to the United States, and undertook to organize a lecture tour of several American universities and museums. The National Gallery in Ottawa was added because of the Canadian connection. Costakis had been in North America once before. In 1967 the Canadian government had brought several senior and hard-working locally engaged employees from various Canadian embassies around the world to Montreal for Expo. The trip was a reward for faithful service to Canada, and an experience which, it was hoped, would help them do their jobs still better. But a chance to tour the United States as a respected collector was a very different proposition from a visit to Montreal as a humble clerk. Costakis accepted the invitation at once, without much hope that anything would come of it. But a few weeks later an air ticket and a full itinerary arrived. At the same time Costakis received an invitation to show part of his collection at the Fisher Gallery in London. He added this to the program. Getting permission to make the trip was not easy, but in the end it was given. Officialdom may have thought that even if Costakis' kind of art was unacceptable and officially non-existent in the Soviet Union, a lecture tour in the United States would be good for the policy of detente, then in full swing, and for the Soviet image. So Costakis got his exit visa and in mid-October, 1973, boarded a Pan-Am flight for New York.

In many ways the lectures were the least of Costakis' adventures in America. Except for Harvard, where very few people turned out ("Harvard," remarked Costakis, "is very snobbish, very unpleasant") and Ottawa, to be described later, the tour seems to have been remarkably successful. Costakis had never lectured before even in his own language, much less in English. He had no formal training in art history, nor indeed in anything else, and at some of the institutions he was facing audiences of three and four hundred, including international authorities on his subject. But his passion for his artists and their work was so evident, and so infectious, that almost any audience was swept along.

And he was a naturally good speaker. He seldom referred to his notes, and took time in advance to think out the shape of his speech or lecture. Using slides as well as some works from the collection, he spoke simply but eloquently about who these artists were and what they meant to Russia and to him. He recalls that although he was warned in most places not to go on longer than forty-five minutes, that being the usual length of an academic lecture, he in fact talked for twice that time and, so he said, held his audiences. Of course he had to be extraordinarily prudent in what he said about the state of this art in Russia, and chose the wise course of saying nothing about the official attitude. At that time it had not occurred to him that within a year his troubles would begin, and within five he would be persecuted to the point of having to leave the country he thought of as his own.

If the lectures went well, other things did not. Arriving from Moscow at Kennedy Airport late at night, Costakis collected his suitcase and two boxes of paintings, and made his way by taxi to the Hilton hotel. There he was assigned a large suite, "with a bed five people could sleep in," and sat down with a cup of tea. He found himself staring at his suitcase, which contained his slides, lecture notes, and everything he needed for his tour. The suitcase did not look quite the same as when he had last seen it. "So I opened it, and on the top – ladies' underwear, ladies' shoes." Then followed a hair-raising night at the airport. Costakis' Chinese taxi driver, to whom he explained his plight, parked his cab at the airport and took charge of the problem. The suitcase was found just as the sun rose. Costakis says he made his way through three packs of cigarettes in the course of the night, and his best suit was drenched with sweat. But the Chinese taxi driver got a hundred-dollar tip, and the tour was launched. It continued to be plagued, however, by bad luck. Costakis found that he could not manage his suitcase and his two boxes of paintings. Travelling by train whenever he could (because he thought American trains marvels of modern efficiency, a comment on Soviet ones), Costakis came close on more than one occasion to losing one or the other of his precious boxes. But they survived, as did he, and after two weeks he came to the last stop of his tour, Ottawa, where he was to lecture at the National Gallery of Canada.

He had been looking forward with intense anticipation to this visit. Here were his Canadian friends. Everyone who had served in the Canadian embassy for the past thirty years knew him and wanted to see him and hear him lecture. But things got off to a bad start. As Costakis recalled it fifteen years later, he was relaxing in his Lord Elgin Hotel room with a cup of tea, when he heard a knock at the door. Two men, who identified themselves as RCMP officers from the security branch. "Ah," thought Costakis, "how kind of the Canadians to send somebody to look after my two boxes of pictures." But the matter was something different. The two officers wanted to interview Costakis about his relations with the KGB and wanted him to tell them who on his Soviet staff, in addition to himself, was working for the KGB in the Moscow embassy. Costakis recalls the two policemen

telling him that the KGB had entrapped and compromised a junior member of the embassy staff. Having got him under their thumb, they asked him to give them certain information and transmit it to them through Costakis: "He is our man."

Costakis of course denied any connection with the KGB, and refused to speculate about which driver or maid might be suspect. He agreed with the two officers that many people were probably reporting to the KGB, but he doubted if they had much of value to give them. The Soviet staff had no access to information, except possibly about the personal lives and habits of the Canadians working in the embassy. And to Costakis, the story was absurd. If the KGB had a senior agent in the embassy in the person of Costakis, would they be likely to reveal this fact to a man who would be certain to report it and perhaps cause Costakis to lose his embassy job and thus his value as a spy? In fact, he found the whole affair ridiculous and distasteful, and lost no time telling his Ottawa friends all about it when he saw them the next day.

But there was worse to come, and it had nothing to do with the KGB. The National Gallery, where the lecture was to take place, had advertised it for the wrong day, October 28 instead of October 27. It was too late to make the change. Costakis had telephoned a few friends, who telephoned their friends, but he lectured to a mere handful, "a curator and the cleaning woman, a few students, and a few of my friends from the Canadian embassy in Moscow. In Canada I got the coldest reception of the whole tour." But the friends organized a gala dinner in his honour, lionized him, sympathized about "the Canadian KGB," and sent him on his way feeling he was in touch again with very close friends, some of whom he had not seen for many years. Then he went to London, where he left six works at the Fisher gallery and gave two illustrated lectures, at London University and the Tate Gallery, and so back to Moscow and, after all this glory, back to his shabby office in the embassy.

Costakis' memories of his first visit to the United States were happy ones. He considered his lectures to have been well received, except in Cambridge, Massachusetts. He enjoyed being met and seen off, riding on American trains, living in university guest houses. He was astonished to find that he was paid a fee of between one thousand and two thousand dollars by each of the universities, somewhat less by the museums. He was impressed by the interest everyone had in the still relatively unknown Russian avant-garde. And he was delighted when Professor S. Frederick Starr, then of Tulane University and later president of Oberlin College, who helped organize the tour and accompanied him on part of it, proposed a book about the collection and took Costakis to see the New York art publishing firm of Harry N. Abrams to discuss the possibility. The result of that initiative was the publication, in 1981, of the splendid *Russian Avant-garde Art: The George Costakis Collection,* elegantly edited by Angelica Rudenstine, then a curator at the Guggenheim Museum,

with a preface by Costakis and an introduction by Starr, a useful chronology by John Bowlt, and over eleven hundred incomparable reproductions of works from the collection.

But what stood out most strongly in Costakis' memory was a dinner given by Paul Mellon, then chair of the board of the National Gallery of Art in Washington, D.C. The dinner took place in the gallery. Costakis pointed out that he had been to a few grand dinners and receptions in his time, including the one he helped organize for Stalin and Churchill in 1944, but never to one like this. Five hundred guests in five galleries, at tables for six, surrounded by masterpieces. A string quartet playing in each room. The women wearing jewels "so that you could hear them coming from ten metres." Food and drink "as you can imagine." And after dinner who should come up to Costakis but Joseph H. Hirshorn, one of the most important patrons of modern art. He had attended Costakis' ninety-minute lecture earlier in the day, liked it, and now wanted to propose that the collection should come to the United States and be the centrepiece for the opening of the Hirshorn Museum. Costakis, suitably pleased and flattered, nevertheless said that he doubted if the Soviet government would let the collection leave the country. Hirshorn was sure he could manage this problem, but he was wrong. After his return to Moscow Costakis put the request to the ministry of culture, and was firmly turned down. This was 1973, and the Soviet authorities had their own plans for the collection, which did not at that time include letting any significant part of its five thousand works slip away.

How well advised was Costakis to undertake this high-profile tour? It got him a lot of publicity, not all of it positive. It was certainly known in detail to the Soviet embassies in Washington and Ottawa (although they of course would not have attended the lectures) and to the authorities in Moscow. We have seen how Soviet toleration of Costakis' activity was beginning to wear thin. A long list of Western museum directors, practically every ambassador in Moscow, Western journalists in a steady stream (some of them, like Alexander Marshak, creating a lot of trouble with what they wrote), all these and more were familiar with Costakis, his apartment, his collection – the collection of art officially considered a disgrace to the art history of Russia and the Soviet Union. And to this list of visitors were about to be added Senator Edward Kennedy, Marc Chagall, Igor Stravinsky, David Rockefeller, and others no less known. Why were Kennedy and Chagall and Stravinsky not coming to the Academy of Art to look at the beautiful paintings of happy steel workers and monumental statues of Soviet war heroes? Who was Costakis to be leading the high life in the United States when no other collector or artist was invited there? These questions were inevitably being asked in places of power in Moscow. The Alexander Marshak article, although it had appeared more than ten years before Costakis' tour, had clearly accused the Soviet government of depriving its citizens of their own great art. Now Costakis, in parading this very art before American audiences, was reinforcing Marshak's message, even if he was careful not to do it in so many words.

Senator Edward Kennedy went to the little apartment in April 1974. George was in a frenzy of excitement. He and his wife scrubbed and cleaned, and rushed out to buy a new carpet. Then, he says, he got hold of himself and said, "Don't be a damned fool." Anyway,

Kennedy came. He came without his wife, because their boy had something wrong with his leg, and she couldn't come. And I can tell you that within five minutes I knew he was a simple man like me or you. He was amazingly easy. I had made a really elegant reception. He told people after that he had never been to such a reception, not even in the U.S. He was probably right. On the right of the table I had a two-kilo tin of caviar, and on the left another. There was a big sturgeon, and another kind of sturgeon, and a whole ham with pineapple, and every kind of salad, and all of this surrounded by icons, and candles, and paintings. It was a reception in a small but excellent museum. Kennedy took three or four helpings. Then he made a speech, and I thanked him. It was a warm atmosphere, agreeable, and Kennedy spent I suppose three and a half or four hours with us, and he talked with everybody. I had invited a lot of Russian artists. Plisetskaya [at that time the prima ballerina of the Bolshoi Ballet] I remember, but she couldn't come. She sent her brother, also an artist. Then they started taking photographs. He had his official photographer with him. He sent them to me after, pictures of me and Zina and the children with Kennedy, but you won't find them in any book because you had to get permission to use them (it said so on the back), and we couldn't get permission. Anyway, he liked the collection very much, and afterwards we had a correspondence. He invited me to Washington and said that if I came I should stay with him. But I never did.

Kennedy's letter to Costakis addressed him as the Canadian ambassador, thus causing some strain between him and the real ambassador, who presumably received the letter first and had to pass it on. (It is unlikely Kennedy himself made the mistake. His "correspondence secretary" might be forgiven for thinking that nobody less than an ambassador would produce such abundance, and Kennedy probably forgot to mention that the reception took place in a cramped Russian apartment.)

It is hard to describe the effect of such a visit in the atmosphere of Brezhnev's Russia, and at that particular time. International affairs were far from the top of Costakis' agenda, although he took an intelligent interest. But the Kennedy visit to Moscow came at an exceedingly delicate time. Richard Nixon was about to leave the presidency in disgrace over the Watergate affair, and it was with Nixon that the Brezhnev regime had laboriously constructed its policy of détente with the United States. With the Vietnam war raging and the bombing of Hanoi by the Americans only two weeks past, Nixon had paid an official visit to Moscow in 1972, the first by an American president in ten years, and Brezhnev had reciprocated it a year later. Now, in April 1974, Edward Kennedy and a number of other prominent American figures had come to Moscow for a seminar on Soviet-U.S. relations, and

Kennedy's first act had been to demand a meeting with Jewish dissidents, which the Soviet authorities very grudgingly permitted. Knowing practically nothing about any of this, Costakis stumbled into it all. The American embassy in Moscow had to make a program for Kennedy. The Jewish dissidents were to be one part of it, and Costakis, since Kennedy liked and was knowledgeable about art, another. But this, in combination with the lecture tour, was the beginning of the end for Costakis. What right had this miserable Greek clerk to meddle in the grand affairs of state, and especially to invite to his apartment a famous American who was using his fame to stir up trouble by encouraging Jewish dissidents? We forget, in more liberal days, when the problem of family reunification no longer exists, how fiercely the KGB resisted dissidence and the desire of Jews to emigrate. That the Soviet economy was headed rapidly for collapse meant nothing to the authorities. They saw the ship of state imperilled above all by people who wanted to leave the country, people who wrote and said what they thought, people who sought to publish their work abroad when it had been refused in Russia. Kennedy was helping those people, and Kennedy was helping George Costakis. If Costakis had done nothing more, and he did quite a lot more, the Kennedy reception alone, offered in all innocence with its pathetic caviar and new carpet, was enough to try him and find him guilty.

◤

Then there was the Chagall connection. It was 1973 when the great master visited Moscow and Costakis' apartment. But the story goes much further back:

In those years, beginning about 1952, I started getting letters from Chagall. There was a cultural attaché in the French embassy called Alexandre Kem. He told Chagall that here in Moscow is a man who has your works, that he is making a lot of publicity for you, and so on. So Chagall sent me a letter and, I recall, a little book. I don't remember whether it was that little book, or another one, but I have this little book with Chagall's signature. And he wrote, you know, "To George Costakis, with gratitude. Marc Chagall." When specialists in Paris saw this book, they said that there is no other book signed by Chagall "with gratitude." He usually wrote "thanks," but "with gratitude," only this one. This is understandable, because in those years Chagall was ... especially in Russia, very ... But I think that even in France he wasn't among the first. His ascent began in 1959, when there was a big Chagall exhibition in Hamburg. After that Chagall went to the top, and started having exhibitions.

Costakis went on to describe how Chagall sent him on a futile search for some Chagall works which had been lost in Leningrad since 1910. He then introduced the subject which would, over

many years to come, form the core (for Costakis, at least) of the Costakis-Chagall relationship. That subject was a painting. Was it or was it not by Chagall? It was certainly of Chagall's first wife, Bella. It had been offered to Costakis, who described it as "an oil, painted on both sides of the canvas. On one side was a portrait of a woman, Bella. On the other side, a very typical Chagall with crooked little houses, Jewish, outrageous behaviour in the village, ramshackle churches."

Costakis sent Chagall a photograph of this work, asking for confirmation that it was indeed by Chagall. Chagall replied that the photo was not very clear, and anyway he couldn't remember. Costakis was annoyed ("To hell with him") but bought the painting. By then it was 1955.

Costakis, desperately ill and "green in complexion," according to people then in the embassy, went to Sweden to have his remaining kidney examined. He remarked laconically that "since Stalin was dead, it was possible to get out." Possible but not easy. It took the combined efforts of the Canadian and Swedish embassies, the latter in the person of the nephew of Dag Hammarskjöld, to get a Soviet exit visa for Costakis. Zina and the children stayed at home, as was the invariable practice in those days, to ensure the traveller's return. This was his first trip outside the Soviet Union, and since he might never have another he decided to go to Paris to see the last living avant-garde artists, Goncharova and Larionov, and if possible to go to the south of France to see Chagall.

Natalia Goncharova and Mikhail Larionov, both born in 1881, met in art school in St. Petersburg and lived together for the rest of their lives. They were fully active members of the avant-garde from its beginning, and participated in the major activities of the group, including its quarrels and bickering. They exhibited and worked abroad more than most members of the avant-garde, and in 1917, after Larionov had been invalided out of the Russian army, they left Russia permanently to go to Lausanne, where Larionov became chief artistic director of the costumes and sets for the Diaghilev ballet, and both worked for several years on the design of various major productions, including Stravinsky's *Firebird*. They lived the rest of their lives in Paris where like all Russian émigrés they resented their hosts, and where like many they largely lost their creative impulse. Goncharova died in 1962, Larionov in 1964. For Costakis, a visit to them was a rare opportunity to talk to members of the group he was trying to reconstitute.

Costakis related that before his arrival only one visitor from Russia had called on these two émigrés. During their first year in Paris, in about 1920, a Soviet musicologist had gone to see them. Then nobody until Costakis in 1955.* He got a warm welcome from these two old painters, living in a cluttered suburban apartment, and cherishing the illusion that they were still known figures in Russia:

* Soviet visitors to foreign countries were strictly forbidden to have any but essential contacts with the local people, and normally had to travel in groups of at least three or four, one of whom would have been briefed by the KGB to keep an eye on the others. That this regime did not apply to Costakis is yet another mark of his special status as a foreigner working in the Soviet Union.

They gave me a warm welcome, with hugs and kisses. Right away Larionov said, "You know, Costakis, I hear you have a very good collection. Now listen, my dear fellow, I want you to buy absolutely nothing here. No record players or records or anything. I want you to keep all your baggage allowance and take as many of my pictures and Natasha's as you can back to Russia. If you haven't room for them in your collection, give them to other collectors. I know that in Russia they love us and collect our work. And when you get back to Moscow I want you to go to the ministry of culture and tell them that we have decided to send all our work to Moscow after we die. The reason is that the French have treated us very badly. They don't even consider us artists." He spoke very bitterly of the French.

This was Costakis' first experience of Russian émigrés, one that left a lasting impression on him. Here were two great artists, rejected by their new country, producing and exhibiting little, embittered by the way France was treating them, and in a complete fog about what was going on, artistically at least, at home in Russia. Costakis must have found it very hard to tell them that except for a few collectors like himself, nobody in the Soviet Union knew their names, and that their work was officially non-existent. The fate of Larionov and Goncharova was to be the text for the many sermons Costakis later preached to the young "unofficial" artists back in Moscow, many of whom wanted passionately to emigrate. He continued his description of this odd couple:

They lived in a two-storey apartment somewhere on the outskirts of Paris. The place was jammed with things – boxes, paintings, drawings. There was no place to take a step. And they had both got very old. Larionov's hands shook, hers too. When I arrived she was working on a still life, and she held the brush with two hands. She couldn't manage it with only one. As for Larionov, he took a catalogue and wanted to write a message for me on it, in memory of my visit. But this took him more than an hour. He wanted to write something like "To dear Georgii Dionisovich from Mikhail Larionov in memory of our meeting in Paris." But after every letter he had to stop and ask Goncharova, "What comes after 'o'? What's the next letter?" And when he'd finished that word, he'd ask her again, "What's the next word? What comes after 'memory'?" And so on. So it took him an hour and a half to write these ten words.

Then we had tea. They got out maybe a dozen tins of jam: raspberry, strawberry, apricot, everything you could think of. And every tin was covered with paper and tied with string, and every one had to be opened. It took hours. But Goncharova gave me a drawing of a nun, and she wrote on it, "To Dear Georgii Dionisovich in remembrance, and so that he, and others, will remember me. Natalya Goncharova." She gave me also a rayonnist oil, but from the late period, with reddish-orange colours.

The visit to Larionov and Goncharova ended with a bit of art history. The art world has spent quite a lot of time, and generated quite a lot of heat, discussing the question of who created the first abstract work of art. The generally accepted answer is that Kandinsky did, in 1910. But Costakis found his host, Larionov, in a state of some emotion on the matter. Costakis recalled that both Larionov and Goncharova were emotional about many things, especially about their treatment at the hands of the French. But Larionov was deeply offended by the notion that he had not been the creator of the first abstract painting. Costakis explained:

The problem was that Kandinsky insisted that the first abstract piece was made by Vasily Vasilievich Kandinsky in 1910. "But I," said Mikhail Fedorovich [Larionov], "can prove that the first abstract piece was not by Kandinsky, but by me, Mikhail Larionov. I did the first rayonnist painting in 1908."[*]

"But the thing is, my rayonnism was firmly established only in 1912. And this happened because we, Russians, are a very indolent people. We rely on our memories, and on tomorrow. We say that tomorrow we will paint something, tomorrow we'll make a statement. But Kandinsky was a European, a different kind of person. He planned every step. He had it all fixed and arranged according to protocol." And when he said this, when he told how he had been insulted, Fyodor Fyodorovich [Larionov] had tears in his eyes. It was such a big insult.

So he tried to get me involved. He asked me to prove that, in fact, he was the first artist to make an abstract piece. He said that his rayonnist period was a very experimental one, very short. He did very few things, very few. After rayonnism he went to a soldatsky [Atanasio Soldati, Italian abstract painter] period. Rayonnist pieces were very, very few. He had left a few, he told me, probably in the Tretyakov gallery. There were a few in private hands. And that was all. He thought that Zhegin [L.F. Zhegin (Shekhtel), collector and Moscow friend of Larionov] might have two or three rayonnist pieces, painted on icon boards. So I told Larionov that, yes, I had got some rayonnist pieces from Lev Fyodorovich [Zhegin], and probably he still had others.

So, returning to Moscow, I went to see Zhegin, told him about my meetings, gave him Larionov's greetings, and told him about how offended Larionov was on the subject of who was the first abstract artist. Lev Fyodorovich [Zhegin] started remembering things. He turned to his wife. "Do you remember when we were married?" She thought it had been in 1908, towards the end of the year. Then Lev Fyodorovich said, "I remember that one of these rayonnist things – one that you [Costakis] now have – Mikhail Fyodorovich [Larionov] gave me on my wedding day."

[*] Rayonnism is a style of painting developed by Larionov. It is invariably abstract.

So that's how it was. Larionov showed that it was 1908. And Zhegin was no kind of falsifier of dates. The things that he had sold to me he sold for very small amounts. I don't think it would have made any sense for Zhegin to change the dates.

It's a strange story. But to prove that Larionov painted the first rayonnist work in 1908 – that of course is not possible.

The visit continued with a reception for Costakis, organized by the expatriate Russian community. Costakis had meant to telephone Chagall, living in Saint-Paul-de-Vence. But before he found time to do so, an invitation arrived from Chagall, asking Costakis to spend "two or three weeks" with him. Costakis was on his annual vacation from the Canadian embassy, and did not have two or three weeks, but he agreed to ten days, and next morning, accompanied by a Russian friend of Chagall, flew off to the South.

By the time of his visit to France, he already had a roomful of the master's work, and was steadily finding more. Until the collection was divided, in 1977, Chagall remained its focal point and its most dramatic component. Dazzling and joyful works looked down on the visitor to the apartment on Bolshaya Bronnaya. For most non-specialists, Chagall's was until quite recently the only familiar name in the canon of Costakis avant-garde artists, and it was probably his name that brought such non-specialists as Edward Kennedy to Costakis' door.

Yet Chagall was really, in an artistic sense, on the fringe of the avant-garde. It is true that he participated in the major avant-garde exhibitions, Donkey's Tail of 1912, Target of 1913, Jack of Diamonds of 1916. Like most of the others he supported the revolution and was rewarded in 1918 by being appointed head of the art school in his native Vitebsk. Yet neither his exuberant village love scenes, done to celebrate his marriage in 1915, nor his deeply emotional treatment of subjects from his Jewish heritage have much in common with the other great works of the avant-garde. Indeed, he and Malevich quarrelled over these issues, to the point where Chagall was forced to surrender direction of the Vitebsk school to his rival. He differed from most of the others also in that he was seriously influenced by what he learned during a four-year sojourn in France, 1910-14. His fellow avant-gardists generally resisted the attraction of Western art and went their own "Eastern" way, as Goncharova put it. And of course the greatest difference of all, Chagall's story had a middle and an end, whereas for most of the others there was only a beginning. Who knows where Malevich or Tatlin might have gone, artistically, if their work had not been distorted and finally suppressed altogether before they had a chance to mature? Or Popova and Rozanova if they had not died very young? Chagall went on to the age of ninety-eight, creating furiously during most of those years. Thus, although the Chagall Costakis flew south to see was already at the centre of the Costakis

collection, and certainly at the centre of attention of art lovers everywhere, he was not and never had been at the centre of the Russian avant-garde.

Costakis records that Chagall came out of the house to meet him:

We embraced and kissed. Vava, his wife, was introduced. Chagall lived at that time at Saint-Paul-de-Vence, in an old house. Later he moved, and I've visited him there, too. But this was an old house, and as is usual in France (and you see it in Greece, too) there's one house on the ground, and three or four metres higher, a second house, with a flat roof. He worked in the higher part. There was Chagall's studio, and some other rooms, including a guest room. And you could walk out of that guest room straight into the garden. That's what I did. I remember, I opened the window and let out a gasp. A big garden full of white plum trees, the kind called "rhinegold," and the ground was covered with a quarter metre of these plums lying in a layer, and another mass of plums ripening on the trees. So I waded into the pile and picked a few ripe ones from the tree. Later I asked Chagall, "Why are you letting all this go to waste?" He said, "You know, nobody wants them. Nobody's interested. Everybody has some, and the price in the market is very low. They used to come from the monastery to collect them, but they've stopped."

Well, I stayed ten days with Chagall. We had breakfast and lunch together, and spent a lot of time together. Chagall told me how he had designed the stained glass windows for the synagogue in the Hadassah-Hebrew Medical Centre in Jerusalem.* He said that at first he was very dissatisfied because the building didn't suit what he wanted to do, but he liked the final result. He asked me a lot of questions about artists in Moscow. One he asked about was Lentulov [Aristarkh Vasilievich Lentulov, 1882-1943]. I told him that Lentulov was dead. "Yes, I know, Costakis. He was one of the very best, one of the great artists of the Jack of Diamonds. And how is my friend Fonvizin?" [Artur Vladimirovich Fonvizin, 1883-1973]. I said Fonvizin was still alive, and still painting his little horses. Chagall said, "You know, Fonvizin is also a very interesting water colourist, and if his work were here, he'd have great success."

Chagall had a very strict regimen. Vava would interrupt him literally in the middle of a word and say, "Marc, time for your rest." And he would get up and go for his rest. No phone calls permitted. Even if the prime minister called, or anyone, Chagall didn't take it. Nobody was allowed to disturb him.

My time there was quite astonishing. Several times Chagall took me to a little restaurant in Saint-Paul-de-Vence, late in the evening. Four or five little tables, a couple sitting in the corner. We were Vava, Chagall, and I. Sometimes his brother came. I remember an open fire where they cooked the meat. The owner brought a basket of fresh fish. Chagall pointed. He said, "That one." They cooked this fish, then they brought the meat. You know, I was in some kind of paradise.

* Costakis' memory is faulty. These beautiful windows were commissioned only in 1959, three years after Costakis' visit. Chagall must have spoken about them during one of their several subsequent meetings.

This sybaritic life continued for the full ten days. Chagall took Costakis to a café frequented by artists, with important works on the walls, Picassos, Kandinskys, in addition to Chagalls. There Chagall was received by everyone with every mark of affection. And there an important conversation took place, one that years later would cast a shadow over the Costakis-Chagall relationship. Referring to the correspondence between them, which had been going on for some years, Chagall said, "Costakis, so you bought *Portrait of Bella?*" •

I said, "No, Mark Zakharovich, because you didn't say anything precise about it, and I was afraid to buy." "No, no," he said, "I wanted to write to you. Go ahead. Buy it. On the back you will find a landscape." So I agreed. Then I remembered that when I had seen this *Portrait of Bella* there had been a number, the number ten, stencilled in one corner. So I asked him what this number meant. He said, "You know, Costakis, in those days it was very hard to come by canvases. There were very few of them, and they gave them to us by number. This was number ten, and I decided to leave it behind when I left Russia." So I said, "Mark Zakharovich, then I'll buy it." He said, "Yes, of course, buy it."

There were visits to Nice, picnics in the country, Costakis had the time of his life, and then he went home.

Several things are interesting about this account. It is not easy to put oneself in Costakis' shoes. This was his first trip outside the Soviet Union. In 1955 his country was still suffering from the war, even though it was ten years past. There were shortages of everything, especially food and housing. Towns and cities which had been in the war zone, virtually the whole country west of a line from Leningrad to the Crimea, were still rubble. The streets were full of maimed and crippled veterans. Moscow, though not much damaged by the war, nevertheless remained grey, dirty, dilapidated, over-crowded. To be transported from that to Chagall's sunny garden in the south of France, to a restaurant where you picked out your fish and they cooked it to order, to civilized talk with the master and his family – it was a kind of fairy story. When Costakis later advised the young "unofficial" artists not to emigrate, and told them they were better off in Russia, the example he took was not that of Chagall, but of the wretched Larionov and Goncharova in their Paris loneliness.

Another point worth noting is how Chagall and Costakis addressed one another in Russian, according to Costakis' record. Costakis called Chagall politely by name and patronymic, "Mark Zakharovich," the equivalent of "Mr. Chagall" in English. Chagall called Costakis "Costakis," which in Russian as in some kinds of English carries a distinct note of condescension, of a master

• Bella Rozenberg was Chagall's first wife, whom he married in 1915 in Vitebsk, and who inspired some of his finest work in the ten years that followed. She died in 1944.

addressing a servant, or the chairman of the board saying good morning to the doorman. Costakis did not record this by chance or absence of mind.

And the history of *Portrait of Bella* was not over.

Back in Moscow, in the fall of 1955, Costakis wondered how to get in touch with the owner of *Portrait of Bella*. There was no telephone book. You wrote down the numbers of your friends and contacts and guarded them jealously. Only the KGB had a telephone book. Costakis wanted passionately to buy this *Portrait of Bella*. It was now authenticated by Chagall; Costakis had found it, and hungered for it. Then, a gift from the gods, within a few days of Costakis' return, the owner called. He wanted to sell, and he wanted eight thousand roubles, a vast price for this obscure and unacknowledged work. Costakis said, "Bring it." It took him only two minutes, he says, to look at the work, establish that it was the same that he had seen before – landscape on the back, stencilled number ten in the corner. Usually, he remarked, he would have taken an hour to study the technique, be sure there was no mistake. But here there could be no mistake, no fake. The master had authenticated the piece. That night he slept well.

Four years went by, with *Portrait of Bella* adorning the Costakis wall, along with many other paintings of Chagall now famous in the world. Then in 1959 there was a Chagall exhibition in Hamburg, a very important one. Chagall wrote to Costakis. Could he come to Hamburg himself, and bring his Chagalls to be part of the exhibition? Not so easy. But at this time, at the height of Khrushchev's power, the Russians were beginning to realize that even if Chagall was forbidden at home, he could be useful outside the country. And Costakis was the prime collector. So after a lot of trouble he got his exit visa and went to Hamburg. There began the decline of his relationship with Chagall. In his testament it is possible to hear Costakis' disappointment – more, his anger and his sense of betrayal. Nor was there ever a reconciliation, although until their last meeting, in 1973, they maintained a civilized relationship.

I had thirteen or fourteen Chagalls at that time, including this one of an old woman, his granny, the *Portrait of Bella*, and others. It was very hard to get permission to leave Russia, but finally I got it, and arrived in Hamburg literally three or four hours before the opening of the exhibition. The hanging of the pictures had already taken place, and I came along with my works. Chagall himself wasn't there, but his daughter Ida was, and the curator, who had written a monograph about Chagall. They and the director looked at the works. Suddenly the curator said, "Yes, the old woman, it's Chagall, but we're not going to hang it." Ida said, "I agree." I said, "Why not?" "Well, Costakis, this is a very important exhibition. As the English say, 'To be, or not to be.' Today will decide the future of my father. Is he going to be the top artist in the world or not. So everything has to be absolutely choice." I said, "Ida, this is an incredible stupidity, because this

work [the old woman] was done around 1906 or 1908 – very early Chagall. Everyone knows that he worked in grey-brown tones in those days. And," I said, "I'm not a Jew, but when I look at this piece I think I want to weep. It's the Jewish Mother. How can you refuse this work?" Well, they didn't hang it, but later this piece hung in the Louvre, and the Louvre wanted to buy it, they wanted it badly. Never mind.

As for the *Portrait of Bella* and the landscape on the other side, the curator said, with the director and the museum workers standing there, that it was a big fake. I said, "How can it be a fake, when Mark Zakharovich himself told me it was his work?" "Well," they said, "he's an old man." So Meyer was a bit embarrassed, but he didn't change his decision. Then the show closed. It went to the Louvre, three or four other places, and that was that.

Still more was to come. Back in Moscow, Costakis had a letter from Chagall, thanking him for his contribution to the Hamburg show ("very precious works") but commenting on the *Portrait of Bella*. "I've got to have another look at it," wrote Chagall, "and be absolutely convinced that it's really mine." In the meantime, Costakis, in his charitable way and with his passionate sense of family, had been trying to help heal a rift between the painter and his sister Aniuta, who had never left Russia, and lived in poverty in Leningrad. As part of this labour, he and Zina invited Aniuta to visit them in Moscow. Walking for the first time into their apartment, she spotted the *Portrait of Bella*, of her sister-in-law, standing in a corner, with double glass because of the landscape on the other side. "Oh," she said, "that's Bella." I said, "Yes, and your little brother says it isn't." "What rubbish is he talking?" she said. "I remember perfectly the name of the seamstress who made this dress, with green thread, for Bella. And Bella wore this dress for seven years, because in those days the Chagalls weren't as rich as they are now. What are you talking about? I remember this portrait perfectly!"

So Costakis, who was nothing if not stubborn, wrote to Chagall, told him about his sister's visit, and reminded him of their evening in the Vence café, when Chagall had volunteered to sign a photograph of the work, authenticating it as his own. He had a nice reply from Chagall. "Life is very pleasant here in France. We have blue skies – azure – and my soul is bursting with joy. I am loaded with work, working from dawn to dusk." But about the picture, not a word.

Some years passed. Costakis found himself again in Paris; trips abroad had become relatively easy for him by this time. There he met Chagall.

He took me to a famous restaurant, on the island there, where you see the cathedral of Notre-Dame de Paris. There were sausages hanging from the ceiling, and hams. Waiters in aprons with their sleeves rolled up. They laid a table for us. Everyone ordered for himself, but Chagall just asked for the chef's special. So they brought him a big dish of some kind of soup with a big onion in it, potatoes, a chunk of meat,

vegetables, some kind of bouillon. He ate it all, and then they brought us cognac. No name on it, just a number typed on a piece of paper. Wonderful cognac.

So we left the restaurant. Chagall took my arm. "You know, Costakis, I am now a very famous man. But there are a lot of fake paintings around. Not long ago I was brought a Chagall from Moscow. The experts in London said it was genuine, but it was a clear fake. And this piece was brought to me by the chargé d'affaires of Iran." I told him I had seen this work. "This woman came to my place and showed me this piece. She bought it in a commission shop on the Arbat. I told her it was a fake, copied from three of your paintings, and she should go back to the shop and ask for her money. Obviously she didn't take my advice." Chagall turned to his wife, who was walking behind. "There you are, Vava. I told you Costakis was a man with an eye. He knows my work." We walked on. I said, "Mark Zakharovich, what about the *Portrait of Bella*?" "What should I say, Costakis?" he replied. "You know, Costakis, we artists are like women. Sometimes we say yes, sometimes no. Of course it's my work. But you know what a mess has happened. Meyer told everyone that it was not my work. Ida, my daughter, was afraid that if I recognized it, it would be bad for Meyer's reputation." I said I didn't see why I had to be the one to suffer. He said, "No, my dear chap. You know how I love you. Everything's okay. Send me a photo of the painting, and I'll sign it." His wife Vava, walking along behind, said, "You see, Costakis, everything's all right. I knew that in the end he would say it was his painting."

Well, thanks be to God, I came safely back to Moscow. I sent him a photograph. And I got a reply. But no photograph. "You know, Costakis, I think it would be a good idea if you brought this oil to Paris. Then I would sign it here." A few more months went by. Another letter. "You know, I think it may be the work of my teacher Pen [Yury Pen, Chagall's first art teacher, in a private school in Vitebsk] because Pen envied me a lot and wanted to do something in my style. Then Chagall's daughter Ida came to Moscow. I asked her what her father was talking about. "How could Pen paint a portrait of Bella? He wouldn't let anyone near Bella. Robert Delaunay [French painter 1885-1941] tried to paint her, and Chagall nearly cut his throat. It was a big scandal at the time. So how would he let Pen paint her?"

To this Costakis got no answer, but a few years later, in 1973, Chagall himself made his much-publicized visit to Moscow, the first of the returning artistic expatriates whose fame abroad made it impossible for the Soviet authorities to ignore them any longer.

I met him with a big bouquet of roses, flown in from Finland. One for each year of his life, and he was eighty-eight. He received them like a patriarch. Everybody in Moscow invited him – famous ballerinas and well-known people. He went to almost none of these – I think two of them, one in Moscow and one in Leningrad. But he came to see my collection. He prowled around all the rooms, looking at the walls, literally

touching every work with his hands. They were his friends: Olga Rozanova, and Popova, and Rodchenko, Tatlin, Malevich. "Ah! There it is. I remember it. We were friends. Malevich was a very good artist, an excellent artist. We quarrelled a little, but afterwards, we became friends. And look! How wonderful: Olga Rozanova! I remember her! Costakis, you have done a great work here. I can't believe my eyes. They ought to give you a medal." Then he went up to a wall with nothing but Chagalls on it. He knew every work as though they were his own kin. "I'm ready to buy them all, if they're not too expensive," he said. I said they were not for sale. Then with a trembling heart I went into the next room, and brought back this "Chagall-not-Chagall," the *Portrait of Bella.* "Mark Zakharovich," I said, "you promised to sign this, and you have said three times that it's your work." I laid it in front of him, and he looked at it. Then he turned to his wife. "Vava, what do you think? Is it me?" "I very much doubt it, Mark," said she. "Costakis, my dear chap ..." And that was that.

So they drank tea, took photographs (one of which, as we have seen, was to appear fifteen years later in a Moscow newspaper, the first fruits of glasnost), and Chagall signed the Costakis' guest book, illustrating his signature with a little drawing of a pair of roosters. Then some of Costakis' "young painters" arrived, having been invited to meet the master. Chagall asked them why they didn't come to see him in Paris. They replied that even if they could get out of the Soviet Union, they would never be able to come back, and they didn't want that. "In that case," said Chagall, "better not come. Artists have a hard life in Paris. For years I couldn't make ends meet." Then he asked them how they made a living in Moscow. Volodya Yankirevsky, a young painter, replied that he managed to make a living by doing graphics and illustrations for books. "Then don't come to France," said Chagall. "Nobody wants illustrations there. If by chance there's a job doing illustrations, you can be sure there's some artist sitting on it. You'll have to wait, and you'll die before he does. So you'd better stay here."

Costakis thought the same:

In the course of this period, when I was collecting both the avant-garde and the young artists, the young artists were selling, of course, for low prices: three hundred roubles, five hundred roubles, some maybe for eight hundred to a thousand roubles. Not more. And everyone talked about them and felt sorry for them, especially foreigners, who said that the situation of these artists in the Soviet Union was tough, and they were given no opportunity to exhibit, and so on. But with hand on heart, I have to say that the situation wasn't like that at all.

This group of artists, twenty or thirty of them from Leningrad and Moscow, who worked and painted their pictures [in their spare time], they had their clientèle. Generally speaking these were foreigners, various

ambassadors, embassy counsellors, foreign correspondents. Occasionally a poet like Yevtushenko might buy from them, or a writer. They survived. Because if, let's say, an artist sold one picture a month for five hundred roubles, that was enough for food, paint, canvasses and sketch-books. Not a fat life, but a life. If you compare them with the thousands of "official" artists, whose studios were piled up with hundreds, even thousands of canvases, you'll see that these were in a worse state than my young artists. Because people paid

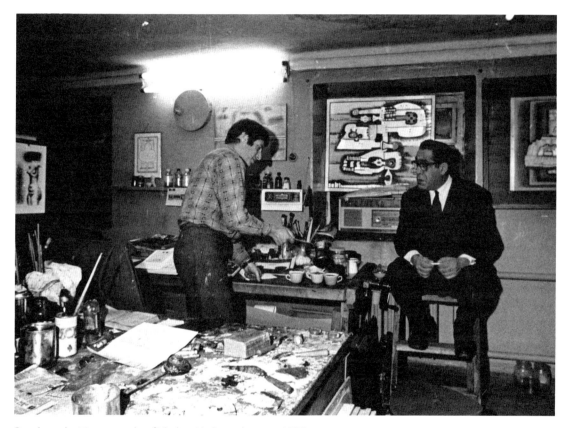

Costakis in the Moscow studio of Vladimir Yankiryevsky, circa 1970.

attention to the young artists. Foreigners came to see them. Their names were known, artists such as [Oskar] Rabin, not to mention Ernst Neizvyestny. People asked how to see their work, and bought it. They even wrote about them. Sometimes on the radio, on Voice of America, and Deutsche Welle, these also spoke of them. So in this sense they were winners, in a better situation than the official artists. Because the official artists depended entirely on the commission stores, which once or twice a year would buy something from

members of the Moscow Artists Union, so they wouldn't die of hunger and could pay the rent on their studios, even though the rent was only seven or ten roubles.

I was acquainted with many of these artists, most of them simply bad. So they would participate in a show and sell something, and they would say, "You know, Georgii Dionisovich, this is pretty good. Here are my drawings from the war, and the commission shop has bought them for two hundred roubles." As a matter of fact ten roubles would be too much. For two or three paintings, maybe they got eight hundred roubles. But these bandits like Gerasimov [Aleksandr Gerasimov, establishment Soviet painter, responsible for many heroic pictures of Stalin and other Soviet leaders], and others, members of the academy, at the same show they would get twenty or thirty thousand roubles, maybe even fifty thousand.

But the others were totally unknown, and their works, bought for five hundred or six hundred roubles, were never shown. They piled up somewhere, lay around for years. Then, occasionally, maybe some of them might be given to a state holiday resort or something similar, to cover the walls. And what was left of them after ten or so years was written off and chucked out.

Indeed, there were exhibitions of unofficial artists during Costakis' last years in Moscow:

In Moscow there were also lady collectors. There was Liudmila Kuznetsova, and a second whose name I've forgotten, but also very interesting. They had a salon, and exhibited the work of the young artists, sometimes sold things. But their business always ended with a scandal, because they gave it all so much publicity. They would organize an exhibition, hang up some stuff, and then they'd start phoning the Americans, the British, the French. Come on over; we're having an exhibition. They came over, and behind them came the KGB. A big scandal, Oi! Oi! Oi! And next day you could hear the result: Voice of America, or the BBC, broadcast that in Liudmila Kuznetsova's salon there was such and such an exhibition with this that and the other on display … Then the KGB would close the show down, and there would be a big public scandal. For the lady collectors it was the stuff of life; they loved it. I said to them, to these girls, I said, "Why do you have to do this? Make your exhibition, people will come and look and go away. Why create such a sensation?" "Because it's amusing," they replied. Then the KGB smartened up a bit, and started to ignore the whole thing. They knew there was an exhibition, but they didn't bother going. There were no police cars, nobody got stopped. The organizers of the exhibition looked in every direction. Nobody was being followed. Quiet and peaceful. And the exhibitions began to fail.

So Chagall went back to France, and Costakis was left with his Chagall-not-Chagall, which he kept, "gathering dust in Greece," but never hung. It was in limbo, part of the collection but not part of it. He might have sent it to experts for authentication, but never did so. He said that if you had a

Costakis (in the sheepskin collar) at an underground exhibition of "unofficial" art in Moscow, c.1970.

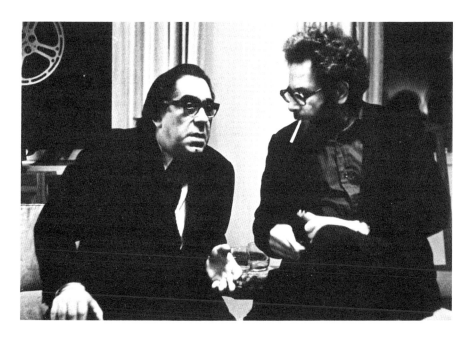

Costakis with American sculptor George Segal, Moscow, 1975.

good eye for tiny detail, you could often establish whose work you were looking at just by looking at it. Thus he satisfied himself that one of his best-known Chagalls, a painting of an old Jewish woman in a traditional dress, was indeed by Chagall, by recognizing that a tiny but complex pattern of rose petals ornamenting the dress was identical to a pattern in an already authenticated Chagall gouache. He was convinced that he, and the world, were cheated of an important work of art in order to preserve the professional reputation of the Hamburg museum curator who had refused it for the 1959 exhibition. And although he would never have said so, he clearly believed that Chagall knew perfectly well the work was his but lacked the courage to claim it in the face of his determined wife and daughter.

The bad taste left in Costakis' mouth was made more sour by Chagall's behaviour towards Aniuta, his sister. Thinking that Chagall would like to be reunited with her, Costakis had made a point of tracking her down, even sending Zina to Leningrad on this errand. During one of his visits to France he told Chagall about Aniuta, saying that she longed to be invited to France to visit him, or if not herself, then her daughter. He got the following response:

You know, Costakis, I've thought about this, and I think it's a bad idea. You know why? I'm an old man, and as you know, old people don't have very good health. My sister Aniuta is also not young. We haven't seen one another for over fifty years. And if we meet, the first thing that will happen – we'll start crying. We'll cry, and we'll suffer. It would be bad for us both. And then, I couldn't think of taking her in permanently. You know, she comes for a month. You tell me that she's living in one room in Leningrad, in hard communal conditions. And here she sees that her brother lives in a house with ten rooms, warm, with a garden, with servants. So after her month here, she's sure to find it very hard to go back to what she has in Leningrad. So it's a bad idea.

"In short," said Costakis, "he refused." And that was not the only unpleasantness involving Aniuta. Although (so Costakis thought) Chagall did not see his sister during his 1973 visit to the Soviet Union even though he went to Leningrad, his daughter, Ida, did. She was in search of Chagall works and knew that Aniuta had some, in particular a dress which Chagall had designed for her. Other relatives in Leningrad also had some paintings, and these Ida Chagall bought. But calling on Aniuta, she learned that the dress had become worn, and Aniuta, so she said, had thrown it out. This philistine act was duly reported to Chagall. Some time later Costakis was again in France. As he was leaving, Chagall took down a book and signed it to Costakis with an affectionate message and another little drawing. Costakis asked him if he would do the same for Aniuta. Costakis would deliver the present upon his return to Russia. Reluctantly, the great Chagall took down another book

and wrote in it, "To Λniuta from her brother Mark." "What," said Costakis, "not a few rose petals?" "No," was the answer, "she wouldn't understand. She neither understands nor likes such things." Costakis, a man of infinite generosity, could not help but see that as a mean-spirited act. Costakis' portrait of Chagall, probably the greatest artist he knew well, is a realistic portrait of a human being with faults; to his credit, Costakis drew him warts and all.

◼

It is hard not to believe that the North American tour and the visits to their apartment by people as eminent, and about whom the Soviets were as neuralgic, as Kennedy and Chagall, contributed significantly to the active persecution of the Costakis family, which began during this same year, 1974, and continued for four years until they were finally driven out. When Yury Andropov made his dramatic intervention and Costakis decided not to remain in the Soviet Union, Andropov ruled (no doubt after consulting museum directors as well as his own KGB advisors) that Costakis could leave with twenty percent of his collection. How did this division, twenty percent for Costakis, eighty percent for the Tretyakov Gallery, come about, and on what basis were the decisions made? They are among the most important decisions in the story of twentieth-century art, and Costakis had something to say about them.

In *Russian Avant-Garde Art: The George Costakis Collection*, there is a photograph of Costakis, looking very much his rotund self, in shirtsleeves, standing in his Moscow living room in a welter of avant-garde art, surrounded by Tretyakov Gallery officials, most of them seeing these wonders for the first time. On a sofa his daughter Lilya takes notes. And Costakis is unmistakably laying down the law about who gets what. But he said afterwards that it was not like that. He insisted that the division of the collection was amicably done. Many years later someone remarked to him that it was a pity Malevich's *Portrait of Matiushin*, a pivotal work in the development of that artist, had stayed behind in Russia. But Costakis disagreed:

No, I was glad. You know, I never once suffered in my heart. And you know what's interesting? When I parted with this collection, I would have thought it might be like parting with my children, as though every piece that stayed behind in Moscow was like a piece of flesh cut from my living body, with the blood flowing. But it turned out differently. When I handed all this over, my wife and children were astonished at how stoical I was. But it wasn't stoicism … You know, it was comical. When Manin came, the deputy director of the Tretyakov Gallery, and we started dividing up the collection (and I have to tell you that Manin was a gentleman, a very kind person) we almost started to quarrel. He would say, "Georgii Dionisovich, you've

got to keep this piece." And I would answer, "No. This one must be for you, because it's unique, and there isn't another." That's what happened, for example, with my relief *Nature*, which I absolutely worshipped. I mean the Kliun on the cover of the big book.* And I knew that of Kliun's work, this was the only one of its kind. Once there were others, but during the war …

Costakis went on to describe how he felt at that moment, and why:

I didn't want to take this piece with me. I insisted it remain in Russia. And it continued the same way during the whole division of the collection. Because my mood was … somehow I felt like this, that my collecting was a very big affair, but why? For myself? I don't need these things, because a person's life, and my life, is very short. In ten years or twenty, I will be gone, and for me everything will be gone. So you've got to leave something behind, if only your good name. I managed to pull together these things, that were lost and ignored and thrown away by the authorities, and I saved them, and that's my service. And that doesn't mean that these things belong to me or to the people I give them to. They belong to Russia, they must belong to the Russian people. The Russian people must not suffer as a result of the stupidity of the Soviet government. So in that kind of mood it was very easy for me to hand over most of the collection, and I tried to give them the best things, and I gave them the best things. If you look in the book, you'll see.

Costakis then explained that although Soviet museums, the Tretyakov in particular, knew about the Russian avant-garde artists, were interested in them and even secretly owned considerable numbers of works, they had no real expertise and scarcely knew even the names of many of them. Fifty artists are represented in the Costakis collection. He estimated that there were another twenty or so who should be considered part of the movement but whose work he did not find. The Tretyakov experts really knew only ten or twelve. The only place in Moscow to find out about the others was in Costakis' apartment. The Tretyakov staff, like ministry of culture officials, would not have been allowed to go there even if they had wanted to. Thus the Tretyakov curators had no interest in Rodchenko, whom they considered a photographer. The division of the collection left Costakis with nearly all Rodchenko's works, although he tried to persuade the gallery officials to keep representative pieces. If they had been more perspicacious, the fine "hanging construction" now in the Museum of Modern Art in New York would instead be in Moscow.

* The dust jacket of *Russian Avant-garde Art: The George Costakis Collection* shows the work Costakis refers to. It is there titled *Landscape Rushing By.*

You can believe me, that it would have been easy for me to keep the best things for myself. I could even have kept *Portrait of Matiushin*. One of the proposals they made to me was to take it, and leave them instead certain works of Larionov, and some other things. But I said I would not take it. Because, while I lived in Russia and created this collection, I had many friends, people who valued me and treated me well. And I thought, if I take the supreme pieces, pieces like *Portrait of Matiushin*, what will my friends say? They'll say, "He had no concern for art, for the Russian avant-garde. He was out for himself. He knew which were the best pieces, and the son of a bitch took them and cleared out." Even my closest friends would condemn me. And for these reasons I didn't go that way, and I think I did the right thing.

Thus the Costakis collection, which had become famous around the world but had been seen by relatively few people, came to an end. Most of it disappeared into the vaults of the new Tretyakov Gallery, opposite the entrance to Gorky Park in Moscow; the rest followed Costakis into exile. Of that part several major works, of Chagall and Kandinsky in particular, are no longer there, Costakis having sold them at auction to provide himself with the means to live in the West ("to buy these stupid houses," as he put it). The Moscow part of the collection should, in theory, now be available to the Russian public. But in fact only some parts of it have been, although experts have no difficulty getting access to it.

Costakis' original plan for the collection was altogether different. He wanted to give all of it to the Tretyakov on condition that they exhibit it to the public, identify him as the donor, and make his daughter Lilya its curator, since she worked with him putting it together. That is what should have happened. The splitting of the collection cannot yet be called an artistic tragedy, because we do not yet know the end of the story. But it is bewildering to think that the Soviet government, and now the Russian, might have had the whole collection, a magnificent jewel in their artistic crown, without doing an injustice to anyone.

Costakis was certain that the KGB "mafia" who had been persecuting him for at least four years before his emigration, made a final effort to "get" him almost on his last day in Moscow. When the negotiation with the Tretyakov came to an end, there followed the long bureaucratic process of packing the twenty percent and getting official permission to take it out of the country. Lists had to be prepared and approved. Every work had to be photographed, the photos authenticated and stamped. In the Soviet Union these were interminable procedures. Finally everything was ready. Costakis borrowed the embassy truck, loaded his precious freight, and headed for the customs house, where he had gone, on the embassy's business, at least weekly for the previous thirty-five years. He took sandwiches and tea with him, knowing that he would be there many hours. The head customs officer, Boris Borisovich Klucherev, was an old friend, but Costakis did not rely on that to get him by easily.

Passage of goods across the Soviet frontier was a serious matter, almost as serious as the passage of people. Customs officers were diligent.

But this time he was wrong. Klucherev greeted him cheerfully and shuffled absently through the pack of authenticated photos which Costakis handed him. "Okay Georgii Dionisovich, you can load them." Costakis was incredulous. "Aren't you going to look in the crates?" "We trust you," was the reply, surely the first time those words had been heard in that place. Obviously the message had come down from high places.

Relieved, Costakis went home to pack his bags. Never a tidy man, he began to discover some art works he had neglected to include in the boxes which he had just despatched. There was a roll of drawings, some works of his "young artists," all things which had not been part of the Tretyakov negotiation, but which he had permission to take with him. Then, looking under beds and in cupboards, he came upon a painting by Kliun, an important work which he did not have permission to take. And there was no time to get permission. Furthermore, his daughter Natasha, who was staying behind and moving with her family into the apartment, discovered three sixteenth-century embroidered wall hangings from Samarkand. Nothing special, said Costakis, but definitely museum pieces. Natasha insisted he take these, "because Mama likes them and you'll want to hang them in your new house," and Costakis similarly persuaded himself that he should take the Kliun. Presumably this box, like the others, would pass without examination. So these things were put in the box with the rest, the top nailed on, and the whole wrapped in strong brown paper.

But the Kliun worried Costakis. He knew that his enemies would be glad to go to Andropov and say "We told you so. The man is a crook. You've been too soft on him." That night he couldn't get to sleep. He remembered a Russian proverb to the effect that an unloaded gun won't go off ninety-nine times, but the hundredth time, it goes off. So in the middle of the night he opened the box and removed the Kliun. But he forgot all about the Samarkand wall hangings.

The next day was fixed for the final departure of Costakis, his wife and their son. Two daughters had gone ahead some days before, Natasha would stay behind. Early in the morning Costakis went with his box to the customs house, expecting no trouble now that the Kliun was gone. He had stamped photographs, he thought, of all the remaining contents. This last box would be loaded on the Interdean truck, with the others, to be shipped to the West, and the family would go to the airport to leave forever.

The reception at the customs house was not the same as before. Boris Borisovich, it seemed, had other business. A junior customs officer took charge of Costakis, who handed over his pack of photographs. The officer "started to play cards with them." He looked at them once, then twice, then three or four more times. "What's the matter?" asked Costakis. "Do you want to look in the box?"

Very deferentially, because he too had known Costakis for a long time and plainly did not enjoy his duty, he said, "Yes, Georgii Dionisovich, we've got to open the box." And at that moment two strangers in civilian clothes joined the group. KGB, said Costakis to himself. But he still thought, with relief, only about the absent Kliun, and not about the wall hangings, which not he but Natasha had put in the box. The top of the box was pried off. Suddenly it came to Costakis what the very top objects were. Museum pieces, and no permission to take them out. A criminal offence. Worse than the Kliun. "I felt close to death," observed Costakis. The customs officer was now joined by another. Together they began to rummage through the contents of the box. Costakis was convinced they expected to find the Kliun, were certain it was there, were looking for it. Fear drove him into action. He told them they were mishandling these works of art. He would take things out for them. So getting down on his hands and knees, he performed what he says was a miracle of sleight-of-hand. First, he squeezed the wall hangings to one side of the box and fished out a roll of Zverevs. "Hand them over." Then he pushed the wall hangings with his other hand to the other side, keeping the brown paper over them, and pulled out other paintings. "Give them to us." Finally, still terrified, Costakis decided that attack was the best defence. "Get an axe and we'll break the box," he shouted. "Nobody needs this comedy." "Close it up," they said, and he was safe. The box was destined to a German museum. The curator who received it reported to Costakis some time later that "it looked like civil war in there."

Rightly or wrongly, Costakis was certain that the KGB knew, or thought they knew, that he had an illegal work of art in the box. He even thought he knew how they knew, suspecting a person who was at the time but later ceased to be a member of his family, not his wife or any of the children. He had the same suspicions, involving the same person, about many of the events of the previous years: the thefts from his apartment, the fire at his *dacha,* the attempts at compromise and entrapment. And those are the memories he took with him from Russia in January 1978.

The rest of the story is not long. According to Angelica Rudenstine, who was destined to play an important part in the future of the collection, when Costakis got permission to leave the Soviet Union with twenty percent of his collection, he had no idea where either he or it would go. But not long before, two German businessmen working in Moscow had seen the collection and had put Costakis in touch with the director of the Düsseldorf Art Museum, Wend von Kalnein, who offered to exhibit it. Costakis accepted. The crates loaded on the Interdean truck in Moscow were therefore destined for Düsseldorf, and in that city took place the first exhibition of the Costakis collection beyond the walls of George Costakis' Moscow apartment. Costakis started collecting the avant-garde in 1946. The world had waited more than thirty years for this revelation. And of course only a fraction of the collection was there to be seen. The director of the Guggenheim Museum in New

York, Thomas Messer, and two of his curators, Margit Rowell and the same Angelica Rudenstine, had also seen the collection in Moscow, and later they saw it in Düsseldorf; impressed, they proposed to Costakis that he entrust it to the Guggenheim for "thorough study, conservation and documentation as necessary," preliminary to a world tour. Costakis agreed. From Düsseldorf the collection went to New York, where it opened at the Guggenheim to an intensely interested New York public on October 16, 1981. In his catalogue note on the occasion of the opening, Thomas Messer observes dryly that in the design of the exhibition Costakis "asserted a lively interest but not a determining voice." That is to put it diplomatically. Costakis, not accustomed to polite language, said, "They treated me like a nigger who has found a jewel and doesn't understand its value." Speaking even more bluntly, he added, "They castrated me."

What was all this about? First, Costakis thought he knew the West and its ways from his many trips, but in fact he did not. It was the Guggenheim Museum which had found a jewel, they did know its value, and they were, perhaps rightly, not willing to let anyone beyond their own eminently qualified staff make decisions about how to exhibit these wonders. What upset Costakis was that in putting together the exhibition at the Guggenheim, the curators rejected what he considered the great central pieces of his collection, the great Chagalls, the great Kandinskys, on the grounds that New Yorkers who frequented contemporary art exhibitions knew Chagall and Kandinsky but did not know Redko, Rozanova, Rodchenko, Kudriashev, and Klucis. So, Costakis believed, the exhibition at the Guggenheim was crammed with relative trivia, far too many minor works, while the great works were omitted because the curators wanted to titillate their viewers with novelties. He believed, moreover, that the most important of the lesser-known artists were omitted in favour of those who were just beginning to become fashionable. Kliun's name was known, and he was favoured over others who were, in Costakis' view, as artistically important. Worse, he believed the same was true of "his" book, *Russian Avant-Garde Art: The George Costakis Collection*, which was made by essentially the same people who made the exhibition at the Guggenheim. In the book as in the exhibition he thought there were too many minor things to distract the reader's attention from the masterpieces:

And what they did, they took the whole collection as it was and tried to put in everything, everything – which was wrong. When you turn the pages, you see a ring with a big emerald. Then you turn more pages, and you see a silver ring with a stone that is worth nothing. And they are all crowded up together. For example, they have many drawings and gouaches of Larionov, none of them of great importance. I would have put one of his big gouaches, or his *Soldiers*, or the big one with the prostitutes. All of that. But not those small things.

The calamitous outcome of all this, Costakis later came to believe, was that it distorted his hitherto impeccable judgment about his collection and the works in it. If the great Guggenheim did not want to exhibit his Chagalls and Kandinskys, perhaps they were not what he had thought. He had to sell something, to support himself and his family. What to sell? What better than these rejected works, which seemed to have a good market value despite the museum's refusal to exhibit them? So he sold them, for very large amounts, and thereby made himself rich, but made his collection poor. Or, more accurately, less rich. And less seductive in the art market.

The Guggenheim Museum would, quite properly, dispute this version of events. As they saw it, they had picked up Costakis and his collection from a kind of no man's land: once again, according to Angelica Rudenstine, who with Margit Rowell curated the exhibition and who herself edited "the book," Costakis had no idea when he left Moscow what he would do next. The Düsseldorf exhibition was arranged, but nothing else, not even where he and his family would live. The Guggenheim organized an exhibition, which drew extraordinary attention in New York, and a subsequent tour of the United States and Canada and many European cities, which made Costakis rich and famous. They were the experts in putting on exhibitions in New York, a highly specialized market. What was Costakis complaining about?

In any case, there was some compromise, according to Costakis. "They agreed to put in one or two works of the painters they hadn't wanted to show. And the exhibition opened." It opened, and Costakis, who liked to be lionized, was. He thoroughly enjoyed his moment in the sun:

What can I tell you? Before the exhibition, the *New York Times Magazine* carried a big article [October 11, 1981] with Popova on the cover. And Tom Messer told me that it was the first time for thirty years that something from one of their exhibitions had been on that cover. The first time. The article was by Hilton Kramer and was very interesting – seventeen pages of text and illustrations, including the Rozanova *Green Stripe*. Kramer says in the article that in the United States this kind of painting didn't begin until the sixties, and that "the Russians were forty years ahead of us." It was a great success.

Of course they had a black-tie reception, and many people came, and speeches and so on. On that day I gave as a present to the museum a big oil by Popova, which is hanging there now. And the next day was the opening for the public, and the museum was full. People going up and down, up and down. One man came up to me and said it was like an Orthodox Church at Easter, except people weren't carrying candles. They stayed many hours.

The next day, and every day, many people came. There were painters and art critics, crowds of them, standing there and staring at the small works of Kliun, Popova. It wasn't like an ordinary exhibition, with big paintings, big names, and not many small things. This was a kitchen, a kitchen of the avant-garde. There

were some big, beautiful Popovas and Kliuns, but they were paying more attention to the small things. Altogether I gave about thirty interviews to the press. And I had to stay in New York and pay my own expenses – it cost about twenty thousand dollars for those few days. But it was a great pleasure.

I gave a lecture in New York University, and I had a cold reception. The Americans are patriots, and they like to think their art is the best.

The difficulties with the Guggenheim curators were patched up, and Costakis remained on good terms with them. But despite the success of the New York exhibition and of the world tour which followed, he harboured a feeling that his "children" were not properly assessed. He recalled his conversations with the curators. By his account, he told them they should hang a work called *Dynamite*, by Kliment Redko, one of Costakis' personal discoveries. They told him it was not an important work (but included it in the exhibition, one of their concessions to Costakis).

Look. People like you came to see me in Moscow twenty or so years ago, and I showed you Popova and Kliun, and you'd never heard of them.* You knew Chagall and Kandinsky. Then you thought Popova and Kliun weren't important. Now you know all about Popova and Kliun, but you think Redko isn't important. Never say something is good or bad. You can make a big mistake. Don't be in a hurry to put stamps on things.

The exhibition closed in New York on January 3, 1982, and then went triumphantly on to the Museum of Fine Arts in Houston, (February 15-April 15), the National Gallery of Canada in Ottawa (June 25-August 22), the Museum of Art in Indianapolis (October 25-December 15), and the Museum of Contemporary Art in Chicago (January-March, 1983). The Ottawa event was a success this time, despite the fact that the National Gallery was not then in its magnificent new quarters near the confluence of the Ottawa and Rideau rivers, but in a decaying and hopelessly crammed downtown office building. There were no policemen, Costakis no longer being part of the Canadian public service, nor were there any wrong announcements. The bad memories of the 1973 visit, while not erased, were somewhat eased. The exhibition was crowded, an unusual event in Ottawa. Friends once again arranged a dinner, and two of them, Marshall and Doris Crowe, took George to the country where, in a barn, he practised his new-found hobby of painting and left a respectable work behind, perhaps to compensate for the anxiety he had caused his hosts by chain smoking in a loft full of dry hay.

* Costakis' memory was often faulty. Angelica Rudenstine first met Costakis in New York in 1973 and first saw his collection in Moscow in 1977, when she was there for an international conference on icons. The division of the collection had already taken place.

Then followed the European tour, starting in Stockholm at the Moderna Museet (May-July, 1983), going on to the Royal Academy of Arts (Burlington House) in London (September 15- November 15) and the National Art Institute and the National Gallery in Frankfurt-am-Main (January-April, 1984), and ending at the Kaupungin Taidemuseo in Helsinki (June-September, 1984). In London, at Burlington House, George was introduced to the Queen, and later had dinner with Princess Margaret. These were high moments. In Stockholm Costakis was dissatisfied with the presentation of the exhibition (as much as, a few months later, he was delighted with it in London) but nevertheless made a present to the museum of a late figurative work of Malevich, the delightful *Portrait of Una*, of which every tourist in Stockholm can now buy a postcard reproduction at the museum shop. His motive here was to honour the country whose doctors had saved his life. Pleased with this, the Swedish King conferred on Costakis a high honour by making him a member of the Royal Order of the Northern Star. Later he was given, by vote of the members, honourary member- ship in the Swedish Royal Academy of Fine Arts. The Moscow street urchin and truck driver had come a long way. He had jokingly said that the Politburo would be next, but for him it was enough to be an established figure in the outside world, and he knew in his heart that his place in Russia awaited him.

These extensive travels completed, the collection returned in 1985 to New York, where, with the help of Angelica Rudenstine, Costakis found a warehouse to hold it in reasonable security. Since then the collection, or pieces from it, have emerged from hiding twice, once to be exhibited in Dublin as part of the 1988 Rosc, the annual Irish visual arts festival, and once, in 1989, for a major and very beautiful exhibition in the Montreal Museum of Fine Arts. Costakis, then in a wheelchair and seventy-seven years old, went to Montreal for this event and afterwards travelled on to Ottawa to meet his old friends from the Canadian embassy. His arrival in Montreal showed that nothing had changed about the man. After the long flight from Athens his solicitous hosts asked him what he would like: tea, a drink, a rest? None of that. He wanted to go straight to the museum to see his "children." He went around the gallery looking intently at each of them, just as he used to do in his Moscow apartment when he came back from a trip. It had been several years since their last meet- ing, and he took his time about this survey. Then he declared that he had never seen them so well displayed. Indeed, the museum had been generous with its space and immensely discriminating in the way it had displayed the works. There was speculation in the Canadian newspapers that the museum had tried to buy the collection, but could not meet Costakis' price.

There was a second exhibition. Some time after he had settled in Athens, and when poor circula- tion in his legs began to cut into his activity, Costakis himself took up oil painting as a hobby. He was astonishingly prolific, and according to the experts, showed steady progress in the quality of his

work. He took with him to Montreal a selection, some eighty or ninety works, and exhibited them to friends and well-wishers in the handsome downtown gallery of Lavalin Ltée. Costakis had another one-man show, in Stockholm, where several of his paintings sold for good prices. His highly personal style borrowed nothing from the Russian avant-garde; it was rather a kind of naive impressionism. At first the subjects were what Costakis could see in front of him in his suburban Athens home. Then he began to paint Russian landscapes from memory and from photographs: villages, churches, cemeteries. One of these, obviously from memory, is of the gulag at Kotlas, where he visited his brother in 1938. Some of his later works are symbolic. One of them, *The Graveyard of the Avant-Garde,* shows a number of flat gravestones in the shape of the quadrangles and triangles which were the hallmark of Malevich and other avant-garde artists, and was painted in celebration of the rehabilitation in Russia of the Russian avant-garde. Another has a geometric row of leafless, skeletal, trees above a brilliantly coloured field or sea, perhaps the dying and the new, a symbol of what Costakis thought was happening in his own country.

BRIDGEHEADS

he work George Costakis did between 1946 and 1978, and the collection resulting from it, is the single most important bond linking the artistic and cultural life of Russia with its pre-Stalinist past.

Mikhail Gorbachev became General Secretary of the Soviet Communist party in 1985. By 1986 it was clear that he was serious about his reform program, its political and cultural aspects as well as its economic ones. However, as the poet Andrei Sinyavsky remarked, it turned out to be easier to publish *Doctor Zhivago* than to make a decent salami, and in truth perestroika (restructuring) prospered much more in Soviet cultural life than elsewhere. If in the national economy the instinct to innovate, to look at the bottom line, to accept responsibility, to insist on quality, to work hard in exchange for a profit had all been lost during the years of central planning and control, no such phenomenon had occurred in the cultural realm. With the dead hand of state interference removed, the artists seized their brushes, the writers their pens, the publishers their presses, and the new era began more or less over night. It is too early to judge the quality of what appeared on the cultural market, but neither the quantity, the enthusiasm of the practitioners, nor the interest of the outside world is in doubt.

The contrast between the cultural and economic sectors is instructive. Why would industrial managers resist the new responsibilities Gorbachev tried to give them? Why did they have to be sent to school in Britain and Germany to learn how to manage? Why should many collective farmers be indifferent to the opportunity being offered them to farm on their own and make some money? And why, on the other hand, did artists return to their artistic business as though there had not been a ghastly creative wilderness stretching over more than two generations?

The answer is surely that beginning in 1928 the bridges in economic management, which might have linked the new with the old and provided some continuity of experience, were remorselessly demolished. The peasant market continued, in a modified form, and a lively black market sprang up before the revolution was a week old and survived into Gorbachev's time and beyond. But at the level of high management, of making the economy work, no memory and no skills remained from the wicked days of capitalism. Years of propaganda and relentless central control had washed the national psyche clean; whatever desire had once lingered, as during the NEP period of the 1920s, to return to those times, had been truly extinguished within ten years of Stalin's taking power. When the Soviet people were told that there was something to be said for, and learned from, capitalism, they looked back over the chasm stretching away to 1917, and found the far side invisible. To the best of their knowledge, they had never been there, or if they had, they retained no memory of it.

The same, and we may be thankful for it, was not true of the arts in Russia, and the Costakis collection was at the centre of the distinction. In the five years before the October Revolution, Russian art occupied a unique place in the world. Later, with the avant-garde movement collapsed, its works apparently vanished and the artists themselves in obscurity, Russian art seemed doomed. But the labours of George Costakis between 1946 and 1978 preserved what those artists had done and built a permanent bridge over the gulf separating them from contemporary artists. Moreover, the bridge went by way of an island, also created by Costakis, the island of the young artists such as Anatoly Zverev and Dmitri Krasnopevtsev who gathered in the late 1950s and early 1960s at Costakis' apartment to view their artistic roots: the works of Malevich, Popova, Kandinsky, Rozanova. And, even more important, again thanks to Costakis, they were able to practise their art "unofficially" and to eat while doing it. The Costakis collection was one of the bridges, probably the main one, linking the old Russian civilization with the new, crossing the cultural void of Stalin and his successors before Gorbachev. In the industrial and agricultural economy there were no such bridges, or few, and that is one reason Gorbachev found his task so difficult when he came to power.

That Russians knew after 1988 what Costakis had accomplished is clear. There were articles in the press, exhibitions in Moscow and Leningrad of the work of Malevich, Popova, Rodchenko, Filonov, a conscious effort on the part of editors and even public officials to bring these wonders to everyone's attention. What is less clear is whether artists could, or wanted to, accept the challenge.

G.D.G. Murrell, a British writer who knew the scene as well as anyone, wrote (*Survey*, December 1988) that "the other major question [in addition to the question of whether it is possible to turn the clock back] is whether, when the suppressed manuscripts finally run out, and when the last banned film has been taken from the shelf, younger writers and artists can respond to the relative freedom they now enjoy, pick up the torch and maintain the extraordinary momentum of the past two years."

Russian artists themselves ask the same question. One painter talking to a Western journalist (*Encounter*, July/August 1989) described what it was like "having freedom suddenly thrust upon you": "The first thing you discover as you emerge from the underground into well-lit galleries full of the works of your contemporaries as well as your own is that dissidence is not synonymous with genius." The same artist went on to describe his confusion and perplexity when he saw his first, "still inspiring," Malevich, then later encountered what that tradition had turned into in the hands of some of its Western inheritors: "The bloated and literally decomposing Rothkos in Harvard University – the healthy seeds alongside the suppurating fruits … like being parted from your child at birth and meeting him when he is verging towards senility." Continuing in this vein, the Russian painter anticipated three trends in contemporary Russian art: a blossoming of political protest art, indiscriminate imitation of Western models, and a decline of technique. There is a certain amount of evidence to support his apprehension. Costakis himself was bemused and concerned about the attention being given to, and the prices paid for, works by young Russian painters which were, he maintained, "interesting, but no more."

What we have been witnessing in all parts of Soviet, then Russian artistic life – except perhaps in the most conservative, ballet – is a rediscovery of what was lost. The view is retrospective. At the Toronto film "Festival of Festivals" in 1989 there was a focus on Soviet (mainly Russian) film. The organizers of the festival managed to obtain a number of interesting Soviet films made in 1988 and 1989. But in Toronto as in Moscow, public and critical attention went mainly to the much larger retrospective of older Soviet films, *From Stalin to Glasnost*. The star of them all was Aleksandr Askoldov's *Kommissar*, made in 1967 and suppressed by the Soviet authorities before it was seen by anyone but them.

So also in literature. Russians want to read what was so long forbidden, including the works of émigré writers such as Solzhenitsyn and Brodsky as well as the buried poets and novelists of the 1920s. Ghosts rise from the mist, such as Vladimir Dudintsev, whose 1956 novel *Not By Bread Alone* was an early post-Stalin venture into real, if timid, social comment. It got Dudintsev into quite a lot of trouble; he published nothing more until 1988, when his new novel, *White Overalls*, appeared, and won a state prize. The re-emergence of this figure from the fairly remote past was surely another act of retrospection, a sign of the intensity with which Russian artists and the Russian public have been preoccupied with what went before. Anatoly Rybakov's *Children of the Arbat*, an instant success in Russia as abroad, was actually written in the Brezhnev years but not passed for publication until glasnost made it possible.

And in the theatre, although in the late 1980s there were plenty of contemporary plays, public fascination was with such things as Yury Liubimov's early '80s version of *The Master and Margarita*,

Bulgakov's novel completed in 1940, and with why the same director's treatment of Pushkin's *Boris Godunov*, a verse play more than 150 years old, should have driven the great director into a long period of exile, which only ended in 1989.

The playwright Mikhail Roshchin said: "We are living in a wonderful period of social self-cognition; we are exploring ourselves. A great cleaning up, washing, tidying up is in progress, and indeed it is necessary to sort all books on the shelves, as well as all statuettes and portraits." This perceptive remark describes the Russian artistic scene accurately. Most artists, other perhaps than performing ones, have been more concerned with peering into their past than with creating their future. One young painter, Aleksandr Semyenov, was quoted as saying about the Russian avant-garde in the 1920s (*Economist*, January 27, 1990): "Their task was an optimistic one, to create something new. Ours is to build up what has already been broken." These two artists are in fact explaining why the jury must still be out on whether there is a future for the arts in Russia, or whether Stalin and his successors crippled them forever, or for a long time to come.

At a press conference in Toronto during the 1989 film festival, film director Aleksandr Mindadzy made a different but related point:

"In Russia during the nineteenth and twentieth centuries, art has always been created in closed situations. The nineteenth-century poet Pushkin wrote in exile and all of the best Soviet pictures were made under closed conditions. We spent the government's money pretending to make what they wanted. This tradition existed in Russia before the revolution. One can say that Chekhov is a dramaturgical iceberg. When his heroes are talking endlessly of one thing while drinking tea, what they really mean is something else. It remains a big question for me how cinema and drama will develop when it is not necessary to speak in a quiet voice any more."

These are important ideas in Russia, and they help explain why the process of "cleaning up, washing, tidying," as Roshchin calls it, is so necessary before the business of creating art in a new climate can really go forward.

◢

Without exception the arts in Russia – painting, architecture, poetry, novels, music, theatre, dance – had achieved some kind of apotheosis by the time of the October Revolution which would continue for several years after. Why all these creative wonders came together is hard to explain. Some of them grew out of long tradition. The great nineteenth-century Russian poets and novelists, Pushkin,

Lermontov, Dostoevsky, and Tolstoy, were then and still are today the stuff that makes Russians realize they are Russian, far more than, for example, Dickens, Thackeray, Tennyson and Browning make the English-speaking world feel any common destiny. A writer such as Zamyatin or poets such as Blok and Akhmatova can be placed in the Russian tradition. But tradition does not explain the sudden flowering of architecture, theatre, film making and photography. A Marxist interpretation might ascribe these developments to the events following the emancipation of the serfs in Russia in 1861, when there was a vast migration of village populations to the cities, especially Moscow, with the kind of consequent social upheavals which often generate artistic and other forms of creativity. Whatever the cause, the phenomenon is there, the basis of Costakis' activity and the reason for his collection.

Costakis' contribution to the survival of Russian cultural life, if it does survive, is of unique importance for two reasons. First, although the artists whose work he collected began as painters, they were or became much more than that. Contemporary architecture, theatre, film, photography and design all are heavily in debt to the artists of the Russian avant-garde. Second, the visual arts had fewer lifelines to survival than other segments of the arts, notably literature and music, despite the fearful persecution to which practitioners of these were exposed.

Russian writing, to begin with, had its tough roots in the nineteenth-century novelists, poets, and playwrights, roots which Stalin might chop at occasionally but which not even he could destroy. Moreover, Russian literature had, and still has, rich resources in the Russian émigré world. Contemporary Russian literature, in fact, has for a long time been identifiable more through the work of Solzhenitsyn, Nabokov, Sinyavsky, Tsvetaeva, Brodsky, and other writers who are living or have lived and worked in permanent exile, than by that of such writers as Sholokhov, Kazakov, Aksyonov, Voznesensky, Yevtushenko and many others who remained at home and made the artistic and political compromises necessary to achieve publication. (Boris Pasternak remains a case apart.) That is not to belittle the achievement of those who stayed in Russia. Many of them fought valiantly and to some degree successfully, during the Khrushchev and Brezhnev years, for a better Russian literature. But if predictions are being made, a fairly safe one is that two hundred years hence the names that will have endured from this era will be names from the literary emigration.

All that may have begun to change, but perhaps not as quickly as some think. Heartened by change, writers may go back to Russia. More important, fewer will leave, as long as publication is possible for them no matter what their views or what their book says. ("Everything except pornography," say officials. But a viewing of recent films or a walk through the art markets on the Arbat and at Izmailovsky Park in Moscow suggests that even that caveat may not last long.) And those writing abroad will have a readership in Russia and the possibility of being in open and frequent contact with it. The situation may begin to resemble that of English and American literature, many of whose

important writers have lived and worked in the south of France or elsewhere in Europe without losing touch with their audience or their material. The publication in Russia of *The Gulag Archipelago*, once considered unthinkable by Western pundits, marked the end of restrictions of a political kind on publication.

Classical and émigré writers helped. And Soviet literature had another hedge against extinction. There were writers from the 1920s who managed to stay in the Soviet Union and go on writing. Some were famous: Chukovsky, the creator of marvellous children's stories and fairy tales, who somehow continued writing through all the most difficult years and thus became a more important formative influence on Soviet children than the Communist party could ever hope to be. Pasternak, who stopped writing poetry in the worst times, but continued publishing translations from English and German while he worked secretly on *Doctor Zhivago*. Others, like Ilya Ehrenburg, who had to perform the most painful personal and political contortions to reconcile his ideas with those of the regime, nevertheless carried some kind of literary tradition through to and beyond Stalin's death in 1953. Valentin Katayev and Konstantin Paustovsky, less well known to the Soviet public and largely unknown abroad, managed to stay alive and kept writing readable novels which somehow avoided conforming to the demands of the thought police. In *Cancer Ward* Solzhenitsyn has an exiled family in Kazakhstan reading Paustovsky around the fire. That was in Stalin's time, and that was how the literary and linguistic heritage survived.

Like Russian literature, Russian music had certain advantages when it came to lasting out the terrible storms of Stalin's lifetime and the artistically stifling years that followed. As with literature, there was a rich nineteenth-century tradition, all the richer because, like Russian literature, Russian music had practically no eighteenth-century or earlier classical roots and was really self-generated. Beginning with Glinka, there came Mussorgsky, Borodin, Rimsky-Korsakov, Anton Rubinstein and, at the end of the century, Tchaikovsky. Like the nineteenth-century novelists, poets and playwrights, these composers laid a base for Russian music which easily endured the years of repression. Again like Russian literature, music after the revolution had its grand figures in emigration, including one, Igor Stravinsky, who in the opinion of many is the greatest composer of our time. And there was Rachmaninoff, and for fourteen years Prokofiev, until he made the mistake of visiting Stalin's Russia in 1932 only to find that he could not get out again. There were these composers, and the Russian émigré world included as well a disproportionately large number of the world's ablest and most famous performers.

Even more than with literature, the post-revolutionary history of Russian music was a history bound together, and given continuity and significance, by the work of those who managed to remain in the Soviet Union, those composers who produced, and were performed and recorded, through all

the worst times. Among these a single bright dominating thread links the past and the future over the dark chasm: the life and work of Dmitri Shostakovich. That it was a tormented life there can be no doubt, nor any doubt that Stalin personally created the torment, beginning in 1936 with his stalking out of a performance of Shostakovich's opera *Lady Macbeth of Mtsensk.* It was a dangerous time to incur Stalin's displeasure. Nevertheless, Shostakovich survived everything (although many thought he would not, as Costakis recounted) and at his death in 1975 left behind a prodigious legacy. He remains, along with Prokofiev and Khatchaturian, the principal force in Russian music since the revolution and the principal reason for its survival through the dark days.

Above all the other arts, however, music had an ultimate advantage in the business of survival. The commissars and censors and ideological watchdogs did not understand it and had great difficulty deciding what was ideologically acceptable and what was not. They thought they knew an incorrect novel, play, or even poem when they saw it, although in the post-Stalin years writers became adept at fooling them. Stalin knew he did not like *Lady Macbeth of Mtsensk* (no doubt because of the agonizing closing scenes in a concentration camp; although it was a czarist concentration camp, these scenes probably came too close to current reality for him.) But even he had trouble knowing which keys, harmonies, modes, and themes should be viewed as politically acceptable and which not.* Thus Shostakovich and his contemporaries sometimes got away with writing music the literary equivalent of which would have landed its authors in the gulag. And that is one reason why music, together with ballet, which stuck to approved themes (the ballet iconoclasts, Diaghilev, Stravinsky, Nijinsky, Fokin all went abroad), emerged from the days of terror, repression and conservatism in better health than any of the other arts as they were practised inside the Soviet Union.

The importance of the Costakis collection becomes clear when one considers the situation of the visual arts as compared to literature and music. As the years of Stalinist oppression closed in, Russian avant-garde painting, and the architecture, film, photography, and design which derived from it, mainly during the 1920s in the period of "constructivism," had practically none of the anchors to windward which protected the other art forms. The nineteenth-century tradition did not exist for the avant-garde painters: their whole movement was predicated on an explicit rejection of what had gone on in Russian art since 1850. They had no Glinka, no Dostoevsky to see them through what was about to befall them. Neither was their cause bolstered by a Stravinsky or a Bulgakov living in emigration. Although some avant-garde painters went abroad (notably Kandinsky and Chagall, Larionov and Goncharova), either they became unproductive or they lost their roots in the avant-garde and went off in other directions. The heart of the avant-garde remained in Russia to try to deal

*This subject is brilliantly treated in a play, *The Master Class*, by the British playwright David Pownall. The four characters are Stalin, Shostakovich, Prokofiev, and Stalin's long-time and ruthless dictator of culture, A.A. Zhdanov. The play is very funny, yet verges on tragedy.

as best it could with the new world of Lenin and Stalin. Moreover, there was no single long, artistically productive life, no Shostakovich or Pasternak, bridging the gulf, or a large part of it, from Stalin to Gorbachev. The avant-garde painters were for the most part a generation older than Shostakovich and had already accomplished their most important work before the revolution. Although many of them lived to the 1940s and beyond, they lived unknown at home and abroad. More even than the writers and the composers, they were muzzled absolutely during the period of socialist realism, they gave up their art, and were forgotten by almost everyone.

That is one reason Costakis' work is so important. Without him and without it there might be scattered remnants of the Russian avant-garde in museums here and there and in private hands, but there would be no coherent collection representing this massive development in the history of world art. Without Costakis, Stalin and Zhdanov would have succeeded in doing to art what they failed to do to literature and music. In fact, with benefit of hindsight we can now see that literature and music were never in real danger. They were too big, their history too long, their practitioners too many to be destroyed by fiat or *ukaz*. Avant-garde art had none of those advantages, and by 1946, when Costakis got to work, it was dead and all but buried. If its collection had awaited the arrival of Gorbachev and glasnost, there would have been little left to collect.

There is another reason to assign very great significance to what Costakis achieved. He set out to collect paintings, and although by the end he had collected much else, paintings remained his first interest. Yet the importance of the avant-garde extends beyond paintings. Both before and after the revolution the avant-garde artists concerned themselves decreasingly with easel painting. Indeed, the first words of the creed of many of them, after the revolution, was that easel painting was gone forever, and that the true art of the revolution, of the future, was not to represent reality on canvas but to create reality itself. So their interest shifted from painting to architecture, stage design, photography, film making, textile design, type-face design, book illustration, political posters. They made their permanent mark on all of these. That is a second achievement of Costakis' work, to have preserved not just a collection of paintings, important though they are, but also the genesis of an entire artistic era, one of the most influential, and one of the most vivid, in modern times.

For the new revolutionary government of Lenin the most important arts were film and photography. Literature was for the literate, but half the country could not read. Ballet was, in Lenin's view, a pastime for self-indulgent aristocrats. Plays might carry a revolutionary message, but not many people could see them. However films, trundled about the country on *agit-prop* trains,* could reach

* Short for "agitation and propaganda." Under the communists the Russian language sprouted hundreds of these ugly compounds, often derived from foreign words. Thus *Gensec* (*Generalny Sekretar* – General Secretary); *Politburo* (*Politicheskoye Byuro* – Political Bureau); *Gorispolkom* (*Gorodskoi Ispolnitelny Komitet* – City Executive Committee or City Council). Everyday language, written and spoken, was larded with them, to the bafflement of the uninitiated.

everyone, and photography could not only carry a simple, direct message to the masses but become everyone's art form. No more need for artists when a cheap camera and a little practice could turn everyone into a recorder of his or her own reality.

Thus the revolution gave a new impulse to the making of films in Russia, which even before the revolution had been a thriving business. It is interesting that few if any of the avant-garde artists became actively involved in film during the years, about 1924-28, when Soviet film directors were making film history. But what is clear is that Eisenstein and the other great directors who were his contemporaries drew heavily on the ideas of the avant-garde artists, then struggling to keep their heads above water in a rising tide of artistic conservatism. There was some avant-garde participation. Alexandra Exter, for example, designed the sets and costumes for Protazanov's *Aelita,* a film which, together with Eisenstein's *Strike,* set the process of avant-garde film in motion in 1924. But theatre design was more to the avant-garde artists' taste. All the same, Eisenstein was consciously using the language of the avant-garde painters when he wrote: "The 'cinema eye' was not only a symbol of seeing but also a symbol of contemplation. We do not need to *contemplate,* but to act … we do not a 'cinema eye' but a 'cinema fist.'"

Soviet film, like all the arts in the Soviet Union, was reduced to banality after 1928. But Eisenstein lived on and worked on, bullied and harassed but tolerated by Stalin. The war brought some relief to film makers, as to other artists, and after Stalin's death there was enough leeway permitted to enable at least part of the great legacy of the 1920s to be passed on. By 1990, when everything was permitted, the film makers like the other artists were preoccupied overwhelmingly with their past rather than their future. We must wait to see whether young Russian directors can pick up where their talented and inspired predecessors were forced to stop sixty years ago.

In artistic photography there was direct avant-garde participation. Both Malevich and Tatlin had interested themselves in photography, especially aerial, before the revolution. After it, Aleksandr Rodchenko, some of whose other work is in the Costakis collection, turned to photography in a deliberate rejection of easel painting. Photography was the art of the revolution. Painting was dead, or ought to be. Like the contemporary film directors, he sought unusual, even bizarre, ways of looking at everyday objects. Some of his most startling photographs are shot from extreme angles below or above the subject. He became one of the most distinguished photographers of his day, in Russia or abroad, and his work is still exhibited. As with film, it is too early to tell whether any part of the new concepts he created survived the long years of romanticized mediocrity which characterized Soviet photography. But the importance of those concepts to photography beyond the borders of Russia is unquestioned.

If for Lenin the king of the post-revolutionary arts was film, for the artists of the avant-garde it was architecture. And this despite the fact that, following war, revolution and civil war, there was little money for actual construction. Perhaps the knowledge that drawings were unlikely to be translated into structures liberated the architectural imagination. But there was more to it than that. The twenty years before the revolution had seen Russian architects searching for a style of their own. Moscow and, even more, St. Petersburg bear witness to the importance of a neo-classical revival at the beginning of the twentieth-century. Because Russia had been in the forefront of the eighteenth-century neo-classical style in which Peter the Great built St. Petersburg, classical building was thought of as an authentic Russian form. Every visitor to Moscow knows the Pushkin Museum, the Lenin Library, the Kiev Railway Station, all products of this revival.

This was, however, the time of the Mamontovs and their centre for the study of the Russian folk tradition at Abramtsevo. Urban architecture did not escape the popular interest in ancient forms and styles. The result was such fascinating and now-familiar landmarks in Moscow as the Kazan Railway Station, the State Historical Museum in Red Square, the present French embassy building (once the Igumnov house), and some domestic buildings, recalling Russian architecture from the sixteenth-century and earlier, before the construction of St. Petersburg put the European model ahead of the Asian.

The buildings of the end of the nineteenth-century and the first two decades of the twentieth reflected also, as throughout Eastern Europe, the new architecture just appearing in France. The reason for looking West was partly, no doubt, reaction against the somewhat self-conscious nostalgia of the neo-classical and historic styles. There are some splendid examples in Moscow of art nouveau, the finest perhaps the Metropole Hotel, designed by the chief exponent of this style, Fedor Shekhtel. Art nouveau became instantly fashionable for private houses and apartment buildings; few streets in central Moscow do not have one or two examples, most of them now shabby, but some well maintained and freshly painted in recognition of their special character and historical importance.

The artists of the futuristic and idealistic avant-garde, in the main supporting the revolution and the new Soviet regime, by and large abandoned their brushes and easels after the revolution and looked for "useful" work. What more natural than to find it in architecture? True, nothing much was being built, but that left free rein to their imaginations without much need to be concerned about either technical or economic constraints. They were not in search of beauty or elegance. Some of them sought to create structures which would express the new dawn breaking on Russia and soon (they believed) to break on the rest of the world. Others were socially motivated, designing

communal housing which by its very shape and way of functioning would fashion the "new Soviet man" from the raw material of muddy peasants and workers. It was a noble cause, and, as we know now, a pathetic one. Lenin and his followers had given little thought to architecture, and that little mostly to domestic construction of a traditional kind. The official in charge of architecture in the ministry of education (Narkompros, which also dealt with cultural matters) was a traditional neo-classical architect who was probably alarmed, certainly not impressed, by the idealistic ravings of these young men and women. Nevertheless, they moved ahead, an alliance of avant-garde artists and architects who produced many sets of drawings, many designs and a few structures – a few, but enough to create a bridge of comprehension over the dark mess that was soon to begin.

In the early 1920s the young architects and painters were seeking an architecture as radically different from what had gone before as the work of the avant-garde painters had been from that of the nineteenth-century academicians or the Wanderers. It was a new world, demanding structures of a new kind. And the same people were involved, including three artists represented in Costakis' collection: Kandinsky was for a time head of the Institute of Artistic Culture (Inkhuk), the principal post-revolutionary artistic think tank, and was succeeded in the job by Rodchenko. Neither was an architect by training, but Rodchenko especially was full of fabulous and grandiose ideas, which he committed to paper. The most influential of the avant-garde artists, however, was Tatlin, who made the first avant-garde architectural statement with his design for a "Monument to the Third International." That the monument (four hundred metres high, with three glass volumes rotating respectively once a year, once a month and daily) was never built scarcely matters. Tatlin's design became instantly famous around the world, was built in model many times, and had the same impact on contemporary architecture as had the Eiffel Tower, to which Tatlin clearly refers in his structure, in its day.

Since all this febrile activity involved many of the same artists who had quarrelled so vigorously with one another during their most productive years before the revolution, it was inevitable that they would not have the same vision as they worked toward a new architecture. And they did not. Factions appeared, forming new organizations and groupings. One of the most important of these was the Association of New Architects (Asnova), which included another of the painters in Costakis' collection, El Lissitzky, as well as the most prominent and successful of all the avant-garde architects, Konstantin Melnikov. It was, above all, this group that made its mark on the landscape of Moscow. Asnova lasted only five years, from 1923 to 1928, finally succumbing to the conservatism which was sweeping away Russian art by the end of the 1920s. But during that brief period its members, Melnikov in particular, left a rich architectural legacy which stood throughout the 1930s, 40s and 50s in stark contrast to the architectural absurdities ordered by Stalin, and later to the crass

utilitarianism which marked Soviet construction under Khrushchev and his successors. Now these buildings are recognized as national treasures. In addition to Melnikov's own remarkable house, composed of two interpenetrating cylinders, he left four extraordinary workers' clubs, which are still standing and in use in Moscow.

Other architects of the period left other buildings, far ahead of their time, such as the editorial and printing offices of the newspaper *Izvestiya,* the ministry of agriculture building, the *Pravda* building and the central post office. Unlike the work of the avant-garde painters, these works could not easily be hidden or driven underground and were too valuable to destroy, much as Stalin and the architects who built his dreary palaces for him would no doubt have liked to destroy them. Their creators, Melnikov in particular, were harshly criticized during the 1930s. But Melnikov miraculously survived, living on in Moscow in his own unique house, just around the corner from the Canadian embassy, until his death in 1974. His works remain, fresh as the day they were completed, silently communicating their message of genius to anyone who wants to look.*

If the artists of the avant-garde left their mark on Soviet architecture, they left it even more on the Soviet theatre of the 1920s and on the theatre of the world. No theatre director anywhere contemplating trying something new can avoid thinking about and referring to what Popova and Meierkhold did with *The Magnanimous Cuckold* in Moscow in 1922. Malevich, Tatlin, and Alexandra Exter similarly revolutionized the stage in the years just before, and just after, 1917. It is awesome to think how these few artists transformed everything they touched, not just for their own day, but for ours and far beyond.

Russian theatre got off to a late start, lacking altogether the medieval and renaissance theatrical history of England, France and other Western countries. The beginning came only in the eighteenth century, when Western theatre was in full career. By the end of the nineteenth century, despite a rich heritage of literature for the stage – Griboyedov, Ostrovsky, Tolstoy, Gogol and, at the end of the century, the greatest of them all, Chekhov – Russians were still groping to find a Russian way to put plays on. Just at the turn of the century Stanislavsky indeed found a way, one which has survived in Russian theatre as in Western, at least for some purposes. But it was a way that was born middle-aged. If you are doing *The Three Sisters* or *The Cherry Orchard,* you create on the stage an absolutely naturalistic, realistic, copy of the provincial town or country estate where the action takes

* The best book in English about Moscow architecture is by a Canadian, Kathleen Berton, who now lives in England. The book, very readable and well illustrated, is called *Moscow: An Architectural History,* published in 1977. When Pierre Trudeau, then Prime Minister, went to Moscow in 1984 for the funeral of Yury Andropov, he expressed lively interest in modern Moscow architecture, and was taken by Kathleen Berton, living at the time in Moscow, on a whirlwind, police-escorted tour of the most interesting buildings. Melnikov's house was part of the tour; there Trudeau met the architect's son, who was still occupying his father's remarkable creation. Kathleen Berton has since written another book, about the interiors of historic Moscow buildings, entitled *Moscow Revealed.*

place, dress the actors exactly as they would have been dressed, and instruct them to go on stage and be, not pretend to be, the characters in the play. It was a theatrical style well suited to presenting Chekhov and ready-made for the moral tales which were the stuff of the theatre of socialist realism in Stalin's time. But it was not revolutionary theatre, not mass theatre, not theatre for the street or the circus. The avant-garde artists were to create that. During the twenties a very large number of artists who figure prominently in the Costakis collection were actively engaged in theatrical design. And in more than design, because they saw the theatre whole: the directing, the acting, the music and the set and costume design all inextricably linked. The artists of the avant-garde found themselves going beyond their habitual visual art to dramatic and literary art. Some of them became theatre directors.

The involvement of the avant-garde artists in theatre had begun even before the revolution. Tatlin had done the highly original costume design for *The Emperor Maximilian and His Disobedient Son Adolph* (1911). Malevich had designed the sets and costumes for the notorious opera *Victory Over the Sun* (1913), and had, he later said, thereby learned some artistic lessons which took him to his greatest achievements in painting a short time later. Probably most important was Alexandra Exter, another avant-garde painter who, working at the Kamerny Theatre in Moscow (*kamerny* meaning "chamber," and therefore small and experimental), took long strides towards the wholly new kind of theatrical design which was soon to be called "theatrical constructivism." This style of design for theatre was to replace normal realistic sets such as Russians were used to in the Stanislavsky tradition, and even the "symbolic" sets with which the great director Meierkhold was tinkering before the revolution, with a totally different kind of set, one composed of objects from life with no direct reference to anything beyond themselves, just as the abstract squares and rectangles in Malevich's paintings had no external reference. The avant-garde was moving its theories from canvas to stage. The German drama critic Elena Rakitina remarks that "like painting, theatre now sought to construct its own environment by appealing to a new kind of imagination on the part of spectators and inviting them to discover the autonomy of pure forms."

The Magnanimous Cuckold is a Russian version of a play by the Belgian playwright Fernand Crommelynck called *Le Cocu Magnifique.* The director of the 1922 Moscow production was Vsevolod Meierkhold, the designer that central figure of the Costakis collection, Liubov Popova, who was nearing the end of her very short life. The play, although billed as "a farce in three acts," and indeed it has many farcical moments, is in fact a searching tragedy about sexual obsession. It is set by its author in a village mill converted into a comfortable bourgeois house. The interior is described in detail in the author's stage directions, down to the colour of the paint on walls and furniture and the kinds of shrubs seen growing in the garden beyond the stage windows. Popova scrapped all that,

although she did include notionally the sails of a windmill and three circular structures which might suggest millstones. Essentially, however, her set consists of an elevated walkway almost the width of the stage, with a staircase at either end for the actors to go up and down. It is as far from a Stanislavsky set as it could be, yet it must have been strikingly effective in production as the diseased mind of Bruno is gradually revealed. There is nothing here to distract the attention of the audience, who do not realize until well into the action that they are dealing not with bedroom farce but with high tragedy. Yet neither is this a bare stage. On the contrary, it is a striking piece of functional design which somehow manages, in addition to providing objects necessary to the action, to suggest with its wheels and Don Quixote-like sails the terrible and destructive madness which is the play's subject. Neither did Popova pay any attention to the author's notions about how his characters should be dressed. She dressed them in "actors' work uniforms," which she designed. As the set largely removes the action from any particular place, so the costumes remove it from any particular time.*

The Magnanimous Cuckold set the tone for the new Soviet theatre for the next several years, probably the richest, most innovative and compelling years in the entire history of Russian theatre to the present day. Undeterred by a sharp criticism of his production in *Pravda,* written by none other than Lenin's wife Nadezhda Krupskaya ("The portrayal of woman as a servant is an insult to revolutionary activities. The whole thing is offensive"), Meierkhold formed a second artistic alliance with another of the great women artists whose work is in the Costakis collection. Varvara Stepanova, a friend and colleague of Popova and the wife of Costakis' friend Aleksandr Rodchenko, designed the sets and costumes for *The Death of Tarelkin,* a play by Aleksandr Sukhovo-Kobylin. Stepanova, by 1921 an avowed constructionist and opponent of "useless" easel painting, undertook to develop what Meierkhold called "the specific tools of the theatrical undertaking." Like Popova's stage but more so, this one was to be filled with everyday objects, constructed for the theatre. There was, said Meierkhold, to be no elegance: "Let us leave elegance to the hairdressers and shoemakers." The set that emerged had tables that collapsed and chairs that rose up when you sat on them, this not for comic effect but to give the actors maximum flexibility. A central piece of stage furniture, a masterpiece of modern art by itself, was the "meatgrinder," as Stepanova called it, a white slatted construction on six little wooden wheels, representing the police station in the play. The victim climbed up a ladder, fell head first into a drum which could be rotated by hand, and was thus propelled into the

* One of the costumes, that of the Burghermaster, became well known on this side of the Atlantic when it was used for the dramatic cover of the *New York Times Magazine* of October 11, 1981, inside which was Hilton Kramer's review of the Costakis exhibition at the Guggenheim Museum of Art. Unfortunately, in the absence of any explanation, the costume was commonly assumed to be a picture of a Soviet traffic cop. Popova's drawings both for that costume and for the stage set are in the Costakis collection in Russia. A model of the stage set has been made from the drawing and in 1990 formed part of a stunning exhibition of Popova's work, much of it from Costakis' collection, in the New Tretyakov Gallery of Art in Moscow.

adjacent "cell." No realistic representation of a police station could possibly be as effective. The play opened on November 24, 1922, and was instantly successful. The course of Soviet theatre was fixed for the next five years.

Then, with theatre as with the other arts, political pressure began to be applied, slogans such as "Closer to Life" and "Adapt or Disappear" were heard, and the great innovative theatrical work of Meierkhold came to an end. He himself was shot in prison in 1940.

Much of Meierkhold's work consisted of adaptations of Russian or foreign classics, or if not classics then familiar pieces such as *The Magnanimous Cuckold*. Various plays by Ostrovsky, Gogol's *The Inspector General*, Chesterton's *The Man Who Was Thursday*, these and plays like them, sometimes radically transformed, were the core of what was produced. In this may lie the key to understanding how theatrical art survived Stalin, emerged from the shadows in Khrushchev's time with some respectable productions both of the classics and of some new plays which advanced beyond the stereotypes of socialist realism, and finally reappeared in the second half of the eighties with at least some of the Meierkhold tradition intact. Meierkhold's productions were truly productions in the round: the words, sets, costumes, direction and acting served a common purpose. That is why the artistic collaboration with Popova and Stepanova in particular was so important. In a real sense the artists of the avant-garde contributed to theatre, as they did to architecture, its capacity to survive. Meierkhold did not really need new plays to produce his effect; he could produce his effect with almost any play. Yury Liubimov at the Taganka Theatre in Moscow followed a similar path, both before his exile in Western Europe and after his return to Russia.

Although Meierkhold died miserably and his theatre was closed, his experiment was vivid enough to live on. The conservation of stage and costume designs in the Costakis and other collections played an important part in keeping his achievements alive. And indeed, they never died altogether, even in the worst of Stalin's days. Although few good plays were written in the Soviet Union after 1928, many good productions were staged, usually of the Russian and some foreign classics. Since the kind of stage Popova and Stepanova created was politically neutral and, in its utilitarian bareness, quite acceptable to the political commissars, it survived, although it was not the preferred style. Even when it was impossible to stage anything but plays imparting a clear and correct political message, it was still possible to stage them effectively, using at least some of the techniques of Meierkhold and his avant-garde collaborators. When Soviet theatre began to live again in the late 1950s, there was still a folk memory of *The Magnificent Cuckold* and *The Death of Tarelkin* and of what Popova and Stepanova had done for them on the stage. That folk memory is translated today into theatrical reality on Russian stages.

In architecture and theatre, in film and photography, as well as in pure painting, the avant-garde laid down a rich legacy, not just for Russia but for the world. Outside Russia the legacy has been accepted and has had its influence, very large in the case of painting and theatrical design. But the Russian avant-garde is elementally Russian, and in the end it must survive in Russia if it is to survive at all.

Had there been no Stalin, no Zhdanov, no years like those from 1928 to 1953, presumably Russian art in all its forms would have gone on to grow and change on the brilliant base laid down in the 1920s and before. But the chasm of those years is a reality. It is true that Russian artists in all genres are able to look back and recognize what they see as their own. It is true also that these days they are digging, sometimes frantically, to understand their artistic roots.

But it is too soon to say how much damage has been done. During those bad years, art went on developing in the West in its own way, and there is a powerful temptation for young Russian artists to look to that model, rather than to their own seventy-year-old one, blighted just as it attained full bloom. Contemporary Russian art is for obvious reasons heavily politicized, probably too much so for its own good. (It is worth noting that artists of all kinds contributed more than their share of the action in the political events in Eastern Europe during 1988 and 1989.) And technique? The avant-garde painters were technicians of a high order; experts suggest the same cannot be said for many of the young painters who emerged after 1985.

What is certain is that, thanks to Costakis, the legacy is there, more or less intact, in a museum on the banks of the Moscow River. The Russian government, the ministry of culture which for so long obstructed, uprooted and destroyed, has acknowledged its debt to Costakis and has made the works he collected as accessible to everyone as the limits of practical possibility in a museum allow. There are no obstacles to artists' doing what they want to do and being judged by the public and their peers rather than by bureaucrats and policemen. Our hope must be that nothing happens to disturb that tranquillity, unprecedented in Russia, and that in its benign atmosphere the young artists can indeed come into their whole inheritance.

CHAPTER X

THE MAN COSTAKIS IN THE WORLD OF ART

Costakis' greatest concern was the future of his collection. Early in 1990 he decided to test the market, and instructed Sotheby's, the international auction house, to put up for sale twenty works from the collection as well as four of his own paintings. The auction took place in London on April 4 and was a near-total failure. Seventy-six percent of the works (by value) went unsold; the London newspapers next day used the words "disaster" and "catastrophe" to describe what had happened. There was public speculation that the failure marked the beginning of the end of the fantastic prices which modern art has been fetching in recent years. But one London paper, the *Daily Telegraph*, seeking to explain why this was not so, wrote that "these superb Russian avant-garde pictures" failed to find their true market because "Costakis dictated his own impossible estimates to Sotheby's," and that he was thus the author of his own misfortune.

This may be so, but it is a fact that just the day before the Costakis sale, Sotheby's had held another, of impressionist and modern painters. Here the results were only marginally better – seventy-four percent unsold. That, according to the *Daily Telegraph*, was the worst "disappointment" at Sotheby's in five years.

It seemed clear that some of the heat was at last going out of the art market. Japanese and European buyers were still paying fantastic prices for works of the highest quality. But the frantic buying of big-name artists regardless of the quality of the work was slowing down. Japanese buyers in particular, whose undiscriminating bids had fuelled the market for ten years, were now looking twice before they put their money down. It is entirely possible that Costakis' timing was unfortunate. He came to market with relatively minor works just at the moment when the market for such works

was softening. And he may have compounded his misfortune by setting prices at the very top of the range.

The extent of the failure can be seen in a look at the catalogue of the auction and at Sotheby's list of the prices obtained. Of the twenty-four works offered, only ten were sold. Perhaps the least of the surprises is that none of Costakis' own four paintings found a buyer. Interesting and attractive though they are, the reserve price of £5000 each for two of them and £8000 each for the other two was clearly more than even Costakis' most devoted admirers were prepared to face.

It is interesting to see which of the hundreds of his own paintings Costakis chose to put on this prestigious market. The two at £5000 each are Russian landscapes, one a ploughed field with a birch forest in the background, the other a village of wooden houses with a church and orchard. The two at £8000 are different. Both contain an artistic notion which was Costakis' own and which gave him great pleasure: the cemetery of the avant-garde, with tombstones in the shape of the quadrangles, triangles and circles which were the hallmark of the movement. One of these is titled *Kremlin* and has a small kremlin in the background, behind the avant-garde tombstones. ("Kremlin" in Russian means "a fortified place." The Moscow Kremlin is only the most famous of them; there are many others in other towns and cities.) The other £8000 work is similar, but a summer rather than winter scene with a church rather than a kremlin in the background. This one, however, is entitled *Perestroika,* and in the sky over the church appear the Russian words *Mikhail Veliky* ("Mikhail the Great" – referring to Costakis' hero, Mikhail Gorbachev). Lower in the sky, just above the rising sun, are the words Perestroika and Glasnost. There is no doubt where Costakis' political sympathies lay, but they did not help him find a buyer for these labours of love.

The rest of the sale was every bit as shocking as the London newspapers reported. True, these were not the giant works of the Costakis collection. But how to explain, in a fantastically (until that day) overheated art market, that a very interesting early work of Kliun, a portrait of his wife dying of consumption, failed to reach its reserve price of £90,000, while a beautiful and fascinating Popova abstract found no buyer at its reserve price of one million pounds. Only a few weeks earlier, in New York, a smaller and in some ways less interesting Popova sold instantly for almost exactly that amount. Costakis would have been pleased (in so far as anything about this auction would have pleased him) that the highest price paid was for a work of his friend and favourite avant-garde artist, Rodchenko, whose brilliant abstract multi-media work ("watercolour and gouache over pencil and pen and ink") brought £203,500. (The reserve price was, however, £180,000.) But he would have been profoundly and bitterly disappointed that works by two painters whom he regarded as his personal "discoveries," Kliment Redko and Ivan Kudriashev, found no buyer, even though these two oils were, after the Kliun which appears on the cover of the catalogue, visually the strongest pieces in the

auction. Costakis would have seen this failure as further evidence that professional buyers follow their ear rather than their eye when they bid, and he would probably have been right.

The dramatic Kliun oil on wood on the catalogue cover did sell, but only just. Consisting of superimposed white, brown and black quadrangles, with a brilliant orange ovoid shape in the foreground, it brought only £4000 more than its reserve price of £150,000. It should have led the sale.

◪

S. Frederick Starr, former president of Oberlin College and author of the luminous introduction to *Russian Avant-Garde Art: The George Costakis Collection,* describes in a few sentences the extent of Costakis' artistic achievement when the time came for him to break up the collection and leave Russia in 1977:

"Over a two-day period the Tretyakov was receiving one of the largest and most important gifts of art that any museum has received in the twentieth-century ... The sheer quantity of works involved was staggering by any measure. Several years before these sessions, some fifteen hundred works on paper were stolen from the apartment, but their loss did not significantly weaken the collection as a whole. Many times that number had to be dealt with now, not to mention some four-hundred canvases, several score icons of the highest quality, and many manuscripts and catalogues, some of which included original prints, sketches, and paintings.

In number of works the collection far outstripped that of Gertrude and Leo Stein, Peggy Guggenheim, Katherine Dreier's Société Anonyme, or the entire Armory Show of 1913. Yet it was not the quantity but the focus of the works arrayed in the Costakis living room that made the gift so noteworthy. With the exception of the icons, all were works by Russian artists of the first part of the twentieth-century ... In this area the collection was incomparable, surpassing every public or private collection in the West and rivalled within the USSR only by the collection of the Tretyakov Gallery itself and the Russian Museum, in Leningrad. And if these museums had managed to supplement their own holdings of avant-garde paintings in the previous decade, it was in good measure in response to Costakis' collecting activity."

That is an objective description of what Costakis had accomplished over thirty years of collecting. Yet when he arrived in the West with a substantial and carefully selected part of the collection in his baggage, he felt rejected: "They treated me like a nigger who had found a jewel but had no idea of its value."

This remark, made in a tone of deep indignation, not only sums up Costakis' attitude to Western (not Soviet) art historians, professors, and curators, but in many ways sums up the man himself. When he set out on his adventure with the Russian avant-garde, he did so partly because he was consciously in search of fame. His early collection of carpets, silver, and Dutch masters was interesting and valuable, but there was nothing unique about it. The world was full of such collections, many bigger and richer than his: "I started to think that if I went on with this collection, I would bring nothing new to art. Because what I collected was in every museum – in the Louvre, in the Hermitage, in every museum in every capital of the world. And in private collections. So if I went on this way, I might get richer and – that's all." One element in the character of George Costakis was, beyond any doubt, the need or wish or drive to "be somebody." His father, to whom he had been very close, was "somebody" until the Bolsheviks took his name, as it were, off the door and put him and his family on the street. That could have been a factor. His revered older brother Spiridon had been somebody, champion motorcycle racer of the Soviet Union, close adviser to the Greek ambassador. And he was killed. His mother and older sister spoke foreign languages and were educated. But George? No languages beyond the two spoken in his family, not a champion of anything, minimal education, no training. A truck driver, then a chauffeur, then a clerk. A little man, he liked to say. The expression came again and again to his tongue even after he became famous in the art world. But increasingly it was charged with irony. "I am a little man," he said. But what he meant was "All the big men, ministers and ambassadors and museum directors, are finding the way to my door. I am bigger than they are."

The anonymity of his door also bothered him. He was famous and respected, but he had no label, no brass plate. Other people were Doctor this or Ambassador that; he was just George. Thus, although he joked about the honours that were bestowed on him in his later years, they in fact occupied a large place in his heart. When he was finally acknowledged and honoured in the Soviet Union in 1986, he joked about it but was clearly very moved. It was the most important event in his life after his departure from Moscow.

A related facet of this complex personality was a sneaking liking for a lord. And not all that sneaking, either. Deprived by the situation he lived in of most contact with grand persons in the Soviet system, he tended, quite understandably, to be in awe of the titled, rich, and famous from other countries, to feel that their "grandness" somehow rubbed off on him, the little man. He might have been spared much anguish and have ended his days honourably in Moscow if he had said no, firmly, to the ambassadors and ministers and prime ministers and rich men and women who came to see his collection. Astute as he was in dealing with art and with the affairs of the Canadian embassy, he failed to recognize, during the 1960s and 70s, that he was being used, indeed abused, by Western

embassies in Moscow. He was a stop on their VIP tour of the city, like the Kremlin, the Tretyakov Gallery and Gorky Park. The trouble was, he loved it. Other Russians of course loved it too, or would have loved it. But most of them were prudent enough to say no, or to be extremely discreet. Costakis' proudest boast was that he never said no, and he was not discreet when it came to visitors to his collection.

Most Western embassies in pre-Gorbachev days were careful not to compromise the few unofficial Soviet friends they had. Relations with foreigners were a dangerous business in those days, and out of common humanity no self-respecting foreign diplomat or journalist would consciously get a Soviet acquaintance into trouble with the police. But Costakis was thought to be different (in a way he was), and it seemed not to occur to Westerners that this stream of important persons to the Costakis apartment would in the end harm him, as it did, grievously. But neither did it occur to him.

It was not only in Moscow that Costakis showed his vulnerability to the attentions of the titled and famous. That Princess Margaret attended the London exhibition of the collection in 1983, and that he dined with her and was presented to the Queen, was one of his proudest memories. That he was decorated by the King of Sweden was another. The lavish party given for him in Washington by the Mellon family was another. All this is entirely human. But to understand George Costakis it is important to understand that another Russian in his position might well have gone much more cautiously in the hope of averting the wrath of the KGB. Costakis was not cautious. Neither were Solzhenitsyn, Rostropovich or Sakharov. All four of them, and many others less renowned, suffered persecution and exile (internal in Sakharov's case). It was lucky for Costakis that his offensive activity, unlike that of the other three and of many honest people, was not seen as very dangerous. Besides, he was a foreigner, and therefore his fate was less harsh than theirs.

That was one quality of the man, the need to "be somebody." Another was an incredible tenacity, which sometimes turned into stubbornness and even belligerence. It was the tenacity that made the collection; the stubbornness caused the problems. No doubt, if he had gone on quietly collecting, making the occasional excursion outside the country to lecture with slides, selling a piece now and then on the London auction market, he could have spent the rest of his life in Russia and, with the turn things took, could have ended it rich, famous and happy. But his determination to show the world all he had, even when it was quite clear that the Soviet authorities were not amused, was his downfall. He did not want to end his life in exile, and he did not want his collection sold at auction. But the price for avoiding these things was conformity, and he was no conformist.

The bitterness which enveloped many of his artistic transactions and the final disaster of the Sotheby auction on April 4, 1990, must be attributed to his conviction that he was right, often in situations in the West where he had no way of knowing whether or not he was right. The art world he

had spent his life in, in Moscow, was not the art world of New York and London. But he refused to believe that. He was stubborn, and he was convinced. Without these qualities there would have been no collection; with them there was a collection but many attendant difficulties.

The urgent need to be somebody, the stubbornness and tenacity, the street life of the 1920s, the experience as a conventional collector, all these help to explain Costakis' unique achievement in the collecting of modern art. They help to explain what drove him to collect in an unusual field, a dangerous one, and, when he began, an unprofitable one. They help to understand why he went ahead and succeeded when others simply did not try. There were people in Russia collecting the avant-garde — a piece here, a piece there. These little collections are beginning to turn up now. The elements of Costakis' character and experience make it easier to see why his collection was different, not a piece here and a piece there but a massive collection embracing the whole field.

What these elements of character and experience do not explain is the quality of the collection. It is a collection of nonpareils. No waste. Nothing second-rate. No junk. Over the years many people tried to tell Costakis that this work or that was in fact junk. Yes, the Malevich and the Chagall and the Kandinsky are wonderful. We even grant you your beloved Popova. And you are lucky to have things by Tatlin. But surely you have made a mistake with some of these blobs by the Ender family. There's no art in Klucis, just geometry. Rodchenko was an interesting photographer, but as a painter? Many of your Kliuns are childish squiggles. What can you possibly see in these political posters?

To all this Costakis turned an absolutely deaf ear. He took advice about authenticity. Cheated more than once with fakes, he became ever more expert at detecting them and put much energy into thinking about the problem of fakes in the art market. He knew that he was not infallible, and when it came to authenticity he listened to his friends and fellow collectors. Not so with a question of quality. He did not buy everything in sight in the expectation that two or three works out of a dozen would be gems. He knew the gems. He took them and left the rest.

Where did this talent come from?

Costakis' own answer was that he had an "eye." His sharpest criticism of museum buyers was that they bought "by the ear," not by the eye. Price, the reputation of the artist, the state of the market dictated their decisions. That was not his way. By "eye" he meant an enormous capacity for absorbing and retaining tiny details. He was capable of spending literally hours devouring the details of a small painting. He had an exact memory for colour and form. Although his own paintings of Russian scenes were all done from memory, he captured in many of them the precise texture of the Russian rural landscape: the sky pink at the horizon, grey above, the cupola in the distance, the row of wooden peasant houses leaning crazily in every direction. He spent hours in the Moscow commission stores before he had begun to collect anything, the chauffeur waiting for his

ambassador. "Georgii Dionisovich. Who do you think did this? Is it early or late?" And they listened to his answers, because he had seen and remembered in precise detail other works by the same artist or his or her contemporaries.

This genius spilled over into language. Lacking education, not a great reader, he could neverthe-less describe a painting in words that caused it to materialize before the listener's eyes. Schools and academies can probably convey some of this ability to their students. But in the end it is a gift, a tal-ent, something that can be honed and sharpened and practised, but not created where it does not already exist. Costakis disliked art teachers. He thought they usually did more harm than good, that they stifled nascent abilities. He advocated spending long periods in front of the work of art, absorb-ing it in its minutest detail, as one would memorize a long poem, play, or opera.

The fact that when Costakis began collecting the avant-garde, and for more than ten years after, there was virtually no market for the works must have made things easier for him. He did not need to buy "by the ear." He was not selling, the prices were negligible, there was no public, except his wife and children, to react to what he had done. So he looked, and there lay his genius.

The "eye," to which Costakis attributed much of his success, is not, however, the whole story. Equally important, perhaps more so, was this peculiar form of Russian madness called collecting. Russians say of themselves that if they find three of anything, they have to start a collection. In her autobiography, *Galina*, Galina Vishnevskaya recounts how her husband, the cellist Mstislav Rostropovich, started a collection of porcelain when he was out of political favour and not allowed to perform in any major Soviet city or abroad. Like Costakis' collection, Rostropovich's became an obsession and a major passion, almost displacing music. Like Costakis, he scoured the countryside, finding objects in the most improbable places. There are collectors in all countries, but rarely do they display the single-minded zeal common to Russian collectors and possessed in full measure by Costakis. His wife, children and job were important to him, but he never concealed that his pictures came first. In the essay with which he introduces *Russian Avant-Garde Art: The George Costakis Collection,* he gives us some idea of this passion:

There is a special relationship between a collector and his collection. The collection – at least for me – is an organism. If it is a truly personal collection, it carries as it were the spiritual imprint of its founder and is built with a love which can become a strong passion. I have often felt the impulse to go to one of my paintings and caress it, give it a smile, or somewhat like a Chukchi tribesman, exhale smoke upon it as a sign of love … At times we collectors are like madmen who have forgotten everything else in the world. A collector is capable of committing a crime for the sake of a coveted work, not to mention sacrificing the material

welfare of his family. Anyone who imagines that collecting is a pleasant and inoffensive little hobby is deeply mistaken; it is, in its own way, a genuine illness.

Poet Yevgeny Yevtushenko called Russian collectors "true Russian heroes": "There are two kinds of collectors, those who collect to hoard and those who collect to save. In Russia even the hoarders are savers. At considerable risk they collected the Russian past in order to preserve it for the future."•

To understand Costakis' accomplishment in art it is thus necessary to understand all these elements: the Russian collector's "genuine illness" and the special place collectors have long occupied in Russian society; Costakis' eye for quality; his drive to achieve something unique and personal; the central place in his psyche of Russian Orthodoxy and mysticism; his personal tenacity and determination; and the absence of any real market for the avant-garde in the early years of his collecting. No one of these explains his achievement, but if one had to be singled out it should be the "genuine illness," the collector's madness. Had Costakis not been infected by this irrationality, which drove him to put his collecting before all else, we would today know very little of the Russian avant-garde, and the world would be a poorer place.

◣

If one left an account of George Costakis at that, one would leave an impression of a serious, dedicated man but not a very lovable one. The opposite is true: he was eminently lovable. But he was hard on the art professors and museum directors and professional evaluators who he thought did not know how to deal with his collection. With them he was capable of shouting, threatening, bullying, resorting to coarse language. Finding foreign names difficult to remember (although with an astonishing memory for Russian ones), he had the habit of attaching a label to someone he did not like: "stupid bastard," "ignorant bitch," and from that time on no reference would be made to the person without the label.

The story was very different when he was dealing with simple people, his staff at the Canadian embassy, ordinary folk in shops or on the street. He was a natural egalitarian; people were of equal value. The wrinkled and bad-tempered old washerwoman who in those days did the embassy laundry in a shed behind the main building was treated with the same kindly familiarity as everyone else, although most of her Russian co-workers found her intolerable and told her so.

He had an alert sense of humour. Not the kind which tells jokes over drinks or amusing anecdotes after dinner, but rather a self-deprecating, ironical kind, never at the expense of anyone except

• Quoted in an article by Peter Dragadze, in the London *Sunday Times Magazine,* April 29, 1990.

himself, and then only lightly so. (He did occasionally emit an uncontrollable bellow of laughter at the Russian-language gaffes of the newly arrived third secretary, but this was kindly meant, and was always followed by a quick and friendly lesson in how it should be said.)

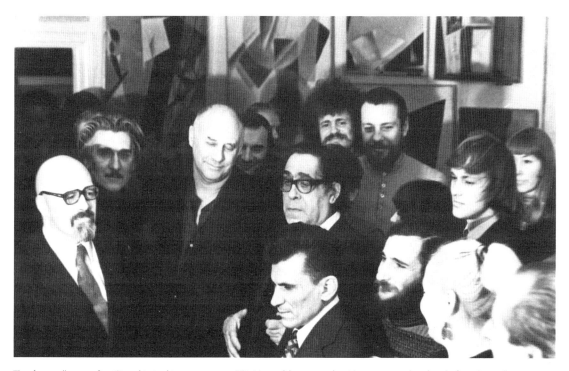

The farewell party for Costakis in his apartment, 59, Vernadsky prospekt, Moscow, on the day before the collection was removed, December, 1977.

It is unlikely that any Canadian who worked in the embassy during the thirty-five years Costakis was there had much real idea of the other side of his character. He had good friends among the Canadians. They saw his collections, enjoyed his hospitality and reciprocated it, listened to him and Zina singing Russian folk songs together to the eloquent accompaniment of George's guitar. He even made it possible for the Canadians to meet some of his group of "unofficial" artist protégés, one of whom, Anatoly Zverev, did portraits of several of them, their wives and their children. His Canadian friends were largely ignorant, however, of the man who, at night and on weekends, went out into the art market. That man was decisive, knowledgeable, fully in command of every situation, the top authority in all Russia in his field. That it was a field with no official standing made no difference. Costakis was king. He knew it, everybody in the art world knew it. Frederick Starr

accompanied him on a successful search for some paintings of Rodchenko and found the man was scarcely recognizable in this kind of action: absolutely sure of himself, decisive about what he wanted and did not want, the supreme collector at work.

Costakis in the embassy was another matter. Not that the embassy Costakis in any way contradicted the collector Costakis. He applied the same intelligence, the same craft, in the one world as in the other. But the people from whom he bought works of art and the traders and dealers and collectors all saw a different Costakis from the familiar rotund and usually genial personage who for so many years inhabited the corridors and courtyard of the Canadian embassy.

Costakis was a man with four stages to move on, and for each he had a manner. In the art world, his natural world, he was confident and serene. With humble Russians he was gentle, familiar, one of them. With his employers at the embassy he was often deferential, depending on the circumstances. And with the professional museum people he was capable of being rough. It was in this last world that he felt least secure and was least himself, especially as he grew older and his contacts with them were more frequent, his temper shorter.

There was a fifth world, a warm and close one, that of his family, especially his immediate family. His wife, Zina, their three daughters, Inna, Lilya, and Natasha, and their son, Sasha, formed the still centre of Costakis' ever-turning world: "In my life as a collector I was very fortunate that I chose as my lifelong friend my Zinochka, Zinaida Semyenovna, my wife, who in the course of all those years of collecting was my great helper and great friend. Zina joined me in my passion and throughout her life went with me, hand in hand. I have to say that in the building of this collection I am enormously in debt to my wife."

◪

His collection, his family, his work in the embassy. There wasn't room for much else. Although Costakis was a talented folk guitarist and an attractive singer, and although he numbered some great musicians (notably the pianist Richter) among his friends, he did not find much time for concert-going, or indeed for the ballet, theatre or movies. Reading suffered the same fate. What spare time he had all went to collecting. His closest friends beyond the confines of his family were also part of his life in art, themselves artists like Dmitri Krasnopevtsev, Robert Falk,* and Anatoly Zverev.

* About Falk Costakis said:

"I always put it this way. Twenty-five or thirty painters, including Falk, were standing on the platform waiting for the train to leave. Twenty-five or twenty-nine of them got on board. For what reason nobody knows, but Falk remained on the platform, and the train pulled out. When the train had gone, and Falk discovered where it was going, he said to himself that his friends were going the wrong way. That included Malevich and the others. So he believed in realistic art. Falk painted a single canvas sometimes for three months, four months, even five

As the collection grew Costakis did feel a need to learn something about recent art history, and by the time he left Russia he was able to write and lecture respectably on the origins of the Russian avant-garde. He also made himself knowledgable, to a point, about trends and fashions in Western contemporary art, and he knew the work of the more important British, American and French painters. But earlier art hardly spoke to him. He used to remark that he could "do" the Louvre or the Uffizi in half an hour each. Like the old Dutch masters with whom he had started his collecting career, the great European paintings, with a few important exceptions, from the quattrocento to the beginning of the twentieth-century, bored him with their dark colours and humdrum (as it seemed to him) subjects.

Not even the despised socialist realism ("sotsrealism," as it was contemptuously called in Russia) escaped his critical eye. And he did not find it all bad:

I understood only later that one did not have to reject [the art of] the thirties and forties. Even at the end of my collecting activity, when nearly everything had stopped, I talked with my friends (these were people who spat on socialist realism), and I said to them, "You know what, boys? The time will come when socialist realism will have its place." There were some outstanding artists among these socialist realists. I mean the ones who in the twenties painted with their left hands and considered themselves part of the avant-garde. Then in the thirties they got a knock on the head and started doing realistic things. But the truth is, if an artist has talent, there's no way to kill it, without killing the artist. Quality remains. We say we don't like this stuff, it's realistic, socialist realism and so on.

I once said to Nalbandyan* – it must be twenty years ago now [that is, about 1960, after Stalin's death] – we were eating at some embassy and I sat next to him. There were round tables of eight each. I heard Russian spoken and thought I would sit down. They were talking about music. I thought he was a composer, but no, he turned out to be this same Nalbandyan. He started talking to me. "People don't like me, they criticize me. You come to my studio. Now I'm doing still lifes, landscapes, wonderful flowers. You don't have to buy, but come and have a look. I live – my studio is across from the Aragvi restaurant." And do you know what I answered? I said, "You know" (I've already forgotten his first name and patronymic), I said, "You don't have to be sorry. I don't think your still lifes and landscapes will become known and hang in museums. That

months. Sometimes he overdid it.

I remember, one day I went to see him and the portrait of Inna [Costakis' eldest daughter]. It was marvellous. Beautiful ... such light. And next day Richter came to see Falk. [Svyatoslav Richter, the Russian pianist]. Richter was with some friends, one of whom told me the story later. Richter got down on his knees in front of Falk and pleaded with him. 'Robert, don't put another touch on it. Leave it as it is. Because it's a masterpiece and you can't improve it.'

But Falk continued and continued, and in the end spoiled it. It was a nice portrait, but nothing ... I remember [the early version]. There was a big difference."

* Dmitri Nalbandyan, an establishment painter under Stalin, especially in the years after the war, famous for having said, "I work in the genre of the Leader," and for his sycophantic painting of Stalin and Mao Tse-tung at their meeting in 1949-50.

sort of thing doesn't happen. But your Mao Tse-tung, your Stalin, at their meeting, all these generals and admirals with their medals and stars – these will hang someday in the world's most important museums. Maybe they'll be in the 'kitsch' department, but they will hang. And they will generate much interest."

Icons were something else. These he knew, loved and collected avidly, and he was as expert about them as any collector in Russia. Obviously his years as an altar boy surrounded by incense-blackened icons had something to do with this enthusiasm, just as the absence of any important art, original or copy, in his parents' house may have had something to do with his lack of interest in the European masters.

Icons were different in another way. Like porcelain, carpets and crystal, icons were collected by many people in post-revolutionary Russia. Collecting them did not set Costakis apart from his fellow collectors, as did the Russian avant-garde, where at the beginning and for many years after he was the only person in the field. With the avant-garde, he had deliberately set out to do something which would distinguish him from the rest of the collecting world and would make a mark. The icons offered no such possibility, yet he collected them for years and with the same vigour he brought to the avant-garde. The work was easier since, as churches were closed in thousands across Russia, many icons, some very rare, some very beautiful, some neither, found their way to the art market. And buying and selling them was not illegal or dangerous. So it was a matter of having a good eye for the quality of the painting and technical knowledge to make dating possible. It is a regrettable loss that Costakis never recorded in any detail how he built up his icon collection. That story is lost.

Preserved, however, is the story of what happened to the icon collection when Costakis left Russia:

After I'd given them the pictures, this Khalturin [official of the ministry of culture] came to see me. "What are you thinking of doing with your icons, Georgii Dionisovich?" I had maybe one hundred and thirty or one hundred and forty icons. Very good ones. The collection was first rate. Of course I knew that to ask permission to take them out – they wouldn't give it. So I thought of leaving them with my daughter. But this Khalturin said, "You know what? Let's do it this way. You give us half, fifty percent, and we'll let you take fifty percent out." Well I thought and thought about it, and it seemed to me that this was a good solution, and I agreed.

Soon after they came from the Rublyevsky museum, and took away the best things, what they wanted. But a few pieces, not bad ones, stayed with me.

Two or three days later I went to the ministry of culture and gave the list to Khalturin. He looked. "Oh. This is from the fifteenth century, the sixteenth. No, Georgii Dionisovich. We can't let you have these. And look

here's the *Byzantine Saviour* from the fourteenth century. We can't let it go." I said, "So why have I given you all these icons?" "Well," he said, "leave them with your daughter." I said, "I will do so." I was furious.

Even if Costakis' passion for art did not extend to the European masters, it extended well beyond the avant-garde and icons. Living in Athens, he started buying the work of living Russian painters and helped his daughter Lilya establish a business for the import and sale of these. And he took up painting himself, at the age of seventy, and was very prolific during the last years of his life, improving steadily in technique and exhibiting and selling his work.

Have the avant-garde, the icons, the young "unofficial" painters of the 1960s, the contemporary Soviet painters and Costakis' own work something in common, something that drew Costakis to them? All are quintessentially Russian. The avant-garde is the grandest Russian contribution to art history. The "unofficial" painters are the track across the desert of Stalin's later years. Contemporary Russian painters are the first fruits of post-1985 policies. George's own work is almost entirely, except a few early sketches of his Athens garden, about Russia, painted from memory or photograph. "God sent me into the world to collect this art for the Russian people": that sums up the man's life and work.

In the end, with George Costakis, you have to come back to this Russian-ness. Costakis had, to say the least, a highly ambivalent attitude to the West. He did not find much to admire in Western countries, was quickly homesick when he travelled abroad, and was permanently homesick once he reached his exile in Greece. In the West he was increasingly hailed as a hero of the art world, while in Russia he was officially nobody; yet he felt he was "somebody" in Russia, nobody in the West. In Russia artist friends and fellow collectors respected him, even those who thought he was bent on a crazy mission. In the West he had the sense that he was being put down. He was resentful of Chagall, who he thought patronized him and treated him as the "little man" he often claimed to be and knew he was not. He was certainly resentful of many of the museum directors and curators with whom he dealt, who did not listen to him when it came to arranging an exhibition. The museum directors and curators whom he liked and admired were those at the Tretyakov, to whom he had to surrender most of his collection. He had not much respect for their understanding of the avant-garde, but he thought they treated him with consideration, even deference. He was probably right; people in the art world who had come through the nightmare years in Russia and were alive to tell the tale had a regard for one another, a kind of softness, a reluctance to apply the sharp edge of criticism or the knife of ambition to their fellow survivors. The driving professionalism of Western art museums, by contrast, left Costakis bewildered and angry.

However, Costakis' dislike of the West had more to it than quarrels with curators or unpleasant encounters with the RCMP or the absurdity of being able to buy strawberries in winter. Those were negative things, and relatively minor. His passionate opposition to emigration as a solution to problems in Russia, especially the problems of artists, was fundamentally positive, and fundamentally religious: Russians outside Russia were severed from their source of spiritual sustenance. Not only the Orthodox Church, although that was part of it. Russian society, mauled and torn though it had been by the communists, was nevertheless not replaceable. Any Russian who went voluntarily into emigration cut off a piece of flesh, and would never find it again. Costakis took this route only when he felt his life and family threatened; once he was an émigré himself, his worst fears were realized.

In thinking this way he was in good company. In *The Gulag Archipelago* Solzhenitsyn remarked on the terrible tragedy which befell Russia when thousands of its most educated people emigrated at the end of the civil war, and he called in almost religious tones for their return to the mainstream of Russian culture. Until that day, he believed, neither the mainstream nor those abroad would be capable of inheriting the birthright of Russian culture. Solzhenitsyn, who unlike Costakis was given no chance to stay in Russia, obviously felt only half a man in his New England place of exile, and longed for the day he could go home.

Anna Akhmatova, perhaps the greatest modern Russian poet, was of the same mind, although she never experienced emigration, and remained in Russia through all the worst years until her death in 1966. She did, however, have two magical visits to Paris, in 1910 and 1911, and might well have gone into exile there after the revolution. She chose not to, for reasons which she put down in 1922 in a poem called "I am not one of those who left the land":

I am not one of those who left the land
to the mercy of its enemies.
Their flattery leaves me cold,
my songs are not for them to praise.

But I pity the exile's lot.
Like a felon, like a man half dead,
dark is your path, wanderer;
wormwood infects your foreign bread.

But here, in the murk of conflagration,
where scarcely a friend is left to know,

we, the survivors, do not flinch
from anything, not from a single blow.

Surely the reckoning will be made
after the passing of this cloud.
We are the people without tears,
straighter than you … more proud …

George Costakis was no poet but if he had been he might have written those impassioned lines himself. He even set himself up as an authority on emigration, basing his ideas on his own several visits to the West, and did his best to discourage young artists from dreaming, as most of them did, of escaping abroad. His argument with them was usually a practical one: artists have a hard time of it in the West, and starve in garrets. But his real motivation was less to save his friends from starving in Paris or New York than it was to prevent their spiritual starvation, which Costakis thought he had experienced even during his short trips, and more than that, to prevent the departure from Russia of still more of its brightest talents. Costakis was a Russian patriot in a very full sense of the term. His patriotism embraced every aspect of Russian culture and society, including some aspects attributable to the years of Soviet power.

Although he has been rehabilitated in Russia, Russian writers still misleadingly write about Costakis as though he were Greek and happened to be in Russia by chance. Western writers do the same. What needs to be remembered about Costakis is not that he had Greek parents and a Greek passport, but that he spent all but the last twelve years of his life in two very different Russias. The critical first five were in the Russia of Czar Nicholas, in the Orthodox Church, in a world that has vanished as surely and totally as the Canada, England, or France of the same time. But those five years left their mark on him, deep and permanent like the mark left on us all by the first five years. All the rest of his active life was spent in the communist Soviet Union.

There seems to be an expectation in the world that because Costakis left and became rich and settled in the West, he must have rejected all those years and everything associated with them. He did not. The Russia of Lenin, Stalin, Khrushchev and Brezhnev was his Russia. He saw its nasty side, but he also saw its rich side, in his family and friends, his colleagues and the ordinary Russians whom he loved. More than that, although the communists killed his brother (as he believed), imprisoned his mother, aunt and youngest brother, tried to kill him, and forced him into exile, they were not all evil. Costakis was no political analyst. Like many Russians, probably most, he tended to blame the troubles of the time not on Lenin or Stalin but on unscrupulous people acting in their

names. He always retained a great admiration for Lenin. He refused to believe what is now commonly accepted by scholars, that Stalin arranged the murder of Kirov, the popular Leningrad party chairman, in 1934.

Costakis even had a personal, family experience to confirm his belief that Stalin's evil was not unmitigated. His older sister Marika had her life changed, Costakis was convinced, through the intervention of the Great Leader and Teacher himself:

Marika married Broneslav Nikolayevich Yurkevich, a member of the Bolshevik party, a very honest and nice man. But Marika had a Greek passport. So after a few years Broneslav said to her, "Marika, why are you holding this Greek passport? Let's get a Soviet passport for you." So they went to the Gorsoviet [city hall], where Marika was congratulated on her decision, and she got a Soviet passport. And with it she lived for about twenty years, renewing it every five years, as is usual. Her son grew up and was in the army and was wounded in the war.

Then one day OVIR [the passport office] sent her a note, telling her to come to see them. She went. The chief of the department was Ryazantsev. He said, "Did you bring your passport?" She said, "No, I didn't know." He said, "Go home, and come tomorrow with your passport." So Marika came with her passport, and Ryazantsev said, "We are going to take this passport from you and gave you a *bezgrazhdanstva* [stateless] passport." That is the worst thing anyone can have. She said "Why, what happened?" He said, "It wasn't properly processed." But she refused to take this passport. They hounded her for months, sent people to her apartment and to her *dacha*. She lost ten kilos.

Then one day she came to see my brother Nikolai and me. She was crying and said, "I don't know what to do. It's impossible." Nikolai said to her, "Let's write a letter to Stalin." At that time they had a box, near the Kremlin, "To Stalin." So Nikolai wrote the letter: "Our dear Father Stalin. I am such and such. What happened to me is thus and so. And I ask you kindly to help me."

One week passed. Two men came to Marika's apartment. "Grazhdanka [citizeness] Yurkevich, Maria Dionisovna, come with us to the OVIR." And she thought they were taking her to prison, you see, so she said "No, No." They laughed. "Don't be afraid, we will take you there." So she went. The same Ryazantsev, smiling. "Maria Dionisovna, hundreds of excuses. Here is your passport. It was a mistake. You can leave and nobody ..."

This is not a story which I heard from someone. This is my own sister.

Russia under the Communists was one of the most dismal places the world has seen in many centuries. But the two hundred million people there lived in a society which, after Stalin, seemed to be

staggering, however uncertainly, toward better things. Reject the Russia he knew Costakis never did. His was not merely a life in art, but a Russian life in art.

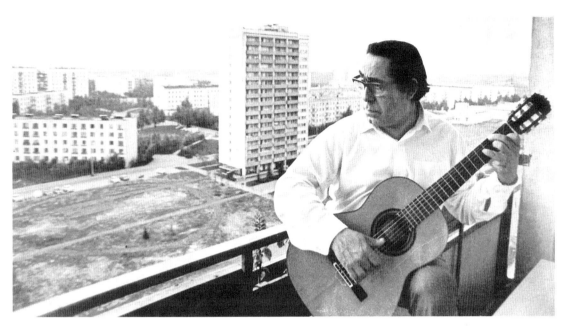

Costakis on the balcony of his last Moscow apartment, 59, Vernadsky prospekt, c. 1973.

◥

George Costakis died of heart failure in Athens on March 9, 1990, a year after he last saw his collection ("my children"), exhibited at the Montreal Museum of Fine Arts. He was seventy-seven. Shortly before his death he had undertaken the last of his many medical trips to Sweden (the first was in 1955) for one more attempt to make his legs work. He had been several years in and out of a wheelchair, and for the last year of his life entirely in one. The verdict of the Swedish doctors was that his heart was too weak to permit any surgery, and they proved to be right. He was buried in Athens on March 13 according to the Greek Orthodox rite (there was no Russian priest available) in the presence of his four children and several grandchildren, the Canadian and Soviet ambassadors, Greek officials, and some fifty friends, mostly Greek. His widow was not well enough to go to the graveside but presided over the reception which followed at the family house in Kifissia, north of Athens.

Moving and appropriate as the Athens ceremony was, under an unusually clear sky, and full of trees, flowers and birdsong, George himself, if permitted a view on the matter, would probably have preferred the other ceremony. This took place on the same day in Moscow, in his old apartment on Vernadsky prospekt, then occupied by his youngest daughter, Natasha, and her husband and children. Natasha herself was at the Athens funeral, but the inhabitants of Costakis' old Russian world, those who remained, crowded into the little apartment, half as big as when he had occupied it, and under the benign gaze of the saints and martyrs of his priceless icon collection, left with Natasha in 1978, marked the passing of their friend.

Costakis did not die a happy man. He was in constant pain, some of it resulting from a great variety of medical and quasi-medical treatments to which he grimly and vainly insisted on subjecting himself. His exile in Greece grated on him no less, and possibly more, than when it had begun ten years earlier. Never much interested in public affairs when he lived in Russia (few Russians were, in pre-Gorbachev days), he was now absorbed by them and utterly frustrated by his inability to view them at first hand and participate in the new freedom. (He had become such an impassioned admirer of Gorbachev that in a speech in Montreal, at the opening of the exhibition of his collection, he fervently besought the Canadian government, one of whose ministers was present, to send a shipload of "milk and razor blades" to help "Mikhail the Great" to survive.)

The April 4 auction in London, when three-quarters of the works offered went unsold, would have devastated him. It is as well he did not live to hear of it. Yet the disaster was really a thing of the moment, possibly Costakis' own fault, as the London newspapers suggested. The real value of the collection, aside from what it might fetch in this or that market, remains what it was – immense, incalculable.

In 1990 the Costakis collection moved from its warehouse in New York to another in Cologne. It demands a permanent home, permanent exhibition, not dispersed around the world on the walls of the rich, but as it was in Moscow, in one place, making the statement its creator wanted it to make. The statement is a strong one, because although the Russian avant-garde can be seen as a historical aberration, its mere existence holds a promise for the future. This small handful of painters, together with an even smaller one of writers, poets, composers, and architects, pointed the way for Russia. They declared in their work that Russia need not forever submit to tyranny. Their works of light let light into a dark world. George Costakis saw that, and by his solitary endeavour made it possible for the Russian avant-garde to speak its powerful message, loud, in Russia and everywhere.

INDEX